Ivory Vikings

ALSO BY NANCY MARIE BROWN

Nonfiction

Song of the Vikings: Snorri and the Making of Norse Myths

*The Abacus and the Cross: The Story of the Pope Who
Brought the Light of Science to the Dark Ages*

The Far Traveler: Voyages of a Viking Woman

*Mendel in the Kitchen: A Scientist's View of Genetically
Modified Food* (with Nina V. Fedoroff)

*A Good Horse Has No Color: Searching
Iceland for the Perfect Horse*

Fiction

The Saga of Gudrid the Far-Traveler

Ivory Vikings

THE MYSTERY OF THE MOST FAMOUS
CHESSMEN IN THE WORLD AND
THE WOMAN WHO MADE THEM

NANCY MARIE BROWN

St. Martin's Press
New York

www.stmartins.com

Library of Congress Cataloging-in-Publication Data

ISBN 978-1-137-27937-8 (hardcover)
ISBN 978-1-4668-7913-3 (e-book)

Brown, Nancy Marie.
 Ivory Vikings: the mystery of the most famous chessmen in the world and the woman who made them / Nancy Marie Brown.
 pages cm
 Includes bibliographical references.
 ISBN 978-1-137-27937-8 (hardback)
 1. Lewis chessmen. 2. Ivories, Romanesque—Scotland—Lewis with Harris Island. 3. Viking antiquities—Scotland—Lewis with Harris Island. 4. Lewis with Harris Island (Scotland)—Antiquities. I. Title.
 NK4696.2.G7B76 2015
 736'.6209411—dc23
 2015002532

St. Martin's Press books may be purchased for educational, business, or promotional use. For information on bulk purchases, please contact the Macmillan Corporate and Premium Sales Department at 1-800-221-7945, extension 5442, or write to specialmarkets@macmillan.com.

First Edition: September 2015

10 9 8 7 6 5 4 3 2

For Will and Mel,
who made me appreciate games

Contents

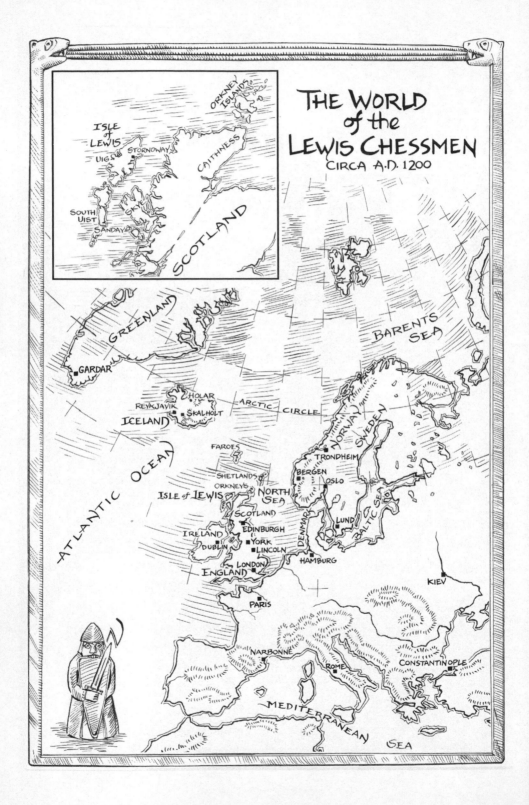

INTRODUCTION

Che Missing Pieces

In the early 1800s, on a golden Hebridean beach, the sea exposed
an ancient treasure cache: ninety-two game pieces carved of ivory
and the buckle of the bag that once contained them. Seventy-eight
are chessmen—the Lewis chessmen—the most famous chessmen in the
world. Between one and five-eighths and four inches tall, these chess-
men are Norse netsuke, each face individual, each full of quirks: the
kings stout and stoic, the queens grieving or aghast, the bishops moon-
faced and mild. The knights are doughty, if a bit ludicrous on their cute
ponies. The rooks are not castles but warriors, some going berserk, bit-
ing their shields in battle frenzy. Only the pawns are lumps—simple
octagons—and few at that, only nineteen, though the fourteen plain
disks could be pawns or men for a different game, like checkers. Alto-
gether, the hoard held almost four full chess sets—only one knight, four
rooks, and forty-four pawns are missing—about three pounds of ivory
treasure.

Who carved them? Where? How did they arrive in that sandbank—
or, as another account says, that underground cist—on the Isle of Lewis
in westernmost Scotland? No one knows for sure: History, too, has many

pieces missing. To play the game, we fill the empty squares with pieces of
our own imagination.

Instead of facts about these chessmen, we have clues. Some come
from medieval sagas; others from modern archaeology, art history, fo-
rensics, and the history of board games. The story of the Lewis chessmen
encompasses the whole history of the Vikings in the North Atlantic,
from 793 to 1066, when the sea road connected places we think of as far
apart and culturally distinct: Norway and Scotland, Ireland and Iceland,
the Orkney Islands and Greenland, the Hebrides and Newfoundland.
Their story questions the economics behind the Viking voyages to the
West, explores the Viking impact on Scotland, and shows how the whole
North Atlantic was dominated by Norway for almost five hundred years,
until the Scottish king finally claimed his islands in 1266. It reveals the
struggle within Viking culture to accommodate Christianity, the ways
in which Rome's rules were flouted, and how orthodoxy eventually pre-
vailed. And finally, the story of the Lewis chessmen brings from the
shadows an extraordinarily talented woman artist of the twelfth cen-
tury: Margret the Adroit of Iceland.

The Lewis chessmen are the best-known Scottish archaeological
treasure of all time. To David Caldwell, former curator at the National
Museum of Scotland in Edinburgh, where eleven of the chessmen now
reside, they may also be the most valuable: "It is difficult to translate that
worth into money," he and Mark Hall wrote in a museum guidebook in
2010, "and practically impossible to measure their cultural significance
and the enjoyment they have given countless museum visitors over the
years." Or, as Caldwell phrased it to me over tea one afternoon in the
museum's cafeteria: "If you knew what they were valued at, you wouldn't
want to pick one up."

Too late for that. I'd already spent an hour handling four of them.
Out of their glass display case, they are impossible to resist, warm and
bright, seeming not old at all, but strangely alive. They nestle in the
palm, smooth and weighty, ready to play. Set on a desktop, in lieu of the
thirty-two-inch-square chessboard they'd require, they make a satisfy-
ing *click*. The king, queen, and rook I chose are all about the same size:
two and three-quarters to three and a quarter inches tall. The bishop is
much bigger—over three and a half inches to the peak of his pointed

miter—obviously from a different set, I thought, though it's hard to sort the fifty-nine face pieces by size. You can make two sets—then the system falls apart. The Lewis hoard may represent more than four chess sets. There may be more pieces missing than we think.

Perhaps some—broken or decayed—were left behind in that sandbank or cist by whoever discovered them. Written accounts of the find are contradictory. But the collection does seem to have been sorted. The chessmen we have are remarkably well preserved for having lain in the ground for six hundred–some years. Except for the spider web of surface cracks no one can explain (worm channels? etching by acids secreted by plant roots? damage by marine gastropods?) and a dark mottling to his creamy color, the bishop in my hand looks brand new. Dressed in chasuble and miter, he clasps his crozier close to his cheek and raises his right hand in an awkward blessing. He has an enormously long thumb. His nose is straight, his eyes close set, his mouth crooked with a bit of an overbite. He's a jowly fellow, too—no ascetic here. He's carved from a prime section of walrus tusk, I see, turning him upside down: I can barely tell where the smooth ivory surface of the tusk gives way to its darker, grainier core.

The rook, too, was made of quality ivory. He's uniformly shiny, though he sports the same speckling of fine cracks as the bishop. He brandishes his sword and bites his kite-shaped shield, berserk fashion. His buck teeth aren't straight. His nose isn't either: It looks broken. Like the bishop's, his garment is simple. It seems to be just a long coat, perhaps of leather. A few strong grooves mark the fabric's folds; a line of dots on his cuff suggests ornament. His helmet is a plain conical cap.

Neither rook nor bishop displays the carver's skill. Their strength comes from the design, not the details. The opposite is true of the king and queen I examined next. Seated on richly decorated thrones, they have terrible posture. Their spines hunch, their heads jut forward; they look old and almost all done in. She is brooding, her jaw clenched. He is morose, gloomy, defeated—I would not want to play with this fey monarch. The carving is incredibly fine. His beard is neatly trimmed; his hair twists into four long locks. Hers is plaited into braids, looped up under a veil that is clipped in the back, very fancy, under an open fleurs-de-lis-topped crown. His heavy robes fall in cascades of folds. She wears

a pleated skirt, a short gown, a robe with embroidered or fur-trimmed edges, a jewel at her throat, her wrists ringed with bangles. He grips a sheathed sword athwart his knees. She claps her right hand to her cheek, cradles her elbow with the left: Her left thumb curves back like mine does.

To me, they are clearly a pair—even the scrolls of foliage on their throne backs are similar. Yet Caldwell's colleague Caroline Wilkinson, a professor of forensic art, believes they were carved by two different artists. Analyzing all fifty-nine face pieces from the Lewis hoard using a computerized grid system, she concluded in 2009 that Artist C carved this queen and fourteen other chessmen; Artist D carved the king. Caldwell, intuitively, lumped together groups B and D and split group C into several artists, since the pieces, to him, ranged from competent to "crudely carved."

I would not call this queen crude. I chose this particular royal pair to examine because I knew their materials were substandard. The sections of tusk they were made from, as you can see by turning them upside down, were defective. Their bases are C-shaped: The smooth ivory rim rings only three-quarters of the pocked and pitted core of the tusk. The king's carver simply made do: One side of the king's face, body, and throne are darker and rougher, as if poorly polished. The queen's carver carefully attached an ivory plate to improve the looks of the throne. The fit is so delicate it's difficult to see, even under a magnifying lens. Not until I blew up my photographs did I notice the four tiny ivory pegs that fasten the plate.

Still, the queen's right hand, the hand pressed to her cheek in worry or grief, shows the irregular pattern of the walrus tusk's core. Over the centuries, a bit has flaked off. There's a hole in her hand. A little longer in that cist or sand dune and she would have lost her wrist where it was cut away, so carefully, from her body. It's an exquisite piece of work using shoddy materials. It speaks to me of thrift, pride, determination, and skill. I can imagine the artist calling out "Don't toss that lump away," then putting all her art into the carving of this, the smallest of all fifty-nine face pieces.

Hold this thoughtful little queen in your hand and it's easy to become enthralled.

AN ARTIST NAMED MARGRET

At the British Museum in London, which owns forty-eight face pieces, the octagonal pawns, the plain discs, and the buckle, the Lewis chessmen are "ideal gateway objects": "Visitors actively seek them out and are drawn to them when they enter gallery spaces," say experts on museum design.

In *A History of the World in 100 Objects,* the museum's popular series on BBC Radio 4, the Lewis chessmen are, chronologically, Number 61, but their curator at the time, James Robinson, admits on the show that "few objects compete with the Lewis chessmen in terms of their popular appeal." Elsewhere he likens them to the marble friezes from the Greek Acropolis: "These Lewis chessmen," Robinson says, "are my Elgin Marbles." He adds, "Despite their miniature size, they might be seen to embody truly monumental values of the human condition."

Chess players are also enamored of the Lewis chessmen. As the earliest sets to include bishops, among the first with queens, and the only ones to use Viking berserks as rooks, they are "the most famous and important chess pieces in history," writes Dylan Loeb McClain, the chess columnist for the *New York Times.* A Lewis knight is embossed on the cover of H. J. R. Murray's nine-hundred-page treatise on the history of chess, published in 1913 and still considered *the* authority on the game. When robotics engineers in 2011 were looking for a chess set to test Gambit, "a custom, mid-cost 6-DoF robot manipulator system that can play physical board games against human opponents in non-idealized environments," they chose the Lewis chessmen—using resin replicas, of course.

The chessmen are icons of the Viking Age—despite having been made a hundred years or more too late. *Viking Age Iceland* (2001), *The Viking Age: A Reader* (2010), *The Vikings and Their Age* (2013), and other histories of the Vikings sport Lewis rooks on their dust jackets. Curators of Viking exhibitions favor the Lewis chessmen too. At the Danish National Museum in 2013, three shield-biting Lewis rooks shared exhibit space with a skull with filed teeth (a Viking beauty treatment); miniature swords, axes, and spears (possibly magical amulets); full-sized weapons, including shield bosses, a bow and arrows, helmets, and

swords; and a collection of folding combs (Vikings were notoriously fussy about their hair).

Generations of British children grew up calling the chessmen "Nogs," the name given them by animators Oliver Postgate and Peter Firmin, whose *Saga of Noggin the Nog* aired on the BBC from the 1950s to the 1990s. They are Harry Potter's chess set: Before a life-or-death match in the 2001 film *Harry Potter and the Sorcerer's Stone,* Harry learns wizard's chess from the Lewis chessmen—which come to life, a queen rising from her royal throne to throw it at her opponent. They come to life, likewise, to whisk a little girl off on a mythic adventure in *The Sleeping Army,* a 2011 children's book by Francesca Simon of "Horrid Henry" fame, and in the 2012 Disney-Pixar film *Brave,* to teach a feisty princess about "war and chaos and ruin."

In Ingmar Bergman's *Seventh Seal* (1957), Max von Sydow plays chess against death using Lewis knights. The chessmen appear in *Le Bossu* (1959), *Becket* (1964), and *The Lion in Winter* (1968).

They grace the cover of an Agatha Christie mystery. They figure in the plots of a 2012 story in the Doctor Who series and a 2013 thriller set on Lewis, *The Chessmen* by Peter May.

Poems have been written about them, and songs. Sings Scottish balladeer Dougie MacLean: "Out of an age when time was young / Across the silver ocean's floor . . . / They come with tales too dark to speak / But the fascination holds / Compels us on to search and seek . . ."

No one disputes the cultural importance of the Lewis chessmen.

No one disputes that they were made of walrus ivory from Greenland (except four made of whale's tooth), and the consensus is pretty firm that, based on the type of miter the bishops wear, they must have been carved after 1140, when episcopal fashions changed.

But ask where the Lewis chessmen come from—or who carved them—and fists start to fly.

In 1832, in the first scholarly account of the find, Frederic Madden of the British Museum zeroed in on "one peculiarity" of the rooks: "the singular manner in which they are represented *biting their shields.*" Such behavior was typical of berserks, stock characters in the Icelandic sagas and said to be the warriors of the Norse god Odin by the thirteenth-century Icelandic writer Snorri Sturluson. For this and other literary

reasons, Madden concluded that the Lewis chessmen "were executed in Iceland about the middle of the twelfth century."

His argument held until 1874, when Antonius Van der Linde of Norway attacked him on (ostensibly) philological grounds. As Willard Fiske noted in *Chess in Iceland* in 1905, the real reason was nationalistic fervor: "The mention of Iceland, or Icelandic chess," wrote Fiske, "is the red rag which is always sure to excite the critical rage of Dr. V. d. Linde. On such occasions, he assumes a sort of ox-eye glare, and proceeds at once to toss the object of his wrath high into the air."

Since then, art historians have compared the elaborate looping scrollwork on the backs of the kings', queens', and bishops' thrones to four ivory carvings in museums in Copenhagen and London. One was found on an island near Trondheim, Norway, in 1715; the provenance of the other three is unknown. The scrollwork also resembles English manuscript illuminations, wood carvings from Norway and Iceland, and stone carvings from England, Scotland, Sweden, and Norway, specifically from twelfth-century Trondheim.

Archaeologists have also turned up evidence. In the 1880s, a broken ivory figurine thought to be the Virgin Mary was unearthed in the rubble of Saint Olav's church in Trondheim. In 1990, it was identified as a Lewis chess queen—based on a sketch, since the figurine itself has vanished—and the researchers posited "a workshop, drawing on a pool of indigenous skills and techniques, an abundant supply of ivory, and located in an appropriate and dynamic cultural setting" at the nearby archbishop's palace in Trondheim, where the Lewis chessmen could have been made.

Yet, a few years earlier, a bit of ivory looking like the front feet of a Lewis knight's horse was found in Lund, Sweden, without claims for a chess-carving workshop there. Nor is a workshop proposed for the similar chess queen found in a bog in Ireland in 1817, a broken (and perhaps unfinished) chess queen recovered from an Inuit camp in Greenland in 1952, or three chess pieces without any provenance at all—a broken bishop in the British Museum, a knight in the Bargello in Florence, and a king in the Louvre in Paris—all of which resemble the Lewis chessmen as closely as does the sketch of the broken Trondheim queen.

Strangely, none of the physical tests archaeologists now standardly use have been tried on the chessmen. Asked why not, Caldwell, of the

National Museum of Scotland, told me, "As curators, we have a respon-
sibility to not damage our objects." Even taking samples the size of a
fingernail paring—all that's needed—from the undersides of a selection
of chessmen would be doing damage and so is anathema to a museum
curator. Nor would the results, Caldwell believes, settle any arguments.
Carbon dating, which relies on the amount of radioactive carbon-14 in a
sample, gives a range of dates, usually spanning fifty years or more; the
debate over the Lewis chessmen swings on twenty to twenty-five years.
An analysis of the strontium isotopes in the ivory could pinpoint Green-
land as the source of the tusk, but that's already generally assumed.

When in 2010 Caldwell and Hall wrote that "the limited evidence
favors Trondheim," their main argument was that "most scholars would
at present expect to locate the manufacture of such pieces in a town or
large trading centre. The craftsmen who made such prestigious items
were, perhaps, more likely to thrive in such a setting."

That same year, Icelandic chess aficionado and civil engineer Gud-
mundur G. Thorarinsson resurrected Frederic Madden's thesis that the
Lewis chessmen were carved in Iceland. At the cathedral of Skalholt in
southern Iceland between 1195 and 1211, he pointed out, a woman was
hired to carve luxury items out of walrus ivory for Bishop Pall Jonsson
to send to his colleagues in Denmark, Norway, Scotland, and Green-
land. The thirteenth-century *Saga of Bishop Pall* records that he sent the
archbishop of Trondheim "a bishop's crozier of walrus ivory, carved so
skillfully that no one in Iceland had ever seen such artistry before; it
was made by Margret the Adroit, who at that time was the most skilled
carver in all Iceland." Margret, Thorarinsson concluded, could have
made the Lewis chessmen under a similar commission from the bishop.

Thorarinsson posted his theory about Margret and Bishop Pall on
the Internet. It was not well received. "The Lewis chessmen were never
anywhere near Iceland!" sniffed a Norwegian chess master on the web-
site ChessCafe.com. Hearing of a seminar planned for Edinburgh, tied
to a traveling exhibition of the Lewis chessmen, Thorarinsson attempted
to present his idea there. When an invitation to speak did not material-
ize, he and a friend went anyway. "These two characters came up from
Iceland, turned up unannounced, and crashed the seminar!" Caldwell
told me, laughing about it in retrospect. "We didn't know how to handle

it." In a prepared statement to the press, Caldwell reiterated his belief that the chessmen were made in Norway, adding, "I am pleased that our own research and our extremely popular exhibition *The Lewis Chessmen: Unmasked* is reigniting debate and discussion."

Alex Woolf, a medievalist from the University of Saint Andrews in Scotland, was less diplomatic. As the *New York Times* reported, "The walrus tusk used to make the chessmen was expensive, and the pieces would have had to have been made where there were wealthy patrons to employ craftsmen and pay for the material. 'A hell of a lot of walrus ivory went into making those chessmen, and Iceland was a bit of a scrappy place full of farmers,' Dr. Woolf said. The pieces are also exquisite works of art, he said, adding, 'You don't get the Metropolitan Museum of Art in Iowa.'"

THE ICELANDIC SAGAS

It was Woolf's snide "a scrappy place full of farmers" that caught my eye. Thorarinsson, I saw, had overestimated his audience. He thought they knew the history of Iceland and Norway in the twelfth and thirteenth centuries. He thought they knew about the influential Bishop Pall.

But why would they? The primary texts are in Icelandic. Not all are available in English translations, and, of those that are, the easiest to find are dismissed as fiction. The *Saga of Bishop Pall* is rarely read. The Bishops' Sagas as a genre, says one expert, are "backwards, stilted in style, and schlocky in hagiographical excess."

Non-Icelandic sources do exist. Clerics writing in Latin in the twelfth century knew about Iceland's powerful bishops. In his *Description of Ireland* of 1185, Gerald of Wales wrote:

> Iceland, the largest of the northern islands, lies at the distance of three natural days' sail from Ireland, toward the north. It is inhabited by a race of people who use very few words, and speak the truth. They seldom converse, and then briefly, and take no oaths, because they do not know what it is to lie; for they detest nothing more than falsehood. Among this people the offices of king and priest are united in the same person. Their prince is their pontiff. Their bishop performs the functions of government as well as of the priesthood.

Adam of Bremen, writing his *History of the Archbishops of Hamburg-Bremen* about a hundred years earlier, said much the same: "They hold their bishop as king. All the people respect his wishes."

For both Adam and Gerald, travel to Iceland was commonplace (if uncomfortable). To situate Ireland on the map, Gerald placed it halfway "between the cold of Iceland and the heat of Spain." Wrote Adam of the North Atlantic (which he poetically dubbed "the Ocean Called Dark"):

> It is of immense breadth, terrible and dangerous, and on the west en-compasses Britain to which is now given the name England. On the south it touches the Frisians and the part of Saxony that belongs to our diocese of Hamburg. On the east there are the Danes and the mouth of the Baltic Sea and the Norwegians, who live beyond Denmark. On the north that ocean flows by the Orkney Islands and then encircles the earth in boundless expanses. On the left there is . . . Ireland. On the right there are the crags of Norway, and farther on the islands of Iceland and Greenland.

To other writers, Iceland was a land of eager historians. The Norwegian chronicler Tore the Monk described the process of compiling his *History of the Ancient Kings of Norway* in about 1180 as "making the most dili-gent inquiries I could among those whom we in our language call Ice-landers. It is well known that they without doubt have always been more knowledgeable and more inquisitive in matters of this kind than all the other northern peoples." In his *History of the Danes,* written around the year 1200, Saxo the Grammarian concurred:

> The diligence of the men of Iceland must not be shrouded in silence; since the barrenness of their native soil offers no means of self-indulgence, they pursue a steady routine of temperance and devote all their time to improving our knowledge of others' deeds, compensat-ing for poverty by their intelligence. They regard it a real pleasure to discover and commemorate the achievements of every nation; in their judgment it is as elevating to discourse on the prowess of others as to display their own. Thus I have scrutinized their store of historical treasures and composed a considerable part of this present work by

copying their narratives, not scorning, where I recognized such skill in ancient lore, to take these men as witnesses.

Both Saxo and Tore had met Bishop Pall.

In Bishop Pall's day, around the year 1200, Iceland was at the peak of its Golden Age: rich, independent, and in a frenzy of artistic creation. Though its population, at 40,000, was one seventh that of Norway, Iceland had long provided the *skálds*, or court poets, of the Norwegian kings; now Icelanders became the official biographers of kings Sverrir (who ruled Norway from 1184 to 1202), Hakon (1217–1263), and Magnus (1263–1280). From 1118 through the 1300s, medieval Icelanders produced prose works at an enormous rate; measured against the handful of medieval Norwegian texts we have, Iceland's literary output was prodigious. First came a law book; next, a history of the island, commissioned by Iceland's two bishops. After this *Book of the Icelanders* came chronicles of the kings of Norway and Denmark and the earls of Orkney; stories of Iceland's first settlers; treatises on grammar, astronomy, medicine, poetics, and mythology; annals; saints' lives, sermons, and collections of miracles; biographies of bishops and the history of Christianity in the country; translations of Bede, Isidore of Seville, Sallust, *Elucidarius, Physiologus*, Saint Gregory's *Dialogues,* and *The Prophecies of Merlin*; romances and fantastical tales of trolls and dragons, werewolves and sorcerers; stories of Greenland, of Viking raids, of voyages to Constantinople or to the New World, of famous feuds and love affairs, of poets and outlaws; even a *Guide to the Holy Land*. More medieval literature exists in Icelandic than in any other European language except Latin.

Confusingly, 140 of these Icelandic texts are labeled "sagas." Derived from the Icelandic verb "to say," *saga* implies neither fact nor falsehood. Today we place the sagas in several genres—Family Sagas, Sagas of Ancient Times, Kings' Sagas, Contemporary Sagas (including the Bishops' Sagas), Knights' Tales (some original, some translated from other languages), and Saints' Lives. Most of these distinctions were unknown in Bishop Pall's day.

The best, the ones people usually mean when they say "the Icelandic sagas," are the Family Sagas. "The glory of the sagas is indisputable"; they are "some sort of miracle," scholars gush. "In no other literature

is there such a sense of the beauty of human conduct." Others praise the sagas' "earnest straightforward manner," their crisp dialogue and "simple, lucid sentence structure," their individualistic characters, their gift for drama, their complex structure, "the illusion of reality which they create," and their sophisticated use of "the same devices that we are accustomed to from modern suspense fiction." The Family Sagas are "a great world treasure," comparable to "Homer, Shakespeare, Socrates, and those few others who live at the very heart of human literary endeavor."

Not all critics have waxed so rhapsodic. An eighteenth-century writer dismissed their theme, memorably, as "farmers at fisticuffs," and farmers—not knights or kings—do take center stage in these stories. In *Njal's Saga,* a farmer on an ungovernable horse rides down another farmer sowing his grain; a feud escalates. In *Egil's Saga,* two farmers argue over grazing rights. In *Laxdaela Saga,* one farmer steals another's horses. Saga heroes feud over dowries, ship ownership, the cutting of firewood, the price of hay, and stolen cheese. But they also go on voyages to Greenland; take part in Viking raids throughout Western Europe; interact with the kings of Norway, Denmark, Sweden, England, various Baltic principalities, and Russia; trade with merchants in Dublin and Hedeby and a dozen other market towns; make pilgrimages to Rome and Jerusalem; and hire themselves out as bodyguards in Constantinople.

Taken together, the forty or so Family Sagas describe Icelandic society from its settlement in about 870 through the conversion to Christianity in 1000 and up until about 1053, when the first Icelandic bishop was elected. Dense with genealogies and overlapping character sets, they paint a believable picture of a country in which complex laws and a strong sense of personal honor let people live with a good deal of freedom and comfort in a harsh environment.

DRAGONS

How faithful the sagas are to history has bedeviled readers for hundreds of years. Icelanders themselves are dubious. One writing in 1957 considered the sagas too good to be true: "A modern historian will for several reasons tend to brush these sagas aside as historical records. . . . The

narrative will rather give him the impression of the art of a novelist than of the scrupulous dullness of a chronicler."

Archaeologists, too, dismiss the sagas as fiction, though there are notable exceptions. Jesse Byock, an American who has led excavations in Iceland for twenty years, and his colleague Davide Zori wrote in 2013, "We employ Iceland's medieval writings as one of many datasets in our excavations, and the archaeological remains that we are excavating . . . appear to verify our method." Of their team's discovery of a Viking Age church and graveyard, they said, *Egil's Saga* "led us to the site."

Like any medieval source, sagas have to be read critically to sift fiction from fact. Dialogue is always fiction. Chronology is usually confused. Rituals and customs are tainted by those of the writer's own times, which could be the vigorous and independent Iceland of 1180, the war-torn new colony of Norway in 1280, or the soon-to-be-forgotten outpost of Denmark in 1380. Poems embedded in the sagas may better preserve the views of an earlier age—but only if we can parse their meaning.

Even scrupulously dull medieval texts are generally more reliable the closer they were penned to the era they describe. When the authors' names are known, or when they cite their sources, we can more easily assess their biases.

Then we hunt for dragons.

The *Anglo-Saxon Chronicle* has dragons. Geoffrey of Monmouth's *History of the Kings of Britain* has dragons. Adam of Bremen and Gerald of Wales both have dragons. Discard every text that mentions dragons and we'd have no medieval histories at all.

The Family Sagas, on a dragon scale of one to ten, rank about four or five. All of these sagas are anonymous, though one of the greatest, *Egil's Saga*, may have been written by Bishop Pall's foster brother, Snorri Sturluson, perhaps as early as 1202. By Pall's death in 1211, several Family Sagas had been composed. In these sagas, omens are common. Sorcerers conjure up snowstorms and cause shipwrecks. The dead come back to haunt. *Egil's Saga* hints at werewolves, though we aren't really sure what happens to the man named "Evening-Wolf" after dark. There are no actual dragons.

One early saga in this genre, the *Saga of the Heath-Killings,* is especially pertinent to the history of the Lewis chessmen. In it, a chess-playing berserk woos a girl over the game while her father pretends it is just not happening. (Berserks were not good sons-in-law.) The word translated as "chess" is *tafl,* a cognate to our word *table,* meaning any game played on a board. Some sagas refer to *hnefatafl,* roughly "fist-table," a game in which a single king, protected by his band of warriors, fights against a horde of enemies that outnumbers them two to one—a very Viking scenario. A few sagas say *skáktafl—skák* is still the Icelandic word for chess—or make it clear which board game is meant by reference to knights or bishops or the word *checkmate.* Here's where interpretation gets tricky. At the time the *Saga of the Heath-Killings* was written, it's safe to say that "chess was already associated with romance in Scandinavia as in the rest of Europe," as historian Marilyn Yalom concludes, "although it was probably unknown in Iceland, circa 1000, where the story was set."

In general, we can think of the Family Sagas as historical novels: They tell us what people of Bishop Pall's time thought was true about Iceland's early days.

The Sagas of Ancient Times, the second genre, score nines and tens on our dragon scale. We would call these sagas fantasy, not history. They have a preponderance of dragons, trolls, ghosts, werewolves, and the walking dead and feature legendary heroes like Sigurd the Dragon-Slayer and Ragnar Lothbrok. But they can still be useful to a historian. The anonymous *Saga of King Heidrek the Wise,* for example, revolves around the legend of a flaming sword made by dwarfs. The story begins in a mythical age of Goths and Huns (possibly the fifth century) and ends with the genealogies of Swedish kings down to 1125. It may have been composed in the twelfth century, since it influenced *Egil's Saga.* It contains a marvelous set-piece, in which a valkyrie-like warrior-woman named Hervor magically opens her father's grave and demands his sword. Hervor, we later learn, is also a chess master. Disguised as a man and calling herself Hervard, she is at court one day watching King Gudmund play chess. "His game was pretty much over when he asked if anyone could offer him some advice. Hervard stepped up and studied the board, and after a little while Gudmund was winning." The word

used here is *skáktafl*—clearly the writer of the saga (if not the valkyrie) knew chess.

Some of the Kings' Sagas also score tens on the dragon scale. In *Ynglinga Saga,* the beginning of his massive collection of sixteen sagas called *Heimskringla,* Snorri Sturluson, writing between 1220 and 1241, traces the founding of the kingdom of Norway to Odin, a one-eyed wizard who could transform into a dragon, raise the dead, foretell the future, converse with ravens, slake fire, still the sea, turn the winds every which way, and crack open the earth with a song—indeed, a figure very much like the god Odin whom Snorri writes about in his *Edda,* where, to explain the art of the skald, or Viking poet, Snorri compiled most of what we know about Norse mythology.

At the other end of the dragon scale is a King's Saga crucial to understanding the world of the Lewis chessmen, the *Saga of King Sverrir.* It was written by Karl Jonsson, abbot of the Icelandic monastery of Thing-eyrar, who was a member of the Norwegian king's court between 1185 and 1190. The abbot wrote the first part of the saga, one manuscript says, "while King Sverrir himself sat next to him and determined what he should say." Karl finished writing before he died in 1212—ten years after the king.

Between these two extremes lie sagas like Snorri's *Saga of King Olaf the Saint.* It includes a famous chess match between Canute the Great, king of Denmark and England, and his captain, Earl Ulf, in the Danish capital of Roskilde on the eve of Saint Michael's day, 1027: "Then the king played a great 'finger-breaker.' The earl put him in check with a knight. The king took his piece back and said that he would try another play. That made the earl angry and he upset the chessboard." The king, already in a foul mood, had the earl killed. H. J. R. Murray, in *The History of Chess,* calls this episode "the earliest appearance of chess in the Norse lands," if, he adds, "the record can be accepted as historical." It can't; Canute probably played the older game, *hnefatafl.* What the record does prove is that chess was the game of kings around 1220, when Snorri Sturluson was writing.

The *Saga of Bishop Pall,* with its story of an artist named Margret the Adroit, falls into the category of Contemporary Sagas. These sagas were composed within a generation of the actions they describe. Like

the *Saga of King Sverrir,* they are as historical as any medieval chronicle can be—twos on the dragon scale—given the era's general acceptance of prophetic dreams, omens, miracles, and divine intercession. Their authors, some of whose names we know, were often eyewitnesses to the events they describe. They wrote, as the author of *Hrafn's Saga* says, to set the record straight: "Many events, as they occurred, fade from men's memories, and some are otherwise told than how they took place, so that many men believe what is false and doubt what is true. And because 'Lies flee when they meet the truth,' we are here going to write about certain events that happened in our own days and concern men known to us, of which we know the truth."

THE CATHEDRAL AT SKALHOLT

Gudmundur G. Thorarinsson, who crashed the seminar on the Lewis chessmen to champion Margret the Adroit, was thought at one time to be a good candidate for prime minister of Iceland. He is patient, soft-spoken, warm-hearted, and, underneath it all, a bit of a showman—it was he who organized the famous chess match between Bobby Fischer and Boris Spassky in Reykjavik in 1972. Thorarinsson likes to give speeches and is often called upon to provide the after-dinner entertainment for meetings of civic groups. For the hundredth anniversary of the Reykjavik Chess Club in 2000, he wanted to do something grand. "I started looking at the history of chess in Iceland," he recalled when we met in Reykjavik. "One of our grandmasters said, 'Have you seen the Lewis chessmen?'"

Thorarinsson read Madden's 1832 treatise on "the ancient chessmen discovered in the Isle of Lewis." He read Fiske's 1905 *Chess in Iceland.* He read Murray's 1913 *History of Chess.* He read Sveinbjorn Rafnsson's 1993 *Páll Jónsson Skálholtsbiskup* and Helgi Gudmundsson's 1997 *Um Haf Innan*—neither of which is accessible to scholars who don't read Icelandic. But mostly he read the sagas, the difference between medieval Icelandic and the modern dialect being negligible. *Íslenzk fornrit,* the Old Icelandic Text Society in Reykjavik, has been commissioning definitive critical editions of the sagas since 1933. Twenty-four volumes, most containing several sagas, have been published. The *Saga of Bishop Pall* appeared,

providentially, in 2002; reading it, Thorarinsson was intrigued by the story of Margret the Adroit and her patron, Bishop Pall.

Born in 1155, Pall was the great-grandson of King Magnus Bare-Legs of Norway, who conquered northern Scotland, the Hebrides, and the Orkney and Shetland Islands, and took his nickname from his fondness for wearing kilts. King Magnus reigned from 1093 to 1103; his line ruled Norway through 1266, when northern Scotland and the isles returned to the Scottish crown as part of the Treaty of Perth. During that century and a half, King Magnus's Icelandic kinsmen routinely visited Norway, where they were recognized as royalty.

Connections between Iceland and the Scottish isles were equally tight. Bishop Pall's brother Saemund was betrothed to the daughter of the earl of Orkney, but the wedding was never held: The two families could not agree on which had the higher status and which should be forced to sail to the wedding.

Bishop Pall himself became, in his youth, a retainer of Earl Harald, who ruled the Orkney Islands and Caithness in northern Scotland and, sometimes, controlled Lewis and other islands in the Hebrides as well. Pall attended school in England, probably at Lincoln Cathedral, where his uncle, Bishop Thorlak, had studied. Back in Iceland, Pall became a wealthy chieftain. Married and with four children, he was known for the breadth of his book learning and his excellent Latin, the extravagance of his banquets, the beauty of his singing voice, and his love of fine things. He is believed to have written both a history of Denmark (now lost) and the *Orkney Islanders' Saga,* a history of the earls of Orkney.

When elected bishop in 1194, Pall sailed first to Trondheim to be consecrated but found no archbishop there: Archbishop Eirik had quarreled with King Sverrir (who was soon to be excommunicated) and had taken refuge in Denmark. King Sverrir was holding court near Oslo; there Pall was ordained a priest, though he apparently refused to divorce his wife. Pall continued south to Roskilde in Denmark, where he met King Knut. Across the bay in Lund (then in Denmark, now in Sweden), Pall was finally consecrated a bishop by Archbishop Absalon, for whom Saxo the Grammarian was then writing his history of Denmark. Pall was likely one of Saxo's sources.

At Skalholt in southern Iceland, Bishop Pall's predecessors had built the largest wooden church in all of Scandinavia, even though the wood had to be imported. (Iceland has no tall trees.) In the *Saga of Bishop Pall*, thought to have been written by Pall's son, we read that Pall beautified Skalholt Cathedral with imported glass windows and a tall bell tower, splendidly painted inside, and commissioned an altar screen of gold, silver, and ivory. The ivory was carved by an artist named Margret the Adroit; the rest of the work was done by Thorstein the Shrine-Smith, also in the bishop's employ. Thorstein had earned his nickname constructing the shrine of Saint Thorlak, Pall's uncle and predecessor, who was declared a saint in 1198. The shrine, or reliquary, to hold Saint Thorlak's holy bones was four and a half feet long; made of wood in the shape of a house, it was plated with silver and gold and adorned with jewels.

When Skalholt Cathedral burned to the ground in 1309, Pall's windows and tower and altar screen were destroyed. Saint Thorlak's reliquary, rescued from the fire, did not survive the Reformation: In 1550 it was stripped of its gold, silver, and jewels, which were sent to Copenhagen, since Iceland was then a Danish colony.

Yet two works of art from Bishop Pall's time remain: his stone coffin and his crozier. In his saga, his son writes, "He had a sarcophagus made with considerable skill, in which he reposed after his death." That stone coffin was unearthed in 1954 when a new church at Skalholt was rebuilt. Found inside, along with the bishop's bones, was a walrus-ivory crozier thought to be the work of Margret the Adroit; a similar crozier was found in a grave in Greenland. Both are exquisite works of art and, if Margret's, prove she was quite capable of creating the Lewis chessmen.

She had plenty of ivory at her disposal. Ships captained by Bishop Pall's kinsmen routinely traveled to Greenland to purchase walrus ivory and other luxury goods, such as white falcons. These Pall sent as gifts to his friends abroad, once via Bishop Gudmund the Good, who took an unplanned detour through the Hebrides on his way to Norway in 1202, and once by the hand of his own son, who visited the Orkney Islands and Norway in 1208. In return, Pall received gold rings, fine gloves, and a bishop's miter embroidered with gold.

Researchers have found no sign of an ivory workshop at Skalholt during Bishop Pall's reign—because they haven't looked. The church

and bishop's residence were located in the same place for centuries; revealing the twelfth-century archaeological layers would require destroying the seventeenth-century layers, uncovered in large-scale digs from 2002 to 2007. These layers date to the time of another important Icelandic bishop, whose interest in medieval manuscripts led to the rediscovery of Snorri Sturluson's works and thus the preservation of Norwegian history, Norse mythology, and much of what we know about Viking culture.

Yet a recent archaeological discovery suggests that the making of figural chess pieces in twelfth-century Iceland was common: A warrior-rook made of fishbone was found in a twelfth-century layer of a fishing station at Siglunes in northern Iceland in 2011. Though half the size and partly decayed from long burial in damp soil, it would not look out of place if lined up next to the Lewis rooks.

"There's a striking resemblance," noted Thorarinsson, who placed photographs of the Siglunes chessman and a Lewis rook side by side on the cover of his book, *The Enigma of the Lewis Chessmen*. "It's quite remarkable if the artist who made this one" —the Siglunes rook—"didn't know about *that* one"—found an ocean away on Lewis.

Did Margret the Adroit carve the Lewis chessmen under a commission from Bishop Pall? Unless the Skalholt dig is reopened and proof of an ivory workshop is found, we cannot say yes or no. But "the limited evidence" places Iceland on equal footing with Trondheim as the site of their creation.

With a single chess set, you can play an infinite number of games. So let's place our pieces on the board: the rooks, who tell us what the Lewis chessmen were made of and, roughly, where; the bishops, who suggest who might have commissioned them; the queens, including Margret the Adroit who could have made them; the kings, for whom the chessman would have been a royal gift; and the knights, who have championed the chessmen from the 1830s to today.

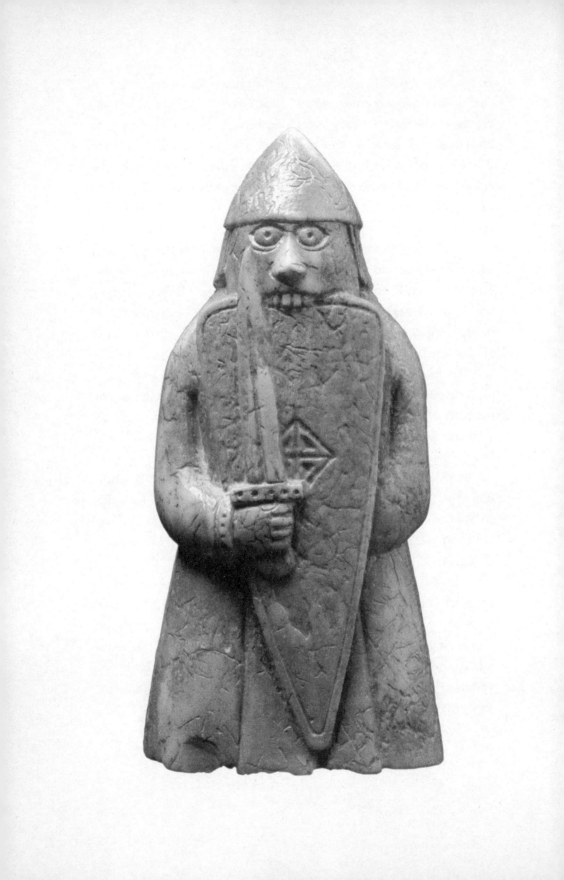

ONE

The Rooks

On the four corners of the chessboard stand the rooks. Ours are not towers. Castles did not come into fashion as rooks until the 1500s. Since the word *rook,* from Arabic *rukh,* means "chariot," you might expect our rooks to look like the four-horse chariots of another medieval ivory chess set, long identified as Charlemagne's own, though now thought to come from Norman Italy in the late eleventh century. Along with its chariot-rooks, this chess set has elephants instead of bishops and a vizier, not a queen: Chess originally, or as far back as history lets us see, was an image of the Indian army.

From India, this war game traveled through Persia to Baghdad, by then the capital of the Islamic empire. Islam prohibits the carving of idols; chess *men* became chess *pieces:* beautiful smooth lumps of stone or bone or ivory, with the merest points and projections to indicate which pieces were which. Abstract chess pieces arrived in Christian Spain by at least the year 1008, when a count near Barcelona bequeathed a rock-crystal set to a local church. One made of whale bone, with little faces peering out from polygonal sides, was found at the English manor of

Witchampton in Dorset in 1927. It has been dated (through a number of assumptions) to the late eleventh century and is thought to be Norse. Two unfinished pieces, one with two nubs denoting elephant tusks, were found beside rough sections of deer antler during excavations at Northampton, England, in 2014; the archaeologists named the site a carver's workshop and dated it to the late twelfth century.

Our twelve Lewis rooks, nine carved of walrus ivory and three of whale's tooth, are not lumps. Neither are they towers or charioteers: They are warriors. Four, as Frederic Madden of the British Museum pointed out in 1832, are rather peculiar: They're biting their shields. The army these chessmen represent is clearly a Norse one—a *late* Norse one, with queens, Christian bishops, and Viking berserks for rooks.

Berserks—meaning "bear-shirts" or "bare-shirts"—were the god Odin's warriors. Foot soldiers in the forefront of battle, they "wore no armor and were as mad as dogs or wolves, bit their shields, were as strong as bears or bulls. They killed other men, but neither fire nor iron could kill them. That is called going berserk," explained the thirteenth-century Icelandic writer Snorri Sturluson.

Sometimes the "bear-shirts" wore shirts of wolf skin instead. Harald Fair-Hair, king of Norway in the late ninth century, had a bodyguard of these "wolf-skins"; sang a skald who lived in Harald's time:

> *The berserks howled,*
> *battle was on their minds,*
> *the wolf-skins growled*
> *and shook their spears.*

In another stanza, a valkyrie, or battle goddess, asks a raven about Harald's berserks. The raven replies:

> *"Wolf-skinned are they called. In battle*
> *They bear bloody shields.*
> *Red with blood are their spears when they come to fight.*
> *They form a closed group.*
> *The prince in his wisdom puts trust in such men*
> *Who hack through enemy shields."*

Harald's Lay is the earliest known mention of berserks. Here they do not *bite* shields but hack through and bloody them. Yet by Snorri's day, when berserks next appear in literature, shield-biting defines them.

Over the next hundred years, they become stock characters—and ultimately buffoons, as in the *Saga of Grettir the Strong*. One of the last Family Sagas, written in the 1300s, Grettir's is almost an anti-saga, in which the values of the Viking Age are indicted. Grettir takes no guff from berserks. This one was on horseback: "He began to howl loudly and bit the rim of his shield and pushed the shield all the way into his mouth and snapped at the corner of the shield and carried on furiously." Grettir ran at him and kicked the shield. It "shot up into the berserk's mouth and ripped apart his jaws and his jawbone flopped down on his chest." End of berserk.

Our Lewis rooks are not yet buffoons, but neither are they Odin's warriors. Instead of animal skins, they wear long leather coats or gambesons; on three the coats are cross-hatched, as if depicting chain mail. All carry kite-shaped Norman shields—not the round shields we envision ranked along the gunwales of a Viking ship. None of our rooks has a spear to shake: They're armed with rather more expensive swords, another sign that these are late-Norse warriors, not Viking Age berserks. All but one have helmets; the odd one wears a chain-mail coif. Nine helmets are pointy caps, most with earflaps; they might or might not have noseguards. Two are quite different: One looks like a bowler hat, the other, a bucket. Some rooks are mustached and bearded, some clean-shaven. Their hair is cropped at the shoulders. Most glare straight ahead, one looks askance. They are stalwart, gruff, bold-looking bluffers, not terribly fierce, except for those four who are biting their shields. Beware: They are going berserk.

That one little detail, the berserk battle frenzy, marks these ivory warriors as men of the North: No other culture claims shield-biters. That and the material most are made of. "Fish teeth," the sagas call it. We call it walrus tusk.

TOOTHWALKERS

In the farthest north, at the edge of the Ocean Called Dark, lie long sloping beaches where walruses haul themselves out of the sea in the

thousands. The story of the Lewis chessmen originates here, where these elephantine relatives of fur seals congregate to this day, heaping themselves upon each other, tumbled so tight that some snooze sitting up, grunting and sighing, while others, roaring their annoyance, lash out at their neighbors to gain more space. Some laze on their backs, their long tusks pricking the sky. Up to twelve feet long and ten in circumference, each walrus weighs a ton or more. Their hides are, in places, three inches thick, wrinkled and scarred and infested with ticks; beneath is a four-inch layer of fat. Their color varies from almost white, when they first wriggle out of the icy sea, to a warm cinnamon brown, to pinkish if they overheat. Their heads are small, with wide, whiskered lips and tiny eyes; both male and female are tusked. All in all, they're silly-looking beasts, a favorite of cartoonists, who dress them in top hats.

They feed, for the most part, on clams. In 2001, for the first time, scientists filmed them eating in the wild: The beasts dived down to the seafloor and stood on their heads, "with their tusks resting like a sledge on the bottom." Waving one flipper over the sand, or squirting water jets from their lips, or grubbing with their whiskery vibrissae in the sediment, they uncovered clams' siphons, then sucked out the soft parts, leaving the clamshells, for the most part, behind. While bivalves make up most of their diet, walruses also eat worms, snails, soft-shell crabs, shrimp, sea cucumbers, and slow-moving fish. Some acquire a taste for seal, or small whales. Others eat seabirds or scavenge dead carcasses.

They are "filled with malice and curiosity," say twentieth-century walrus hunters, and highly dangerous at sea or on land, being prone to attack unprovoked. Startle them on their sunning grounds and they will stampede, humping panic-stricken into the sea to bob and duck and peer, blowing spray and sniffing the wind for an enemy to attack. In the sea their bulk is no handicap. They are streamlined killing machines. They will grab a seal and squeeze it to death. "After that they rip off the blubber fat and then eat the lot, skin and all," a hunter wrote in 1958. "I heard of a herd of walrus chasing a bear on to a rotten ice-floe. They then attacked the ice with their tusks, smashing it to pieces so that the bear fell into the water. The rest was a gory turmoil."

Said an eyewitness from 1914, "Our fragile craft would not have lasted a second if they had come for us."

And they are known to go for boats: "Up they came again immediately around the boat," wrote the polar explorer Fridtjof Nansen in the late 1800s. "They stood up in the water, bellowed and roared till the air trembled, threw themselves forward toward us, then rose up again, and new bellowings filled the air. . . . Any moment we might expect to have a walrus tusk or two through the boat, or to be heaved up and capsized."

One hunter's brother in the 1950s was taken right out of the boat: "He was standing in the prow of his boat, harpoon at the ready, when a great brute leapt out of the sea, struck at him viciously, and carried him off to sea. They never saw any more of him."

Even if you are not hunting them, they might be hunting you; wrote the same author:

> A Dane I knew came across some walruses one autumn in Germania Harbour. They caught sight of him and disappeared. Cursing his luck, our friend started to walk on, when to his surprise and horror there was a rending crack under his very feet, and a huge tusky head broke through the ice and stared at him. For a moment he stood rooted to the spot, then made off as fast as his feet could carry him towards the safety of the shore. As he ran, his footsteps were dogged, and even anticipated, by more resounding ice-cracks as a succession of hairy heads raised themselves from the depths to stare at him.

The Dane gained the land, but even a beached walrus can move fast and kill efficiently. "An eyewitness says that he once saw a polar bear stalk a young walrus and imprudently spring within reach of the maternal guardian," reports the hunter from 1914. "One drop of her mighty head buried the long tusks in his body and a few more blows ended the combat before his teeth or claws could seriously damage her thick hide." In his *Description of the Northern Peoples* of 1555, the Swedish antiquarian Olaus Magnus remarked of the walrus, "If it glimpses a man on the seashore and can catch him, it jumps on him swiftly, rends him with its teeth, and kills him in an instant."

Viking walrus hunters had no harpoons. In the absence of any historical sources, we can only guess how they hunted these dangerous beasts. Most likely not at sea, as dead walruses sink. If wounded on the ice, a dying beast will, with one twist, reach the water—and sink. On land the odds are highest of recovering the kill. Hunters in 1775 used lances and big dogs—both of which the Vikings possessed—and waited for a dark night and a wind from the sea. Then, with the help of their fearless elkhounds, sixteen men "cut" a herd of seven or eight thousand walruses, pushing into its midst, driving some of the beasts into the sea and the others farther inland, up the slope of the beach until "the darkness of the night deprives them of every direction to the water, so that they stray about and are killed at leisure, those that are nearest the shore being the first victims." Once the walruses' escape to sea is blocked by a wall of carcasses, the hunters can take their time spearing the ones trapped on land. The best attack is a blow to the back of the head, just behind the tiny earhole—then the lance will pierce the brain and the walrus will drop down dead. Otherwise the writhing, bellowing, thick-skinned monster is very difficult to dispatch. It can suffer any number of jabs to the body and still fight back. This group bagged fifteen hundred. A hunt recorded in 1603 killed between seven hundred and a thousand walruses in under seven hours. An observer in 1858 noted that "when drenched with blood and exhausted," one group of hunters returned to their ship, had their dinner, resharpened their lances, and went back to the killing fields refreshed; their final tally was nine hundred dead walruses. "In all my sporting life," he says, "I never saw anything to equal the wild excitement of these hunts." The men had gone berserk.

Our word *walrus* comes from the Old Norse for whale, *hvalr,* and horse, *hross.* In the Icelandic sagas, the walrus is called a small whale, but it's hard to see what's horselike about this sea mammal; it weighs twice as much as a Viking Age steed. The "whale-horse" was renamed "toothwalker," *Odobenus,* by taxonomists in the 1700s who thought walruses used their ten- to thirty-inch-long tusks like ice axes to haul their ungainly forms up onto beaches or ice floes to breed and bask. Later naturalists described walrus tusks as overlarge oyster knives, used in cracking open the animals' dinners. Now we see them as swords and shields, the creatures' tools of attack and defense, rank and status.

The Vikings likely did not care why walruses had tusks, only that they did. Light and long-lasting, the teeth of these small whales—or big fish, for so they classified all whales—made the perfect cargo for a Viking ship. Viking raids were bankrolled with fish teeth. Viking trade routes were built on them. Viking explorers sailed west out of sight of land in search of shiny, white walrus tusks. From the eighth to the fourteenth century—well after the end of the Viking Age—walrus ivory was the most sought after commodity of the North. It was Arctic gold.

FISH TEETH

The value of the tusks must have come as a surprise to men who had long hunted walruses in Arctic Norway. They were chiefly after the beasts' thick skin. Black and tough, one hide weighs from one to five hundred pounds. Split, cured, and twisted into rope, walrus hide made the best ships' rigging; one bull supplied enough cordage for two to three large trading *knarrs*. It was the strongest rope known for its weight: A strand half an inch thick could lift a ton. Sixty men could tug on a sail-rope without snapping it. Anchor cables were preferentially made of walrus hide. An Icelandic poem from the tenth century expresses dismay when one broke: One sailor jumps into the sea to salvage the anchor while the rest argue over who hadn't oiled the cord. Other medieval seamen were saved from starvation by their walrus-hide rigging; dismasted in a storm, they lived for eighteen days on ropes smeared with butter. A twelfth-century group, besieged in an island fortress, had nothing but ropes "to eat for their Christmas feast, but there wasn't even half enough."

Walrus-hide rope was also used in the Middle Ages for hoisting heavy objects over pulleys, hanging the great bells in church steeples, and lashing together siege engines and catapults. In a late Icelandic romance, a hero abducts a golden-haired princess from her father's castle "by tying a walrus-hide rope around the tower she lives in, uprooting it, and hauling it on board his ship."

The Inuit, at least in more modern times, used walrus skin to make boats and raincoats and to roof their houses. Walrus hide was once in great demand by knife makers and silversmiths for polishing fine blades. A London company in the early twentieth century thought young

walrus skins made the most elegant satchels: "When properly tanned, the leather is remarkably pliable, and the grain rich and velvety." Older skins became drive belts, carriage traces, the tips of billiard cues—or glue. All of these uses (except the cue tips) had their medieval parallels.

But the considerable value of a walrus's hide in the Viking Age was nothing compared to that of its tusks.

Ivory art had been prized since antiquity. Pliny, writing in Rome in the first century after Christ, noted that from elephant tusks "we obtain the most costly materials for forming the statues of the gods." Early Christians, though shunning monumental sculpture, made ivory covers for Bibles and ivory boxes for unconsecrated hosts, even an ivory throne for the archbishop of Ravenna.

But ivory carvings later than that throne, circa 550 to about 800, whether sacred or everyday, are missing from museum collections in Western Europe. "This is odd," says a 1982 *Introduction to Medieval Ivory Carvings*. That hundreds of years' worth of ivory artwork is missing can only mean it was never created, for ivory, unlike antler and bone, is not fragile. If kept dry, ivory carvings last forever. And, unlike metalwork, ivory carvings cannot be melted down—though the ivory can be reused. In Carolingian France in the early 800s, some old ivory plaques, bearing the names and likenesses of Roman consuls, were scraped smooth and recarved with biblical scenes, proving the material was still prized and exceedingly scarce. Elsewhere, carvers made do with elk antler and whalebone, until the Vikings began bringing "fish teeth" to European markets. By the end of the Viking Age in 1066, ivory was once again the emblem of luxury. Except now it came from walruses, not elephants.

The popularity of walrus ivory peaked in the twelfth century. Creamy white, smooth, and as responsive to the carver's tools as elephant tusks, though considerably smaller, the teeth of the walrus were tougher than elk antler and took a higher polish than whalebone—or even elephant ivory itself. Experts can tell the ivories apart by feel: Walrus is "smoother and shinier" than elephant ivory and "more pleasant to the touch." Crucifixes were carved of walrus ivory, as were statues of the Virgin Mary. Reliquaries and shrines to hold the holy bones of saints. The ornately carved plates called paxes, kissed by each worshipper at

the end of mass while the priest intoned *Pax tecum,* "Peace be with you."
Beakers with feet. Oval pyxides for ladies' trinkets—or to store the un-
consecrated host. Bishops' croziers. Sword hilts, inkwells, snuff horns,
dress pins, belt buckles, buttons, book-binding boards, royal seals, and,
of course, game pieces, including dice, checkers, and chessmen, were all
made of walrus tusk. A walrus skull, with tusks intact, was a royal gift:
In the fourteenth-century Icelandic *Saga of Ref the Sly,* a Greenlander
gives the king of Norway "a walrus head with all its teeth; it was inlaid
with gold all over." A simpler skull, carved with medieval runes but lack-
ing the goldwork, is now in a museum in Le Mans, France.

Elephant tusks did have obvious advantages: They are three times
the size of walrus teeth. You can only make small objects out of walrus
ivory—or objects built up from many pieces—and you cannot carve
as deeply. The lustrous outer surface of primary dentine is much thin-
ner on a walrus tusk, while the core is a darker, marbly, unappealingly
translucent pulp of secondary dentine: To one curator, its texture recalls
popcorn. Though this secondary dentine can be carved—and was for
several of the Lewis chessmen—it is duller, grainier, even dirty looking.
It also fractures more easily—again, as you can see on the chessmen. For
these reasons, the walrus-tusk market crashed when tastes changed to-
ward more monumental and elaborate sculptures, even though the price
of elephant ivory remained high. By 1282, the pope was complaining
that the archbishop of Trondheim sent him too many walrus tusks. In
1327, when the bishop of Greenland contributed a load of walrus tusks
to a crusade, "the problem of profitably marketing such a large cargo
of unfashionable material without further depressing prices" engaged
clerics from Norway to Rome for weeks. Yet as late as 1555, Olaus Mag-
nus would inform his Roman audience that "the tusks of the morse, or
walrus, are carved most artistically for use as pieces in the game of chess,
which all the northern peoples play with amazing skill, especially their
princes and most illustrious men."

THE RIVER OF SILVER

The vagaries of the walrus trade were triggered by events so far to the
east and south, and so far in the past, that they were mere fables to the

Viking hunters. First, the North African elephant herd was overhunted: Not only was ivory artwork prized in ancient Rome, the elephants' cartilaginous trunks, Pliny claims, were a delicacy of Roman banquet tables. By the fourth century, no elephants lived north of the High Atlas Mountains in what is now central Morocco. Next came the sack of Rome in 455: The fall of the Roman Empire cut the ancient trade routes between Europe and Africa. More disruptions to the ivory market came from the great medieval empire known as the House of Islam: Ten years after the death of the Prophet Muhammad in 632, his followers had taken Palestine, Syria, and Alexandria. In 698, they sacked Carthage; by 711, the entire south coast of the Mediterranean Sea was in Muslim hands. Muslim warriors crossed the Straits of Gibraltar to Spain, then entered France, reaching Poitiers before their march was stopped in 732 and they settled in.

During the wars, ships were seized or destroyed, timber for rebuilding grew scarce, and connections across the Mediterranean dwindled. The ancient ivory route, from East Africa to Carthage and across to Italy, closed down. The Swahili middlemen, always practical, looked east and found new markets for ivory in China. When a coup in Damascus in 750 toppled the reigning Umayyad dynasty of the House of Islam, the victorious Abbasid caliph turned his back on the Mediterranean Sea. While Carthage crumbled, a new hub of commerce rose from the sands, perfectly placed between the Tigris and Euphrates at the terminus of the Silk Road. Soon elephant ivory—along with many other merchants' wares, including those of the Vikings—was routed through the new capital, Baghdad.

The remarkable round city of Baghdad, with its circular walls and four grand gates, its green-domed mosque in its central courtyard, and the boisterous suburbs hugging its walls, this fabled city of *The Arabian Nights,* was an Ali Baba's cave of luxuries. Its merchants imported silk, spices, paper, ink, and peacocks from China. From India came tigers, elephants, ebony, rubies, and coconuts. From the Arabian Peninsula, ostriches, camels, and bamboo. From the Maghrib, panthers, felt, and black falcons. From Yemen, giraffes and carnelian. From Egypt, donkeys, papyrus, balsam oil, and topaz. From Oman, pearls. From the North came all kinds of furs; bows and arrows, armor, and swords;

horsehides, hemp, beeswax, honey, raisins, birchbark, white falcons, dried fish, and fish glue; slaves—many slaves; Baltic amber and, oddly enough, walrus ivory, some marketing genius having convinced the Baghdad merchants that walrus teeth, along with narwhal tusks, were unicorns' horns and so an antidote to poison. Spoons of walrus ivory were particularly treasured.

The traders from the North were named "Rus" by medieval writers; we would call them Vikings. They were voyaging through the Baltic Sea, down Russian rivers, and into the Black and Caspian Seas for years— perhaps a hundred—before their presence was recorded by pen and ink. The Latin *Annals of Saint Bertin* in 839 holds the first written record of them: An embassy sent from Byzantium to France included men who called themselves "Rus." When King Louis the Pious, Charlemagne's son, questioned them, "He discovered that they belonged to the people of the Swedes." He had them detained as spies. Louis's biographer, Ermold, explained: "They are also named Northmen by the Franks; they are fast, agile, and well armed. This very people are well and widely known. They inhabit the sea"—or, as another translator phrases it, *they haunt the tide*—"and seek out wealth by ship." By 839, Vikings had been sacking towns on the Carolingian coasts and raiding along French rivers for at least twenty years.

The first Arabic mention of the Rus comes in Ibn Khurradadhbih's *Book of Routes and Kingdoms* from 848. He said the Rus traded on the Caspian Sea and even brought their goods by camel caravan all the way to Baghdad. They passed themselves off as Christians, he added, in order to pay lower taxes.

From Byzantium, the first reference to the Rus comes in 907. A treaty recorded in the much later *Russian Primary Chronicle* begins with a blast of Viking names: Ingjald, Vermund, Gunnar, Harald, Hroar, Angantyr, and more. It offers these Rus merchants a monthly allowance for six months, baths "as often as they want them," and supplies for the journey home, including "food, anchors, cables, sails, and everything they need," provided they reside only in the Saint Mamas quarter, give their names to a certain official, enter by one gate only, "unarmed and in groups of fifty, escorted by an imperial officer," and commit no "acts of violence." If they follow these rules, "they may conduct such business as

they need to without paying dues." A later treaty, however, restricts the amount of silk they are allowed to buy.

According to Ibn Rusta of Isfahan, who wrote a seven-volume encyclopedia between 903 and 913, the Rus "earn their living by trading in sable, grey squirrel, and other furs. They sell them for silver coins which they set in belts and wear round their waists. Their clothing is always clean. The men wear gold bracelets. They treat their slaves well and dress them suitably, because for them they are an article of trade. . . . They are generous hosts, treating their guests well. . . . They are remarkable for their size, their physique, and their bravery. They fight best on shipboard, not on horseback."

Ibn Fadlan, writing in 922, provides more detail. He himself journeyed north, to "a land which made us think a gate to the cold of hell had opened before us." Bundled up in all the clothing he brought, he is astonished that the Rus "wear neither coats nor caftans, but a garment which covers one side of the body and leaves one hand free." He remarked on their weapons (axe, sword, and knife), their tattoos (dark green, from the tips of their toes to their necks), their tall bodies (like palm trees), their coloring (fair and ruddy), their lack of hygiene ("They are the filthiest of God's creatures"), and their funeral rites, complete with blazing ship and willing human sacrifice, that are at least as much Turkic as Viking.

When describing the Rus women, Ibn Fadlan reveals what drew the Vikings so very far from home: Along with the usual oval brooches and beads, these women sported "torques of gold and silver, for every man, as soon as he accumulates 10,000 dirhams, has a torque made for his wife." It sounds like wearable wealth, but it's not. A standard silver dirham coin weighed 3 grams, making each torque, if all the coins were used, 30 kilograms or about 66 pounds—much too heavy to be practical. Yet silver torques from the period are attested to in the archaeological record: Called Permian rings, these thick silver neck rings with spiral grooves and hook-and-loop closures have been found from Perm, near the Ural Mountains, west to Ireland and England. One pretty example from Sweden has a heart-shaped loop. They range in weight from 100 grams (33 dirhams) to 400 grams (133 dirhams). Other Arabic coins came north in bags and belts and treasure chests: More than 300,000 silver dirhams have been found so far in Viking hoards, and more are discovered by

metal detectors nearly every year. Viking Age silver jewelry other than the Permian rings is also, most likely, of Arabic origin: Until silver was discovered in the Harz Mountains in 975, Europe had few mines of its own.

The caliphate had thousands. The richest were east of Baghdad, near Kabul. But silver was mined in the south as well, in modern Saudi Arabia and Yemen. Excavations have uncovered the tunnels, trenches, pits, and waste heaps, picks, shovels, lanterns, and hammers of over a thousand medieval silver mines in the western half of Saudi Arabia alone. One tunnel was over two hundred feet long; one valley had seventy-eight mines; one mining town housed a thousand workers, known to be tough gamblers. From one mine alone came the ore to mint a million silver dirhams a year. Carbon dating confirms that these mines were most active between A.D. 430 and 830. In the ninth century, the river of silver ebbed and flowed as the House of Islam was rocked by coups, revolutions, slave uprisings, and above all, extravagance—think again of those luxurious sultans in *The Arabian Nights,* then recall that the cities of Baghdad and Samarra both rose from the sand in a century. By the year 892, the caliph's treasury was almost empty. About 950 the dirham was devalued. The new coins—spurned by Viking traders—mixed silver with base metals.

Still, over the course of the tenth century, an estimated 125 million Arabic dirhams went north. That equals 375 tons of pure silver, or roughly 150 pounds of silver a week for a hundred years flowing from Baghdad to the Black Sea, detouring to Byzantium, then up the Dnieper River with its seven hard portages—named in Old Norse, Racer, Laughing, Steep Cliff Falls, Ever Dangerous, Roaring, Island Falls, and Don't Sleep—to the Rus cities of Kiev and Novgorod and north again to Lake Ladoga, then west on the Baltic Sea to the Swedish islands of Gotland and Helgo and south to the emporium at Hedeby, over which Charlemagne and the Danish king quarreled. Charlemagne marched up with an elephant in his army—a gift from caliph Harun al-Rashid of Baghdad—but the beast died before it could frighten the berserks.

CHARLEMAGNE'S ELEPHANT

The elephant was named Abu al-Abbas. More than 3,500 miles he had come, from Baghdad to Jerusalem, across the Sinai, along the Egyptian

coast to the city of Kairouan, then across the Mediterranean (the poor sailors: one rampage and they're sunk) to Portovenere near Genoa, then north to Vercelli, and, after the winter's snows had melted, across the Alps. He was slow, "ravenous, and prone to wander." He drank twenty gallons of water a day, desert or no. His keeper was a Frankish Jew named Isaac, one of three ambassadors Charlemagne had sent east to see the caliph five years before, and the only one who survived the trip. Isaac arrived home in Aachen, with Abu Al-Abbas, on July 20, 802.

An elephant north of the Alps—the mere fact that Charlemagne and the caliph participated in reciprocal gift exchange—has excited historians ever since. An influential theory from the 1920s went so far as to blame Europe's Dark Ages on Baghdad's blockade of the Mediterranean trade routes. But the blockade seems to have been a two-way one: Each culture branded the other as "infidel."

It's a pity. Baghdad in Charlemagne's day had much to offer the West. Harun al-Rashid, when he came to power in 786, established the House of Wisdom, with its staff of translators, scribes, and bookbinders. There, over the next two hundred years, works of medicine, mathematics, astronomy, and physics would be translated from the Greek, Persian, and Indian languages, then expanded by Muslim scholars. Algebra and trigonometry came from the House of Wisdom, as did astronomy. The caliph's scientists plotted the positions of the stars, charted the motions of the planets, and calculated the circumference of the earth—arriving at a figure (23,220 miles) not far from the correct one (24,900). The House of Wisdom collected and translated works by Euclid, Archimedes, Aristotle, Ptolemy, and many other great thinkers for whom the original Greek has long since disappeared. Only because the Arabic texts survived to be copied and, eventually, translated into Latin was essential knowledge not lost.

Harun al-Rashid is famous, as well, as the sultan in *The Arabian Nights,* the thousand and one tales of Scheherazade. Harun al-Rashid does not calculate the circumference of the earth in *The Arabian Nights;* his interest in science might clash with Scheherazade's flying carpets, magic lamps, and "open sesame." But he does play chess. This part of those fabulous tales rings true.

The Arabic word for chess, *shatranj,* comes from the Persian *cha-trang,* itself from Sanskrit *chaturanga.* Chess seems to have arrived in Persia from India in the mid-500s. By 728 an Arabic poet wrote, "I keep you from your inheritance and from the royal crown so that, hindered by my arm, you remain a pawn among the pawns." Arabic handbooks on chess playing from as early as 850 have been reconstructed. In the early 900s, an Arab text cites a letter sent by the Byzantine emperor to Harun al-Rashid, supposedly in 802, refusing to pay tribute. The former empress, who had agreed to the treaty, must have "considered you as a rook, and herself as a pawn."

Along with the elephant, legend says Harun al-Rashid sent Charlemagne a chess set. The massive chess set made of elephant ivory, kept in the treasury of the Abbey of Saint Denis in the thirteenth century and now in the National Library in Paris, with its elephants instead of bishops and four-horse chariots instead of rooks, was once thought to be the very one. Now it is considered Norman, from Italy in the eleventh century. Notably, the single remaining pawn is a Norman foot soldier with a conical cap and a kite-shaped shield, somewhat like our Lewis rooks, if not so stiff and dour, but instead agile and fierce—well, perhaps not fierce: A scholar in 1804 described him as "the image of a dwarf with a large shield" and having a "ludicrous expression."

Romances of Charlemagne, written in the 1200s, often feature chess matches in which large shields and ludicrous expressions would be apt. In one, the knight Garin arrives at court preceded by his reputation as a chess whiz. Charlemagne challenges him to a match: If Garin wins, he may have the crown of France and the queen with it. If he loses, off with his head. The chessboard is produced. The barons gather to watch. Garin, indeed, is a fine player, and the emperor loses his temper. The whole room is in an uproar. The duke of Burgundy calms things down and play continues: Charlemagne is checkmated. Garin courteously accepts the town of Lyons—instead of all of France (and the queen)—as his prize.

In another romance, the game does not end so well. Charlot, Charlemagne's son, loses his temper, picks up the chessboard, and whacks his opponent over the head with it, killing him outright. In a third tale, the

duke of Normandy, interrupted in the middle of a game, turns the pieces into projectiles. He kills one man with a queen, another with a rook, a third with a bishop. The pieces are ivory, big and square—perhaps as big as the so-called Charlemagne chess king; contained in a squarish castle, it is twelve inches high and eight wide. It weighs almost two pounds—a deadly missile.

These stories of chess in Charlemagne's time are not likely true. There were board games at Carolingian courts—the Roman legions brought several to the West—but chess seems to have infiltrated Europe only slowly. It may have traveled from Baghdad along several trade routes: Silver dirhams found their way to western hoards and mints from Russia in the late 700s. Charlemagne's elephant arrived via Italy in 802. Knowledge of algebra and astronomy reached Paris through Spain by 972, the same year Princess Theophanu came to Rome from Byzantium to wed Emperor Otto II. No evidence exists to let us choose which travelers (if any) had chess sets in their luggage. Art historians favor the Italian and Russian routes. Linguists note that the Latin spelling of *rukh, rochus,* comes from the western dialect of Arabic spoken in Morocco and Spain, while no Western chess terms show any influence of Byzantine Greek.

Our first datable proof of European chess comes from 997. In a set of parchment fragments recovered from the bindings of old books in Einsiedeln, Switzerland, is a ninety-eight-line poem on chess. "If it is lawful to play games," it begins, addressing churchmen for whom games were often taboo, "here is one which you will rank first among delightful games. It is free from deceit, no stake is necessary"—though, as the romances show, the stakes were often quite high—"and it does not require dice" (also taboo). In describing the pieces, the poet proves that chess has already lost most of its Indian and Islamic trappings. Instead of a vizier, the king's partner is a queen. There are no elephants on this chessboard—but neither have these pieces yet become bishops, as in the Lewis chess set. Here we have counts, "placed to hear with their ears the spoken words of their lords." Next comes the knight and, in the corner square, the rook, "or rather the margrave (*marchio*) in his two-wheeled chariot"—a throwback to the Indian original—all ranked behind an advance guard of pawns, the French word for which is our "peon," with

all the overtones of serfdom and servitude that word holds. From an image of the Indian army, chess had metamorphosed into a mirror of European feudalism.

Whether Charlemagne played chess or not, the romance writers were correct to think the game fit the mentality of the times. Chess is "war over the board," as the twentieth-century chess master Bobby Fischer memorably said: "The object is to crush the opponent's mind." And while a shield-biting Lewis rook is often the icon picked by book publishers and museum curators to represent the Viking Age, some say that Charlemagne—not the berserks—set the tenor of the times when he massacred the Saxons.

In 772, finding France too cramped for his ambitions, Charlemagne conquered his neighbors. But as soon as he turned his back (to hear the Frankish annals tell it), the Saxons would rebel. In 782, their rebellion cost him two envoys, four counts, twenty noble knights, and uncounted peons. Charlemagne lost his temper. He "rushed to the place with all the Franks that he could gather on short notice." Seeing what must have been a massive army, the Saxons "submitted to the authority of the Lord King, and surrendered the evildoers who were chiefly responsible for this revolt to be put to death—4,500 of them. This sentence was carried out."

Four thousand five hundred Saxon men, having surrendered and laid down their arms, were massacred on Charlemagne's say-so. Even his own adviser, the English cleric Alcuin, despaired: "No war ever undertaken by the Frankish people," he wrote, "was more full of atrocities."

Two years later, the Saxons rebelled "again as usual," say the annals. Charlemagne "entered Saxony and went here and there devastating the countryside." Captured, the Saxon leaders could choose death or baptism. They became Christian, whereupon Charlemagne promulgated a new law: If any Saxon "shall have scorned to come to baptism and shall have wished to remain a pagan, let him be punished by death."

Still defiant, if officially Christian, the Saxons rebelled again in 793. Growing tired of this game after ten more years of war, in 804 Charlemagne upset the board: "He led an army into Saxony and deported all Saxons living beyond the Elbe . . . , with [their] wives and children, into Francia." He gave their land to his allies, the Obrodites.

Word traveled north. The Danish king Godfrid "came with his fleet and the entire cavalry of his kingdom," the annals say, to his border with Saxony and watched, as if daring the Franks to cross that line. Then he crossed it himself. He swept down on the Obrodite town of Reric, a major port on the Baltic Sea, and torched it. "Transferring the merchants from Reric, he weighed anchor and came with his whole army to the harbor of Schleswig," on a shallow bay at the mouth of the river Schlei, near the base of the Jutland peninsula on the Danes' southern border. Twenty-two miles up the narrow fjord, on the edge of a wide-open, hummocky field of heather beside the great earthwork known as the Danevirke, he established the market town of Hedeby, "the place on the moor," at a landing spot his people had used for a century.

Godfrid did not mean to choke off trade with Charlemagne's empire; he meant to control it. He and his successors built a hill fort. (The famous thirty-foot-high Oldenburg wall, running eight tenths of a mile around the town and linking up with the Danevirke, came a hundred years later.) They established a mint—the earliest coins bore the image of a ship—and levied taxes. They laid out straight wood-paved streets and a series of jetties. Archaeologists have been active at Hedeby for a hundred years. Excavating the small, fenced-in house plots, whose building timbers, dated by tree-ring analysis, were felled between 811 and 1020, they've recovered hundreds of thousands of artifacts, ranging from Arabic silver dirhams to metal strap-ends in the English Trewhiddle style. Though tiny compared to Baghdad, like the caliph's fabled city, Hedeby was well-sited to intercept trade from north, south, east, and west. Hedeby had weavers and shoemakers, carpenters and shipwrights, blacksmiths and potters. Jewelers worked with gold, silver, amber, brass, rock crystal, and jet. Glassmakers made beads and cups. Carvers made combs, needles, flutes, and game pieces of bone and antler—even of walrus ivory.

From Hedeby's harbor stretched a sea as vast as the Mediterranean. Continuing west, in a week or less a trade ship could reach the Frisian town of Dorestad, near the mouth of the Rhine. Older than Hedeby and eight times its size, Dorestad was established in the 600s. As the biggest market in northern Europe, and one vital to the Carolingian court, Dorestad was Hedeby's chief rival. In 834, Vikings sacked it. When no

retaliation came, they raided Dorestad again in 835, in 836, and in 837, by which time a cleric in the imperial palace could lament "their usual surprise attack."

News in 799 of Vikings "who infest the Gallic sea" had caused Charlemagne to strengthen his coastal defenses. In 810, when a fleet of two hundred ships ransacked the coast of Frisia and took a tribute of a hundred pounds of silver, "this information aroused the emperor so much," say the Frankish annals, that Charlemagne immediately marched his army—and his elephant—to the Danish border, only to learn that King Godfrid had been assassinated and his nephew was eager to make peace.

Now in 834, with the emperor twenty years dead and his empire fracturing, Viking ships again haunted the tide. News of their luck at Dorestad traveled north. "The number of ships increases, the endless flood of Vikings never ceases to grow bigger," a monk wrote in the 860s. "Everywhere Christ's people are the victims of massacre, burning, and plunder," or as a modern Icelander quips, "Vikings had an unerring nose for weakness."

RING BEARERS

Early on they learned the art of ransom: In 841, the abbey of Saint Wandrille paid a Viking band 26 pounds of silver to redeem sixty-eight captives. By 858, the Vikings could demand a ransom of 685 pounds of gold and 3,250 pounds of silver for only two men: the abbot of Saint Denis and his half-brother, a future bishop of Paris, both kinsmen of the king. The Vikings learned, too, the value of peace: The tribute of 100 pounds of silver that so incensed Charlemagne in 799 was paltry compared to what the famous Ragnar Lothbrok received in 845. He sailed up the Seine, hanged 111 prisoners on an island in full view of Paris, and accepted 7,000 pounds of silver in lieu of sacking the town. By 926, the Franks had paid out 22 tons of silver—a significant fraction of the 37 tons that would reach the West from Baghdad over the course of the entire tenth century.

"From the fury of the Northmen, O Lord, deliver us!" is said to have been on every Christian's lips across Charlemagne's empire. It's an exaggeration. A scholar who perused every extant Carolingian litany

found a similar prayer in only one medieval manuscript, a French antiphonal, or music book, from around 900: "Deliver us, God, from the savage Northman race"—or, says another translator, "from the wild Northmen."

But descriptions of that fury, of the terror the Viking raids inspired, are many. A monk who witnessed the Viking siege of Paris in 885 described it as "a frenzy beyond compare." The Vikings "ransacked and despoiled, massacred, and burned and ravaged," he wrote in Latin hexameter verse. "They were an evil cohort, a deadly phalanx, a grim horde. . . . A thousand gave battle, stood shoulder-to-shoulder in the fight . . . all bare-armed and bare-backed. . . . With mocking laughter they banged their shields loud with open hands; their throats swelled and strained as they shouted out odious cries." They had gone berserk.

"Fear seized the city—people screamed, battle horns resounded." The terror in Paris twelve hundred years ago echoes off the page. The Saxons, on the contrary, are silent. They kept no annals of Charlemagne's raids, wrote no verses, so far as we know, on the massacre of 4,500 unarmed men. So we deplore the brutality of the Vikings but not the atrocities of the Emperor of the West.

Other than biting their shields (if they did), berserks were no more barbaric than their foes. The Vikings' "ferocious sacrificial ritual," the "blood eagle," in which an enemy's lungs were torn out his back, is a saga writer's odd misunderstanding of twelve words in an eleventh-century skald's verse. Read correctly, the line is quite conventional: A carrion bird slashes the backs of the slain.

The Vikings seemed more horrible to medieval chroniclers because they did not play by the rules. They did not have one king but many sea kings: A deal with one did not encumber all. They were not, like Charlemagne, expanding a Christian empire. They were not after land, only loot—which they had, until recently, found enough of along the Baltic shores. Then their profitable trade to the East was interrupted by wars of succession, not just in Europe, where Charlemagne's sons and grandsons bickered, but also in the Islamic Empire. Soon after the Viking emporium of Hedeby was established, the flow of silver from Baghdad ebbed: Caliph Harun al-Rashid died in 809 and, like Charlemagne, left behind too many sons.

The kings of the North counted on that river of silver. It filled their coffers, financed their feasting, and rewarded their followers, for the Viking economy revolved around gifts. Vikings did not fight for pay. They fought for honor, made visible by gifts: of arm rings and armor, of swords and slave girls, of chests filled with silver, even of ships. In return, they gave their skill-at-arms, their strength, their loyalty, and often a verse. Spoke a skald in the late 800s:

> *Listen, ring-bearers, while I speak*
> *Of the glories in war of Harald, most wealthy . . .*
> *Prince of the Northmen, tall ships he governs,*
> *With stained shields and red bucklers,*
> *Tarred oars, salt-sprayed deck-covers . . .*
> *Well-rewarded are they, those famed in battle,*
> *Who sit gaming in Harald's hall.*
> *They are graced with riches, with glorious treasures,*
> *With Hunnish steel, slave girls from the East . . .*
> *By their clothing, their gold armlets*
> *You see they are the king's friends.*
> *They bear red cloaks, stained shields,*
> *Silver-clad swords, ringed mailcoats,*
> *Gilded sword-belts, engraved helmets,*
> *Rings on their arms, as Harald gave them . . .*

Slave girls from the East, according to Arabic sources, could cost as much as sixty-six pounds of silver each, the same value Ibn Fadlan ascribed to a Rus woman's silver torque—though the Icelandic *Laxdaela Saga* says you could get a nice Irish slave girl for the price of twelve milk cows.

Silver-clad swords were not cheap. The same saga values one sword—a king's gift—at sixteen cows. The Vikings preferred double-edged, one-handed swords, with hilts of walrus tusk or wrapped in silver wire. About thirty-five inches long, Viking swords were made light and flexible by a broad shallow groove, or fuller, running the length of the blade—you can see this groove on the swords of the Lewis chessmen. The most famous Viking swords were of Frankish make and inlaid with the trade name "Ulfberht" (though there were fake Ulfberht swords in

circulation, as well, of inferior steel—buyer beware). We don't know what it cost to buy a silver-clad Frankish sword, or an engraved helmet or a ringed mail coat or byrnie, but if you sold one to a Viking, or used it to ransom your abbot after 864, it was worth your life. Said the Edict of Pitres: "Anyone who, after July first next of this indication, should give a byrnie, or any sort of arms, or a horse to the Northmen, for any reason or for any ransom, shall forfeit his life without any chance of reprieve or redemption, as a traitor to his country, exposing Christianity to the heathen and perdition."

Rings for their arms, fingers, ears, or necks; swords, axes, spears, and knives; ornamented shields with round brass bosses; sword belts, helmets, chain mail, saddles; spurs and bits and bronze bridle mounts; red cloaks, fur cloaks, trousers and tunics of linen, wool, and silk; brooches and cloak pins; chests of coins and hack silver (just what it sounds like: silver rings and bars and chains hacked to bits to be shared out by weight); chalices, drinking horns, cups of Frankish glass; glass beads, or beads of amber, crystal, carnelian, and jet; game pieces of whalebone or walrus ivory—all these, found in Viking graves or hoards, could be a king's gift.

Sometimes a king asked, as imagined in the thirteenth-century *Eyrbyggja Saga*, "Is there something I can give you to mark your success here? Something of mine that you want more than anything else?"

In this saga, our hero is not too smart: Vermund wanted the king's two berserks.

"Here you're asking for the one thing, it seems to me, that will be of no use to you," the king said.

Vermund should have asked for a sword or a ship. For as soon as he got them home to Iceland, one berserk demanded Vermund find him a wife. "Vermund thought it unlikely that any woman from a good family would bind herself to a berserk for life, so he put off doing anything about it." Finally, before the berserk went berserk, Vermund invited his brother Styr to visit. The two brothers had not been on good terms for some time. As the *Saga of the Heath-Killings* tells it:

The day Styr was to leave, the brothers sat drinking at the table. Both were pleased now, and all was well between them. Then Vermund

said, "You have my thanks, brother, for honoring me with a visit. . . . Here is a gift that, it seems to me, will suit you well. It's these two berserks that I have here with me. . . ."

Styr said, "That is a great gift. I know I have nothing to equal it in my possession. So I can't give you any better gift in return than to give those two berserks right back to you, so that you can enjoy them yourself."

Vermund took offense at that. He said it wasn't right for Styr to value it so little when he showed him the honor of offering him such a useful gift.

Styr answered, "Say rather, brother, that you regret you have the berserks. For now you find you're not man enough to control them."

Styr takes the berserks home and arranges their death.

The Icelandic hero Hrut, in *Laxdaela Saga,* knew better than to ask for berserks. "The king gave him a ship at their parting, and said he had found him to be a worthy man." To set this magnificent gift into context, consider that a team of modern craftsmen at the Viking Ship Museum in Roskilde, Denmark, took forty thousand working hours—the labor of a hundred people for a year—to produce a hundred-foot-long dragonship using replica Viking Age tools, including making the iron for the rivets, twisting the ropes, and weaving the woolen sail. Then there was the decoration. For a replica of the beautiful Oseberg ship, dated by tree rings to A.D. 820, two artists, using mostly hand tools, took a year to carve the glorious interlace design along her gunwales and up her slender spiral prow. Then to paint her, to gild the prow, to affix brass weathervanes to show how the wind blows: Only a rich man could afford to build a Viking ship.

DRAGONSHIPS

Yet Vikings are defined by their ships. Even the Arabs noticed: "They fight best on shipboard, not on horseback." To the Franks, Vikings were the horde that haunts the tide. Norse poets extolled their love of ships:

"It was like fire in the mouth of the serpent, when we saw our ships coming from the south," said one Viking skald.

"Water washes the craft where the sea thuds on each side, and the fine weathervanes rattle."

"The mane of the serpent glitters."

"Froth was piled in heaps, the swollen main surged with gold, and waves washed the frightening warships' heads."

They named their ships: Bison, Crane, Wave-Stallion, Long Serpent, Otter. They dyed the sails blue, red, and purple; often sails were striped. They carved "wave runes" on the stem, on the steering blade, on the oars "to ward your sail-steeds on the sound. . . . No broad breaker will fall, nor waves of blue, and you will come safe from the sea."

Dead, they sailed to Valhalla: The Oseberg and Gokstad ships were burial ships. Preserved in the blue clay of southern Norway, they've taught us much about the development of Viking ship technology. In other rites, the ships were burned. In the early 900s, on the isle of Groix off the coast of Brittany, a forty-three-foot Viking ship became a pyre. The ship was dragged onto a headland; the dead—a man and a boy, dressed in fine clothes with gold trimming and precious jewels—were surrounded by the trappings they would take to the Otherworld: two swords, two axes, four lances, arrows, twenty-four shields (to represent their followers?), tools, bowls, cauldrons, riding equipment, dogs, and a set of game pieces possibly made of walrus ivory. All was torched, the ashes covered by a mound.

Even their name, Vikings, may come from their ships: The word, by one derivation, means a shift of oarsmen, and the first Viking ships were exclusively rowed. By 800, like the ship buried at Oseberg, they also carried sail. By 900, like the Gokstad ship, they were robust seagoing vessels, streamlined to be fast under sail or oars, shallow-drafted enough to penetrate most rivers, double-ended, their side rudder lifting clear so they could be beached or rowed backward, able to carry seven tons of supplies, with room for loot and forty fighting men. A hundred years later, Viking ships had split into two types: the ever-longer, ever-sleeker dragonship, carrying eighty or a hundred warriors, and the rather tubby but practical knarr, the oldest with a cargo capacity of thirteen tons, then twenty-four, and by 1025, when one sank in Hedeby harbor, sixty tons.

The Viking ship created the Viking Age. The Vikings developed a keel that gave their ships stability and speed under sail. They invented a light and flexible hull, clinker-built, or lapstrake, meaning the

planks overlapped like clapboards on a house. Because they split the planks with an axe, instead of sawing them, the wood fibers lined up and ran the length of the boards, so that the planks could be thinner—making the boat lighter—while remaining strong. Seaborne raiding was not new. The Franks were pirates in the fifth and sixth centuries. The Anglo-Saxons invaded England by sea at that time. Viking ships were just more effective. By the time a lookout spotted a Viking fleet, even on a clear day, the berserks were only an hour's sail away.

Though sometimes their coming was foretold: "In this year dire forewarnings came over the land of the Northumbrians, and miserably terrified the people: There were excessive whirlwinds and lightnings, and fiery dragons were seen flying in the air. A great famine soon followed these tokens; and a little after that, in the same year, on the sixth of the Ides of January, the havoc of heathen men miserably destroyed God's church on Lindisfarne, through rapine and slaughter."

The standard history of the Viking Age begins with this "bolt from the blue": The account from the *Anglo-Saxon Chronicle* (dragons and all) of the sacking of Lindisfarne Abbey on an island off the northeastern coast of England, some seventy miles south of Scotland, in 793, the exact date usually being corrected to June 8, not January 8, as the *Chronicle* says—for what right-minded Viking would go harrying in the winter? To hear Simeon of Durham tell it, writing in about 1100, the raiders went berserk: They "laid all waste with dreadful havoc, trod with unhallowed feet the holy places, dug up the altars, and carried off all the treasures of the holy church. Some of the brethren they killed; some they carried off in chains; many they cast out, naked and loaded with insults; some they drowned in the sea."

In 795, dragonships descended on a monastery near what is now Dublin. The Vikings established a base there for raiding in the Irish Sea, but they soon learned that Irish monasteries were not such easy marks as English ones. Ireland in the 800s was a Christian society with many kings—and no clear rules of precedence. Since the abbots were entangled in politics, ransacking monasteries was accounted fair in war: Out of 113 raids from 795 to 820, only 26 were by Vikings. Irish monks studied martial arts. They made fun of monks who simply prayed, as in this ironic poem from 895:

Alas, holy Patrick!
unavailing your orisons—
the Vikings with axes
are hacking your oratories.

Viking bands in the Irish Sea soon found it more profitable to make alliances with one king against another. The first "Viking" named in the Irish annals, in fact, was half Celtic: Godfrey MacFergus, with a Norse mother and an Irish father, aided the king of the Scots in 836. In the thirteenth-century Icelandic sagas, the Norwegian chieftain Ketil Flat-Nose—perhaps the same man as the Ketil the White of the Irish annals—marries one daughter into a noble Irish family and another to the Viking king of Dublin. Other sagas tell of Eyvind, a Norwegian Viking who "led the country's defense" upon marrying Rafarta, daughter of the Irish king Kjarval.

In 890, an Irish monk penned this eloquent lament in the margins of a manuscript:

Bitter is the wind tonight
white the tresses of the sea,
I have no fear the Viking hordes
will sail the seas on such a night.

But Viking hordes were fighting on both sides of Irish battles, in spite of a chronicler's insistence, in the inimitable Irish prose style of the late-eleventh century, that "on the one side" of the famous Battle of Clontarf of 1014 "were the shouting, hateful, powerful, wrestling, valiant, active, fierce-moving, dangerous, nimble, violent, furious, unscrupulous, untamable, inexorable, unsteady, cruel, barbarous, frightful, sharp, ready, huge, prepared, cunning, warlike, poisonous, murderous, hostile Danes." By this time, the Vikings in Ireland were pawns of the Irish kings.

The game played out differently in England. At first, Viking raids were sporadic. Then in 865, a "great heathen army" of Danes—a term used then to mean any Viking, whether from Denmark, Norway, or Sweden—arrived in East Anglia, one of five English kingdoms. Bartering peace for horses, the Vikings rode to Northumbria and conquered

the city of York. Next they took East Anglia (so much for their bargain). They rode into Wessex, where King Alfred, later known as the Great, promptly paid them to leave. They turned toward Mercia instead and sacked London. Rallying the English, King Alfred retook London and by 890 had brokered a deal to divide England into two kingdoms (not five). "All the English people submitted to Alfred," says the *Anglo-Saxon Chronicle*, "except those who were under holding of Danish men." This "holding" became known as the Danelaw.

The game board was upset a hundred years later when new players arrived. The king of England was a boy of twelve. The Vikings in the Irish Sea, with their "unerring nose for weakness," intensified their attacks on England's western shores. At the same time, Olaf Tryggvason, soon to be king of Norway, allied with Svein Fork-Beard, the reigning king of Denmark. They landed their combined Viking forces, "an insolent and fearless army," says the chronicler, on England's east coast, and "wrought the greatest evil that ever any army could do, in burning, and harrying, and in manslayings. . . . And at last they took them horses, and rode as far as they would, and were doing unspeakable evil." The *Anglo-Saxon Chronicle* blames everything on the incompetence of the young English king, known to history as Aethelred the Unready: "When the Vikings were in the east, the English army held to the west. And when the Vikings were in the south, our army was in the north."

Meanwhile, English tax collectors kept making their rounds. In 991, 10,000 pounds of silver were paid to Vikings in Danegeld, or peace payments; 16,000 in 994; 24,000 in 1002; 36,000 in 1007; 48,000 in 1012. In 1013, the English accepted Svein Fork-Beard as their king. He soon died but was succeeded (after more battles) by his son, Knut, or Canute the Great, who exacted another 82,500 pounds of silver to pay off his army. He must have been impressed by the efficiency of those English tax collectors, for Canute made few changes in how the realm was ruled. Instead, he remade himself into the image of a proper English king—he was already Christian—by marrying King Aethelred's widow, Emma of Normandy, and becoming a benefactor of the church. Like Charlemagne, Canute had imperial ambitions. He inherited Denmark in 1019, conquered Norway in 1030, and claimed Sweden, Scotland, and Wales.

This grand Viking empire fell apart at Canute's death in 1035. His two sons did not live long, and in 1042, Edward, Aethelred and Emma's son, gained the English throne. But upon Edward's death in 1066, all three rivals for the English crown had Viking roots: the half-Danish Harold Godwinsson, the Norwegian king Harald Hard-Rule, and the Norman conqueror, William, whose forebears included the Viking sea king Gongu-Hrolf, or Rollo, given the duchy of Normandy as a peace payment in 911.

OTTAR'S VOYAGE

So ends the Viking Age in 1066, according to most books. What's missing in this view of history are the fish teeth.

In 890, about the same time as Paris was being besieged by the frenzied horde and the Irish monk was blessing bad weather, a Norseman named Ottar arrived at the court of King Alfred the Great. Alfred had been battling Viking hordes for twenty years. But this Norseman presented himself as a merchant and was welcomed. An account of his visit was written down in Latin—we used to think by the king himself, though probably the scribe was a cleric. Ottar—spelled "Ohthere" in the Anglo-Saxon text—said "that he lived furthest north of all Northmen." The land, he added, "extends a very long way north from there, but it is all waste, except that in a few places here and there Finns camp, engaged in hunting in winter and in summer in fishing by the sea." Ottar sailed to the Finns' lands, he explained, "for the walruses, because they have very fine bone in their teeth" and "their hide is very good for ship's rope." The Anglo-Saxon writer adds, "They brought some of the teeth to the king." These were not so much a gift as a canny merchant's free sample.

All the while Viking hordes were harrying, pillaging, plundering, burning, "doing unspeakable evil," and generally going berserk across the British Isles, they were also engaging in trade—as they had for at least fifty years prior to 793, according to researchers who see changes in the goods imported, the houses and settlements built, and the styles of art in Scandinavia from the early 700s on. Even in the 600s, Norwegians were building bigger boathouses and Swedes were establishing trading centers.

That bolt-from-the-blue idea—that the monks of Lindisfarne were taken completely unawares, that they had never even imagined a Viking ship—is a misreading of a letter to the king of England from the Northumbrian cleric Alcuin, who then resided at Charlemagne's court. In the standard translation it reads: "Lo, it is nearly three hundred and fifty years that we and our fathers have inhabited this most lovely land, and never before has such terror appeared in Britain as we have now suffered from a pagan race, nor was it thought that such an inroad from the sea could be made." But the Latin word translated as "inroad from the sea" more generally means a disaster. What horrified Alcuin was not that Viking ships sailed to England but that the holiest place in Northumbria, Lindisfarne on the Holy Island, had not been protected by God.

How could this have happened? Perhaps, wrote Alcuin, the fault lies in ourselves. "Consider the dress, the way of wearing the hair, the luxurious habits of the princes and people. Look at your trimming of the beard and hair, in which you have wished to resemble the pagans. Are you not menaced by terror of them whose fashion you wished to follow?" Far from being some new species of devil, the Vikings were all too familiar, in Alcuin's opinion: Englishmen were even imitating their long hair (some wore it rolled into a bun, others shaved all but one lock), their beards, and their flowing mustaches.

In fact, "the first ships of Danish men to come to the land of the English," according to the *Anglo-Saxon Chronicle*, were not the raiders at Lindisfarne in 793 but "three ships of Northmen" who arrived in the south at Portland Harbor, near Weymouth on the English Channel, in 787 or 789. The incident is remembered, one scholar quips, because of "a slight but fatal misunderstanding with the customs." When the Vikings landed, "the reeve rode up and wanted to drive them to the king's manor because he did not know what sort of men they were, and then he was killed."

In 789, Vikings used the same ships for both raiding and trading: Ship technology had not yet separated the dragonship from the *knarr*. When trading, they set up tents on the shore and did business beside their ships—without the interference of a king or his lackeys. When raiding, they also set up ship-side camps. The reeve could not have known

"what sort of men they were." Nor do we. In this earliest version of the *Anglo-Saxon Chronicle*, compiled at King Alfred's court in the late 800s, there are no hints. Later manuscripts add information to tip the balance toward trading: The "Danish men," we learn, came from Hordaland in Norway. No reeve, sighting three boatloads of attacking Vikings, would stop to ask them what district they hailed from. The two sides must have conversed. And someone lived to tell the tale.

In Norway, five hundred graves and settlements, most of them datable to the 800s, have yielded jewelry, riding equipment, merchant's scales, and bits of book mounts, shrines, and reliquaries from England and Ireland. Some of those objects were mementos of raids, others the profits from trading—it's hard to say which are which. Yet Norway itself gets its name from a trade route: the "North Way" behind the barrier islands from the Oslo Fjord north to the resource-rich Arctic that Ottar described to King Alfred in 890. Already more than a hundred years before Ottar sailed, Frankish and English goods were reaching these "furthest north of all Northmen."

At Borg in the Lofoten Islands in far northern Norway, on a hill with a sweeping view of the sea, archaeologists in the 1980s unearthed a grand chieftain's hall. Established in the fifth or sixth century, it stood until about 950. A beautiful piece of Anglo-Saxon goldwork from the mid-800s was found in the house; it's thought to be the head of a pointer meant to be used when reading manuscripts. Other rare finds were shards of fine glass and ceramics: The chieftain of Borg poured his beer from ceramic jugs, now known as Tating ware, with a glossy black finish and designs made of pieced tin, a style made in the Rhine valley between 750 and 850. He and his guests drank from delicate glassware, some of which came from England.

The chieftain's hall overlooked fine grazing lands and fertile fields where some barley was grown (at least enough for the beer). The area was densely populated. The harbor was well protected; the boathouses were huge. Fishing was Borg's main industry—dried cod, or stockfish, was an important export already in the 700s. Light, nutritious, and lasting for up to six years without rotting, dried fish was the perfect food on a Viking ship. In addition to selling stockfish, the chieftains of Borg paid for their southern luxuries by trading iron and silver objects to their

neighbors farther north, the people Ottar in 890 called the Finns and we now call the Sami. Known for their proficiency on skis, the Sami herded reindeer and hunted bears, wolves, lynxes, foxes, martens, otters, badgers, beavers, squirrels, and ermines for their valuable furs. The Sami were also the main suppliers of walrus tusks and walrus-hide ropes until the mid-800s.

Before the river of silver dirhams arrived in the North from Baghdad, before Frankish ransoms and English Danegelds filled their coffers, the chieftains of Norway grew rich—rich enough to build Viking ships—by trading Sami furs and walrus ivory to the South. Control of this "Finn trade" was crucial to King Harald Fair-Hair's campaign to unify Norway in about 872. Harald did not so much conquer the land as rule the seas. Once his earls commanded each strategic harbor on the North Way, the rich northern chieftains were forced to submit.

Ottar may have been one of them. From his home in the far north, he told King Alfred in 890, Ottar sailed for more than a month—hugging the coastline and landing to camp each night—down the North Way to Skiringssalr, or "Shining Hall," a market town in southern Norway now identified as Kaupang in Vestfold, near the mouth of the Oslo Fjord. Among the hundreds of thousands of artifacts found at Kaupang are Arabic dirhams, Baltic amber, carnelian, amethyst, and rock crystal from the Russian trade routes, pottery and glass vessels from the Carolingian empire, Irish and Anglo-Saxon ornaments and weapons, and bits of walrus ivory.

From Kaupang, on his usual run, Ottar said, it was five days east, with the right breeze, to Hedeby; chips of walrus ivory have been found there too. This time, to visit King Alfred, Ottar had chosen to sail southwest. He was not the only northern trader to do so in the late 800s. By then both Dublin and York were major Viking ports, and at each site archaeologists have found walrus ivory. It might not have come through the Finn trade, however. By then the Vikings had a new hunting ground.

THAT FISHING CAMP

"Sailing ships skillfully over the sea," as an Irish poet said, was the key to "the gluttony and commerce of the Vikings."

Norway is a coastal country. Its people looked outward, seaward; the North Atlantic, to them, was a "binding force," a Way, not a barrier. From Hordaland, home of the Vikings who killed the English reeve at Portland, you're but a short sail due west to the Shetland Islands, another day or two to the Faroes—and west is the way the prevailing winds blow during the spring sailing season. Another week of sailing with the wind and you'll spot the high white ice cap of Iceland.

The first to do so, in 770, according to one version of the twelfth-century Icelandic *Book of Settlements,* was a Viking called Nadodd. He was heading for the Faroes but was "blown westward out to sea, and discovered there a great land." He and his crew went ashore, "scaled a high mountain in the East Fjords, and looked all around to see if they could see smoke or any other sign that the country was settled." They saw nothing but snow. In the east of Iceland is the largest glacier in Europe. They sailed back to the Faroes.

Word of Nadodd's "Snowland" got around. A Swede called Gardar next went west. The story goes that he was egged on by his mother, who was a seer—we don't know what she envisioned, but possibly a land of riches, of furs and fish teeth, like Norway's far north. Gardar sailed around the country, proving it an island; he built a house on the north coast and overwintered there. Returning to Norway the next summer, he left behind two men and a woman. The *Book of Settlements* makes it sound like an accident; it probably wasn't. Walruses have frequently been sighted near where the three settled.

Raven-Floki set out next; he came from Hordaland and apparently brought his family along. First they went to Shetland—the stopover is recorded because his daughter drowned there. Floki earned his nickname by taking three ravens in his boat. When he set the first one free, it flew back east toward Shetland. The second, released a day or two later, circled the ship and landed on the mast. After another day passed, the third flew west: Floki followed it and found the island he named Iceland. He cruised by the south coast and landed in the west, beside a fjord that "was full of fish, and they were so busy fishing that they gave no thought to making hay, and their livestock all died in the winter." Still, they stayed two winters before returning to Norway.

What kind of fish caused Floki and his family to go berserk? Perhaps the fish with valuable teeth: walrus. The *Book of Settlements* makes no mention of walruses. By the time the account was written, around 1120, the breeding population in Iceland was extinct. But the word used for fish is *veiðiskap*, which applies to any kind of catch, fish or game, while close by the strand where Floki landed are a cluster of place-names that mean walrus breeding grounds.

Historians have long wondered why the Vikings sailed west out of sight of land, into waters unknown, to Iceland, to Greenland, to North America, rather than concentrating on their lucrative raids and conquests in Western Europe or their busy trade routes eastward to Russia, Byzantium, and beyond. Did population pressure drive the westward expansion? A sense of adventure? A love of freedom?

The Family Sagas argue strongly for "love of freedom." Ketil Flat-Nose, for instance, appears in several sagas. In *Laxdaela Saga,* he's called "a powerful chieftain in Norway, from a noble family." He ruled in Sogn, a little north of Hordaland. "Toward the end of Ketil's days, the power of King Harald Fair-Hair rose until no other kings or chieftains could stay in the land unless he gave them rank and title. And when Ketil learned that King Harald planned to give him the same choice as other leading men—to have no compensation for the deaths of his kinsmen, and himself to become a hireling—he called a meeting of his kinsmen." Ketil's sons suggested the family move to Iceland. They had heard "many intriguing reports of it, saying there was good land to be had, free for the taking, there was great whale hunting and salmon fishing, and there were fishing stations for both winter and summer." Ketil nixed that idea, saying "That fishing camp will never see me in my old age." He preferred to head to Scotland. "Those lands were well known to him," the saga says, "because he had raided there extensively."

Laxdaela Saga was written in the mid-1200s, though it reports these events from the mid-800s. This anecdote was told and retold for centuries before being reimagined by the saga writer. How much is true? How much was left out? Under the rubric "great whale hunting," were Ketil's sons referring to walrus, which, as we have seen, the Norse considered a small whale? Though Ketil died in the Hebrides, his sons and daughters

and many other kinsmen ended up in Iceland, most of them in the west, where walruses were indeed once found.

The official first settler of Iceland, the one to whom statues are erected, is the Viking sea king Ingolf Arnarson, who also comes from the Hordaland and Sogn area of Norway. To conclude a feud, he and his brother-in-law Hjorleif were fined "everything they possessed." They packed up and sailed two ships west. Reaching Iceland in 874, they were separated, and Hjorleif was killed by his Irish slaves. After exploring a bit, Ingolf decided to settle at the edge of a large bay in the southwest of the island, where the capital city of Reykjavik now lies. *Here?* complained Ingolf's man, Karli. "It's not much use our traveling across good country, just so that we can live on this out-of-the-way headland," he said. "After that," reports the *Book of Settlements*, "he disappeared, taking a slave girl with him."

The *Book of Settlements*, despite the occasional dragon, troll, sorcerer, or ghost, is considered history, not fantasy. It was begun in about 1120, maybe by Ari the Learned, who was commissioned by Iceland's two bishops to write the earlier *Book of the Icelanders*. The *Book of Settlements* was heavily revised a hundred years later and exists in several different versions. Systematic and carefully structured, it proceeds clockwise from Reykjavik, naming 430 of Iceland's first settlers, their farms, their families, their feuds, and their source, if any, of fame. But Karli's astonishment at Ingolf's choice of "out-of-the-way" Reykjavik is not history. Instead, it reflects the surprise of the twelfth-century Icelanders who told the tale. Chieftains then, in Iceland's Golden Age, were rich in butter and wool: Their wealth was on the hoof, their chief resources vast grasslands and a good winter's store of hay. But for the first settlers, the situation was different. The future grasslands were covered by brush and scrubby trees. Cows and sheep, brought over in open boats, two by two, take five years to double, thirty years to increase a hundredfold—at which point they might provide enough food to support their owners. Until then, the settlers had to survive on out-of-the-way headlands and offshore islands where seabirds, seals, whales, and fish were plentiful.

Walrus was added to that list of resources in 2003, when a team from the Archaeological Institute of Iceland finished excavating a Viking Age longhouse in Reykjavik. Icelandic archaeologists have an advantage over

their peers elsewhere: Iceland's volcanoes periodically deposit a layer of ash over parts of the island; these layers make definite strata in the soil and can be dated exactly by chemical comparison with the ash in the Greenland ice cores. One eruption has been particularly helpful. In 871, plus or minus two years, a volcano beneath Iceland's vast eastern glacier spread dark-gray ash over the entire country and as far west as Greenland. The longhouse in Reykjavik was built just after this eruption. It's not a fishing camp but an ordinary farmhouse, with signs the farmers raised cows and sheep. Nearby, a bit of wall discovered in the 1970s predates the eruption—and so the official settlement of Iceland—but it, too, seems to be from a farmhouse, not a hut for walrus hunters.

Yet walrus hunters were here. Built into one wall of the longhouse was a walrus backbone. Secreted away beneath a sleeping bench, and apparently forgotten, were three walrus tusks. All were left-hand tusks: They came from three different animals. Fragile and crumbling from long contact with the damp soil, only Specimen 1 could be fully examined. It must originally have been about eighteen inches long—average size. Tool marks show it was expertly cut from the walrus's skull, a difficult process that takes time to learn. Sawing the tusks at once from the dead animal is inefficient: The tusks tend to break off. It's better to wait a few weeks until the bone starts to decompose, then chisel the tooth from the skull, chipping away above the gum line. In this, Specimen 1 shows the work of a practiced hand.

Walrus tusks had been found in Reykjavik before—eleven times before—without anyone taking much notice. Walrus bones, including the bones of newborns, had also been found, proving there was a nearby breeding population. Since the 1980s, historians had tried to connect the old name of the peninsula south of Reykjavik—Walrus Point—with the impetus for Iceland's settlement, yet it seemed a long shot. Then the archaeologists found the hidden tusks. Reassessing old digs, they realized that walrus tusks and bones had been found in several Viking Age excavations around the island. The connection between walruses and Iceland's first settlers suddenly became clear.

The longhouse—with the walrus vertebrae visible in the wall—is now preserved in situ beneath a new Reykjavik hotel. It represents a new way of thinking about Iceland's early years. The saga version, with

chieftains fleeing King Harald's tyranny, may still be partly true. But someone was in Iceland before them—possibly long before them—hunting walruses.

AS FAR AS THE POLAR STAR

Walrus ivory lured the Vikings to Greenland as well, we now believe, though the *Book of Settlements* tells a different tale. There, Eirik the Red, outlawed from Iceland for killing his neighbors, bravely sailed west and chanced upon Greenland. When his three years' exile was up, this famous Viking explorer returned home and convinced twenty-four shiploads of Icelanders to colonize the new land with him in 985. Fourteen ships made it, carrying perhaps four hundred people.

The *Book of Settlements* hints that Eirik duped them, promising a "green land" more fertile than Iceland—which Greenland is not. Seventy-five percent of the huge island is ice-covered. Like Iceland, Greenland has no tall trees, and so no way to build seagoing ships. Farming is marginal. Only two places, Eirik's Eastern Settlement of five hundred farms at the island's southern tip and his Western Settlement, a hundred farms near the modern-day capital of Nuuk on the west coast, are reliably green enough to raise sheep and cows. But a good marketing ploy doesn't explain why the colony lasted into the 1400s. Walrus ivory does.

A thirteenth-century treatise from Norway, *The King's Mirror*, written as a dialogue between a father and son, concurs. "I am also curious to know why men should be so eager to fare thither," the son says of Greenland. There are three reasons, answers his father: "One motive is fame and rivalry, for it is in the nature of man to seek places where great dangers may be met, and thus to win fame. A second motive is curiosity, for it is also in man's nature to wish to see and experience the things that he has heard about, and thus to learn whether the facts are as told or not. The third is desire for gain." Men go to Greenland, he said, for walrus-hide rope "and also the teeth of the walrus."

By the time Greenland was discovered, Iceland's walruses were a fond memory. They were never as numerous as the Greenlandic herds. Even now, walruses thrive along Greenland's icy northwest coast, near

Disko Bay, where Eirik the Red had his Northern Camp. It was not a nice place to work. In the *Edda,* written around 1220, Snorri Sturluson preserved a few lines of an earlier poem describing it:

> *The gales, ugly sons*
> *of the Ancient Screamer,*
> *began to send the snow.*
> *The waves, storm-loving*
> *daughters of the sea,*
> *nursed by the mountains' frost,*
> *wove and ripped again the foam.*

And that was the summer weather. The Northern Camp was a three-week sail north from Eirik the Red's estate in the Eastern Settlement. From the Western Settlement it was closer— about four hundred miles, only a fifteen-day sail in the six-oared boats the sagas mention. Once there, cruising the edges of the ice sheet looking for walruses, the Vikings could see the easternmost rim of North America. One saga of the discovery of the Vikings' Vinland traces this route: north to the walrus grounds, west across the Davis Strait, then south along the coast of Labrador to Newfoundland, where Viking ruins have been found at L'Anse aux Meadows. From there the Vikings may have explored all of the Gulf of Saint Lawrence south to the mouth of the Miramichi River and up the Saint Lawrence River toward present-day Quebec.

They found salmon and tall trees, wine grapes and self-sown wheat in Vinland, the sagas say, along with an overwhelmingly large population of hostile natives. Strangely, no saga mentions the vast herds of walrus on the Magdalen Islands off Newfoundland's southwestern tip. It was here, in 1775, that hunters used dogs to cut through a herd of seven to eight thousand walruses, killing fifteen hundred beasts in one night. Hundreds of years before, the Micmac tribes summered in these islands, supporting themselves on walrus. A few bones that may be walrus were found at L'Anse aux Meadows, but if walrus ivory led the Vikings to Vinland, it wasn't sufficient to convince them to stay. The encampment at L'Anse aux Meadows was lived in for only a few years, and no Viking settlements farther south have been found.

Vinland was very far to go. About two thousand miles from Green-
land, it could be reached in nine days from Eirik the Red's Northern
Camp—if you were lucky. The crew of one replica Viking ship was at
sea for eighty-seven days. You needed luck, as well, to return home with
your cargo of tusks and hides. Even the most successful Vinland voyage
in the sagas—the expedition in about 1005 by Gudrid the Far-Traveler
and her husband, Thorfinn Karlsefni—lost two of its three ships. Ac-
cording to the *Saga of Eirik the Red,* Gudrid and Karlsefni were accom-
panied by two ships of Icelanders and one of Greenlanders, totaling 160
men. The tiny Greenland colony could not afford to lose a shipload of
men. The six hundred known farms were not all active at the same time.
At its peak in the year 1200, Greenland's population was only two thou-
sand. By comparison, Iceland's population in the year 1200 was at least
forty thousand.

Greenland's labor shortage was severe. The time-consuming trips
to the Northern Camp had to be planned around the summer chores
required to survive: hunting the migrating seals, gathering birds' eggs
and down, fishing, berrying, and most important, haymaking. The
walrus hunt began in mid-June (after the seals left) and ended in Au-
gust (before the haying). Four or five boats would row north, each
crewed by six or eight men—the most that could be spared from the
Western Settlement's hundred farms. It was a dangerous undertaking.
Men died not only from shipwrecks and exposure but during the hunt
itself: As we have seen, walruses are not easy prey. It was also profit-
able. According to one calculation, each of the Greenlanders' six-oared
boats could carry an estimated three thousand pounds of cargo: That's
about two whole walruses, or twenty-three walrus hides and heads, or
160 heads alone.

To save on weight, the hunters chopped the skulls in two and took
only the tusked upper jaws south. There the tusks were worked free of
the jaws over the long winters. It took skill and training—but every
farm in the Western Settlement, it seems, had someone assigned to the
task. Chips of walrus skull have been found on large farms, on little
farms, even on farms a long walk from the sea. The chieftain's farm of
Sandnes—where Gudrid the Far-Traveler once lived—may have been
the center of the industry. Walrus ivory was extracted there for 350

years, longer than at any other farm, and the amount steadily increased from the year 1000 to 1350. The Sandnes ivory workers also grew more skilled at their trade, leaving fewer chips of ivory as compared to chips of jawbone.

From the Western Settlement, the ivory was shipped south to the Eastern Settlement. It seems to have been stored in the large stone warehouses at the bishop's seat at Gardar, which—with barns for a hundred cows and a grand feast hall—was the biggest farm in Greenland. A haunting find in the churchyard there hints at the walruses' cultural importance: Archaeologists unearthed nearly thirty walrus skulls, minus their tusks, some in a row along the church's east gable, others buried in the chancel itself.

Greenlandic ivory found a ready market. Modern museum inventories of ivory artwork show a spike around the year 1000, soon after Greenland was settled. The popularity of walrus ivory continued to rise through the next two hundred years, and Greenlanders strove to meet the demand: The waste middens beside their farms become richer and richer in walrus debris. In the 1260s, when the Greenlanders, like the Icelanders, agreed to accept the king of Norway as their sovereign, King Hakon the Old made it clear that his jurisdiction extended all the way north to the walrus hunting grounds. His official court biographer, the Icelander Sturla Thordarson, wrote in a verse that the king would "increase his power in remote, cold areas, as far as the Polar star."

How much ivory came from Greenland is hard to know. The only historical record tells of the shipment sent by the bishop of Greenland to Bergen in 1327 in support of a crusade. Estimated at 520 tusks, or less than two boatloads from one year's hunt, that one shipment was worth 260 marks of silver, equivalent to 780 cows, sixty tons of dried fish, or 45,000 yards of homespun wool cloth—more than the annual tax due from Iceland's four thousand farms that year.

Another indication of the riches available in Greenland comes from the fourteenth-century *Saga of Ref the Sly*. Set in the days of the settlement, it's a picaresque tale of a master craftsman whose foul temper and violent overreactions get him kicked out of Iceland, Norway, and Greenland. He and his family are finally taken in by the king of Denmark, who is pleased to learn that "they had a wealth of ropes and ivory goods and

furs and many Greenlandic wares seldom seen in Denmark. They had five white bears and fifty falcons, fifteen of them white ones." Earlier in the saga, the king of Norway ordered one of his men to sail to Greenland and "bring us teeth and ropes." It was to win the Norwegian king's aid against Ref the Sly that the Greenlanders sent, as well, a gold-inlaid walrus skull and a walrus ivory gaming set made for playing both the Viking game of *hnefatafl* and chess or, as one translator construes it, "both the old game with one king and the new game with two."

The Greenlanders kept very little ivory for themselves. They carved the peglike back teeth into buttons, they made tiny walrus and polar bear amulets and a miniature figurine of a man in a cap, and they fashioned a few ivory belt buckles, like the one found with the Lewis chessmen. But only two pieces of more elaborate ivory artwork have been discovered in Greenland.

One is a broken chess queen, picked up by a Greenlandic hunter from the remains of an Inuit summer camp on a small island close to the modern town of Sisimiut, about halfway between the Vikings' Western Settlement and their Northern Camp. The hunter presented it to the queen of Denmark in 1952, and though it passed from Queen Ingrid's private collection into that of the Danish National Museum in the 1960s, it was not put on display until the early 2000s. No one has mentioned it before in connection with the Lewis chessmen, though the visual similarities are striking: The Greenland queen is roughly the same size. She is seated on a throne, though hers has a higher back or hasn't been finished—the ivory is in such poor condition, it's hard to tell. The Greenland queen wears a rich gown, though the folds in her dress are sharper and more V-shaped than the pleats on the Lewis queens' gowns. She rests her left hand on her knee; her right arm is broken off and her face and chest are chipped away, so we cannot say if her right hand touched her cheek.

The second work of art found in Greenland is the ivory crook of a bishop's crozier. Adorned with a simple chevron design, the center of its spiral is filled with four curling leaves in the graceful Romanesque style, which displaced Viking styles of art throughout the North in the twelfth century. The crozier was discovered in 1926 buried with a skeleton under the floor of the northern chapel of the large stone church at Gardar.

The archaeologist who excavated the grave dated the crozier stylistically to about 1200. He suggested it was made for Bishop Jon Smyrill, who died in 1209, by Margret the Adroit, who is named in the *Saga of Bishop Pall* as "the most skilled carver in all Iceland." And so we bring our next chess piece onto the board: the bishop.

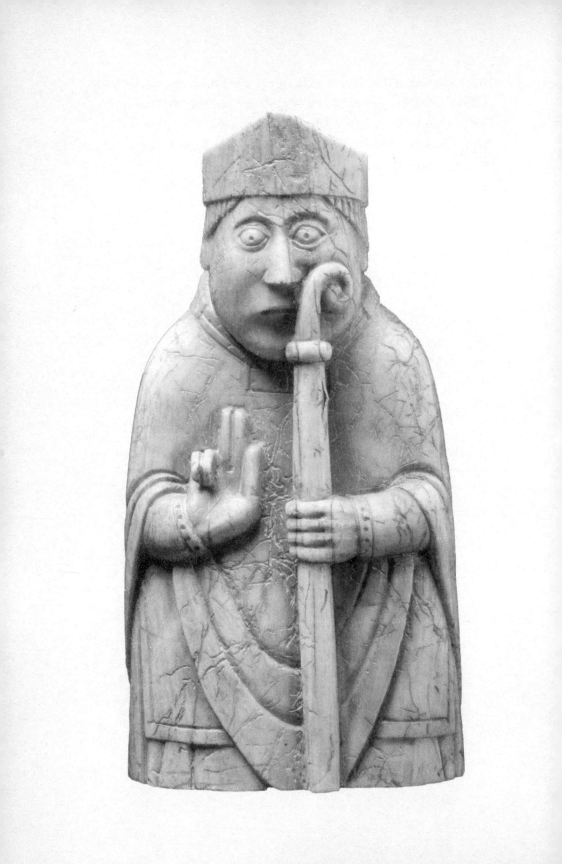

TWO

The Bishops

The bishops stand flanking the king and queen. How odd, if you think about it. Chess is a war game. What is a churchman doing on the chessboard? If you were king, who would you want closest to hand: a berserk? a knight? or a bishop, who, as the archbishop of Trondheim saw fit to remind the Icelanders in 1173 and again in 1189, owed "obedience to God and Saint Peter and me"—not to a king or queen—and was to involve himself only in those disputes that "do not require the use of weapons."

Our sixteen Lewis bishops are not armed. Snug against his body each carries the ceremonial shepherd's crook, or crozier, that marks his office; its curlicue touches his cheek. Seven hold books, likely gospels or psalters, too slim to be Bibles; six volumes are closed, the seventh is open and brandished as if to banish Satan. Three bishops raise their right hands in blessing, thumb and first two fingers extended, ring finger and pinky curled. Their clothes are finely detailed. Some wear the hooded, cloaklike chasuble, others a cope, open in front to clearly show the dalmatic, stole, and alb beneath. The fabrics fall in rich folds; the edges are trimmed with punch-dotted rows of ornament. None of our bishops is

an archbishop—all are missing the pallium, the bejeweled and embroidered ribbon an archbishop wore draped around his shoulders and dangling down front and back. (An archbishop, as well, would carry a cross, not a crozier.) Most of our bishops are fat—not fighters. Only six could be called lean, none ascetic. The expressions on their round, bejowled faces are mild, resigned, grim, glum, numb, determined, nonplussed, astonished, grieving, bereft, afraid—only one seems to glare in righteous fervor. Their hair is cropped short. None is bearded, though beards were in style in the twelfth century, judging from an image of six bishops in the psalter of Henry of Blois, bishop of Winchester from 1129 to 1171.

All sixteen Lewis bishops, however, wear the latest in ecclesiastical hats. Before 1049, bishops covered their heads however they pleased. That year, Pope Leo IX introduced the Roman miter "to remind you that you are a disciple of the Roman see." At first it was a soft white cap with ribbonlike lappets hanging down the back. As the caps grew more imposing, the material tended to sag, making horns. Most bishops did not care for the connotations of horns. On their seals—used to authenticate their letters by stamping their image in sealing wax—we see their responses. The bishop of Lincoln was unbothered: In 1140, he wore horns. The bishops of Worcester stiffened the fabric so it couldn't collapse; they wore these domed miters in 1125 and 1164. The more common response was to swivel the hat.

Scholars since 1832 have used the bishop's miters—all "gabled," with peaks front and back—to date the carving of the Lewis chessmen to between 1150 and 1200. Yet no pope promulgated an order telling the West's bishops when to twist their hats. In France, the fashion arrived by 1144. In England, the bishop of Durham wore a gabled miter in 1153, while as late as 1174 the archbishop of Canterbury wore horns. The first archbishop of Uppsala wore horns in 1185, but the new gabled miter reached Scandinavia by at least 1202: The miter of Absalon, archbishop of Lund from 1178 to 1202, matches that of the Lewis chessmen.

Archbishop Absalon consecrated Pall Jonsson as bishop of Skalholt, Iceland, in 1195. Either of these two men could have commissioned the Lewis chessmen—for one answer to the question of how a bishop ended up on the chessboard is that a bishop put him there. The Lewis chessmen, being the oldest extant sets that unmistakably include bishops,

could mark the debut of the bishop on the board. If they were made in the Norse world after gabled miters became the rage, the bishop who had this bright idea could be Pall, bishop until 1211, or Absalon, who, before he became archbishop, was bishop of Roskilde for twenty years. Another name often raised in connection with the chessmen is Eystein, archbishop of Trondheim from 1157 to 1188. A fourth, less likely possibility is Pall's predecessor, Thorlak, bishop of Skalholt from 1178 to 1193. Nor can we rule out Pall's friend Bishop Bjarni of Orkney (1188–1223), though we know little about him.

Chess terminology doesn't veto the idea that a late-twelfth-century bishop put a piece in his own image on the board. The game in the Einsiedeln verses, from 997, placed counts beside the king and queen, close enough "to hear with their ears the spoken words of their lords." A Latin verse from twelfth-century England calls the piece *calvus,* or "bald-head," which might allude to a tonsured churchman, except that the sentence continues, "as a guard." Unarmed bishops do not make good guards. A later line adds, "he lies in ambush like a thief"—very unbishoplike behavior.

Other early texts use a form of the Arabic name for the original piece on these squares, the elephant, *al fil,* though they show no awareness of the word's meaning. The eleventh-century French *Romance of Alexander* names the piece *aufin,* as does the short Latin "Elegy on Chess." The English cleric Alexander Neckam, writing in about 1180, included chess in his book *De Naturis Rerum,* though he did not admire the game, decrying "the sudden fits of passion to which the players seemed peculiarly prone" and remarking that "often the game degenerated into a brawl. How many thousands of souls were sent to hell," he moaned, in the battle that broke out after one of Charlemagne's knights slew another with a chessman? To Neckam, who believed that chess was invented at the siege of Troy, the piece next to the king was "the old man, commonly called *Alphicus.*" He was "a spy wearing the form of Nestor." Elsewhere, the *aufin* or *alphin* is not only a spy, a thief, or old baldy the guard but a fool.

The Arabic elephant and the Christian bishop are not clearly linked until the mid-1200s. A sermon on chess makes the meaning plain: "*alphini sunt episcopi,*" "the *alphins* are bishops." In the Middle Ages this sermon was attributed to Pope Innocent III, who reigned from 1198 to

1216. But Pope Innocent could not have written the version we have. It begins beautifully: "The world resembles a chessboard which is checkered white and black, the colors showing the two conditions of life and death, or praise and blame. The chessmen are men of this world who have a common birth, occupy different stations, and hold different titles in this life, who contend together, and finally have a common fate which levels all ranks. The King often lies under the other pieces in the bag." From here, though, the sermon degenerates into an anti-establishment rant. The *alphins* "take obliquely because nearly every bishop misuses his office through cupidity." The sermon then insults archbishops, cardinals, even the pope. It is now believed to be the work of the Franciscan friar John of Wales, written between 1238 and 1262; Franciscans, pledged to poverty, had no sympathy for greedy bishops.

Another clear reference to the chess bishop comes from an Icelandic manuscript dated about 1300. In two sets of chess matches, games end in *biskupsmát*, or mate by a bishop, along with mates by a rook, a bare king, and the delightfully vulgar *fretstertumát* (loosely, "farter's mate"), which is "the most shameful" and seems to involve a king's pawn. The story in question, *Magus Saga*, does not belong to any of the genres of Icelandic saga discussed earlier. On the dragon scale, it scores high—it makes no pretense at history. It is a *riddarasaga*, or "Knight's Tale," one of forty-plus known translations or imitations of French chivalric romances. Most readers dismiss these tales as derivative kitsch, "among the dreariest things ever made by human fancy." Some were written in Iceland in the thirteenth century, at the same time as the Family Sagas, the "great world treasure." (They may have been considered kitsch even then. The author of one complained, "I think you shouldn't find fault with the story unless you can improve on it.") Other Icelandic Knight's Tales, especially those for which a French model can be found, were commissioned by the Norwegian kings Hakon the Old (1217–1263) and his grandson, Hakon Magnusson (1299–1319), who had a taste for French culture. *Magus Saga* may be one of these: It was based on the same *chanson de geste* that Alexander Neckam alluded to, in which a knight slew his opponent with a chessman while at Charlemagne's court.

Sometime between 1144 (when the French bishop twisted his miter) and the mid-1200s, then, bishops debuted on the chessboard. They were

standard in Iceland and, perhaps, Norway by at least 1300. But they were not universally adopted. As late as 1562, an English playwright could comment, "The Bishops some name Alphins, some fools, and some name them Princes: other some call them Archers, and they are fashioned according to the will of the workmen." The *Oxford English Dictionary* cites this line as the first use of the chess term *bishop*, which has remained the name of the piece in English. Modern Norwegian, Swedish, Danish, and German use a word that means "runner" or "courier," a fact that suggested to Willard Fiske, as he wrote in *Chess in Iceland* (1905), that the game was introduced to Iceland via England. Fiske could even put his finger on the three men most likely to have carried chess north, two of whom are bishops: Thorlak and Pall. The third is the chieftain Hrafn Sveinbjornsson.

LUCK OF THE WHITE CHRIST

Hrafn came from a wealthy family in Iceland's West Fjords, an area once known for its walrus breeding grounds. In fact, the only description of a walrus hunt in any medieval Icelandic text comes from *Hrafn's Saga;* in the saga, the terms *walrus* and *whale* are used interchangeably. One spring, the story goes, "a walrus came up on land, and men went after it and wounded it, but the whale leaped into the sea and sank, because it had been wounded internally. The men took to their ships and began to drag the bay, hoping to draw the whale up onto land, but nothing came of it. Then Hrafn called on the Holy Archbishop Thomas to help them recover the whale. He vowed that he would give him the whale's tusks, still fixed in its skull, if they could bring the whale up onto land. And after he made that vow, it wasn't long before they got the whale." From the frenzy of the hunt and the determination with which many men went after one lone beast, we can see that by Hrafn's time the native Icelandic walrus herds—with their valuable supplies of ship ropes and ivory—were gone.

The hide alone was worth the effort, apparently, for Hrafn made good on his vow. The Holy Archbishop was Thomas Becket, martyred at the altar of Canterbury Cathedral in 1170; about twenty-five years later, Hrafn went to Canterbury "and presented the tusks to the Holy Thomas

and contributed money to the church and asked to be included in its
prayers." He stayed in England long enough—if Willard Fiske is right—
to learn to play chess. Then he traveled on to Santiago de Compostela,
Saint-Gilles, and Rome, possibly stopping in at the medical school in
Salerno, for by the time he returned to Iceland, Hrafn had learned how
to cauterize a wound, let blood, and extract kidney stones following the
techniques taught there.

In 1200, an Icelandic priest named Berg translated Robert of Crick-
lade's *Life of Saint Thomas*. In 1202, Berg traveled to Norway with Hrafn,
and he is thought to be the author of *Hrafn's Saga*, penned after 1213,
when Hrafn was killed, but before 1228, when his sons took revenge. As
the saga begins, "We are here going to write about certain events that
happened in our own days and concern men known to us, of which we
know the truth." The story, still, has a slant: Hrafn is a Christian hero
who turns the other cheek. When his rival, Thorvald, surrounds and
sets fire to his house, Hrafn gives himself up, hoping his men will be
spared. Says the saga:

> Thorvald declared that Hrafn should be put to death. When Hrafn
> heard that judgment, he begged to be allowed to go to confession and
> to hear mass. He made his confession to the priest Valdi and recited
> the creed and received the *Corpus Domini* and knelt in prayer, shed-
> ding tears of deep repentance. Then Thorvald ordered Kolbein Bergs-
> son to kill Hrafn, but he refused. Next Thorvald spoke with Bard
> Bardarson, and said that he should kill Hrafn. Hrafn got down on his
> hands and knees and lay his neck against a balk of driftwood. Then
> Bard struck off his head against the log.

Compare Hrafn's killing in 1213 to that of the great Viking leader Thorolf
in *Egil's Saga*, written at about the same time, but set in the late 800s.
Though one story takes place in Iceland and the other in Norway, the sit-
uation is roughly the same: Thorolf is trapped inside his feast hall, sur-
rounded by the army of the king of Norway. The king allows the women,
children, old people, servants, and slaves to escape, then sets the place
ablaze. Greatly outnumbered, Thorolf and his warriors arm themselves.
They break through a wall of the house and come pouring out. "Thorolf

leaped forward, striking out on both sides, making straight for the king's banner. . . . He reached the shield wall and ran his sword through the man who carried the flag. Then Thorolf said, 'I'm three strides short.' He'd been struck by both swords and spears, but the king himself gave him his death wound, and Thorolf fell at the king's feet." Hrafn dies like a saint; Thorolf dies like a Viking, sword in hand, quip on his lips.

There needn't be a conflict between saint and hero: After all, the patron saint of Norway, Olaf, was a Viking. The idea that Vikings were anti-Christian is an accident of how we write history. We date the beginning of the Viking Age to the sacking of Lindisfarne Abbey in 793, the monks killed, carried off in chains, cast out naked, or drowned. We forget that every fighting band in the Middle Ages targeted churches, with their tall silver candlesticks, jeweled processional crosses, and iron-bound chests full of tithe pennies.

The story of the Viking Age is, in part, a story of how Christianity transformed the North. Charlemagne's "death or baptism" ultimatum to the Saxons in the late 790s may have triggered the earliest Viking raids on the continent, but the Danes were not immune to the new religion's appeal. Charlemagne's son Louis the Pious sent the missionary Bishop Ebo of Rheims north in 823. Ebo had enough success that, when he got caught up in a failed coup against Louis some years later, he fled with the help of his new friends, "some Northmen, who were familiar with the routes and ports of the sea." In 826, Harald Klak, aspiring to be king of the Danes, sought King Louis's backing. Harald let himself and his four hundred Viking warriors be baptized, after which he and Louis went hunting, then amused themselves playing board games. Harald Klak was defeated despite carrying the banner of Christ. Yet Christianity steadily worked its way north: The first Christian crosses, worn as jewelry, appear in Scandinavian burials before 900; the last pagan amulets in the shape of Thor's hammer date from the early 1100s.

King Harald Blue-Tooth raised an enormous runestone at Jelling in honor of his parents and himself, who "made the Danes Christian." He reigned from about 958 to 987, when he was deposed by his son Svein Fork-Beard. Svein, a Christian, led the Viking army that conquered England in 1014. His son Canute the Great, who ruled England, Denmark, and, for a time, Norway, was a great benefactor of the church. Canute

went to Rome in 1027, where he attended the coronation of the Holy Ro-
man Emperor Conrad, arranged a marriage between his daughter and
Conrad's son, and established a hostel for Norse pilgrims near St. Peter's
Basilica.

Fighting beside Svein Fork-Beard in England in 994 was the pagan
Olaf Tryggvason. The *Anglo-Saxon Chronicle* claims he was baptized
later that year, with the English king Aethelred the Unready standing
as his godfather. A year later, Olaf was proclaimed king of Norway and,
according to the Icelandic Kings' Sagas, set about converting his country
with the help of several English bishops.

The first version of *Olaf's Saga* was written in Latin between 1180 and
1200 by an Icelander known as Odd the Monk. Around 1230 Snorri Stur-
luson reworked it in Icelandic for his collection of sixteen Kings' Sagas,
Heimskringla. Here we see King Olaf facing down the farmers outside of
Trondheim: "When the farmers saw the odds against them if they fought
the king, they petitioned for peace, leaving the terms in the king's hands.
They came to this agreement: All the farmers there would let themselves
be baptized and would swear the king an oath to hold to the true faith
and give up all heathen sacrifices. The king kept all these men by his side
until they produced a son or a brother or another near kinsman to be his
hostage." Those who did not acquiesce were more roughly treated: "The
king asked him with kind words to become Christian. . . . Eyvind refused.
The king offered him gifts and great riches, but Eyvind wouldn't have
any of it. The king threatened him with torture or death. Eyvind was not
cowed. Then the king had them bring a washbasin full of glowing coals
and set it on Eyvind's stomach, and soon his stomach burst."

How much of this is true is anyone's guess. Adam of Bremen, writ-
ing in 1076, mentions English bishops in Norway around the year 1000
but dismisses the king as Olaf "Crow-Leg"—or, as one translator con-
strues it, "Crack-a-Bone"—for his reliance on soothsayers.

Nor was the faith King Olaf proclaimed in 1000 much like that held
by Hrafn in 1200. Christ in the Viking Age was always shown trium-
phant: not as the suffering and dying savior, but as the victorious har-
rower of Hell. He stands vigorously upright even on the cross, the crown
on his head not of thorns but of gold. He is a warrior: more like Thor the
Thunder God than our modern image of Christ. He also took on traits

of Odin, the Norse creator god, the trinity being a complete mystery to the Vikings. Christ is "king of the wind-house," "sole king of the sun," say the eleventh-century skalds. He "fashioned earth, sky, and faithful peoples." Those who were baptized "received great luck of the White Christ" and were guaranteed entrance to paradise. The concepts of sin and redemption were unknown, or at least unmentioned.

Hrafn's humility was of no use to the Viking king of Norway. What drew Olaf Tryggvason to Christianity was its infrastructure. Clerics keeping written records, he saw in England, could operate an efficient tax-collecting apparatus. Bishops at a king's right hand, as those of the tenth century were, gave him control over all aspects of religion—from who could perform a rite to who could enter a church. The pomp and prestige of the new faith was also a draw: Only as a Christian could Canute consort with Emperor Conrad. Finally, baptism was the ultimate gift in an economy that, like the Viking one, revolved around gift giving. By standing as Olaf's godfather, Aethelred forged a bond between the two kings as strong as a marriage alliance. And Olaf could offer that sacred tie (at no cost to himself) to his followers. Or he could place basins of live coals on their bellies.

THE SEA ROAD

No sooner had Norway converted than King Olaf turned his missionary eye on Iceland. But, as elsewhere in Scandinavia by 995, Christianity was not news to the Icelanders.

Raised to esteem the Roman Empire, its smooth roads and strong bridges still visible in the European landscape, we tend to forget there were older roads, well traveled before the Romans ever reached the North: the sea roads. If what defined the Viking Age was the ship, what defined the Viking World was the sea. Gaze at a map of the North Atlantic with that attitude, and it won't surprise you to learn that some of Iceland's first settlers were Christian.

We've already met Ketil Flat-Nose, the Norwegian chieftain who fled King Harald Fair-Hair's tyranny in the late 800s. He settled in Christian Scotland, instead of "that fishing camp," Iceland, but his family found no peace there. The fate of his daughter, Unn the Deep-Minded, is

striking. The twelfth-century Icelandic *Book of Settlements* mentions her marriage to the Viking king of Dublin. Upon his death, she left Ireland, traveling north through the chain of islands to return to her father's house in the Hebrides. Her son became a king in mainland Scotland—briefly. When he was killed, Unn gathered the rest of her kin, had ships built, and departed for Iceland. *Laxdaela Saga*, written in the late 1200s, traces the usual trade route through the isles: Unn sailed north from the Hebrides to the Orkney Islands, then north again to the Faroes, and from there west to Iceland. She arrived in around 900, claimed land, and, like a chieftain, parceled it out among her twenty followers. On a hill near her house she erected a cross.

One of her men, Erp, was the son of Earl Maelduin of Argyll and Muirgeal, daughter of King Gljomal of Ireland. Another was a Scotsman named Hundi. Unn's grandson, Olaf, had an Irish nickname, *Feilan*, meaning "Little Wolf"; he married a girl known as Alfdis from Barra, an island in the Hebrides.

Unn's clan was not the only one to have a substantial admixture of Scots and Irish: Of the names in the *Book of Settlements,* at least 20 percent are Celtic. As if echoing that twelfth-century statistic, genetic tests find the men of modern Iceland to be about 80 percent Norse in ancestry and 20 percent Celtic. Icelandic women are nearly 40 percent Celtic. To explain these results, we can imagine Viking men descending on the isles, each capturing a bride, and taking her off to Iceland. A DNA study of Viking Age skeletons from Norway backs up this theory. It also indicates that Ketil Flat-Nose was far from the only Viking to bring his daughter along. The Norwegian skeletons' mitochondrial DNA, inherited from their mothers, closely matched that of modern Orkney and Shetland Islanders, as well as Icelanders.

Place-name studies suggest that some Norse families lived in Scotland and the isles for generations. Thousands of islands, headlands, rocks, skerries, bays, farmsteads, and villages there have Norse names. On the Isle of Lewis, for example, Norse place-names outnumber Gaelic names by at least four to one. In the Bay of Uig area—where the Lewis chessmen were found—the ratio is thirty-five Norse names to four Gaelic ones. *Uig* itself comes from the Norse word for bay, *vík,* possibly the root of "Viking."

A Viking Age burial was found in Uig in 1915. The skeleton, of a woman, wore the characteristic pair of bronze oval brooches Viking women used to clasp the straps of their dresses, but she was also buried with a cloak pin and belt buckle bearing Celtic designs. The grave of a second Viking woman—complete with a pair of oval brooches, a necklace of glass beads, a ringed pin, knife, needles, and sickle—was found in 1979. Both woman died in the tenth century, at about the time Unn the Deep-Minded took her extended family to Iceland.

Six more Viking Age burials were found near Uig in the 1990s, after a windstorm ate into the dunes. They were discovered by two teenagers on a trip to the beach. Reading like the beginning of a young adult novel, the scientific report states, "In a blow-out, high up on the machair-covered slopes of Cnip headland, Marie spotted what turned out to be the bleached remains of a human skull lying in the sand." The seven skeletons in these six graves dated to the ninth century. An analysis of the strontium isotopes in the enamel of their teeth show that two, a man and a woman, came from away. Neither was born in Norway, though the woman was wearing traditional Norse jewelry. According to her teeth, she may have been raised in Denmark or England, while the man came from Ireland or possibly even Iceland.

Archaeologists using systematic surveying and remote-sensing techniques in the last twenty-five years have begun finding Viking settlements across northern Scotland and throughout the Hebrides, including two on Lewis. Added to the place-names and the few lucky grave finds, the settlements upend our expectations. These were not "people on the edge, eking out a miserable subsistence" on the margins of the Viking world, the archaeologists note. They were players in a huge cultural network, trafficking in goods and ideas.

In spite of Ketil Flat-Nose's disdain for fishing camps, for example, one of the new technologies the Norse introduced to Scotland and the Hebrides—as revealed by the bones in their garbage middens—was a better way to catch cod. The Norse increased the cultivation of flax for making linen and may even have introduced it to some areas. At one site, Norse settlers collected whelks and extracted a valuable purple dye from their shells. Changing fashions in the styles of combs—particularly, the use of reindeer antler to make Pictish style "double" combs, with teeth

facing in two directions—show that, at least occasionally, the Vikings and the natives got along.

Friendly trading links between Scotland, which turned Christian in the fifth century, and pagan Norway may, in fact, long predate the Viking Age. From Bergen in Norway, on the sea road, the Shetland Islands are as close as Trondheim. In the spring, when the prevailing winds are from the east, the Bergen-to-Shetland run takes twenty-four hours. From there the hundred-plus islands along the north and west coasts of Scotland are stepping-stones on a five-hundred-mile sailing route south to Dublin and beyond. In the autumn, the winds conveniently reverse. Norse traders (or raiders) had no need to spend a winter away from home, unless they wanted to.

Some did. In the Orkney Islands, especially, artifacts speak of a long period of overlap between native and Norse cultures. In 2013, for example, an Orkney mason gathering building stone found one with a series of Viking runes carved on its side. His daughter being a specialist in Norse church history, he soon learned what the runes said: "who art in heaven hallowed." It was a bit of the Lord's Prayer, in Latin.

THE CHANGE OF WAYS

When Norse families left Scotland and the Hebrides for Iceland in the late 800s, some took their farm names with them: A cluster of place-names around Iceland's capital, Reykjavik, matches a cluster around Stornoway, the largest town on the Isle of Lewis.

Those emigrants who had converted to Christianity, like Unn the Deep-Minded, also brought their religion to Iceland. Yet without priests and churches, communion wine and candles, it was hard to keep the faith. Unn may have prayed before her cross on the hill, but when her generation passed, Christianity in Iceland lapsed.

Still, pagan Icelanders visiting Christian countries like England often accepted a preliminary form of baptism, called prime-signing, as a requirement of doing business. The great Vikings Thorolf Skalla-Grimsson (nephew of the Thorolf killed by the king) and his brother Egil, for example, fought as mercenaries for King Athelstan of England at the Battle of Brunanburg in 937. Before the battle, explains *Egil's Saga*, "The

king asked Thorolf and his brother to let themselves be prime-signed, since that was then the usual custom, both for merchants and for other men who had dealings with Christians, since men who were prime-signed could sit at table with both Christians and heathen men and hold whatever beliefs they liked. Thorolf and Egil did as the king wished."

When Olaf Tryggvason began sending missionaries to Iceland in the late 900s, the Icelanders were less inclined to do "as the king wished." They were not against the religion: They were against taking a king's orders.

Some Icelanders were already Christian. An earlier missionary, Bishop Frederick, had been popular in Iceland, the story goes, for his skill in disabling berserks. At a bridal feast, for instance, two berserks challenged him to a test of faith—walking through fire:

> The bishop robed himself in all his vestments and blessed water, and when he was ready, he went over to the fire; he had his miter on his head and his crozier in his hand. He blessed the fire and sprinkled the water on it. Next, in came the two berserks, howling horribly and biting the rims of their shields, and they bore swords in their hands. They tried now to wade through the fire, but it all happened more swiftly than they had intended, and their feet stumbled on the burning logs, so that they fell facedown and the fire engulfed them and burned them for a short while with such great force that they were dragged from it dead.

Bishop Frederick then walked through the fire and "not even the tiniest fringe of his garment was singed. Many turned to God, who saw that great miracle."

A similar tale is told about King Olaf's missionary, Bishop Thangbrand, who made some converts too. But after he killed some nonberserks, Thangbrand was sent packing. Back in Norway, the king was not pleased. He impounded the Icelandic ships then in port and took their crews hostage. He threatened to have them all killed. Two Christian Icelanders in the crowd talked him around—one of them, the chieftain Gissur the White, happened to be the king's second cousin. They were sent home with the king's ultimatum. They took it to the Althing.

King Olaf had no royal power in Iceland. The island was independent, its only government a loose form of parliament, the Althing, at which the thirty-nine leading chieftains met for two weeks each summer to settle disputes. The only government official was the Lawspeaker, who presided over the debates. The Althing was held in the great rift valley of Thingvellir, the "Assembly Plains," coils and curls of old lava marking it as the site of an ancient volcanic eruption. As argument over King Olaf's message waxed furious, according to the *Saga of Christianity*, news arrived of a new eruption in the South.

"It is no wonder," people muttered. "The gods are angry at such talk."

"And what were the gods angry about," said one chieftain, "when they burned the place we're standing on now?"

This remark, though apocryphal, encapsulates the Icelanders' pragmatic attitude toward what they called "the Change of Ways." The official account in the *Book of the Icelanders*, commissioned by Iceland's two bishops and written before 1133, says that when the assembly broke into two uncompromising factions, the leader of the Christian party secretly approached the heathen Lawspeaker and persuaded him to decide the law. The Lawspeaker went into his tent and lay down with his cloak over his head. The next morning, he called everyone to the Law Rock and began his speech with the observation that Icelandic society would fall apart if everyone on the island did not share the same set of laws. He then confirmed that each side agreed to accept the law he would proclaim. Next, we can assume, he took a deep breath. Iceland would become Christian, he decreed, and everyone would be baptized—though he pointed out that they could continue to worship whomever they wished, so long as they did so in private. The chieftains, accordingly, were all baptized, some in the cold waters at Thingvellir, others waiting until they passed the hot springs on the way home. "With laws shall our land be built," they agreed—not with religion.

They also looked to their pocketbooks: Norway was their biggest trading partner. In return for woolen goods, dairy products, dried fish, and the portion of Greenlandic furs, falcons, ship ropes, and walrus ivory that passed through Iceland, Norway sent wood for shipbuilding and house timbers, Iceland itself having no tall trees. Except for the little

bit of barley grown in Iceland, all grain came from Norway, or lands at least nominally under the king's control, like the Orkney Islands. The clay in Iceland was not conducive to making pottery, nor was there soapstone to carve into cooking vessels: Dishes and kitchenware came from abroad. And while Iceland had bog iron, it was difficult to smelt; much iron and all other metals were imported, as were the luxuries Iceland's chieftains enjoyed: jewels, silk and linen clothing, walnuts, honey, wine, and candle wax. If baptism was the price of keeping trade flowing, Iceland's chieftains were happy to be called Christian.

"THEY HOLD THEIR BISHOP AS KING"

The Change of Ways brought with it a fad for Latin education. Like King Olaf, eleventh-century Icelanders were impressed by Christianity's infrastructure; they quickly saw the value of a lingua franca. Latin let them communicate with learned men throughout the Western world. Latin books opened new worlds to them, from the siege of Troy to the scientific inquiries of the House of Islam. The act of writing itself would soon revolutionize Icelandic society. Once they learned to make ink and parchment and to capture the sound of Icelandic in an alphabet, they began to write the sagas, those world treasures for which Iceland is rightly famous. But first they learned to read and write and converse in Latin.

The chieftain Gissur the White, King Olaf's second cousin, started the trend: He sent his young son Isleif to school in Saxony. Isleif learned enough Latin there to be ordained a priest. He returned to the family estate at Skalholt in southern Iceland around 1030 and, his father having died, took over as chieftain. He acted as priest of the Skalholt church as well and established a school. When the Icelanders "saw that Isleif was more accomplished than any other learned man in this country, they sent many of their sons to him for schooling and let them be ordained as priests."

In 1053, the Althing made Isleif Iceland's first native bishop. No story tells how they decided that a parliament—and not a king, as was then standard—could choose a bishop. Until then, Iceland's bishops had come from Ireland, England, France, Saxony, and possibly Armenia, some sent by the king of Norway, others by the archbishop of

Hamburg-Bremen, who was officially in charge of the Icelandic church, and a few apparently on their own initiative.

Isleif, then in his late forties, set off to be consecrated. It's clear he did not know the protocol. According to *Hungrvaka* ("Hunger-Waker"), a collection of Bishops' Sagas composed in about 1200, he took along a live polar bear: "He went abroad and traveled south to Saxony and visited Emperor Henry, the son of Conrad, and gave him a white bear that had come from Greenland, and that animal was a great treasure. The emperor gave Isleif a letter with the seal of his realm on it. After that he went to meet with Pope Leo. And the pope sent a letter to Archbishop Adalbert in Bremen saying that he should consecrate Isleif as bishop."

Imagine a Lewis chess bishop, plump and mild, clutching his crozier tight to his breast with one hand and with the other leading a tamed polar bear on a leash off the dock at Trondheim, through the winding streets of Lund, and up the granite steps of the emperor's summer palace at Goslar in the Harz Mountains. It's ludicrous—and even more dangerous than it seems, as the medieval Icelandic tale "Audun of the West Fjords" explains. There a poor man, Audun, trades all he owns for a polar bear cub, meaning to present it to the king of Denmark. Yet, sailing from Iceland on the normal route, he passes through Norway first, where King Harald Hard-Rule—the same king Isleif would have met—takes a fancy to the bear and offers to buy it. Audun will not sell.

The king said, "Will you give it to me?"

Audun answered, "No, lord."

"Then what are you going to do with it?"

"Take it to Denmark and give it to King Svein."

Said King Harald, "Which is it: Are you so stupid that you haven't heard of the war between our two countries? Or do you think your good luck is so strong that you can get yourself safely there, with this treasure in tow, when others can't get there unharmed though they're taking nothing?"

Of course, Audun *is* luckier than everyone else, and King Harald shows his nobility by offering his assistance. Isleif, too, must have had the help of King Harald of Norway and King Svein of Denmark to take the bear through their territory. Unlike Audun, Isleif would not have traveled alone. He had at least a bear tamer and a baggage handler,

probably a retinue of twenty or thirty men. Still, as he made his way across Europe, he must have been trailed by a train of children: *Look at the bear! It's white as snow!* Icelanders have always known how to get attention.

The emperor's seal got Isleif (minus the bear) safely to Rome; the pope's letter got him back to Bremen, where he should have gone in the first place. Isleif was consecrated first bishop of Iceland on May 26, 1056. Writing twenty years later, Adam of Bremen brags that "little Bremen was, like Rome, known far and wide and was devoutly sought from all parts of the world, especially by all the peoples of the north. Among those who came the longest distances were the Icelanders, the Greenlanders, and legates of the Orkney Islanders." Archbishop Adalbert, he continued, "appointed a certain Thorolf to the Orkneys. . . . Isleif he sent to the island Iceland."

Isleif apparently talked to Adam about his country, though perhaps his Latin was not as good as we think, for Adam's report is a bit garbled. Iceland, Adam says, takes its name "from the ice which binds the ocean"; Icelandic texts derive it from the great ice caps that make the center of the island uninhabitable. Iceland's people raise cattle, Adam notes, and "no crops are grown there"—true, though sheep were the mainstay of the medieval Icelandic economy. "The supply of wood is very meager. On this account the people dwell in underground caves," Adam says, unable to imagine an Icelandic turf house, with its post-and-beam structure made of imported wood or driftwood and its thick insulating walls laid up from blocks of sod. Volcanoes are another mystery: "The ice, on account of its age, is so black and dry in appearance that it burns," Adam says. He then praises the Icelanders' "holy simplicity," noting that "instead of towns, they have mountains and springs as their delights." Towns, indeed, would not appear in Iceland until the 1700s. Throughout the Middle Ages, the bishop's residence at Skalholt was the largest settlement in the country. Concludes Adam, "They hold their bishop as king."

For Isleif, that was wishful thinking. Back home, "he had great difficulties of many kinds during his time as bishop due to men's disobedience. Of these we may note," says *Hungrvaka*, "that the Lawspeaker married both a mother and her daughter." (We're not told if the

marriages were concurrent.) The fact that Isleif, as a bishop, was also married was not then considered disobedience. Rome did not require priests and bishops to be celibate until after the First Lateran Council in 1123, and the rule took nearly a hundred years to take root in Iceland.

It was Isleif's son, Gissur (named, following Icelandic custom, for his grandfather), who metaphorically crowned himself king. Like his father, Gissur went to Saxony for his education. Returning home, he married and established himself as a merchant. "He was highly thought of wherever he went and was surrounded by noblemen when he was abroad," says *Hungrvaka*. From his father, Gissur inherited the estate of Skalholt with its church and school. He inherited the title of chieftain. He even, more or less, inherited the role of bishop. Abroad when his father died in 1080, Gissur arrived home just as the Althing was about to pick a priest to succeed Isleif. Seeing Gissur ride into the assembly, the priest declined the honor. Before he would accept it, Gissur exacted a pledge from Iceland's other chieftains: They would obey his orders on all church matters.

Gissur sailed immediately to Bremen, only to find that the archbishop had been defrocked, one of many caught up in a power struggle between the pope and the Holy Roman Emperor. Who had the right to appoint an archbishop? Until 1076, kings did. Pope Gregory VII changed all that. The Gregorian reforms classed kings as mere laymen, with no say in church business. When Emperor Henry IV protested, Pope Gregory excommunicated him, adding "I release all Christian men from the allegiance which they have sworn or may swear to him, and I forbid anyone to serve him as king." The German nobles rebelled. To keep his throne, Henry rode to the pope's fortress in the Alps and presented himself as a penitent, standing barefoot in the snow until the pope forgave him.

Gissur rode from Bremen straight to Rome. He met Pope Gregory, who sent him on to the archbishop of Magdeburg in Saxony, where he was consecrated bishop of Iceland. Gissur reorganized the Icelandic church—making himself the richest and most powerful chieftain in the land. First, he donated his own estate of Skalholt to the church to be the bishop's see. Then he conducted Iceland's first census, counting each farmer who was considered "self-supporting"—Iceland at the time had

no towns and no separate merchant class. The total came to 4,560 men, from which you can calculate the population in Iceland to be at least forty thousand, or one seventh the size of Norway. Depending on how you estimate the size of a family—or how many farmers were not self-supporting—that figure could bloom to seventy thousand.

In 1096, with the approval of the Althing, Gissur instituted the tithe—the first in any Scandinavian country. Rather than 10 percent of income, the tithe in Iceland was an annual 1 percent property tax. Each of the 4,560 farmers was required to pay. Says the *Book of the Icelanders*, written in 1118, "It was set down in the laws that all men should calculate the value of their own property and swear that it was valued correctly, whether it was in land or in moveable goods, and then pay a tithe on it." Once collected, the tithe was distributed in four parts: one quarter to the bishop, one to the churches, one to the priests, and one for the poor. Why was this tax palatable to Iceland's chieftains? They stood to gain from it. After the Change of Ways, every chieftain had built a church. By the days of Bishop Gissur, says the *Saga of Christianity*, "Most noblemen were educated and ordained as priests, even if they were chieftains." The chieftains, by then numbering forty-eight, thus collected half the yearly tithe: the quarter for the church and that for the priest. Plus, the value of any property they donated to a church (including to their own private chapel) was tax-exempt.

The person who stood to gain the most, however, was the bishop. Each year he received one quarter of 1 percent of the value of 4,560 estates. His own property—which grew to include a huge chunk of southern Iceland and the entire Westman Islands, still the best fishing grounds—was tax-exempt. A fair man, Gissur agreed to split this largess with a second bishop, after the men of Iceland's North Quarter requested their own. In 1106, Jon Ogmundarsson, who had been trained to the priesthood by Gissur's father, was elected the first bishop of Holar. Bishop Jon's diocese was limited, however, to the North Quarter. The bishop of Skalholt retained control over the other three quarters of Iceland.

In spite of the sweeping changes he introduced, Bishop Gissur was popular. He "kept the peace so well," says the *Saga of Christianity*, "that there were no great disputes among the chieftains and the carrying of weapons passed for the most part out of fashion." He was so esteemed,

adds *Hungrvaka*, that everyone would "sit or stand when he said to, young or old, rich or poor, women or men, and it is fair to say that he was both king and bishop over the land while he lived." Like King Olaf of Norway, Gissur used the rules of the new religion to consolidate his own power.

THE POWERFUL RULER

Christianity also brought new arts to Iceland. Each of the 220 churches in the diocese of Skalholt (as counted in 1200) needed, at bare minimum, a bell, a silver or gold chalice and paten for communion, a pair of candlesticks, a *Life* of its patron saint along with other holy books, and a complete set of vestments for its priest; a hundred churches each had two priests.

When outfitting their churches, Iceland's bishops went far beyond the minimum. They traveled abroad and brought home books and bells, window glass and sacred relics. They hired teachers and scribes and built schools and scriptoria. They bought calfskins and trained men to transform them into parchment (an average book required the skins of seventy-five calves). They commissioned sacred music and artworks of gold, silver, ivory, brass, jewels, wood, fabric, and glass, from altar cloths to crucifixes to pyxides to reliquaries. They saw themselves as patrons of the arts.

The first bishop of Holar, for example, heard King David playing a harp in a dream; on awakening, Bishop Jon had a harp brought to him and tried to re-create the heavenly music he had heard. He also had a fine singing voice and recruited a French cantor to bring the glories of Gregorian chant to Iceland. Equally interested in books, Bishop Jon acquired an extensive Latin library, including such rarities as Ovid's *Art of Love*.

One student at the Holar school, Klaeng, was chastised for spending too much time poring over these poems of "the love of women" and "the tricks with which they beguile men." He grew up to become bishop of Skalholt and a master poet himself. To celebrate the dedication of the cathedral he built between 1152 and 1174, Bishop Klaeng commissioned

a poem in the untranslatable skaldic style, full of metaphors and double meanings:

Strong is the building
which the powerful ruler
built for the gentle-minded Christ.
Such plans have a good foundation.
It was a fortunate thing
that Bjorn built God's house.
Peter has received
the handsome creation of Arni and Bjorn.

Peter is Saint Peter, Arni and Bjorn are the master carpenters, but who is "the powerful ruler"? Bishop Klaeng himself. His cathedral at Skalholt was the biggest wooden church in all of northern Europe: Returning from his consecration, Klaeng had brought with him two shiploads of Norwegian timber. A model of Klaeng's church in the National Museum of Iceland, based on archaeological excavations at Skalholt in the 1950s, shows a cross-shaped basilica 160 feet long; by comparison the extant wooden stave church at Borgund, Norway, built at about the same time, is 50 feet long. Not all of Klaeng's parishioners were pleased with the bishop's budget. To some it seemed "that the contributions put toward church building each season were very large," *Hungrvaka* notes. Perhaps to make up for this, Klaeng himself lived like an ascetic "in vigils and fasting and clothing; he often went barefoot at night in snow and frost." Still, his vision for Skalholt Cathedral was so grand, "it required nearly endless wealth to support it."

His successor, Thorlak, was chosen mostly to put the see's finances in order. Unlike many of Iceland's bishops, Thorlak was not a chieftain's son. His mother, who saw her bright boy destined for great things, arranged for him to be educated at Oddi, a chieftain's estate in Iceland's South Quarter where there was an excellent school. (She also accompanied him there, fatefully bringing along his sister Ragnheid.) Thorlak became a priest at the uncanonically young age of nineteen, then went abroad in about 1152 to continue his schooling in Lincoln and Paris.

How could he afford such an education? Perhaps he paid his way with walrus ivory or, better yet, unicorn horns—as the medieval world considered the long spiral-grooved tusks of the narwhal, small whales that were hunted off the coast of Greenland. The Contemporary Sagas record a connection between Thorlak and an Icelandic merchant involved in the Greenland trade in the mid-1100s: The merchant's son worked at Skalholt Cathedral. It may be no coincidence that two narwhal tusks appeared in Lincoln at the same time Thorlak did. There, they were beautifully carved with a Romanesque dragon-and-foliage design that matches a stone carving on the west end of Lincoln Cathedral. According to the Victoria and Albert Museum in London, where one now resides, the tusks were embellished with gilt-copper strips and metal knobs (now missing). They might have served as processional candlesticks.

Lincoln, at that time, was the largest bishopric in England. With a population of six to ten thousand people in the town alone, it was a good place to learn to administer a diocese the size of Skalholt, its population between thirty and fifty thousand. Sixty miles southeast of York, the ancient Viking capital, Lincoln had long-standing connections with Norway and the North. When Norway's king Magnus Bare-Legs was killed in Ireland in 1103, his banker—a merchant of Lincoln—was captured by the English and forced to pay a ransom of twenty thousand pounds of silver, presumably from the Norwegian king's coffers.

In the 1150s, when Thorlak arrived from Iceland, Lincoln was a bustling city of a thousand houses, with thirty or more churches, a stone cathedral, a bishop's palace under construction, a royal mint, and a Norman castle that, with its walls and ditches, covered forty acres. Three main streets and three cross streets were dense with thatch-roofed shops and workshops; farther out lay mansions and gardens and lanes leading down to the river.

Bishop Alexander "the Magnificent" had recently died. The patron of two great English historians, Geoffrey of Monmouth and Henry of Huntingdon, Alexander was known for his extravagant lifestyle and grandiose building schemes. Some art historians believe the stone-carvers of Nidaros Cathedral in Trondheim came to Lincoln to study under his tutelage, given the similarities between the two churches. But it's

hard to be sure: Lincoln Cathedral was "split from top to bottom" by an earthquake in 1185 and rebuilt, in a different style, in the 1200s.

Along with architecture and finance, law was another specialty of the clerics at Lincoln. Alexander's successor, Bishop Robert, commissioned an updated copy of the Code of Justinian. Compiled in the sixth century for the emperor of Byzantium, this collection of Roman laws was rediscovered in the 1100s; it became the basis for legal studies throughout the Middle Ages and into modern times.

Paris, meanwhile, was the largest city north of the Alps. Its population would grow to fifty thousand by 1200, thanks to the efforts of King Philip II, who reigned from 1179 to 1223. More than any previous French king, Philip made Paris his capital. He built new city walls, erected covered markets, and paved streets and squares. Tradesmen and craftsmen—buoyed by royal monopolies—blanketed the banks of the Seine with their shops and workshops. Over them all towered the limestone skeleton of Notre-Dame Cathedral; it was not completed until 1345.

Thorlak, arriving a decade before the great cathedral was begun, found Paris to be the epicenter of debate in theology and philosophy. The powerful abbot Bernard of Clairvaux, recently deceased, still cast his spell over the city. A champion of the Gregorian reforms, with their rebalancing of power between church and state, it was Bernard who preached the Second Crusade. King Louis of France and his queen at the time, Eleanor of Aquitaine, knelt at Bernard's feet; the emperor Conrad and his nephew Frederick Barbarossa received the pilgrim's cross from Bernard's hands. When the crusade failed, after the disastrous siege of Damascus in 1148, Abbot Bernard took the blame, apologizing to the pope (while adding that the crusaders' own sins were the real cause of their misfortune).

In Paris, Bernard had ferreted out the heresies of the popular teacher Peter Abelard. Considered today to be the first modern thinker, whose ideas led to the founding of the University of Paris in 1215, Abelard is best known for his treatise *Sic et Non* ("Yes and No"), which presents his method of arriving at the truth of an idea by debating the arguments pro and con. In the thirteenth century, Abelard's idea would be made orthodox by Thomas Aquinas. To Bernard in the twelfth century, such

free thinking was heresy. By allowing students in theological debates to advance the *Non* argument, Abelard was denying God. There was also Abelard's youthful love affair with his student Heloise to take into account. In spite of their secret marriage, the affair ended with Heloise in a nunnery and Abelard castrated by her angry relatives. In 1142, Abelard died in a monastery, in disgrace.

The death of his student Arnold of Brescia was worse than Abelard's. Arnold had some incendiary ideas of his own. Gregorian reformers like Bernard believed clergy of all ranks should be celibate and that the body should be denied all pleasures. Arnold applied that reasoning to the church itself. Rich bishops, he preached, "cannot possibly be saved." Temporal wealth belonged to Caesar, not to the church. When Bernard denounced him, Arnold brushed him off as "puffed up with vainglory, and jealous of all those who have won fame in letters or religion, if they are not of his school." On the pope's order, Arnold was hanged as a heretic in 1154.

Four years later, Thomas Becket arrived in Paris and feted all the schoolmasters and their students, perhaps including young Thorlak from Iceland. As the story of Hrafn and the walrus hunt shows, Becket would become a favorite saint in Iceland. His efforts as archbishop of Canterbury to "free the church from the world" and his clashes with King Henry II encapsulated the challenges of the Gregorian reforms. At heart was the issue of who controlled those rich bishops Arnold of Brescia had lampooned: king or pope? How a bishop answered that question might also reveal who commissioned the Lewis chessmen.

THE CULT OF SAINT OLAF

The pope who hanged Arnold was the Englishman Nicholas Breakespeare, Pope Adrian IV. He was well known to Icelanders. As papal legate, he had established the archdiocese of Nidaros at Trondheim in 1153. From then on, the archbishop of Trondheim oversaw the Icelandic church, consecrating—and chastising—its bishops. The archbishop was also in charge of the churches of Greenland, the Faroes, the Orkney Islands, the Hebrides, and the Isle of Man, as well as the four other

bishops in Norway, at Hamar, Oslo, Bergen, and Stavanger—in short, all the churches in Norway's cultural sphere.

Trondheim was his seat, rather than the larger and more central city of Bergen, because of Saint Olaf. This Olaf was not the missionary king Olaf Tryggvason who had converted Norway and Iceland. He was Olaf II, Olaf Haraldsson, known to Icelanders as Olaf the Fat and to Norway's petty kings, while he was alive, as a tyrant. Said a contemporary poet:

> *Each king fled far away*
> *from you, prince!*
> *And all such knew*
> *that you cut out the tongue*
> *Of the one*
> *who lived northernmost.*

Canute the Great supported Olaf's enemies. Upon Olaf's death in 1030, on a battlefield near Trondheim, Canute added Norway to his empire, alongside Denmark and England. Not long after, the Tronders, led by their English bishop, Grimkell, had a change of heart. The dead tyrant's body was dug up. Its hair and nails were found to have miraculously grown. The corpse was enshrined in a chapel. The miracles accumulated. Wrote another poet:

> *There do bells ring of themselves*
> *over his wooden-walled bed....*
> *There comes an army*
> *where the holy king himself is,*
> *kneeling for help.*
> *And the dumb and the blind*
> *apply to the prince*
> *and go healthy away.*

The earliest reference to Saint Olaf comes from England, in a version of the *Anglo-Saxon Chronicle* written about 1050. By 1070, Olaf's shrine was "frequented by a great multitude of peoples," wrote Adam of Bremen.

He gave exact directions to potential pilgrims: "boarding a ship, they may, in a day's journey, cross the sea from Aalborg or Wendila of the Danes to Viken, a [province] of the Norwegians. Sailing thence toward the left along the coast of Norway, the city called Trondheim is reached on the fifth day. But it is possible also to go another way that leads over a land road from Scania of the Danes to Trondheim. This route, however, is slower in the mountainous country, and travelers avoid it because it is dangerous."

At the grand consecration of Norway's first archbishop, Christ Church in Trondheim must have felt small and cramped, with all the priests and pilgrims milling around the elaborate house-shaped reliquary that held Saint Olaf's bones. The only record we have of the event is a long poem commissioned by King Eystein, one of three reigning kings of Norway. For seventy-one stanzas, the poet, an Icelander named Einar Skulason, wraps his meaning in the elaborate metaphors of a skald. Invoking "the battle-strong beam of the sun of mercy," he declares that "Trondheimers and all Norsemen should listen to the splendid poem of the strong-minded thane of Christ; he lives in the highest hall. . . . I know that the rulers of the world brought an archbishopric here to this place; the quick prince of the sun saves men."

The young Thorlak may have attended this ceremony on his way to school in Lincoln and Paris. Going home to Iceland in 1161, he passed through Trondheim again, where he may have met the second archbishop, Eystein Erlendsson, just returned from Rome with his pallium. They could even have traveled together from Paris, for Eystein stopped there to visit his old teachers at the school of St. Victor's.

Archbishop Eystein belonged to one of the wealthiest families in Norway. His great-grandfather, as Thorlak would certainly have known—genealogy being a beloved Icelandic pastime—was the Icelander Ulf Ospaksson, who could trace his lineage back to Ketil Flat-Nose. Ulf was King Harald Hard-Rule's right-hand man. He had fought by Harald's side as a young mercenary in the hire of the emperor of Byzantium; afterward, Ulf married Harald's sister and settled in Norway. Eystein's own father, Erlend, was considerably less Viking-like: His nickname in the sagas translates as "the Flabby" or "the Lazy."

Eystein was the opposite of lazy. He had been elected archbishop some years before 1161, but his consecration was delayed by a complication. When Pope Adrian IV died in 1159, two popes had been chosen to succeed him: Pope Victor IV was supported by Germany's emperor Frederick Barbarossa and Denmark's king Valdemar, and Pope Alexander III by the kings of England and France. The schism would not be reconciled until 1180. By sending Eystein to Alexander III, Norway underscored its independence from Germany and Denmark (each of which, for a time, had directed the Norwegian church). Meanwhile, Eystein plunged into building a stone cathedral around Saint Olaf's shrine. On November 26, 1161—as a Latin inscription in the string course of the wall proclaims—he dedicated the south transept chapel of Nidaros Cathedral. He built himself a grand bishop's palace and oversaw construction of a chapel and mausoleum, in the shape of a miniature cathedral, for the ruling family. He then began work on a striking new cathedral chancel—in the shape of an octagon—to better display Saint Olaf's relics.

To build a stone cathedral took more than one lifetime—the foundations of the west wing of Nidaros Cathedral were not laid until 1248. But the master plan may have been Eystein's; he took great interest in the matter, as one of the miracles of Saint Olaf shows. It also hints at Eystein's personality: One day the master builder asked Eystein to come take a look at something. As they climbed to the top of a wall, the scaffolding broke, and Eystein plunged into a tub filled with chalk, breaking his hip. He was carried "almost lifeless" to his room and lay in pain and anguish, fearing "that he would not be able to participate in the feast of Saint Olaf three days later. He then prayed to Saint Olaf with great devotion. On the day of the feast, he was carried into the church" and—this is the miracle—was able to give a long sermon.

Eystein's efforts at beautifying his new diocese did not end with architecture. He was a patron of music, literature, and law, as well. On the feast day of a saint, in the twelfth century, a Latin song of celebration, or "sequence," was inserted into the Mass after the Alleluia, poetically presenting the saint's life. Eystein had a proper sequence written for Saint Olaf. On July 29, the cantor would sing "in honor of the joyous and glorious light shining on the land of darkness":

Triumphant king and martyr, our special protector,

free your spiritual offspring from the evils of this world . . .

As we are threatened by the forces of the flesh, the general depravity . . .

may your right hand place us safely underneath your wings.

Altogether Eystein collected over one hundred sequences—a third of them based on chants sung in the German church, the others French or English—into the *Nidaros Ordinal,* a liturgical handbook meant to contain all the texts and music his clergy needed to perform their duties. He wrote or commissioned the collection of Saint Olaf's miracles, a more complete *Life of Saint Olaf,* and two histories of Norway.

Eystein also seems responsible for a legal text, the *Nidaros Canons,* which brought the Gregorian reforms to Norway, setting down the church's position on such matters as the rights of church patrons, the election of church officials, and the proper conduct of the clergy. Eystein was a pragmatist, not a fanatic reformer. For example, while churchmen were to aspire to celibacy, a monk who had sex with a nun, he ruled, could still become abbot "after some time of penance," and a bishop whose mistress lived with him should be dismissed only if "his behavior had caused a scandal." When it came to church versus state, however, Eystein was more dogmatic. He clearly sided with Bernard of Clairvaux and Thomas Becket. In 1163, he connived with the aristocrat Erling Skew-Neck to crown Erling's young son Magnus king of Norway. As Snorri Sturluson tells the story, at least sixty years later, Erling convinced the archbishop by saying, "Now here in the land is an archbishopric, and it is a great and dignified honor for our land. Let us now increase its power still more."

ICELAND'S PATRON SAINT

These were the ideas Thorlak brought back to Iceland: The power of asceticism and of a forceful morality. The dangers of love and any form of free thinking. The church's right to amass riches and to force kings and queens to kneel.

Willard Fiske, in *Chess in Iceland,* thinks Thorlak also brought home knowledge of the game, but it's not likely. As a reformer, Thorlak

would have frowned at chess as a waste of time. He might not have been offended if others played it—he was not as rigid as Bishop Peter Damian, who wrote a letter to the pope just before the First Crusade denouncing a fellow bishop. On a journey together, when the two stopped for the night, Peter Damian writes, "I withdrew myself to the neighboring cell of a priest; but he remained with a crowd of people in a large house of entertainment. In the morning, my servant informed me that the bishop had been playing at the game of chess; which thing when I heard, it pierced to my heart like an arrow. At a convenient hour I sent for him and said, in a tone of severe reproof, ' . . . Are you not aware that by the canonical law bishops who are dice-players are ordered to be suspended?'" The bishop replied that "dice was one thing, and chess another," but Peter Damian insisted the prohibition covered all games. The bishop, chastened, agreed to pay alms, to say the psalter three times, and to wash the feet of twelve peasants in penance.

These two were not the only bishops in the late eleventh century who disagreed on the sinful nature of chess: Chronicles of the crusade often mention chess favorably. In the early twelfth century, the Spanish cleric (and converted Jew) Petrus Alfonsi considered chess a proper part of any nobleman's education, lay or clerical. He wrote in *The Clerk's Instruction*, "The skills that one must be acquainted with are as follows: riding, swimming, archery, boxing, hawking, chess, and verse-writing." But well before the Second Crusade, the Council of Troyes in 1129 noted that for crusaders in the order of Knights Templar, chess was strictly forbidden (along with hawking and hunting). Thorlak would have known of this rule: It was written by Bernard of Clairvaux.

Even if Thorlak, dismissing Bernard's view, accepted chess as an appropriate pastime, he could not be the one responsible for placing the bishop on the board. Neither could Archbishop Eystein of Trondheim, though his reign is often linked with the Lewis chessmen. The bishop—or *alphin,* or whatever piece was in those four spots on the board at the time—was a very weak piece. Its move, throughout the Middle Ages, was restricted to a single jump over a diagonal square, like a move in checkers (whether there was a piece in the way or not). It was a servant of the king and queen, meant to die for their sakes: not at all what the reformers preached. Neither Thorlak nor Eystein could have stomached

the idea that a bishop should be ordered about by a king. Rather, according to the Christian doctrine of *rex iustus* around which Eystein wrote Norway's new Law of Succession in 1163, kingship was bestowed by God, represented on this earth by Holy Church. The duty of a king was to rule justly, in accordance with ecclesiastical doctrine, as interpreted by his bishops and archbishops and ultimately the pope, who reported only to God on high. To place bishops on the chessboard—close enough "to hear with their ears the spoken words of their lords"—required a completely different conception of the relationship between a bishop and a king: one that was held by another of our likely candidates, Bishop Pall Jonsson of Skalholt.

Thorlak met the young Pall Jonsson—under less than favorable circumstances—as soon as he returned home to Iceland. Thorlak "was just as humble, or more so, after he came home from his journeys as he had been before he went away," says *Thorlak's Saga*—which is a quiet way of saying he did not express his outrage when he found out that his sister, Ragnheid, was the mistress of the young (and already married) chieftain of Oddi, Jon Loftsson, and mother of Jon's illegitimate son, Pall. Thorlak did not confront Jon. Instead, he entered a monastery. In 1176, when time came to choose a new bishop of Skalholt, Jon nominated Thorlak.

Jon Loftsson was the most powerful chieftain in Iceland in the late twelfth century. Modern readers have dubbed him "the uncrowned king," but his peers treated him like royalty too. Everyone knew that his mother, Thora, who lived with Jon at Oddi until her death in 1175, was the daughter of the kilt-wearing king Magnus Bare-Legs of Norway. When Jon attended the coronation in 1163 of Magnus Erlingsson, whom we'll meet in chapter 4, the young king of Norway acknowledged their kinship. Jon judiciously did not point out (so far as we know) that he was as eligible to be king, by the old rules, as this Magnus was: Both were the sons of kings' daughters (which meant neither had any claim to the throne at all). In the Contemporary Sagas, Jon Loftsson is portrayed as a great peacemaker. One chieftain, requesting his assistance, calls Jon "the noblest man in this land, and the one to whom everyone sends their lawsuits." *Thorlak's Saga* admits Jon was an accomplished man (with a fine singing voice) but says he was also proud and impetuous. He "would yield to no one, nor quit what he once began."

The new bishop of Skalholt did not compete with Jon for the title of uncrowned king. Instead, on the urging of Archbishop Eystein of Trondheim, Thorlak tried to bring the Gregorian reforms to Iceland. In this he clashed so repeatedly with Jon—and persevered with such patience—that he soon acquired the reputation of a saint.

One dispute concerned church ownership. According to the new canon law, churches were owned by the bishops, no matter who built them. That was nonsense to Icelanders, who had kept family churches since the Change of Ways. When Thorlak tried to enforce the rule, he butted heads with Jon Loftsson. A gale had blown down a church on one of Jon's many farms. He rebuilt it and called for the bishop to come consecrate his new church. Thorlak refused unless Jon handed over the deed, at which point Jon decided an unconsecrated church suited him just fine. Thorlak threatened him with excommunication. Jon replied, "Call down excommunication upon whomever you wish. Never will I give up to you the least part of my property, whether a little church or a big one." The question would not be settled for a hundred years.

Another dispute (no surprise) concerned the sanctity of marriage. As early as 1173, Archbishop Eysteinn had written to Iceland's bishops decrying the chieftains' loose morals: "Some have put away their wives and taken concubines in their place; some keep both together in their homes and thus lead a life of iniquity." A letter from 1180 singles out Jon Loftsson—whom the archbishop had met at the coronation of King Magnus. An anonymous Icelandic sermon proves the problem was not limited to Jon: "Lust in this country is made the subject of jesting talk, as is drunkenness in Norway."

That marriage was a sacrament was a new concept: It would not become church law in the North until 1280. Historically, marriages in Iceland were arranged for the families' benefit. In a society where disputes were settled by negotiation or feud, marriage brought responsibility. Love had nothing to do with it. But neither was an illegitimate child—or its mother—shamed. If the father was a powerful chieftain like Jon Loftsson, the whole extended family stood to gain. The church held a different opinion. Christian marriage meant the sacred union of one man and one woman who vowed to be faithful to each other for life. It echoed the union of Christ and the church. All other unions were evil,

as Bishop Thorlak made clear to Jon Loftsson on numerous occasions, threatening to excommunicate him if he persisted in seeing Thorlak's sister Ragnheid. Jon refused to deny his heart; they had been in love since childhood, the saga says. "I know that you are right to excommunicate me; the cause is enough," he tells the bishop. But no one will separate him from Ragnheid "until God breathes it into my breast" to part from her. Thorlak eventually did succeed in separating them, and Ragnheid was quickly married off. By then, however, Thorlak had taken a great liking to his illegitimate nephew, Pall.

Unlike his predecessor Klaeng, a patron of the arts, Bishop Thorlak's contributions to Icelandic culture came mostly after his death when, due to the many miracles associated with him, he became Iceland's patron saint. Sainthood was a local matter in those days. The pope had no part in it; not even the archbishop in Trondheim was consulted. Thorlak was declared a saint, instead, by the Icelandic parliament. The benefit to the bishopric of Skalholt was immediate: Medieval sainthood was a moneymaking proposition. After Thorlak was sainted, Icelanders no longer made so many vows to the English saint Thomas Becket, as Hrafn did to speed his walrus hunt, or to Saint Olaf in Trondheim. After 1198, such vows—and the promised walrus tusks or other gifts—went instead to Skalholt Cathedral. "Because of the holy bishop Thorlak's good deeds," says a saga written shortly after his death, "much money was given to the see in Skalholt from all the lands in which his name was known, mostly from Norway, much from England, Sweden, Denmark, Gautland, Gotland, Scotland, the Orkney Islands, the Faroe Islands, Caithness, the Shetland Islands, and Greenland; but most came from within Iceland."

The man who had charge of spending all this money, ironically, was Pall Jonsson, who became bishop of Skalholt in 1195. He was known as a great art lover, having in his employ a wood-carver, a goldsmith, and a painter—as well as Margret the Adroit, the most skilled ivory-carver in all Iceland, whom we'll meet in the next chapter.

MASTER OF NINE SKILLS

"I have mastered nine skills," bragged a young Norwegian poet in the early twelfth century. Putting a northern twist onto Petrus

Alfonsi's "riding, swimming, archery, boxing, hawking, chess, and verse-writing," Kali Kolsson—who would become Earl Rognvald Kali of Orkney—announced:

> I am eager to play chess,
> I have mastered nine skills,
> I hardly forget the runes,
> I am interested in books and carpentry.
> I know how to ski,
> my shooting and sailing skills are competent.
> I can both play the harp and construe verse.

The word Kali used for chess is *tafl*. Scholars have long disagreed about whether he meant "the old game with one king," *hnefatafl*, or chess, "the new game with two." Judith Jesch, a professor of Viking Studies at the University of Nottingham, argues that "the latter is very likely, in that chess was the latest fashion for young aristocrats in northern Europe in the twelfth century"—and Kali was a stylish guy. On a trading voyage as a youth, he went to England; on the way home, he stopped in Bergen, where he was spotted in a drinking hall "dressed in a showy fashion with his English gear." Another of his poems also seems to refer to chess, using the term *hrókr* in both its old meaning of "scoundrel" and its new meaning, the chess rook.

By the time Kali's poems were set down in the *Orkney Islanders' Saga*, around 1190, chess was well known throughout Europe; most likely it was known in Iceland too, though the first datable reference to it is in Snorri Sturluson's *Heimskringla*, written between 1220 and 1241. The *Orkney Islanders' Saga* was one of Snorri's sources for his history of Norway's kings. Its author is thought to be Snorri's foster brother, the future bishop Pall Jonsson. Both Snorri and Pall grew up at Oddi, Jon Loftsson's main estate in the south of Iceland, though they did not live there at the same time: They were twenty-three years apart in age. Pall, born in 1155, was in the Orkney Islands when his father, to settle a feud, offered to raise and educate his adversary's three-year-old son. This boy, Snorri Sturluson, grew up to become Iceland's richest and most powerful chieftain, twice its Lawspeaker, and one of the most influential writers of the

Middle Ages. His works are our main source books for Norse mythology, the poetry of the Viking Age, and the early history of Norway.

Snorri's life and works, even more than Kali Kolsson's poem, let us guess what skills Pall Jonsson knew: poetry, the myths on which skaldic verse draws for its metaphors, the history of the North, genealogical lore, Icelandic law, and the rhetoric required to win a lawsuit. Pall, too, was taught chant and church Latin. Snorri apparently was not, for in 1190, the archbishop of Trondheim decreed that chieftains could no longer be ordained priests; Latin became superfluous for a chieftain's son. Pall may have been exposed to Hebrew and Greek as well as Latin: At some point between 1125 and 1175, a scholar at the Oddi school drew from all three languages to create a new alphabet and set of rules for spelling Icelandic.

Saemund the Wise, Pall Jonsson's great-grandfather, had started the Oddi school after studying abroad, perhaps in Paris, in the late eleventh century. We don't know how he earned his nickname, "the Wise." Folktales say he was clever enough to catch the devil and carry him in his pocket locked in a marrowbone. Bishop Gissur asked his advice on instituting the tithe in Iceland. Ari the Learned, for his *Book of the Icelanders,* consulted Saemund on Norwegian history, and other sources back up the idea that Saemund wrote the first Kings' Saga, now lost. A poem written to celebrate Jon Loftsson's seventieth birthday, in 1194, refers to this saga, saying "Now I have counted ten rulers, each of whom sprang from Harald. I narrated their lives according to the words of Saemund the Wise."

Pall was not this poet. According to the *Saga of Bishop Pall,* he was "good at learning things by heart, scholarly even as a youth, and skillful in everything he did, in writing and everything else. . . . He had a strong voice and was such a good musician that his singing surpassed that of all the men of his time." If he were a poet, it would have made the list: Poetry was prized in medieval Iceland.

Pall is, though, credited with writing two sagas: *Skjoldunga Saga,* now lost, was the first written history of Denmark. From a seventeenth-century summary, we know it traced the kingdom from the mythical Skjold, son of the god Odin, to the historical tenth-century king Gorm the Old, father of Harald Blue-Tooth. The *Orkney Islanders' Saga* still

survives, though in a revised form. It, too, begins in the mythic past, with a story of Prince Nor, eponymous founder of Norway, and his kinsmen, the demigods Fire, Storm, Frost, Snow, and Sea. From there it skips quickly to the ninth century and King Harald Fair-Hair—the Harald in Jon Loftsson's birthday poem. To the people of Oddi, this King Harald is not the tyrant who harassed Ketil Flat-Nose but the friend and benefactor of their ancestor, Earl Rognvald the Powerful, to whom Harald gave three provinces in Norway as well as the Orkney Islands; Rognvald gave the islands to his brother Sigurd, from whom the Orkney earls descend.

The *Orkney Islanders' Saga* seems originally to have ended in 1171, during the reign of Earl Harald Maddadarson, whom Pall knew well. As a young man, Pall spent several years in the Orkney Islands—perhaps as many as fifteen—as a member of the earl's court. The author of the *Saga of Bishop Pall* says little about Pall's youth. Even so, there's a strange gap. We're told he "married young," to the beautiful and talented Herdis Ketilsdottir. But "when they had been together a few winters, Pall went abroad and became a retainer of Earl Harald of Orkney, who valued him highly, and after that he went south to England and went to school there." Assuming "young" is eighteen or twenty, Pall left Iceland before 1175; his first child is his son Loft, born about 1190, who is thought to have written his father's saga.

One clue to what Pall may have been up to during those fifteen years lies in the genealogy of his wife, Herdis: She came from a family long involved in the Greenland trade. Her great-uncle Hermund, for example, was an important merchant called in to help Greenland's first bishop settle a famous dispute. According to the *Saga of Eirik the Red*, Greenland became Christian in about the year 1000, like Iceland, through the coercion of Norway's king Olaf Tryggvason. Leif Eiriksson, son of Greenland's founder, Eirik the Red, wanted to see the world, so he sailed to Norway as a young man. His ship was blown off course and landed in the Hebrides. Foul winds kept him there all summer, but eventually he made it to Norway, where he was made much of by the king, who sent him home with a mission to convert the Greenlanders. When Leif tried to squirm out of it, "the king said he had never seen a man better suited to the task than Leif—'and you will have the luck to do it.'" Leif the Lucky was blown off course (again) on the way home and discovered

the New World, what the Norse called Vinland. When he finally reached Greenland, his mother was his best convert. She built a church and refused to sleep with Eirik the Red so long as he remained pagan, "and that put him in a foul temper," the saga says.

A hundred years later, the Greenlanders still had no bishop. A short saga called *The Greenlanders' Tale* says they petitioned Norway's king Sigurd the Jerusalem-Farer to send them one. Sigurd, being a crusader, would surely look favorably upon their request. Still, they sweetened the deal by sending along a shipload of walrus tusks and skins as well as a live polar bear. King Sigurd agreed to trade a bishop for a bear. He called over a clerk named Arnald and appointed him bishop of Greenland.

A group of Norwegian merchants—impressed by the Greenlanders' luxury wares—decided to accompany Bishop Arnald to his new post. At sea, the two ships got separated. Bishop Arnald landed in Iceland and spent the winter at Oddi with Saemund the Wise. When he arrived in Greenland the next summer, there was no word of the merchant ship. It was later found wrecked, its crew dead. The Greenlanders, with the bishop's blessing, split the cargo. Then one of the merchant captain's kinsmen arrived in Greenland, in about 1133, looking for his inheritance.

In the ensuing feud, several men were killed. The Icelander Hermund Kodransson—the great-uncle of Pall's wife, Herdis—was called in as a neutral party to negotiate a truce between the Greenlanders and the Norwegians. He is identified as a trader dealing with Greenland's Western Settlement, where, archaeologists have found, every farm had someone assigned to chip the tusks from walrus skulls.

Hermund's home in Iceland was on the river Hvita in the West Quarter. The Hvita had a good harbor for oceangoing ships near the chieftain's estate at Borg where, in about 1202, a merchant ship from the Orkney Islands landed. Its captain, Thorkel Walrus, was the nephew of Bishop Bjarni of Orkney, a good friend of Pall Jonsson's. Walruses do not live in the Orkneys; Thorkel's nickname refers to the goods he traded in. On this visit, he was selling flour and malt from the Orkney Islands and probably looking to buy walrus tusks from Greenland. Since his last trip, though, there'd been a change of leadership at Borg. The

new chieftain and harbormaster was Pall's twenty-four-year-old foster brother, Snorri Sturluson. When Thorkel and Snorri had a fatal misunderstanding over the price of flour, Thorkel, having killed Snorri's foreman, fled to Oddi. There Saemund Jonsson, Pall's half-brother, took him in and protected him from Snorri's vengeance. Saemund, too, had strong ties to the Orkney Islands. Twenty years before, he had been betrothed to the daughter of Earl Harald. The wedding plans fell through when the earl and Saemund's father, Jon Loftsson, the uncrowned king of Iceland, failed to agree on who should hold the feast (and who should be inconvenienced by sailing to it).

The sagas reveal many other links between Greenland, Iceland, and the Orkney Islands. Thirty years after Thorkel Walrus's visit, for instance, another Orkney ship landed at Borg, captained by Thorkel's cousin. Merchant ships in the Contemporary Sagas are mentioned for two reasons: They sink, or their crews cause trouble. These two suggest the Orkney-to-Borg route was well traveled for many years.

The Iceland-to-Greenland leg of this sea road began just north of Borg, at the tip of a long peninsula with a prominent landmark: a towering glacier-capped cone. From there, Greenland was a four days' sail due west. A ship owned by the bishop of Greenland sank just south of this peninsula, apparently on its way to Borg, in about 1266, strewing walrus tusks up and down the coast; tusks were still being found in the seventeenth century, when an account of the wreck was written. Some were marked by runes, dyed red, and the beachcombers "thought it remarkable that the red color should remain for so long." Some of the Lewis chessmen, too, were dyed red, according to the 1832 report by Frederic Madden of the British Museum. Since then all signs of coloring have disappeared (perhaps due to the cleaning methods used in the nineteenth century) but the same long-lasting technique might have been used on the chessmen as on the Greenland tusks.

Western Iceland, the sagas imply, was the hub of the Greenland trade. Was it a walrus-ivory monopoly that made Snorri Sturluson the richest chieftain in thirteenth-century Iceland? Could this have been Jon Loftsson's plan? If the Oddi clan conspired to control the ivory trade, one step was Pall Jonsson's trip to the Orkney Islands in 1175.

THE LAST VIKING

The Orkney Islands sit at the intersection of two sea roads: one from Norway to Ireland, the other from Scotland to Iceland. Like Iceland, the Orkneys had no real towns in the twelfth century, but the islands abounded in safe harbors. They also had a consistent surplus of grain, something Icelanders and Greenlanders craved—not for baking bread, but for brewing ale. The earl's hall, the *Orkney Islanders' Saga* reports approvingly, was famous for the number and size of its ale casks.

Whatever his official mission in the Orkney Islands, one result of Pall's trip was this saga. Soon after he arrived, Pall met a poet named Bjarni, who would become bishop of Orkney thirteen years later, in 1188. Pall stayed friends with Bjarni all his life; in 1208, Pall sent his son Loft to visit him. As young men, Pall and Bjarni collaborated on the *Orkney Islanders' Saga,* with Pall finishing it after he returned to Iceland and before he was elected bishop of Skalholt in 1194. It's a lively tale of Viking derring-do—hardly the work of churchmen. In it we meet such bloodthirsty characters as the Scottish kings MacBeth and Malcolm; the Viking king of York, Eirik Blood-Axe; Earl Sigurd of Orkney, who flew the magic raven banner; kings Olaf Tryggvason and Harald Hard-Rule of Norway; and the high king of Ireland, Brian Boru. We read of bloody battles—brother against brother, friend against friend—including the Battle of Clontarf (1014) and the Battle of Stamford Bridge (1066). There are memorable vignettes: One haughty earl of Orkney kills the king of the Scots and ties his severed head to his saddle as a souvenir. On the ride home, the dead king takes his revenge: His buck tooth scratches the earl's leg, which swells up with gangrene and kills him. In a different scene, another Orkney earl escapes a burning hall, leaps a barricade, and rushes through a ring of enemies to disappear into the fog, only to be given away (oh, his soft heart) by the yapping lapdog under his arm.

One hero of the saga is Svein Asleifarson, sometimes called "the last Viking": He was still raiding a hundred years after the Norman Conquest in 1066, when textbooks say the Viking Age ended. Svein lived a stone's throw from Bjarni's farm and died in 1171, when Bjarni was twenty; Svein's son (not a Viking) married Bjarni's sister. There might,

for these reasons, be some truth to this passage describing Svein's ultimate Viking life:

> It was Svein's habit, at that time, to sit at home on Gairsay during the winter, keeping nearly eighty men there at his cost. He had such a big drinking hall that there wasn't another of its size in the Orkneys. Sveinn had much to do every spring, for he had a great deal of seed sown, and he oversaw the work himself. But when that task was finished each spring, he went raiding, and harried in the Hebrides and Ireland, coming back home in midsummer; he called that his "spring raid." He stayed home then until the fields were cut and the grain was gathered in. Then he went raiding again and didn't come home before the end of the first month of winter; he called that his "autumn raid."

One spring, Svein and his Vikings captured two English ships loaded with fine cloth. To show off their prize, the saga says, "they sewed the cloth to the front of their sails, so that it looked like the sails themselves were woven of the finest stuff." That detail would be hard for the young boy at the next farm to forget.

We don't have a description of Bjarni, but Pall, at least, was not the Viking type. The *Saga of Bishop Pall* describes him as "good-looking, with beautiful eyes and a keen glance, curly blond hair, shapely hands and small feet, a bright and glowing complexion, of medium height, and the most courteous of men." All the bishops in the sagas have "beautiful eyes," and a nobleman can always be recognized by his piercing gaze. Pall's complexion and his curly hair can't be assessed. But Pall's bones, discovered in a stone sarcophagus when Skalholt Cathedral was rebuilt in the 1950s, corroborate much of the rest of the description. One archaeologist termed Pall's skeleton "gracile." Another carefully measured it against other medieval Norse skeletons. He found that Pall was indeed of medium height: about five foot six-and-a-half-inches tall, or 169 centimeters; average height for his time was 172 centimeters. His feet were quite small, as was his skull, which was well shaped and finely made. He was broad-shouldered, with long arms, but was short from the knees down. He would have looked fine in the saddle but a little awkward afoot.

Was Pall "the most courteous of men"? The word does not mean
"polite." The Icelandic *kurteiss* comes directly from the French *courtois,*
meaning "courtly" or "chivalric"—and the authors of the *Orkney Is-*
landers' Saga certainly seem fascinated by chivalry, as illustrated by the
attention they give our Norwegian "master of nine skills," Kali Kolsson.
Kali, who became Earl Rognvald Kali of Orkney, is the most chivalrous
of Norse heroes. In 1151, he sailed off to see the Holy Land. It wasn't an
official crusade, though it's hard to call it a pilgrimage when he led a flo-
tilla of fifteen well-armed ships, some from Norway and others from the
Orkney Islands. One of his captains was the Norwegian nobleman Er-
ling Skew-Neck, father of the future king Magnus Erlingsson. Traveling
on Kali's own ship was Bishop William of Orkney, ostensibly the earl's
translator, though Kali calls on him more often for advice on battle tac-
tics. Also in Kali's crew were two Icelandic poets.

They sailed from the Orkney Islands south to Scotland, then
along the coast of England and across to Normandy, the saga says, and
"nothing is said of their journey until they came to the harbor called
Narbonne." Here we suddenly enter the world of the troubadours. The
ruler of Narbonne had just died, and his beautiful daughter Ermingerd
invited the Vikings to stay in her castle. "She held a drinking cup in
her hand, made of gold. She was wearing her best clothes, with her hair
loose like a maiden's, and her head covered with gold lace. She filled
the earl's cup, as her women played music for them. The earl took her
hand along with the cup, and set her on his knee." So far this passage
echoes other sagas—but Kali does not take her to bed and beget on her
his heir, as you might expect. Instead, he declaims a poem and sails
away.

All the way to Jerusalem, Kali and his pair of Icelandic poets make
verses on the fair but unattainable lady. Besieging a castle in Islamic al-
Andalus: "war-weary / we proved worthy of Ermingerd." Running into
a gale by the Straits of Gibraltar:

To my linen-decked lady
my lips spoke this promise.
Now, to the Straits
the storm speeds us.

Even in the midst of plundering an African merchant ship—the battle
in which Erling will be gravely wounded and earn his nickname, Skew-
Neck—Kali remembers his lady in the best troubadour style:

> . . . *the black*
> *warriors, brave lads,*
> *we captured or killed,*
> *crimsoning our blades . . .*
> *north, at Narbonne,*
> *she will hear news.*

Most likely Kali did not understand Ermingerd's *langue d'oc*—it wasn't
the same French that his friend Bishop William had learned in Paris.
Doubtless Kali's Norse poems were nonsense to Ermingerd. Could the
art of courtly love have been practiced in the Orkney Islands at the same
time it arrived in northern France, around 1150? Or was it the authors of
the *Orkney Islanders' Saga*, Pall and Bjarni, thirty-some years later, who
knew of the troubadours?

A glance at a map is revealing: The saga and the poems it contains
don't quite match. Kali and his fleet had long passed the Straits of Gi-
braltar and plundered the Andalusian shores by the time they met Lady
Ermingerd: Narbonne lies on the Mediterranean coast of southern
France. (And Kali took a land route back from Rome, so he did no plun-
dering on the way home.) Just as Pall and Bjarni romanticized Svein
Asleifarson's Viking life, here they shaped a set of poems to the pattern
of their own times, when the cult of courtly love pervaded the North.
Along with poetry, this new meaning of "courtesy" included the ability
to play chess—often with the lovely woman of one's poems—making it
even more likely that Pall (or Bjarni), steeped in this tradition, commis-
sioned the Lewis chessmen.

THE KING'S BISHOP

We cannot say how long Pall lived in the Orkney Islands, only that af-
terward he spent a short time at a school in England, where he "learned
so much that there is hardly another example of anyone accomplishing

so much in the same amount of time," says the *Saga of Bishop Pall*. He may have studied at Lincoln, following in his uncle Thorlak's footsteps. He may, at Thorlak's request, have gone to England earlier, in search of Archbishop Eystein of Trondheim, who fled there in 1180 after backing the losing side in Norway's game of kings. Eystein took refuge at the monastery of Bury Saint Edmunds for six months, then spent a further six months—at the command of King Henry II of England—as the acting bishop of Lincoln, before returning to Norway in 1183. There he patched things up with King Sverrir and concentrated on the building of Nidaros Cathedral, which shows striking similarities to Lincoln Cathedral.

Wherever in England Pall roamed, with Archbishop Eystein or alone, the year 1190 found him back in Iceland, a chieftain, still married to Herdis, and now the father of a son. That was the year Eystein's successor at Trondheim, Archbishop Eirik, son of an Icelander himself, decreed that an Icelandic chieftain could no longer be ordained a priest. Pall likely had no opinion either way: He had no inclinations toward the priesthood. His estate was prospering. Three more children arrived. Then, in 1194, Bishop Thorlak died and Bishop Brand of Holar—Pall's great-uncle—picked Pall to be bishop of Skalholt.

Pall was an unusual choice—ineligible on three counts: He was a chieftain, married, and a bastard. But the Icelandic church had never yet followed Rome's rules. After his father talked him into accepting the post, Pall set off for Norway carrying "certain treasures," confident that his irregularities would be overlooked. But he found no archbishop in Trondheim. Archbishop Eirik, too, had quarreled with King Sverrir and been exiled. Pall traveled south to meet the king, who was then holding court in the region north of Oslo. "The king treated him as if he were his son or brother," the saga says. Like Pall, Sverrir—whom we'll meet again in chapter 4—was an illegitimate descendant of King Magnus Bare-Legs. At the king's request, Bishop Thorir of Hamar ordained Pall a priest, defying the archbishop's order about chieftains. The king then demanded that "all the bishops in the country"—some of them having fled with Archbishop Eirik to Denmark—sign a letter supporting Pall's elevation to the bishopric of Skalholt. With that reinforcement, Pall traveled on to

Lund, across the bay from Copenhagen, where he arrived on Easter Sunday 1195 and was warmly welcomed by Archbishop Absalon.

Absalon, like Trondheim's archbishop Eystein, came from a rich, noble family. Both Absalon and Eystein studied in Paris at the same time as Iceland's bishop Thorlak, but Absalon had no interest in the church reforms the other two embraced. His idea of the proper relationship between king and bishop was more like the one portrayed on the chessboard—on the Islamic chessboard, that is, not that of twelfth-century Europe. Absalon would die for his king, certainly. But he would not share power with a second bishop. He acted more like the Arabic vizier, which was replaced on the European chessboard by a queen. He was the king's partner.

Canute VI, on the throne of Denmark when Pall Jonsson arrived, was Absalon's foster son. Absalon and Canute's father, Valdemar, had been raised together; from childhood, they'd been inseparable. When Valdemar, Canute V, and Sweyn III signed a treaty in 1157 splitting Denmark into three kingdoms, Absalon was there. When Sweyn invited his two co-kings to a celebratory feast at Roskilde three days later, Absalon came too.

But he was not in the banquet hall, where Valdemar sat playing chess, with Canute watching by his side, when Sweyn's warriors treacherously burst in on the unarmed kings. According to the thirteenth-century *Knytlinga Saga*, Valdemar sorely missed him, for Absalon was not only the king's dearest friend, he was "of all men boldest and most daring with weapons." Valdemar wrapped his cloak about his arm and struggled out the door, taking only a flesh wound to the thigh; Canute, less lucky, fell with his head split open. Absalon rushed in. Thinking it was Valdemar on the ground, he drew the young king into his lap. As Saxo the Grammarian—who, much later, worked for the archbishop—described the scene in his *History of the Danes,* Absalon "sheltered his head with his hands and chest, as the blood poured out, and chose to forget his own safety amid the clash of arms. . . . At last he discovered from the marks of his dress that it was Canute he was holding, and he felt happiness mingling with his sorrow." The traitor Sweyn was soon defeated, putting an end to twenty-three years of civil war in Denmark.

King Valdemar rewarded his friend Absalon by naming him bishop of Roskilde and bestowing upon him the castle and town of Copenhagen, along with land in sixteen nearby villages. In 1177, Absalon became archbishop of Lund—without giving up his post at Roskilde. The two, king and bishop, ruled the realm side by side. A high point of their reign was the crusade against the pagan Wends and the sacking of the large island of Rugen, now belonging to Germany, in 1168. Leading this crusade, Absalon used more than his spiritual sword. Writes Saxo: "Since Absalon abounded in courage, and was foremost in his knowledge of the art of war, he led the vanguard while the army was advancing, and on the way home usually acted as a rearguard, always having as his companions, whether it was the loot or the glory they wanted, the younger and liveliest Danes."

On one campaign, when the king asked for advice, Absalon "had his plan ready": "The king was to disembark his cavalry onto the mainland, and make his way to the narrow stretch of the river to protect the fleet, while the others proceeded one by one to the same spot, in ships manned by few armored oarsmen; and as soon as they were numerous enough, they would burst through the enemy fleet. When they all laughed, and asked him whether he would like to go first, he said, 'Yes, I would, or it will look as if I were all talk and no action.'"

Fighting against these pagans on the shores of the Baltic Sea, the "penitent crusader," according to a letter from Pope Alexander III, received the same reward as a crusader in the Holy Land: remission of all sins. The effect on Denmark, remarks one modern historian, was to unite the kingdom. Another has a slightly different interpretation: "The real issue was putting the royal dynasty and Absalon's own powerful Hvide family in control of the rest of the country."

Absalon and Valdemar's ambitions were not confined to Denmark. Trondheim was a new archbishopric, celebrated in poetry and song, when King Ingi killed his brother-kings Sigurd Mouth (in 1155) and Eystein (in 1157). Ingi, in turn, was killed by Sigurd's son in 1161, and his partisans fled to Denmark. Among them was Erling Skew-Neck, whom we have already met traveling through the land of the troubadours in the company of the Orkney earl. King Valdemar received Erling with great

honor, Saxo writes, because Erling's wife was Valdemar's cousin. Valdemar agreed to help place Erling's son, Magnus—descended through his mother from King Sigurd the Jerusalem-Farer—on Norway's throne. Saxo fails to mention the price of Valdemar's assistance, but Snorri Sturluson, in *Heimskringla,* is clear: Denmark was to get Viken, the province around modern Oslo Fjord.

Valdemar sailed north to Viken in 1163 and was hailed as king. Magnus Erlingson, all of eight years old, was crowned king of Norway by Archbishop Eystein in Trondheim in 1164. He ruled ten years—his warlike father beating back all rivals—until Sverrir, bastard son of King Sigurd Mouth, arrived from his hiding place in the Faroe Islands. Valdemar and his successor, Canute VI, aided Magnus until his death in battle in 1184.

Even after Sverrir became sole king of Norway—and had retaken the province of Viken—Archbishop Absalon continued to fight, this time with his spiritual sword. When Archbishop Eirik of Trondheim fell out with his king—in part over the number of warriors and the size of the warship an archbishop was due—Absalon took him and his retinue in. The two archbishops sent a letter to the pope accusing King Sverrir of atrocities against the church and calling for his excommunication. Notes the *Saga of King Sverrir,* "From the pope came the decision the archbishops had requested: The pope excommunicated King Sverrir unless he let the archbishop have everything he wanted and all that he claimed for himself."

When the pope excommunicated Emperor Henry IV in 1076, he specifically released "all Christian men from the allegiance which they have sworn or may swear to him" and forbade "anyone to serve him as king." The German nobles threatened to elect a new king unless the emperor made peace with the pope. Things went differently in Norway. Worn out from years of war, King Sverrir's people—lay and churchmen alike—stood by him. Churches remained open. Masses were sung. The dead were buried, babies baptized, and marriages blessed. The king, who had been educated for the priesthood himself, before he learned of his royal blood, wrote a lengthy reply to the pope. Archbishop Eirik and the clergy who followed him into exile, the king said,

are blinded by covetousness, excess, ambition, arrogance, and injus-
tice. . . . They point us to no ways but those of death; some of them
supply our land with excommunications and anathemas; some collect
a crowd together, with weapons and shields, deprive us of our property
and our freedom, incite themselves and us to much slaughter, and so
wish to destroy alike our bodies and our souls. . . . Now although we
receive rebuke from the bishop of Rome, or cardinals, yet can we not
impute it to the pope, for he neither knows what goes forward in this
land, nor in any other that lies far distant from him. Our bishops and
clergy are to blame, for in their enmity to us they carry gossip and lies
to the pope. . . . And though the pope has pronounced sentence, his
condemnation will not touch the king or any innocent man in the land,
for God is ever a righteous judge, and His judgments are according to
right, and not according to the iniquity of lying and deceitful men.

The ban on King Sverrir may not yet have been in effect by the time
bishop-elect Pall Jonsson arrived in Lund on Easter Sunday, 1195, hold-
ing the king's letter of recommendation. Pall did not stay long. He was
quickly consecrated bishop of Skalholt by Absalon, since Archbishop
Eirik had indeed gone blind. (As King Sverrir would later remark, "The
same ban and curse that he called down upon me have now been driven
into his own eyes.") To each of these archbishops Pall gave a gold ring,
and he bestowed gifts on everyone who honored his consecration, his
saga says. His gift to Saxo the Grammarian might have been a manu-
script, for in his *History of the Danes* Saxo praises Icelanders and admits
to having "composed a considerable part of this present work by copying
their narratives." One of the narratives he seems to have copied is the
Orkney Islanders' Saga.

Surely while in Denmark Pall discussed King Sverrir's pending ex-
communication—Lund was crawling with exiled Norwegians. Surely
his new superior, Archbishop Eirik the Blind, impressed upon him his
duty to shun the unrepentant king. Yet Pall returned to Norway after his
consecration and acted as King Sverrir's counselor for a season before
sailing home to Iceland. One case he adjudicated, along with his fellow
bishops, was the peace settlement for his former liege lord, Earl Harald
of Orkney, who had backed a rival to the Norwegian throne.

Once home in Iceland, Pall kept in touch with his royal kinsman, who remained excommunicated until his death in 1202. In 1198, Pope Innocent III sent a letter to Iceland's churchmen admonishing them for corresponding with Sverrir, *excommunicato et apostate*. Pall ignored it. For to Bishop Pall Jonsson of Skalholt, the rules of chess simply made sense. Of all the Scandinavian bishops (and archbishops) who could have commissioned the Lewis chessmen between 1150 and 1200, it is Pall Jonsson whose role in real life most closely matches that of the bishop on the chessboard. For him, the bishops served the king. And the queen, of course, whom we are now ready to place on the chessboard.

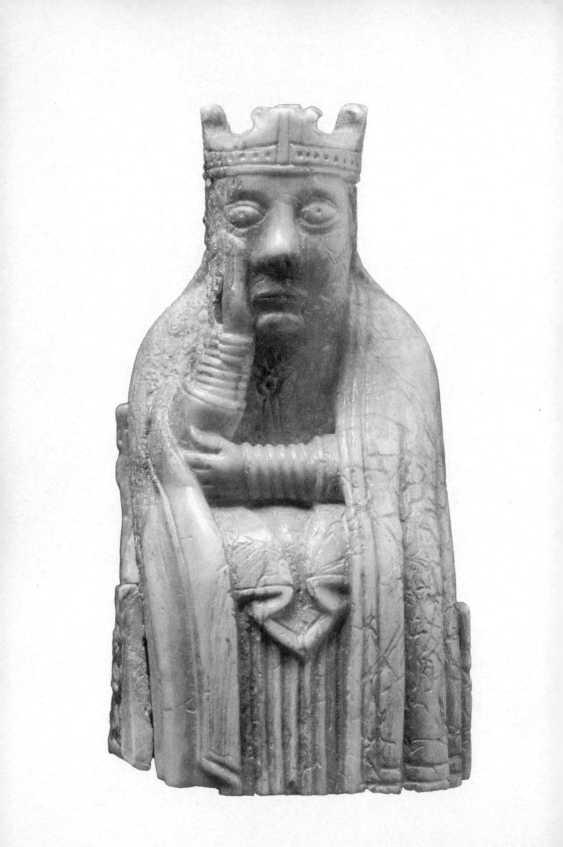

THREE

The Queens

She is "an icon of female power . . . an awesome warrior," rhapsodized Marilyn Yalom in *Birth of the Chess Queen*. "She defies the narrow constraints that bind the rest of her army."

But not in the twelfth century.

When the Lewis chessmen were carved, the queen moved one space per turn, and only on the diagonal, or "aslant," as a thirteenth-century sermon explains, because "women are so greedy that they will take nothing except by rapine and injustice." The queen was the weakest piece on the board, even weaker than the king, and Western chess players had no clue what to do with her. Mostly they kept her close to her king, ready to block a check by a rook. Medieval Arabic chess treatises show a much better grasp of the piece's value. Arabic sets had a vizier, or *firz*, at the king's side, not a queen (who is called *fers* as often as *regina* in medieval texts). Arabic chess masters sent the *firz* "into the heart of the enemy's position"; Europeans kept their *fers* close to home. Until, that is, the queen "went mad," acquiring the sweeping moves of the modern game: any number of spaces, in any direction.

Medieval chess was a very slow game—it's been compared to a castle siege—and bored players invented a variety of ways to speed it up. Some house rules used dice to determine which piece moved next. Some gave the pawn its initial leap of two spaces or started with the pawns already engaged. Some let the king and queen take a leap as well. The first hint of the queen as an "awesome warrior" comes in a thirteenth-century French poem comparing the Virgin Mary to a chess queen: "Other ferses move but one square, but this one invades so quickly and sharply that before the devil has taken any of [her men], she has him so tied up and so worried that he doesn't know where he should move. This fers mates him in straight lines; this fers mates him at an angle; . . . this fers drives him out from square to square by superior strength." The poet is describing a "king hunt," a chess strategy still used today. Yet it's doubtful anyone in the 1200s played chess with this awesome queen. Not until 1497, when Isabella of Castile ruled Spain and its New World colonies, does a chess treatise recognize the queen as the strongest piece on the board. After that come many references to "queen's chess" or "mad chess"—our modern game.

If Isabella inspired the "mad" queen, then Theophanu, who ruled the Holy Roman Empire five hundred years earlier, may have modeled the original queen on the chessboard. The Einsiedeln verses, first proof of chess in the West, place a queen, not a vizier, beside the king; the poem was written in 997, seven years after Theophanu's death, at a monastery she sponsored.

Theophanu was "born to the purple" in Byzantium, where kings and queens were equals. Negotiating her marriage pact in Rome in 972, she insisted upon equal treatment—and got it. An ivory book cover now in the Cluny Museum in Paris is one of many objects to portray Theophanu and her husband, Otto II, as co-rulers. Here, they stand on either side of Christ, receiving his blessing. Above their heads is inscribed "Emperor Otto" and "Emperor"—not *Empress*—"Theophanu."

Theophanu understood the game of kings. She accompanied Otto to war, holding the cities he captured. Once, writes the chronicler Thietmar of Merseburg, her quick thinking rescued Otto after a disastrous defeat in the south of Italy. Separated from his army, Otto swam out to

a passing ship, whose occupants decided to sell him to his enemies; he suggested they first collect the empress and the imperial treasure. When word reached her, Theophanu met the ship with a well-loaded mule train. But she insisted that her husband dress in his royal robes of state before she came aboard, sending a bishop and a few knights ahead with the garments. Otto II caught her drift. Pretending to change clothes, he jumped overboard. Theophanu collected her naked lord and took him back to the castle.

Other episodes in Theophanu's reign reveal the mind of a chess master—for instance, how she played her bishops to be named regent for her three-year-old son, Otto III, after the sudden death of Otto II in 983. Theophanu ruled the Holy Roman Empire, alone, from 984 until her death in 990. But the tenth century was an age of reigning queens; four others may have inspired the queen on the chessboard. Plus, there's no knowing when the chess queen caught on in different kingdoms. The earliest extant chess pieces to look like women are the two queens in the so-called Charlemagne chess set, made in southern Italy about 1100. Both are ladies enclosed in a tower, with two attendants manning the door. An Italian queen from a little later sits on an enormous throne, while another, from Spain, peeks her veiled head above what might be a throne or a tower. The next, chronologically, are the eight Lewis queens.

The rise of the chess queen, from the weakest piece on the board to the strongest, parallels three social trends: The cult of the Virgin Mary, Queen of Heaven, became popular in the eleventh century. Courtly love, with its fixation on the unobtainable woman, was fashionable in the twelfth. At the same time, the Christian doctrine of *rex iustus* changed the concept of kingship. Queenship, too, was affected. Kings were newly charged to be monogamous. Bastards were disenfranchised. As the concept of primogeniture caught on—and the king's eldest legitimate son disinherited his siblings, half-brothers, uncles, and cousins—a queen became, first and foremost, the mother of the true prince. Controlling the succession gave her power; when the king was absent, she ruled. And, as in the past, she presided over the royal household, in charge of food, clothing, housing, and entertainment, which included chess. Two romances, one written in 1170, describe the court of King Henry II of

England: Queen Eleanor of Aquitaine (having left the king of France) enjoyed singing, dancing, drinking spiced wine, hunting with her sparrow hawk, and playing games of dice, backgammon, and chess. An "icon of female power" herself, who incited her sons to rebel against their father, Eleanor would not have hesitated to raise the chess queen to be the most powerful piece on the board—if she had thought of it.

VALKYRIES

The chess queen—unlike the bishop—caught on quickly. Medieval queens were expected to wage war, at least by proxy. Empresses, like Theophanu, accompanied their men to the battlefield. In the North— at least in poetry—queens even fought. These awesome women warriors, the valkyries, were battle goddesses, sometimes beautiful, sometimes troll-like. They were sent by Odin, the supreme Norse god, to fetch slain heroes to Valhalla and pour them mead—or to drizzle troughs of blood over the battlefield and whip men's heads off with bloody rags. Legends also tell of shield-maidens: Sometimes they ride flying horses and cast storms of spears. Sometimes they are real Viking women who dress and fight like men. Today, the word *valkyrie* is often used for all three: the mythological, the legendary, and the (perhaps) historical.

Take Hervor in the *Saga of King Heidrek the Wise*. This saga, with its flaming sword and interludes of chess, may have been written for Queen Ingigerd of Sweden in the early 1100s. Its not-too-talented author stitched it together from two poems. One is thought to be the oldest Germanic heroic verse. The second, "The Waking of Angantyr," was the first Old Norse text to be translated into English; it was published in 1705 and inspired generations of Gothic tales. The plot of the saga is hard to follow. The action takes place during the fourth-century wars between Goths and Huns, making the Viking adventures about five hundred years too early. But the valkyrie is magnificent: Strong and fearless, better with a sword than an embroidery needle, the young woman Hervor dressed as a man, assumed a man's name (Hervard), joined a band of Vikings, and became their leader. She sailed to the

island where her warrior father died, entered his barrow, and woke his corpse, which cried out:

> *Graves begin to open,*
> *flame flickers over the island;*
> *awesome it is to look outside.*
> *Don't stay here, maiden! Make haste to your ships! . . .*
> *You are not at all like other people*
> *if you go to grave-mounds at night,*
> *helmed, in ring-mail, spear in hand,*
> *to stand here, warlike, and wake us in our halls.*

"Men always thought me human enough before," his daughter quipped and demanded he hand over his famous sword.

Could Hervor and her kind be historical? Certainly valkyries are prevalent in Viking art. They're carved on runestones, woven into tapestries, cast as brooches or amulets. In December 2012, a man learning how to use a metal detector on a muddy site in Denmark found a little face looking up at him. It was the first three-dimensional valkyrie figurine ever found. Made of silver, this thumb-sized warrior woman carries sword and spear and wears her long hair knotted up out of the way, forming a convenient loop for hanging her on a necklace—though a helmet would have been more practical in battle.

Saxo the Grammarian, usually sober and historical, was convinced that "there were once women in Denmark who dressed themselves to look like men and spent almost every minute cultivating soldiers' skills." He even names names, including Lathgertha, "a skilled female fighter, who bore a man's temper in a girl's body; with locks flowing loose over her shoulders she would do battle in the forefront of the most valiant warriors." A good twelfth-century cleric, Saxo disapproved of such women. "They put toughness before allure," he complained, "aimed at conflicts instead of kisses, tasted blood, not lips, sought the clash of arms rather than the arm's embrace, fitted to weapons hands which should have been weaving, desired not the couch but the kill."

Archaeologists occasionally find a Viking woman buried with weapons. These weapons are usually "explained away, in more or less convincing fashion, as representing gifts," wrote historian Neil Price in the catalog for the 2013 Viking exhibition in Copenhagen. "However, there is no reason why they should not simply represent the possessions of the dead while they were alive: women with weapons."

Those comments sparked a storm of rebuttal. Skeletons are not always well enough preserved to tell if they are male or female. When we can sex them, archaeologist Martin Rundkvist pointed out, skeletons buried with weapons are male and those with jewelry, female. Graves with female bones and complete sets of weapon are so rare as to be just "noise in the data." Historian Judith Jesch concurred: Most of the burials of women warriors are "problematic." Some were dug up a hundred years ago, not using modern scientific techniques. Some were double burials—a man and woman in the same grave. Some burials could have been "mixed," a more recent burial settling into an older one. Ancient cemeteries are often messy. "That the very few women buried with weapons were warrior women in life," she concluded, "seems the least likely explanation of all."

The Lewis chess queens are not carved to look like valkyries. They carry no weapons, though two hold drinking horns, as valkyries in art often do. All are seated on elaborate thrones, crowned, wearing gorgeous robes and pleated headdresses of a style popular in the late twelfth century. Their most distinctive feature is their pose: Each queen presses her right hand against her cheek. No one agrees on what emotion this gesture was intended to represent.

Actors in classical Roman theater held a hand to the cheek to express grief, and Anglo-Saxon artists picked up on this gesture. In eleventh-century manuscripts from Canterbury, Adam and Eve, cast out from Eden, lament their fate with their hands on their cheeks. Other figures in a similar pose are identified as a psalmist whose "spirit has failed" and a female personification of "unrighteousness." Yet there's a subtle difference between these images and the Lewis queens: In the manuscripts, the hands are cupped and the fingers spread almost like claws. They hide the eye, sometimes even the nose and mouth. And rather than glaring

at the observer, as the Lewis queens do, these grievers are hunched and cowed.

A twelfth-century *Life of Saint Alexis* depicts the saint's virgin bride standing stoically at the door, a hand pressed flat to her cheek like a Lewis queen's, as Alexis abandons her to become a holy beggar. Following Christian law, she would not be able to remarry while he lived. Still, her grief is hardly commensurate with that of the Virgin Mary who, in some twelfth-century Crucifixion scenes, likewise holds her hand to her cheek.

Grief, despair, contemplation, composure, patience—art historians find all these emotions in the poses of the Lewis queens. To others, the queens seem calculating, cold, focused, determined, or disapproving. Still others find them surprised, taken aback, even aghast.

The meanings of gestures mutate over time, much like the meanings of words. We cannot assume the carver of the Lewis queens intended to portray the emotions we now perceive. Today, a hand clapped to the cheek is more likely to call up Homer Simpson's "D'oh!" than the Virgin Mary's grief. Often your interpretation depends on which of the eight Lewis queens you look at—and how you turn her to the light. Yet everyone can agree that the Lewis queens do not look pleased. Though not warrior women, they are women at war.

QUEEN GUNNHILD THE GRIM

Intimidating, cold, calculating, focused, determined—those words well describe the most notorious Norse queen in medieval Icelandic literature, one who was perhaps the model for the Lewis chess queens: Queen Gunnhild the Grim, also known as Gunnhild Kings-Mother, the wife of King Eirik Blood-Axe.

Eirik's father, Harald Fair-Hair, was the king who unified Norway. Eirik and his half-brothers parceled it out again—until Eirik, earning his nickname, killed all but one, who happened to be in England. Blood-Axe ruled Norway, alone, from 930 to 935. Then his surviving half-brother, Hakon the Good, forced him to flee. Hakon had been brought up at the court of King Athelstan of England, which is where

Eirik headed. With Athelstan's consent, Eirik became the Viking king of Northumbria, based at York.

How closely the historical Gunnhild matches the saga character we can't say. She appears in at least ten sagas, in some as a scheming bride, in others, a randy old widow. Snorri Sturluson introduces her in *Heimskringla* as a girl "whose beauty had no equal." She was "wise and knew many things"—one way of hinting she was a witch. She was "cheerful and talkative," but underneath it all, "wily and grim." In one source, her father was King Gorm the Old of Denmark. In most, however, he's one of the chieftains in Halogaland, the province north of Trondheim, who controlled the Finn trade in furs and walrus tusks. Even so, Eirik met her far, far to the north, in Finnmark itself, where she was studying witchcraft. She cast a spell on her two tutors, sprinkling them with magic dust, so that Eirik's men could kill them. Then Gunnhild eloped. Later, she's not so impressed by Eirik.

Egil's Saga, which Snorri may also have written, clearly casts Gunnhild as a villain. For example, after Egil, drunk, killed the queen's friend, she hunted him down—unsuccessfully. "I made a mockery of / their Majesties' majesty," Egil bragged in one poem. When King Eirik agreed to spare Egil's life, Queen Gunnhild scoffed: "How soon you forget the evil done to you." She saw to it that Egil was outlawed from Norway and lost his wife's inheritance. He responded by killing Gunnhild's ten-year-old son. In a pair of poems, he boasted:

> *Grim-tempered Gunnhild must pay*
> *for driving me from this land . . .*
> *I dabbled my blade*
> *In Blood-Axe's boy.*

Grim-tempered for good reason, it seems, Gunnhild plotted revenge on Egil long after she and King Eirik fled Norway. Through witchcraft, the saga says, she finally lured Egil to York. Heading for King Athelstan's court, Egil was shipwrecked upon her doorstep—though again, King Eirik's "forgetfulness" and Egil's powerful friends set the Icelander free. Egil traded a praise poem for his own head. "Do you forget, king, what

Egil has done?" Gunnhild erupted—you can almost see her clapping her hand to her cheek, aghast.

Gunnhild proves herself more focused and determined (if still cold, calculating, and intimidating) after King Eirik's death. Like Unn the Deep-Minded, Gunnhild Kings-Mother evacuated her entire extended family—and their wealth—from a desperate situation. According to the *Orkney Islanders' Saga,* Eirik sailed on his usual summer raid, going first to the Orkney Islands, where he was joined by the earls, and then to the Hebrides, where he recruited additional warriors. He and these Vikings plundered through Ireland, Scotland, and into England, until they were cut off, far from their ships, and slaughtered. Gunnhild, now forty-one, with eight children in tow, left Northumbria, taking all of King Eirik's ships and all of the warriors who would follow her, according to *Heimskringla.* They also took "a great amount of money, some of which had been collected in England as taxes and some taken as plunder." They went to the Orkney Islands, where Gunnhild married off her only daughter. Then, hearing of war between Norway and Denmark, Gunnhild made her next strategic move. "When Gunnhild arrived in Denmark with her sons she went straight to meet King Harald [Gormsson] and received a good welcome"—not too surprising if, as a twelfth-century Latin history says, Gunnhild was Harald's sister. "King Harald granted them such large revenues in his kingdom that they could support themselves and their followers in style. He set Harald Eiriksson on his knee and made him his foster son; he grew up there at the Danish court."

Harald Eiriksson would become, with Danish help, King Harald Gray-Cloak and rule Norway from 960 to 975 with his mother and brothers by his side. Notably, none of Gunnhild's sons killed any of his brothers. Though "grim and bold" and so greedy "it was said they hid money in the earth," they stuck together—unlike their father, Eirik Blood-Axe, and his brothers. Nor were there any half-brothers: Eirik Blood-Axe apparently never strayed. The Gunnhildarsons, as they were called, even valued their mother's advice. Says *Heimskringla,* "Gunnhild Kings-Mother and her sons often consulted each other about the governing of the country, talking things over and holding councils." It was, said another medieval chronicle, "the Age of Gunnhild."

Njal's Saga and *Laxdaela Saga*, both written in Iceland after 1240, portray Gunnhild Kings-Mother in her fifties sending her squires to the harbor to see who sails in. When the handsome Icelander Hrut arrived— "tall and broad-shouldered and slender at the waist"—she invited him and his uncle to stay the winter. Said the uncle, "I know Gunnhild's temper: If we decide not to stay with her, she will hound us out of the country and confiscate all our goods; but if we go to her, she will show us all the honor she has promised."

When Hrut appeared before the king Gunnhild said, "If your body-guard had more men like this, it would be well manned."

"I believe," said Harald Gray-Cloak to Hrut, "that my mother wishes you to receive whatever title you ask for."

After Hrut became the king's liegeman, he asked, "Where should I sit?"

Said the king, "My mother will decide that."

She also decided where Hrut would sleep. "You will stay in the loft with me tonight, just the two of us."

Gunnhild showered Hrut with presents—from a luxurious robe to two fully manned warships. When Hrut wished to return to Iceland, she asked him point-blank, "Do you have a woman out there?"

"No," Hrut lied. (He was engaged to be married.)

The old queen was miffed. "I wish that were true," she said. She clasped a gold ring around his arm, saying, "If I have as much power over you as I believe I do, then this will make certain that you never enjoy that woman you have in mind for yourself out in Iceland, though you'll be able to have your way with other women. So now neither of us will be happy, because you didn't trust me with the truth."

Hrut laughed—but the spell worked. Soon after they wed his wife divorced him, complaining that he was unable to consummate their marriage.

Some years later, says *Laxdaela Saga,* Gunnhild met the eighteen-year-old Icelander Olaf Peacock, who believed he was the grandson of an Irish king but couldn't get to Ireland to prove it. Said Gunnhild, "I will give you what you need for this voyage, so that you can travel as splen-didly as you wish." She gave him a ship with a crew of sixty warriors. The last we see of this determined queen in the Icelandic sagas is when

Olaf returns, acknowledged as royal: "The king received him well, and Gunnhild even better."

"WOMAN HAS NO AUTHORITY"

If the Lewis chessmen were made in Iceland in the late twelfth century, when these tales were being told for entertainment, who better to model the queen than Gunnhild the Grim? The Lewis queens are not young and beautiful. They are women of experience—women of power.

It may, however, take a woman's eye to see Gunnhild as the model of a medieval queen. To the mostly male writers of the Icelandic Family Sagas, she was a threat. "You whet me to cruelty, Gunnhild, more than others do," King Eirik complained in *Egil's Saga,* and we can trace this motif of the "whetter" throughout the sagas. One reader counts fifty-one examples in which a woman goads her man into killing when he would rather not. Historian Jenny Jochens, in *Old Norse Images of Women,* finds that total far too low; she also sees in this motif the inky fingerprints of priests. In pagan times, revenge was a civic duty. In Christian times, it was monstrous unless enacted by the state. For the Norse, that change of ways took centuries to accept; Icelanders exchanged revenge for restraint only in the mid-thirteenth century, when feuding among the chieftains caused such devastation that joining the kingdom of Norway seemed a better plan. For the Christian saga writers, struggling to explain the chaos, a woman's sharp tongue became the perfect excuse for strife.

Blaming women for men's failures was a fallback option for the medieval church. Women were either Mary or Eve—usually Eve, which justified the increasing control men took of women's lives. "Since Adam was led to temptation by Eve, and not Eve by Adam, it is right that man should assume government over woman," wrote Ivo of Chartres in about 1100, adding, "Woman has no authority, neither is she able to teach." A few churchmen disagreed, at least in part. Thomas of Chobham, in 1215, thought women should cultivate their inner Mary and become "preachers to their husbands, because no priest is able to soften the heart of a man the way his wife can. . . . Even in the bedroom, in the midst of their embraces, a wife should speak alluringly to her husband, and if he is hard

and unmerciful, and an oppressor of the poor, she should invite him to be merciful; if he is a plunderer, she should denounce plundering."

At the same time, the church's new definition of marriage reduced queens to pawns. Pagan laws ensured that a daughter received a fair inheritance from her father. Her dowry, when she married, was hers to do with as she pleased; if the marriage did not satisfy her, she could divorce and take her property with her. The Christian law of primogeniture disinherited daughters. Christian marriage, at the same time, was indissoluble—and placed a woman's dowry permanently in her husband's hands.

In this regard, Icelanders were unorthodox well into the thirteenth century. Primogeniture was ignored. Icelandic women might be criticized for their sharp tongues, but they were still treated as queens, not pawns. As the Contemporary Sagas show, Bishop Pall's niece Solveig and her six brothers each inherited an equal amount from their father (all seven siblings were illegitimate). Pall's niece Hallveig inherited both from her father and from her husband, becoming the richest woman in Iceland; she declined to remarry, but formed a loose partnership with Snorri Sturluson that seems to have been based on mutual esteem.

Icelanders also ignored the stricture that "woman has no authority." One of the few teachers known from the twelfth century is Ingunn, who taught Latin at the Holar Cathedral school "to anyone who wanted to learn." According to the *Saga of Saint Jon*, she corrected the texts in books read aloud to her while she worked. Exactly what work she did is unclear. She sewed, *tefldi*, and did other handiwork illustrating saints' legends, the saga says, "making God's glory known to men not only through the words she spoke but also through the work of her hands." "Sewing" encompasses embroidery. *Tefldi*, in most contexts, means "played board games," though one dictionary defines it as "weaving checks"; it can also mean "played chess." But correcting Latin grammar while playing chess sounds too much like a stunt. Nor does chess fit in a triad with sewing and handiwork as ways to make God's glory known. Perhaps the root of the verb *tefla* here is not *tafl*, or game board, but *tafli*, or tablet: What Ingunn may be doing, while listening to the reader, is tablet weaving, an intricate kind of braiding using a stack of four-inch-square tablets

of wood or ivory to produce the intricate borders sewn on the hems of medieval cloaks.

Finally, Icelanders ignored the rule that women could not marry priests. Reformers had preached against clerical marriage for hundreds of years. The Lateran Councils of 1123 and 1139 officially banned it. If previously married, upon ordination a priest must eject his wife and children from his home and take a vow of celibacy: The church should be his only bride. Otherwise, "What business have you to handle the body of Christ, when . . . you use your hand to touch the private parts of harlots," fulminated Peter Damian, the same bishop who was pierced to the heart upon learning of a fellow churchman who played chess.

THE DROWNING OF HERDIS

Celibacy separated churchmen from the world—and demonstrated their superiority to other men. Pall Jonsson, married twenty years before becoming bishop of Skalholt, understood the intention of the rule. In 1198, he oversaw the ceremony making his uncle Thorlak a saint. For it, he commissioned the *Office for Saint Thorlak,* or he may have written it himself: As a musician he surpassed all other men, his saga says. This beautiful cycle of Gregorian chants still exists; performed by six singers in 1993, it lasted three hours. "The darkness flees; / the light illuminates the mind, / a devoted nation dances," it begins. The first nocturne praises Thorlak's purity:

> *In youth he rejects the corruption of the world . . .*
> *He keeps the lily intact,*
> *fighting the battle for celibacy . . .*
> *He was filled within by heavenly nectar,*
> *outwardly he sparkles with virtue.*

Did Pall take a vow of celibacy? Possibly. When he returned to Iceland from his consecration in 1195, he moved into the bishop's quarters at Skalholt, leaving his wife and four children at their family estate of Skard. A year later, however, Herdis and the children moved to Skalholt,

and Herdis took over running the household. Whether she shared Pall's bed, we do not know; they had no more children. But forgoing her management skills was more than Pall could accept.

The archbishop of Trondheim, a practical man, had already conceded that a bishop with a live-in "mistress" should be dismissed only if "his behavior had caused a scandal." Herdis, far from scandalizing the Icelanders, was praised for her management of the bishop's see, says the *Saga of Bishop Pall.* The author, most likely her son Loft, repeatedly refers to her *skörungskapr,* one of the most untranslatable of Icelandic words. The standard Old Icelandic–English dictionary defines it as "nobility" or "generosity." But there's more to it. *Skapr* means "temper." *Skörungr,* when used to describe a man, means "a leader"; when applied to a woman, English translators reduce it to adjectives like "high-spirited" or "brave-hearted." In Herdis's case, the saga says, "So great were her *skörungskapr* and her oversight that she had been there only a few winters before there was enough of everything that was needed, and nothing was lacking at the estate even if a hundred and twenty people arrived, on top of the seventy or eighty in the household itself."

At the same time, Herdis continued to manage the family estate at Skard. An ordinary farmwife would be in charge of making butter and cheese, smoking and pickling meat, preserving berries and eggs. She would rake and dry the hay her menfolk cut and see it stacked behind the barn, covered with turf. She would pluck, spin, and weave the wool from a hundred sheep a year to keep her husband and children well dressed, along with weaving extra cloth for barter. Weaving, on the standing warp-weighted loom, was uniquely a woman's chore, and cloth was the basis of Iceland's economy as well as its main export for hundreds of years—underscoring the importance of women in the society. Herdis likely had many women, at both Skalholt and Skard, working at these chores alongside her, but it's clear she didn't shirk. Skard "stayed in good shape while she lived," wrote her son Loft, "for of all women she was the most zealous, both concerning her own work and that of other people, as experience well shows."

Skard lies between ice and fire: The roiling glacial river Thjorsa marks its western border, the foothills of the looming, cloud-shrouded volcano Hekla rise to the east. The mountain's name means "Hooded

One," though in the Middle Ages it was more widely called the Mouth of Hell. Herdis knew of three eruptions: during Bishop Gissur's time (1104), Bishop Klaeng's (1158), and her own (1206). The 1104 eruption destroyed several farms in the vicinity; the others caused only "darkness across the south" and blanketed the fields and farmhouses with ash that, luckily, was not high in toxic fluorine, as volcanic tephra can be. Late in the fourteenth century, however, an eruption destroyed the eastern part of the Skard estate, covering it with a rubble of lava chunks that remain barren and jagged.

Skalholt is fifteen miles from Skard, as the raven flies; with two rivers to cross, it's not an easy horseback ride. Thirty miles from Iceland's south coast, Skalholt lies in a wide open bowl of rippling grassy hillocks, mires, and meadows, surrounded on three sides by distant snowcapped peaks, Hekla being the most prominent. The glacial river Hvita takes a wide bend at the southern edge of the Skalholt fields, where it meets the Laxa, or Salmon River. To the west, a third river converges with these two, narrowing the grasslands into a long tongue. In winter, these rivers, iced over, became the main roads. In summer, they were the main obstacles. But somehow, Icelanders made it to Skalholt in all seasons: The bishop's see was the de facto capital of Iceland for seven hundred years. Besides the bishop's quarters, there was a school and scriptorium, a smithy, kitchens, barns, a collection of workshops, and the largest wooden cathedral in the North, Bishop Klaeng's 160-foot-long basilica.

Skalholt Cathedral sat on the highest hilltop, where the wind was fierce and unceasing. In Pall's day, a stone-paved tunnel, reopened in the 1950s, connected it to the school and the other main buildings. A drawing from 1772, the earliest we have, shows a cluster of grass-roofed houses rising beside the church; a lower row of doors opens directly into the hillside. Scattered through the pastures were copses of woods—the name Skalholt may mean "great house on the wooded hill." It is a good place to raise cattle; in a seventeenth-century land register, Skalholt owned three thousand head. Horses and sheep were also raised in Pall's time, and probably a few fields were plowed and sown: Archaeologists have found signs that barley grew there at the time of the settlement. Due to Iceland's harsh climate, only rare spots on the island are suited to growing any grain at all, and Skalholt was apparently one. Nearby

streams were full of fish, and hot springs provided unlimited boiling water for washing, bathing, and cooking. Inland, the bishop had rights to cut firewood and collect bog iron; on the coast, his people gathered driftwood, butchered beached whales, and controlled an ocean harbor as well as the harbors on the nearby Westman Islands, from where fish, seabirds, birds' eggs, and ciderdown were harvested.

To manage all this—and the family farm at Skard as well—took a masterful planner. Yet on top of it, Herdis also kept track of the bishop's yearly income from the tithe. One quarter of 1 percent of the value of every farm in three fourths of all Iceland—3,120 farms, by one count—poured into Skalholt, paid in such things as butter, cheese, mutton, beef, fish, flour, salt, or homespun wool cloth. With this and the produce of the estate itself, Herdis bartered for what both church and household needed from abroad: wax for candles, wine and wheat for communion, timber for boats and buildings, pine tar for preserving the wood, linen and other fine cloth, iron tools, vessels of soapstone or pottery, additional barley and hops for beer, and honey for mead, not to mention the precious walrus ivory, jewels, glass, silver, gold, and other metals required to create the artworks Bishop Pall commissioned to beautify the cathedral and to give as gifts.

One day soon after Easter in 1207, Herdis, then in her late forties, went to Skard to check on the farm there. With her went her son Ketil and daughter Halla, leaving Loft and his sister Thora at Skalholt. While Herdis was there, the glacial river flooded. The ford across the Thjorsa became impassable. Determined to return to Skalholt on the day arranged, Herdis hired a ferry. Ketil, then sixteen, and a priest named Bjorn crossed first, carrying over the riding gear and leading the horses, which were forced to swim behind the boat. One horse—Herdis's own—broke free of its rein and was swept downriver. Herdis did not respect the omen.

On the second trip, the wind gusted up. The ferry hit a shoal and flipped, spilling Herdis, her daughter Halla, and her niece Gudrun as well as the deacon who oversaw Skard, and a man named Sigfus into the icy, turbulent water. Sigfus made it to land, exhausted. The others, while the priest and the boy watched, helpless, drowned. The women,

especially, had no chance, weighed down as they were by their heavy wool gowns and cloaks, against a current strong enough to overcome a horse. "When the news came to Bishop Pall's ears, suddenly, in the middle of the night," his son Loft wrote, "it seemed to everyone that God had nearly given him more than he could bear. He could not eat, he could not sleep, until the bodies were buried, though he tried to cheer up everyone else as much as he could."

The pathos of this description—"in the middle of the night . . . he tried to cheer up everyone else"—are, above all, what indicate Loft as author of the saga. Loft was for many years close to the saga master Snorri Sturluson, who encouraged everyone around him to write. Snorri's nephew Sturla characterizes Loft in the contemporary *Sturlunga Saga* as a storyteller, if a bit of a gossip: "At Skard in the west lived Loft, the son of Bishop Pall, the most handsome of men. People expected him to become a great chieftain, though Ketil, the bishop's younger son, was the more popular of the two. Thorvald Gissurarson said of them that the bishop's two sons behaved quite differently. Ketil wanted everything good for everybody, but Loft, he said, wanted to talk about it." Ketil died in 1215, about twenty-two. Loft lived to old age, entering a monastery late in life and dying in 1261, about seventy years old. He had not only the time and the means but a motive for writing the saga. Describing a feud between Loft and his neighbors, Sturla writes: "The men from Breidabolstad lampooned Loft in verses; they made up ditties about him to dance to and made sport of him in many other ways." Among their nasty comments were some about Bishop Pall, that bastard and uncelibate bishop. The *Saga of Bishop Pall* may be Loft's defense of his father's memory.

DRAGON IMAGINATION

As Loft describes his parents, Pall and Herdis were well matched: She excelled at creating wealth, the bishop at spending it. Pall liked nothing better than a lavish feast, with wine to drink and the finest delicacies to eat; like a chieftain of old, he sent his guests home laden with lavish gifts. He sent gifts abroad, too, to his fellow bishops in Greenland

and Norway and the Orkney Islands, to the archbishop of Trondheim, perhaps even to Norway's kings, to whom he was related. No Gregorian reformer, Pall limited the delivery of sermons to special days. He took no interest in his countrymen's morals or in who held the deed to which church. Instead, he commissioned (or wrote) music, like the *Office for Saint Thorlak,* and books, including the miracles of Saint Thorlak, the saint's *Life,* a collection of homilies, and the church chronicle called *Hungrvaka* ("Hunger-Waker"), with its charming tale of Bishop Isleif and the polar bear. And Pall beautified his church, sparing no expense. He surrounded himself with the finest artists in the land, four of whom are named in his saga: Amundi the Smith, Atli the Scribe, Thorstein the Shrine-Smith, and Margret the Adroit. This lover of fine things, Bishop Pall Jonsson, had the means, the motivation, and the taste to commission the Lewis chessmen.

Sailing to his consecration in 1194, Pall brought along "certain treasures," Loft writes, but he doesn't describe them. Returning in 1195, Loft says, Pall brought home a set of windows. They may have been of opaque, greenish glass, like the windows Bishop Jon Smyrill took to Greenland in 1189, shards of which have surfaced in an archaeological dig. Next Pall bought two beehive-shaped bells from a Norwegian merchant named Kol. Pall's bells were probably of two different sizes, to toll in harmony like the twelfth-century pair still pealing from a church near Reykjavik. One of Pall's bells is in Skalholt today, returned to the church in a roundabout fashion.

Pall commissioned a bell tower from Amundi the Smith, "the handiest woodworker in all Iceland," Loft writes. Pall supplied him with "four trees, which he'd imported along with the bells, each tree being twenty ells high and an ell broad"—sizeable timber, though probably not all that was required. An Icelandic ell at that time was the length of one's arm from the elbow to the tip of the middle finger. Since that measure varied considerably, a law from Pall's day (and said to be his idea) fixed the ell at eighteen inches and required all cloth merchants to use a double-ell stick, what we would call a yardstick. All told Pall spent, brags his son, more than 480 "hundreds" on Amundi's bell tower. That was more than most men were worth: You could buy a farm for eighty hundreds. Each "hundred" was the value of one hundred ells (fifty yards) of

wool cloth. Weaving enough cloth to pay for Amundi's bell tower would take Herdis or her best weaver twenty-two weeks of full-time work, if the thread was already spun and the loom strung.

This extravagant price might not have included Amundi's labor: He seems to have been a respected member of Bishop Pall's household, not an itinerant tradesman. He was important enough for his death—and his occupation, "smith"—to be recorded in the Icelandic annals, alongside the passing of kings and bishops. Loft names him "a wise man" and calls on him to witness the truth of the *Saga of Bishop Pall*. Amundi was also the poet who composed Bishop Pall's eulogy.

In general, we know little about the status of woodworkers or other smiths throughout Europe in Amundi's day; craft guilds aren't mentioned in medieval texts until the 1260s. In Viking times, hammers and tongs were placed in many male graves—implying that most men could do a little smithing. The two spectacular tenth-century tool chests that have been unearthed, however, must have belonged to professional craftsmen. A grave on the farm of Bygland, in a remote Norwegian valley, held twenty-five tools, ranging from a blacksmith's heavy tongs and sledgehammers to a goldsmith's fine jewelry-making tools. A chest found at Mastermyr on the Swedish island of Gotland contained 150 tools: adzes, anvils, axes, bores, a chisel, drills, files, a gouge, hammers, knives, saws, scissors, a stamp punch, tongs, and a whetstone. This smith could have worked in iron and wood; gold, silver, copper, and tin; antler, bone, and ivory.

The Mastermyr smith is thought to have traveled about, lugging his tool chest along, taking on work here and there. The Bygland smith, in contrast, lived in an area rich in bog iron and seems to have specialized in weaponry—along with his tools, he was buried with seven axes, four swords, four spearheads, and two shield bosses, all of which he presumably made. How did he sell them? Did his customers seek out his mountain fastness?

Kings established towns, one theory goes, to lure such craftsmen out of the woods and off the roads—and to control their output. Following an influential 1980 study on the combs found in early Lund, archaeologists have imagined that comb making—and, by extension, other crafts—evolved in four steps: First, all combs were homemade. Then

good comb makers began traveling about, peddling their wares. Third, combs were commissioned. Fourth, combs were standardized and made for market by artisans based in towns.

It's a tidy model, but what is the evidence that combs were ever homemade? To make something as simple as a comb from a deer antler, argued an archaeologist in 2002, takes many steps. Outlining them, he found comb making to be "extraordinarily meticulous," calling for special tools, talent, and knowledge. Meanwhile, the other three stages of the model—peddling, commissions, and urban workshops—now look to be intermingled. Craftsmen could thrive in many environments. Excavating in towns like Hedeby (established in the ninth century), Dublin (in the tenth), or Trondheim (in the eleventh), archaeologists do find groups of identical combs or brooches. Urban artists were indeed mass-producing goods for unknown buyers. Yet these craftsmen don't seem to spend all year in town but to come and go, while in rural areas, "new places with traces of specialized crafts have turned up on average every second year," noted another archaeologist in 2008. The new sites are hard to categorize, but all are connected to people of wealth and standing. Not only kings, but chieftains, it seems, had smiths living on their estates. Though, again, these artists seem to come and go.

According to the Icelandic sagas, some artists were themselves chieftains. Being deft with one's hands was still a sign of prestige in the late twelfth and early thirteenth centuries, not the mark of low status it would later become. The Icelandic chieftain who took the walrus tusks to Canterbury in about 1205 is described in *Hrafn's Saga* as a poet, a lawyer, a medical doctor, and a learned man who attended Latin school long enough to earn his tonsure, well spoken, with a good memory, and wise in all things. He is also "a Volund of a smith" in both iron and wood, a reference to the elvish jeweler and swordsmith said, in *The Lay of Volund*, to be married to the valkyrie Hervor.

This and others of the Eddic poems, found in an Icelandic manuscript dated about 1275 but generally considered much older, provide another clue to where artists fit in Northern society: The poets imagine them as dwarfs or elves; not mere humans but magical beings with whom you meddle at your peril. *The Lay of Volund*, for example,

explores both the power and the powerlessness of the artist. Volund the Elf is taken captive by a greedy king who schemes to keep the smith's art all to himself: He severs Volund's hamstrings so he cannot leave. Outraged, the crippled smith takes terrible revenge: He kills the king's sons and makes exquisite jeweled cups from their skulls. Then he fashions himself bird's wings and escapes. The moral of the story is that kings need artists more than artists need kings. Without artists, kings and other great men would have no beautiful objects through which to proclaim their status.

The church, too, relied on artists to establish its standing. At the same time as Amundi was building Bishop Pall a bell tower, woodworkers across Norway were erecting tall, pagoda-like churches with an "abundance of roofs and turrets" and splendid dragon-themed carvings. These stave churches had first become popular in the early eleventh century. By the twelfth, however, the bases of their walls had rotted, and they had to be torn down and replaced. The new architectural design incorporated ground sills that kept the damp out of the ends of the wall staves. All of the thirty-one extant medieval stave churches are of this twelfth-century type. No one knows how much of the decorative carvings on their posts and doors are "original," either reused or copied. Only a few stave churches—or parts of churches—can be dated more precisely by inscriptions carved in runes. One says, "In the summer when Earl Erling fell at Nidaros, the brothers Erling and Audun let [timber] be felled for this church." Earl Erling Skew-Neck, whom we met in chapter 2, was killed in 1179.

One hundred twenty-six portals from about eighty stave churches have been preserved. They are a riot of entangled vines and leaves, dragons, lions, humans, and heads, some of which spew vines out of their mouths. Some of the motifs are quite old, such as the sinuous "beast chain" on the Urnes church, which gives its name to a phase of Viking art. These Urnes beasts biting each other are found on silver brooches and runestones as well as on church doorways throughout Scandinavia and the British Isles. Datable by coin hoards or inscriptions, the Urnes style began about 1040 and persisted through the twelfth century. Other motifs on these portals, particularly the plant motifs, are so new as to

"belong to another world," exclaims Erla Bergendahl Hohler, an expert on stave-church sculpture: It's the world of the stone cathedrals of Romanesque Europe.

"Any scholar's view on how a particular work of art has been created depends of course on what he already assumes about the artist, his milieu, and the working methods of the time," Hohler noted in 1999. Nineteenth-century scholars, she continued, thought stave churches were the work of ordinary people who merely "gave vent to their 'dragon imagination.'" Now we believe the carvings were done by traveling specialists. Forty-six of the remaining portals carry the same basic design, with two paired dragons attacking a third, which is carved spreadeagled, head downward, centered over the doorway. These very similar portals are scattered about Norway, not centered on any one town or bishopric. Two technicalities suggest the artists carved them on site, using whatever wood was at hand: The two planks of the door jambs often don't exactly match in width, and the wood usually has shrunk after the carvings were finished.

These traveling twelfth-century portal carvers challenge the assumption, once again, that medieval artists flourished only in towns. We know the names of three of them. Two neighboring churches bear the runic inscription "Torolf made me," though a look at the two churches makes us wonder if it's the same Torolf: One church is well made, the other crude. "Eyvind" signed a third church portal; "Eindride Gentlefinger" left his evocative signature on a fourth. None of these men is mentioned in any historical document.

Two texts do give us a glimpse into a twelfth-century artist's life. *On Divers Arts*, written in northern Germany around 1126 under the pen name Theophilus, contains forty chapters of instruction on painting, thirty-one on glassmaking, and over a hundred on jewelry and metalworking; two short chapters give tips for working with ivory and bone, including how to dye ivory red. Theophilus is thought to be a monk named Roger, who lived in the abbey of Helmarhausen in northern Germany. This Roger of Helmarhausen is otherwise known from a charter that ascribes to him a portable altar, made for Bishop Henry of Paderborn, which still survives in the church there.

On Divers Arts was clearly written by a practicing smith—one who had weathered numerous disasters. "Only a person who had actually cast a bell," notes its modern translator, "could give his detailed instructions for every stage of the work: as for example, that when the mold is being filled one should lie down near it and determine what is happening by the noise inside, instantly checking everything 'if you hear a slight murmur as of thunder.'" Theophilus also warns against working with gold leaf near a draft or using quicksilver (liquid mercury) on an empty stomach.

More than just a handbook, though, *On Divers Arts* is a well-structured narrative expressing Roger's theory of art. To him, spiritual growth and technical mastery go hand in hand; the process of making art is the practice of virtue. In this, Roger agrees with Hugh, master of the abbey of Saint Victor in Paris, who in his 1125 philosophy of education, the *Didascalion*, saw the "mechanical arts" as "aiding the pursuit of divine wisdom." Such a philosophy meshes well with Bishop Pall's love of beauty and explains his extravagant spending on the church at Skalholt.

THE KNIGHT OF THE LION

Amundi's wood carvings for the bell tower at Skalholt were the most beautiful in the land, says the *Saga of Bishop Pall*. We can imagine what they looked like—entwined with Romanesque vines and replete with dragons—for stave churches were built throughout Iceland, as well as in Norway, in the twelfth century. None has survived. Iceland's National Museum owns about twenty posts, panels, chairs, and one door from medieval times. They vary in quality and in state of preservation. But they demonstrate that, even in a country with no tall trees, wood carving was an established craft.

The door from the Valthjofsstad church is the most famous single object in the museum. Made of imported pine, it stands about six feet tall, though originally it may have been a third taller, with three pictorial roundels instead of the current two. The lower circle contains a nest of four identical winged dragons biting their tails. This sort of serpent

knot had long been a specialty of Viking design. Though winged drag-
ons are new, dragons—as symbols of chaos and change—are the domi-
nant animals in Viking art. Similar knots of biting beasts can be seen,
for example, on the Viking ship and the carved wooden objects buried
with it at Oseberg in Norway in about 834.

The upper roundel of the door is more staid, less Viking in influ-
ence and more Romanesque. The story it depicts, strangely, is one of the
tales of King Arthur. In one half of the circle, a questing knight slays a
dragon to free a lion. In the other half, the grateful lion first follows the
knight, then curls in mourning on his gravestone, upon which is written
in runes, "Behold the mighty king buried here who slew this dragon."

The runes, like the serpent knot, link the door to Viking Age art.
The knight's saddle and helmet are also antique, looking like those em-
broidered on the eleventh-century Bayeux Tapestry. His kite-shaped
shield, however, was introduced in about 1150, and the world through
which he rides is purely Romanesque, an international style of art dis-
tinctive for its looping vines and fleshy foliage, its lions, and, above all,
its winged dragons. The door's theme also dates it to the late 1100s. The
most famous version of the tale is Chretien de Troyes's *Yvain, the Knight
of the Lion*, written in French verse about 1170, but the story was popular
in Iceland too. While the Icelandic prose *Ivens Saga* dates from the reign
of King Hakon the Old (1217–1263), faithful lions crop up in six other
Icelandic Knights' Tales, some of which may date to the twelfth century.

The symbolism of the design is made plain in a Latin bestiary writ-
ten under the pen name Physiologus. This *Book of Beasts* was extremely
popular in England in the twelfth and thirteenth centuries, appearing
in forty manuscript copies. Two translations into Icelandic were made
in the late 1100s; though only scraps are left, these are Iceland's ear-
liest illustrated books. According to Physiologus (who apparently had
little knowledge of real lions), the king of beasts is a symbol for Christ:
"When a lioness gives birth to her cubs, she brings them forth dead and
lays them up lifeless for three days—until their father, coming on them
on the third day, breathes in their faces and makes them alive. Just so did
the Father Omnipotent raise Our Lord Jesus Christ from the dead on the
third day." Likewise, the dragon is the devil: "He is often borne into the

air from his den, and the air round him blazes, for the Devil in raising himself from the lower regions translates himself into an angel of light and misleads the foolish with false hopes of glory."

The Contemporary Sagas offer clues to the age of the door and the identity of its artist. *Hrafn's Saga* mentions a twelfth-century man named Markus who went to Norway, had timber cut, and brought it to eastern Iceland, where he built a church for the chieftain at Valthjofsstad. Some years later, Markus returned to Norway, bought more timber, and built a second church in the West. Markus died in 1196. Could he have carved this famous door?

Perhaps, but the person most frequently linked to it is Randalin, the housewife at Valthjofsstad and the granddaughter of Bishop Pall's brother, Saemund Jonsson. Randalin is mentioned in the contemporary *Sturlunga Saga;* she married in about 1250. She is arguably the model for a character in the classic *Njal's Saga,* set around the year 1000 but written around 1270, some say by Randalin's brother-in-law. This character, Hildigunn, is a famous "whetter" who egged her men on to bloody revenge. She is also said to be "so deft with her hands that there were few women who were more adroit"—a description that some readers think pertains to needlework and others to wood carving. When the same word *hagur,* or "adroit," describes the artist Margret, who worked for Bishop Pall, it's clearly linked to ivory carving. In Hildigunn's case we can only say that the saga does show an unusual interest in wood carvings. One it describes—not owned by Hildigunn—depicts a hero killing a winged dragon just like on the Valthjofsstad church door.

If Randalin of Valthjofsstad did carve the door, she may not have meant it for the church, which burned down in 1361. Travelers in the 1760s noted a great hall at Valthjofsstad "remarkable for its decorative carvings," though, strangely, the door was plain and next door was a church with a fabulous door. A carved door thought to be this one was on the church as early as 1641, according to the bishop's records, and was taken from it in 1851 by the Royal Museum for Northern Antiquities in Copenhagen (in exchange for a new, plain door and two candlesticks). The Valthjofsstad door was repatriated to Iceland, with great ceremony, in 1930.

THE SAINT'S SHRINE

Bishop Pall made the base of Amundi's bell tower into a chapel dedicated to his uncle, Saint Thorlak. He commissioned a man named Atli to paint murals on its ceiling and gable walls, as was common in twelfth-century churches. Most often these were biblical scenes set against a dark-blue background—but not always. Sometimes they illustrated famous battles. In the *Saga of Bishop Pall*, Loft identifies Atli as a "scribe"; he probably worked in Skalholt's scriptorium, painting the beautiful illuminated initials in sacred books, many of which Pall ordered made for the 220 churches in his diocese. Atli may have used the same patterns for both the murals and the miniatures: Among the Icelandic manuscripts remaining from the 1300s is a Romanesque painter's sketchbook, in which many of the details—of dress and armor and expression, knotwork, leaves, lions, and dragons—recall the designs of the Lewis chessmen. It is the only medieval sketchbook known from the North.

The lower walls of Pall's chapel were decorated with tapestries. Embroidery, as well as weaving, was wholly a woman's task in medieval Iceland, but Loft does not record the names of the women who made these wall hangings. Nor does he describe what they depicted, though one Icelandic church of the era had tapestries illustrating the life of Charlemagne.

To display Saint Thorlak's relics in the chapel, Pall commissioned an extravagant shrine or reliquary from a goldsmith named Thorstein, who was "the most skillful metalworker at the time." Pall made sure Thorstein lacked nothing, Loft says: He "paid out an immense amount of money in gold and jewels, as well as pure silver. . . . This work of art was so well made that it exceeded in beauty and in size all other reliquaries then in Iceland, being better than four and a half feet long, while no other shrine in Iceland at the time was longer than eighteen inches." Loft saw the shrine as a measure of Bishop Pall's glory, not Saint Thorlak's: "No wise man would wonder, if he saw this shrine, what a great man he was, who had this treasure made."

According to medieval church inventories, there were once over a hundred reliquaries in Iceland. Two still exist, little house-shaped wooden boxes, about twelve inches square, stripped of their gilding and

precious stones. Four similar ones are found in Norway, and two in Sweden. All were likely modeled on the shrine of Saint Olaf in Trondheim, which Snorri Sturluson saw in 1219. He described it in *Heimskringla* as "decorated with gold and silver and set with precious stones." It was "like a coffin, both in its great size and its shape, with an archway underneath and on top a lid shaped like a roof with heads on the gable ends." It weighed at least two hundred pounds. To carry it in procession around the streets of the city (with the archbishop also standing on the platform) took a team of sixty men.

Saint Olaf's shrine is thought to have been commissioned by King Magnus Erlingsson, Bishop Pall's kinsman, in about 1175. During the Reformation, it was stripped of its ornaments, which were melted down and sold. Still extant is an eighteenth-century copy of the Royal Treasurer's receipt for 95 kilograms of silver from the shrine, along with "170 crystal stones, small and large, mounted with silver, weighing altogether 10.9 kilograms. Also, another 11 crystal stones that fell off the shrine when it was broken up. Also a blue stone, fitted in gold . . . weighing 65 grams. Also another small piece of gold, hanging on the shrine, weighing 9 grams." One crystal stone still exists, now in the storeroom of the Museum of Sciences in Trondheim; it was found in the castle where the shrine was hidden before being broken up.

Of Saint Thorlak's shrine, we have not even one crystal stone. It's unclear if it survived the fire that destroyed the cathedral of Skalholt in 1309; church records say two women risked their lives to rescue a reliquary during the fire of 1527, but it may have been a smaller shrine encasing the saint's hand. Saint Thorlak's shrine did not, in any event, survive the Reformation. "If the shrine still existed in all its glory," wrote archaeologist Kristjan Eldjarn, who excavated Skalholt in the 1950s, "it would most likely be the most beautiful witness to the artistic productivity that bloomed around Bishop Pall, and at the same time a frank reproof to the tenacious belief among Scandinavian scholars that mature arts and crafts did not prosper in the Middle Ages in Iceland or the other islands in the western seas."

Thorstein, who made the shrine, is mentioned in three other sagas as a smith or goldsmith. He came from the north of Iceland, where he was discovered by his first wealthy patron, the chieftain Gudmund the

Worthy. According to a Contemporary Saga, "That autumn, Gudmund went out into Svarfadar valley. A man named Thorstein, Skeggi's son, lived there. He was a shrine-smith and more skillful with his hands than any other man. He took in a lot of money in a short time, but he lost it just as quickly, so that he had food and clothing and not much else." Gudmund took Thorstein under his wing, moving him to a new farm and finding him a wife who would manage it for him.

From Gudmund, the smith and his family passed into the household of his second wealthy patron, Bishop Pall. Some years after he made the shrine, Thorstein worked with Margret the Adroit on an altarpiece decorated with gold, silver, and ivory. Before it was finished, however, Bishop Pall died. He was fifty-six years old.

THE SARCOPHAGUS

It was customary for bishops to plan their own funerals. Bishop Hugh of Lincoln, who died in 1200, left instructions on who should wash his body and how it should be dressed. The priests should carry his corpse to church on a bier, preceded by a cross. They should light candles, burn incense, and "toll the bells of my church and open wide its doors and its inner sanctuary with solemn chants," then place the bier beneath the altar, covered "with a rich pall, and with lights and torches go round the body." Afterward it was to be laid in the lead-lined stone coffin Bishop Hugh had commissioned—and which apparently was not yet in place, for his instructions describe the exact spot in the cathedral where he wished it to rest.

The Icelandic ceremony is described less fully, if more magically, in the *Saga of Saint Jon*. The body of the bishop of Holar, who died in 1121, was dressed in all his episcopal regalia and laid before the altar. His priests and clerks sang the *Requiem*, but when they went to carry the bier to the gravesite, they could not lift it. Puzzled, they stared at the body until one of the clerks noticed they had forgotten to place the bishop's gold ring on his finger. Once this error was corrected, the body grew light enough to lift and the burial could proceed.

Like the bishop of Holar, Pall would have been buried in full episcopal regalia. Like the bishop of Lincoln, Pall planned his own funeral. He

wanted to be laid to rest in the bell tower's chapel, and he commissioned for that purpose a stone sarcophagus; the carver's name is not recorded.

Bishop Pall's sarcophagus is the only one mentioned in Icelandic records. The country has no tradition of stone sculpture—the ubiquitous black basalt rock is brittle and not easily shaped. Rock walls are either lacy extravagances of dry-stone construction or sutured together with layers of turf. The first stone church was not built until the eighteenth century. Even Icelanders did not believe the saga account of Bishop Pall's sarcophagus—until they found it.

After the Reformation, Skalholt's importance plummeted. Throughout the Middle Ages, Skalholt had been the closest thing Iceland had to a town. The current capital city, Reykjavik, was merely a small farm. Yet in 1789, an English visitor could describe Skalholt as "twelve or fifteen houses, or rather hovels." When the (by then Lutheran) bishop was transferred to Reykjavik, "which will happen as soon as the church there is finished," the Englishman wrote, Skalholt "will be a place of no importance at all." His prophecy came true. Reykjavik, however, grew; today it and its suburbs hold two-thirds of the country's population of 320,000. Because of this accident of history, the construction of modern sewer lines, housing complexes, and library additions in Reykjavik have not uncovered signs of medieval workshops—as they have in Lund (population 110,000) and Trondheim (172,000), both continuously inhabited since the tenth century.

In the mid-1900s, around the time Iceland declared its independence from Denmark, an association formed to resurrect Skalholt. Its members raised money to build a new concrete church on the same hill where churches had always stood. Some far thinkers in the group commissioned an excavation first; it took place from 1954 to 1958. "From the beginning of our researches," wrote archaeologist Kristjan Eldjarn, "the well-known words from the *Saga of Bishop Pall* were in the back of our minds." It was late in the season, and they were at the level of the huge cross-shaped medieval basilica, whose floor plan Bishop Klaeng had first set out in 1152 and which had been rebuilt, after being damaged by fires, several times. On a day when the chief archaeologists were all away, one of the workers digging in the southern arm of the cross struck stone. "Of all the things that came to light during the excavations at Skalholt," said

Eldjarn, "the grave of Pall Jonsson is the most important and meaning-ful. It is not certain that another such sign and wonder of the Icelandic sagas could ever be unearthed."

Carved out of one large stone, of the soft reddish volcanic tuff found on the hill across the river from Skalholt, Bishop Pall's sar-cophagus is simple and elegant, its rounded lines ornamented only by two cylindrical knobs projecting from the broader end. The lid has been cracked by fire, perhaps by the inferno of 1309, but otherwise the coffin shows little damage. On the day in 1954 when the lid was first lifted, government ministers, academics, clergymen, and the press gathered on the hillside. The archaeologists gave some words of intro-duction, a priest sang *Te Deum*—and then the heavens opened and the rain drummed down. It was something the participants—and those watching later, on television—never forgot, for the same thing had happened, according to the *Saga of Bishop Pall*, when Pall was first buried: The heavens wept.

Resting on the right shoulder of the skeleton was the crook of a bishop's crozier carved from walrus ivory. No gold ring was found on Pall's finger, or signs of any other episcopal regalia, except for one silver thread. Yet heaped over his feet, strangely, was a pile of burned bones mixed with droplets of lead and glass—possibly the remains of stained glass windows and the bones of other dignitaries who had been laid to rest in wooden shrines in the chapel at the base of the bell tower. When the church burned in 1309, Pall's sarcophagus might have been the only coffin to survive, and the other holy remains were swept into it before it was protected further by being sunk beneath the floor of the rebuilt church—for stone tombs were not meant to be buried, as Pall would have known from his visits to cathedrals abroad. His sarcophagus should not have been where they found it in 1954 but sitting, visible, on the floor of the bell tower.

In 2012, any question that the skeleton was not that of Pall Jonsson was put to rest by carbon dating, which dated a bone sample to between 1165 and 1220. The researchers, who were engaged in a multinational study of Viking and medieval nutrition, did not analyze and date Pall's ivory crozier. They were only interested in human remains.

THE CROZIER

Margret the Adroit would have remained a colorful detail in a little-read saga if the Icelanders had not decided to build that new, modern church at Skalholt—and called first for an archaeological excavation. The existence of Pall's sarcophagus vouches for the overall truth of the *Saga of Bishop Pall*. The ivory crozier found inside it calls to mind the one Margret carved out of walrus tusk, the saga says, "so skillfully that no one in Iceland had seen such artistry before." The crozier described no longer exists, so far as we know: Pall commissioned it for Thorir, who became archbishop of Trondheim in 1205, and supposedly sent it to him in Norway. But many experts attribute the crozier discovered in Bishop Pall's sarcophagus to Margret.

Some attribute a second twelfth-century crozier, now in the Danish National Museum in Copenhagen, to Margret as well. This crozier was discovered in 1926 in the grave of a bishop in Greenland. Based in part on the crozier's Romanesque design, the archaeologist identified the skeleton as Bishop Jon Smyrill, who spent the winter of 1203 with Bishop Pall at Skalholt and taught him to make communion wine from crowberries, following a recipe from King Sverrir of Norway. Jon Smyrill is also given credit for building Gardar Cathedral, an impressive hundred-foot-long basilica made of red sandstone with soapstone trim and green glass windows—quite different from the Greenlanders' usual wood-and-turf construction. When he left Skalholt in the spring, heading for Rome, says the *Saga of Bishop Pall*, Jon Smyrill was seen off "magnificently, both in valuable gifts and other honors." This phrase has been interpreted to mean that Jon was given a crozier made by Margret the Adroit. If so, he must have passed it down to a successor; Jon died in Greenland in 1209, but the skeleton with which the crozier was buried has recently been carbon dated to between 1223 and 1290.

The connection between Margret and these two ivory croziers may be tenuous, but we often attribute medieval works to artists on evidence no better than this. Take the supposed author of *On Divers Arts*, the German monk Roger of Helmarhausen. The charter calling him a monk and an artist is a thirteenth-century copy of the twelfth-century original. The

charter records the purchase of a gold cross and a *scrinium,* or shrine, dedicated to Saints Kilian and Liborius, which "the monk Roger" had made. The buyer was Bishop Henry of Paderborn. (The price? A parish church.) An object now in Paderborn carries images of these two saints and is inscribed with Bishop Henry's name. Though experts consider it a "portable altar," they agree it must be the "shrine" of the charter. Similarities in "style, structure, fabrication, or ornament" to the portable altar have led art historians to credit Roger with other artworks found across northern Germany and into Belgium, including a second altar, a jeweled cross, a crucifix, an engraved cross, a book cover, and one (but only one) illuminated initial in a large Bible. Roger now has "a body of work, a career trajectory, and a circle of followers" derived wholly from this one short mention in a thirteenth-century manuscript. Finally, he is credited with the practical handbook *On Divers Arts* because one manuscript of it, now in Vienna and dated about 1150, identifies its author as "Roger." Admits a scholar who compared the manuscripts, "The idea that the name Roger in the Vienna manuscript might refer to the artist Roger of Helmarhausen has been largely based on happy coincidence."

Another example is the walrus-ivory cross that now "forms the centerpiece of the Cloisters treasury" in the Metropolitan Museum of Art in New York. Experts call it a "never-ending visual delight"; they agree on little else about it. Stylistically, they date it from 1050 to 1200. An effort to carbon date two samples from the cross in 1989 came up with "startling" dates of 676 and 694. (The use of carbon-14 to accurately date objects made of walrus ivory or the bones and teeth of other sea creatures has since been revolutionized by the research on Norse Greenland; these dates for the cross are probably not correctly calibrated.) Despite this uncertainty, some experts attribute the Cloisters cross to the English Abbey of Bury Saint Edmunds and its Master Hugo, based on "the quality of its execution" and its similarity to illuminations in a famous Bible. Master Hugo himself is known only from documents dated after 1300. According to these, he is said to have made a bell in about 1125; five years later, two huge church doors, cast in bronze, were "sculpted by the fingers of Master Hugo, who as in other works he surpassed all others, in this magnificent work he surpassed himself." Neither of these works remains. In the early 1150s, a cross was "incomparably carved by

the hands of Master Hugo," the medieval text says. These "scant words," note the authors of a recent monograph, "do not confirm the Cloisters Cross as the one described. The size is not specified, nor is the medium; but the range of material that can be 'carved' includes ivory," they add, a bit wistfully.

Art history is a more intuitive discipline than archaeology. Science plays a part, but it's not privileged. Current methods of carbon dating could tell us if the croziers found in Iceland and Greenland are the right age to be Pall's or Jon's. (So far, only the skeletons have been tested.) Isotope analysis could tell us if the ivory came from Greenland walruses. (Though no one doubts it.) But no known scientific technique can tell us that the croziers were carved by Margret the Adroit.

If Margret did make them, what do these two works of art tell us about the Lewis chessmen? Are there similarities in "style, structure, fabrication, or ornament"?

The crook of the Greenland crozier—the wooden staff having rotted away—is made of walrus ivory, darkened to a warm, ruddy color, and measures about five and a half inches long. Its design is a graceful vine ending in four large curling leaves that resemble—but are not identical to—the larger leaves on the Valthjofsstad church door and the much tinier ones on the backs of the thrones of the Lewis kings, queens, and bishops. Stylistically, they are Romanesque; a date of 1200 fits.

The staff of Bishop Pall's crozier had also rotted away, but its iron point remained in the sarcophagus. Based on the placement of crook and point, relative to the skeleton, the crozier was four and a half feet long. Pressed into the iron cup was evidence the wood was ash, an inch in diameter. Ash does not grow in Iceland: The wood must have been imported.

The honey-colored walrus-ivory crook, now displayed in the National Museum of Iceland in Reykjavik, is just under five inches tall. Chipped in places and splintered at its base, it is shaped as a slender, long-necked dragon coiling its head back to bite at a tiny animal. The dragon's round ears curl forward, its eyes are teardrops, its snout wrinkles in a snarl, its great front fangs pierce the tiny animal, which writhes, head thrown over its back, mouth wide, forelimbs crouched in an effort to escape.

It's a vigorous, violent scene—and a surprisingly common motif for bishops' croziers in the Romanesque era. A bishop carved on the Urnes stave church in Norway holds a crozier with exactly this snapping-jawed serpent. Similar dragons cap the croziers associated with Saint Bernard, now in the British Museum, and Saint Gregory, in Rome. The dragon, as on the Valthjofsstad church door, stands for the devil. The tiny animal being menaced is usually a ram, often bearing a cross—a mature version of the *Agnus Dei*, Lamb of God. Some croziers also include a little lion cub, a reference, as *The Book of Beasts* explained, to the resurrection of Christ.

The tiny animal being attacked on Bishop Pall's crozier has no curling ram's horns and bears no cross, leading some observers to label it a lion cub and to see the long-necked biting animal not as a dragon but as a lioness breathing life into her young. The back end of the tiny animal is too worn to see if it has a lionlike tail or a lambish one. More animals, however, inhabit a protruding band just above the missing wooden shaft. This carving, too, is terribly decayed. But the one tiny animal that can be clearly seen is a duplicate of the animal in the dragon's jaws—and here it has a long lion's tail.

The story of Bishop Pall's crozier, then, matches the story of the Valthjofsstad church door: The dragon-devil is attacking the lion-Christ. (The character missing from the crozier—the knight who saves the lion—would be the bishop himself.) The popularity of "The Knight of the Lion" during Margret's lifetime may have inspired her to carve the little lion as the dragon's prey in place of the traditional *Agnus Dei* ram. Yet in close-up, her dragon is more appealing than threatening— the word that comes to mind is cute. The overall composition of the crozier has an oddly whimsical feel, not unlike the berserks or the knights' shaggy ponies in the Lewis chess sets.

MARGRET THE ADROIT

All we know about Margret the Adroit comes from the *Saga of Bishop Pall*—she is mentioned in no other source—and Loft says excruciatingly little about her. We learn that she lived at Skalholt as the wife of

an important priest. Her high status excused her from the day-to-day drudgery of an ordinary farm woman—milking and cheese making, spinning and weaving—but she likely had some managerial role, especially after the death of Pall's wife, Herdis, when the official role of housekeeper was taken up by Pall's fourteen-year-old daughter, Thora. Upon Pall's own death in 1211, Margret and her husband took complete charge of Skalholt for five years, until the new bishop was named in 1216.

Along with croziers and altarpieces, Margret may have carved practical things: spoons, combs, weaving tools. She may have had a fine hand at embroidery or tablet weaving—we'll never know. Loft is not interested in Margret the Adroit. What he wants to talk about is his father's—and his own—importance. Loft, it seems, acted as his father's emissary, bringing gifts to the bishop of Orkney and the king of Norway, and it is within this context of reciprocal gift exchange that he remembers Margret. His association of her skill in ivory work with Pall's propensity to send "precious things" as "gifts to his friends abroad" is our best clue that Margret made the Lewis chessmen. This short passage has not been published before in English; it reads in its entirety:

> At that time, Loft, the son of Bishop Pall, went abroad and visited noble men in other lands—first Bishop Bjarni of Orkney, and afterward King Ingi of Norway and his brother, Earl Hakon—and received from them splendid and valuable gifts. And while the bishop sat at home, worrying about his son and waiting for news and wondering how things were going, God made him rejoice, for one summer Loft returned with a fine reputation and with the valuable gifts he had received, and could say this: that he had been honored for his father's sake wherever he traveled.
>
> During that summer the treasures that Archbishop Thorir sent to Bishop Pall arrived from Norway: a gold-embroidered miter, the equal of which had never come to Iceland before; a valuable gold finger ring; and a splendid pair of gloves. And the summer after, when Bishop Pall had resided at Skalholt sixteen winters, there came from abroad the wonderful treasures that Bishop Nikulas of Oslo sent Bishop Pall: a heavy gold finger ring set with a precious stone, worth two ounces

of silver. And he sent, as well, so much balsam that it was unlikely Bishop Pall would ever need more. There was nothing equally rare that Bishop Pall needed; it cost no less than several marks of pure silver.

It should also be said that Bishop Pall sent many gifts to his friends abroad, both gyrfalcons and other treasures. He sent Archbishop Thorir a bishop's crozier of walrus ivory, carved so skillfully that no one in Iceland had ever seen such artistry before; it was made by Margret the Adroit, who at that time was the most skilled carver in all Iceland. Both she and her husband were at Skalholt when Bishop Pall died, and Thorir the Priest, Margret's husband, took over the management of the see, but Margret made everything that Bishop Pall wanted. Bishop Pall had commissioned the making of an altarpiece before he died, and had put aside for it a lot of money, both in gold and silver, and Margret carved the walrus ivory extremely well. It is certain that it would have become the greatest treasure, if it had been made according to his design, but Thorsteinn Shrine-Smith and Margret, with their artistry, completed it afterward. There was great dismay at his death, and such things at first came to an end, but only for a moment for the sake of the others in the family. Thorsteinn was chosen to design the altarpiece.

Loft, clearly, was not much of a stylist. His memories drift and wander across the page like the recollections of an old man looking back many years. Reading between the lines, we can reconstruct his train of thought. The honor he was shown on his travels, from 1208 to 1210, took visible form. Though he doesn't describe the wonderful gifts he received from the bishop, king, and earl, they remind him of the gloves and ring and miter sent to his father in 1210—and which perhaps he himself delivered—from Archbishop Thorir of Trondheim. Next in the cascade of remembrances come the treasures sent by Bishop Nikulas of Oslo in 1211: another gold ring, this one set with a large gemstone, and a great quantity of aromatic balsam, which was blended with oil to make the consecrated chrism used in baptism, extreme unction, and other Christian rites.

"A gift demands a gift," as the old Icelandic saying goes. Loft recalls that his father "sent many gifts to his friends abroad, both gyrfalcons and other treasures." The mention of gyrfalcons hints at what those other treasures might have been made of. These large white falcons, prized as hunting birds, were one of Greenland's most valuable exports. Another key export from Greenland, of course, was walrus tusk, the raw material for the next treasure Loft mentions: the walrus-ivory crozier carved by Margret the Adroit. Perhaps Pall sent it to Thorir, who was elected archbishop in 1205, by way of the eighteen-year-old Loft in 1208. In thanks, Thorir sent back with Loft the miter, ring, and gloves.

Growing up at Skalholt, Loft knew Margret the Adroit. He watched this spectacular object being made, "so skillfully that no one in Iceland"—particularly not the young author—"had seen such artistry before." He could have told us much more about her in this jumbled account. Instead he dismisses her with the intriguing line "but Margret made everything that Bishop Pall wanted." What else did he want, besides a crozier and an altarpiece? How marvelous if Loft had written "The second [thing she carved] was a board game skillfully made of walrus ivory. . . . The board game was both for the old game with one king and the new with two." But he didn't. Those sentences come from the *Saga of Ref the Sly* and concern a fictional ivory-carver from Greenland. All they tell us is that someone in thirteenth-(or perhaps fourteenth-) century Iceland, when this saga was written, thought a walrus ivory chess set made a good gift for a king.

THE ARTIST

Did Bishop Pall ask Margret to make the Lewis chessmen? We can't say. But she certainly was capable of it. Faced with Margret's nickname, *hin Haga*, translators have tried the Skillful, Ingenious, Dexterous, Deft, and, the most common, the Adroit. As the best ivory-carver in Iceland—a land with ample supplies of walrus ivory through the Greenland trade—Margret must have been adept at using the various saws, files, rasps, chisels, bow drills, knives, gravers, scorpers, and gouges known to ivory workers ranging from Viking Age craftsmen, like the one whose tool chest was

discovered at Mastermyr, to modern-day Inuit artists. She may, in fact, have needed very few tools. One expert suggests only "a knife, an awl, perhaps a fine drill" were used to sculpt even the most elaborate medieval ivories. Another watched an Inuit artist carve walrus ivory in the 1960s with simply an adze, a rasp, and two files.

Ivory's unforgiving hardness, however, makes it a material only for a practiced hand. Margret would have trained on wood, which, like ivory, is best carved with the grain. "Cutting across the grain is difficult and unproductive—since it causes the fibers to 'pick up'—in both materials," writes an authority on medieval ivory carvings. Where did Margret learn wood carving? It's not inconceivable that she and her husband accompanied Bishop Pall to Trondheim and Lund when he went abroad to be consecrated. In 1202, when the bishop-elect of Holar sailed abroad, he took along twenty Icelanders, including at least one woman. Or Margret may have traveled in different company. The Contemporary Sagas tell of many Icelandic women who sailed abroad in the twelfth and early thirteenth centuries to visit relatives in Norway or even to make pilgrimages to the Holy Land. It's most likely, though, that she learned at home. The National Museum of Iceland's collection of Romanesque wood carvings suggests she had ample role models.

Lacking a tool chest from the twelfth century, our best clues to Margret's technique come from *On Divers Arts*. There, Theophilus describes the steps to making a chessman (or anything else) out of ivory: "First trim a piece of it to the size that you want, and then spread chalk over it. Draw the figures with lead according to your wishes, and score the outlines with a sharp tracer so that they are quite clear. Then, with various chisels, cut the grounds as deeply as you wish and according to your ability and skill carve the figures." To decorate a knife handle, Theophilus recommends the kind of designs seen on the thrones of the Lewis kings, queens, and bishops: "All around, delicately portray small flowers or animals, or birds, or dragons linked together by their necks and tails." The final step is to polish the carvings with wood ash or the silica-rich grass *Equisetum arvense*, field horsetail, which is common throughout Iceland. When Frederic Madden of the British Museum examined the chessmen in 1832, he noted that some of them were red. All trace of

coloring has since disappeared, possibly due to nineteenth-century cleaning methods, but ivory can be dyed red using madder, Theophilus notes; the same root was used in medieval Iceland to dye wool. To piece together several panels, or to apply a patch, Theophilus recommends using glue made from fish bladders. The small patch on the Lewis chess queen number 22 in the National Museum of Scotland was attached with tiny ivory pegs. Theophilus also mentions this technique, noting that it is necessary to use "pieces of the same ivory" and to secure them "with ivory pins so subtly that no one can detect" the joint.

To make chessmen, Margret would first segment her material into blocks, taking into account the curvature of the walrus tusk, its oval cross section, and any wear or flaws. One thirty-inch-long tusk, for example, could produce five chessmen: The widest piece, the knight on his horse, would come from the base of the tusk, then the king, queen, and bishop, each a bit narrower than the last, with the tip made into a rook or pawn. Sometimes two slender pieces—rooks or pawns—were carved from one section of tusk.

Chalk and lead are not easy to come by in Iceland, but Margret still may have scored the design on her ivory blocks, as Theophilus recommends, before beginning to cut. Most of her tool marks were smoothed away during the final polishing, but, flipping the chessmen upside down, curators have found signs of saws, chisels, and files on their bases. To rough out a figure, Margret began with a saw; when making a knight, for example, large blocks of ivory have to be cut away above the horse's head and tail. Next Margret picked up a knife, chisel, or gouge, tilting and scraping them across the surface to refine the shape. Opening small spaces—between a queen's wrist and her neck—called for a drill or an auger. Subtle details—hair and horse manes, the draping of gowns and robes, or the patterns on shields and crowns—required gravers and scorpers. These sharp tools come in a variety of shapes, the most common being V and U. Finally, to make the pupils of the eyes—which give the chessmen their endearing if hard-to-read expressions—Margret used a tiny circular punch.

She was careful not to cut too deeply. Unlike elephant ivory, which is the same color and consistency all the way through the tusk, walrus

ivory has that grainy, dark core that fractures so easily. At the base of the tusk, nearest the skull, or if a tusk is badly worn, the core can come quite close to the surface, leaving only a thin shell of smooth ivory. In some cases, carving into the core was unavoidable—as in the fashioning of that littlest queen, number 22, which was made from an ivory block a lesser (or less thrifty) artist might have thrown away. But in other cases, exposing the dark innards of the tusk might have been done on purpose. One observer believes the "graining" was used "to enhance the flanks of the knights' horses or to heighten the effect of folds in the vestments of some of the bishops."

THE WORKSHOP

Where some see enhancement, others find error. For David Caldwell of the National Museum of Scotland and his co-author Mark Hall of Perth Museum and Art Gallery, "The hoard clearly contains pieces varying enormously in quality." Breaking through to the grainy core was minor compared to other mistakes: One knight is marred by "a horizontal slot in the chest of the horse, possibly caused by the craftsman carelessly sawing too deeply when he was cutting the outline of the horse's head."

Other errors suggest to Caldwell and Hall that more than one carver was at work. "Two chessmen have not been properly finished," they write. One bishop's hair is "merely blocked out, not striated, to indicate strands, like the hair on every other piece"—not counting the knight whose "hair is striated on one side of his head only." That these pieces are properly polished rules out the idea they were still being worked on when lost. That they are otherwise "well-designed and executed" lead Caldwell and Hall to conclude they were "the output of a workshop under pressure to deliver," one with several workers, each assigned different tasks. In this case, the hairdresser was remiss.

Altogether, Caldwell and Hall believe the Lewis chessmen represent the work of at least four artists. They reached this conclusion after a major reexamination of the faces of the fifty-nine chessmen, published in 2009, on which they collaborated with Caroline Wilkinson of the University of Dundee. A professor of forensic art, Wilkinson is famous

for having reconstructed the heads of King Richard III, Mary Queen of Scots, and Johann Sebastian Bach, among others, based on their skulls, whether fresh out of the grave (King Richard's) or cast in bronze (Bach's) or, in Queen Mary's case, on portraits of her at different ages.

Wilkinson started with the assumption "that a craftsman regularly turning out chessmen would tend to give them the same facial features, in the same way as a modern cartoonist or a carver of holiday souvenirs." Applying a computerized grid system to photographs of the chessmen's faces, she evaluated their proportions both horizontally and vertically. Then, using magnification and measurements, she classified their eyes, mouths, and noses. She confidently sorted fifty of the fifty-nine faces into five groups, A through E. All had "round open eyes," though group B had "asymmetrical eye heights," while C, D, and E showed a crease below the eyes. A through D had down-turned mouths; D also had an overbite. The noses were most variable: They were long, straight, narrow, defined, or bulbous; they had flat bases and "inferiorly placed nostrils," or round alae ("the fleshy part of the nose surrounding the nostrils") and visible nostrils, or "an up-turned base, flat alae, and visible nostrils," or a "rounded tip," or a "shaped nasal base"—more technicalities than anyone except an artist accustomed to creating three-dimensional noses out of the hole in a skull (or, perhaps, a plastic surgeon) could think of.

The nine remaining chess pieces—the X group—"were either too damaged and indistinct or too different" to categorize. So there may have been more than five face carvers in this hypothetical ivory workshop. Add to these the workers assigned to different tasks—such as the remiss hairdresser—and the size of the workshop grows even larger. When sorted by size, the fifty-nine chessmen form two sets that are "quite tightly grouped," while sets three and four show more variation. But the four size sets and the five face groups hardly overlap. Caldwell and his colleagues conclude: "Since there are no clear divides between our putative sets this may be taken as evidence that most of the chessmen were produced in the same workshop, a largish establishment with four or more master craftsmen working on ivory chess-pieces at any one time."

Or perhaps their initial assumptions "about the artist, his milieu, and the working methods of the time" are not valid. Perhaps the Lewis chessmen were not made by a craftsman—or a large workshop full of craftsmen—"regularly turning out chessmen." Perhaps we should not think of the Lewis chessmen as standardized trade goods, like combs, but as unique artworks, like croziers. No two Lewis chessmen are, after all, alike. Perhaps they were made not quickly, "under pressure to deliver," but slowly, over a period of many years by an artist developing her craft. Perhaps she made use of bits and pieces of ivory scavenged from other commissions. Perhaps the five groups of faces reflect the faces of real people, with all their extremes of noses, whom she knew. Perhaps the faces in the X group that are "too different" were samples brought from abroad from which Margret worked—for other individual chessmen, quite like the Lewis ones, have been found in Greenland, Norway, Sweden, Ireland, England, Italy, and France. And perhaps there was more than one carver: Margret the Adroit and Thorstein the Shrine-Smith collaborated on an altarpiece, after all.

Caldwell and his colleagues strongly believe that more than one artist was involved: "The craftsman who carved the type-D pieces can be reckoned a genius," they write, "while the type-C pieces were being turned out by somebody with less ability or sense of design. This assessment comes from the pieces as a whole."

But into group C is slotted the littlest queen, number 22, the queen with the patched-together throne, the queen who, viewed with different eyes, different assumptions, is a masterpiece.

The Lewis chessmen, noted an expert on Romanesque art, "are psychologically charged to a degree unusual in twelfth-century sculpture." They show a "spontaneity and vividness of a worldly kind" missing from most art of the time. Compared to other ivories, added another, "the Lewis men are wholly naturalistic and remarkably accomplished in their execution." They are "simple but powerful." Concluded a curator at the British Museum, "The coherent and self-confident style of the Lewis chessmen is virtually without parallel. Indeed there is much uncertainty about the origins of the chessmen, both about their style and their date. This is due to a lack of comparable surviving material. There seem to be

no counterparts for the very simply draped, compact and expressive human figures with their strong and forceful faces."

Like Bishop Pall's crozier, the Lewis chessmen are whimsical and bold—and not wholly appropriate. They are the work of an artist who could capture the individuality of a face, of an emotion, of a moment in time; they are the work of an artist with a keen sense of humor and a light heart. That artist could have been Margret the Adroit, making gifts for Bishop Pall to send abroad to his friends: among whom was the king of Norway, whose piece now comes to our chessboard.

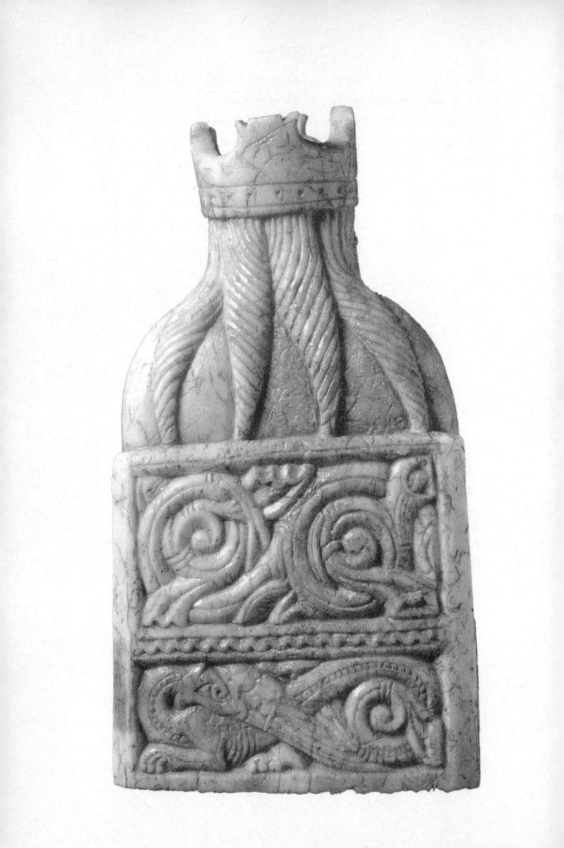

FOUR

The Kings

Of the eight Lewis kings, two are youths with no beards. All but one wears his hair twisted into four or more long locks. Like the queens, they're robed and crowned. They look glum, grumpy, severe, weary, or—the youths—eager.

Each holds a sword across his knees, as in this scene from *Egil's Saga*, after the death in battle of Egil's brother: "Egil sat down and stuck his shield in front of his feet. He had his helmet on his head and lay his sword across his knees, and now and then he drew it halfway out of its scabbard, then slammed it in again. . . . King Athelstan sat on his throne. He also lay his sword across his knees, and the two of them sat that way for a while," until finally the king offered Egil two chests of silver and a weighty arm ring in compensation for his brother's death.

A Pictish stone carving much older than *Egil's Saga*, now fixed above the doorway to the Lewis chessmen display in the National Museum of Scotland, shows a similar scene: a king sitting in judgment, his sword across his knees. More than this basic kingly pose, it's the thrones of the Lewis kings (and queens and some of the bishops) that draw scholarly attention. Solid and square, they are carved on three sides with loops

and swirls and knots and dragons, leaves, vines, pinecones, lions, arches, chevrons, basketweave, and blossoms.

Some motifs call to mind Bishop Pall's crozier: The dragons have the same serpentine necks, dog's muzzles, round bear-cub ears set back on their heads, and teardrop eyes.

But such dragons pop up everywhere in Romanesque art. On the throne of king number 78 in the British Museum is a crook-necked winged dragon, its head curled round and resting on its back. A near twin adorns a walrus-ivory whistle case or quill-pen box in the same collection; only the dragons' wings are different. Other winged dragons of this artistic type, larger and carved in stone, can be seen on a doorway at Ely Cathedral in Cambridgeshire, England, on the remains of a small church in Trondheim, and on a stone displayed in the Trondheim Bishop's Palace Museum, found during the renovation of the cathedral in the late 1880s. The chessman is dated 1150 to 1200; the box, late eleventh century; the doorway at Ely Cathedral, about 1135; and the Trondheim stones, mid-twelfth century. The dates are educated guesses; there's no archaeological information attached to any of them.

The same caveat pertains to four walrus-ivory carvings often grouped with the Lewis thrones: If not from the same workshop, they're said to be from the same "milieu." One sports that crook-necked dragon. Two show lions lurking in "fleshy" foliage, like those on several Lewis throne backs. Two share the pinecones-in-pouches motif from another king's throne. None can be traced to where or when or by whom it was carved. The first, now in the British Museum, is a whole carved walrus tusk that was remade into a reliquary in the fourteenth century, as attested to by the design of its metal hinges; it might originally have been a chair leg. Numbers 2 and 3, in the Danish National Museum, became the guard and pommel, much worn, of a fifteenth-century sword. The identity of the fourth pretty bit, found in 1715 at Munkholmen (Monk's Island) near Trondheim, is a mystery. Also now in the Danish National Museum, it's a segment, smoothed off, of something larger, maybe a bishop's crozier of the kind called a tau crozier, its head curled in two spirals like rams' horns or the Greek letter *tau*.

Summing up the "various scrolls, figures of animals, interlaced arches, and tracery work" on the Lewis thrones in his 1832 treatise on

the chessmen, Frederic Madden called it "the best style of art of the twelfth century, as seen in monuments and in manuscripts." He was vague about where those monuments and manuscripts came from.

Over a hundred years later, a writer in the British Museum's *Quarterly* agreed that *where* the chessmen were made is even harder to answer than *when*. Citing several examples in stone and wood as well as ivory, he showed that the style of art on their thrones "appears as far north as the Hebrides, at least as far south as East Anglia, and as far east as Lund."

A catalog of the British Museum's ivories in 1909 concluded: "There seems no greater reason to assign them a Norse than a British origin. From an earlier period than the twelfth century the relations between Britain and Scandinavia were very close; artistic influences were constantly interchanged, and common features of ornament are found on both shores of the North Sea, with the result that it is often difficult to say to which side a given object belongs."

A 1982 *Introduction to Medieval Ivory Carvings* concurred: "In the eleventh and twelfth centuries there was such an unprecedented exchange of ideas, both stylistic and iconographic, that at times it is difficult to tell where an ivory carving comes from. Artists travelled widely and had ample opportunities to be impressed by what they saw."

Yet in a series of influential studies between 1965 and 1972, Norwegian art historian Martin Blindheim fixed Trondheim as the most likely spot for the workshop that produced the Lewis chessmen. He did so, counterintuitively, by calling attention to the English influence on Nidaros Cathedral. Though the Norwegian church was ruled from Germany and Denmark before 1153, it considered England to be its "mother Church," for King Olaf the Saint had surrounded himself with English bishops. One, Grimkell, was chief in establishing the saint's cult in 1031; it cropped up in England by 1050. The first bishop of Stavanger in southern Norway, about 1112, was Reinald, a Benedictine monk from Winchester, England; he is remembered chiefly for having been hanged by the king. Many Norwegian monasteries were established in the twelfth century as daughter houses of English ones. When Nidaros Cathedral was begun in the mid-1100s, Norway had no long stoneworking tradition. Wood carving, though, had been practiced since Viking times. It stood to reason, Blindheim presumed, that "people trained as

woodcarvers were frequently engaged to work in stone. Perhaps," he added, "they had been sent abroad to learn."

Lincoln—where Bishops Thorlak and Pall of Iceland went to study and where Archbishop Eystein of Trondheim spent six months in exile— may have been their destination. Alexander "the Magnificent," bishop of Lincoln from 1123 to 1148, was among the great church builders of his day, and the cathedrals in Lincoln and Trondheim correspond in many ways. Nidaros Cathedral also has its quirks. The newly taught Norwegian stone carvers apparently "blended their old traditions with the new trends," Blindheim supposed, "without too much respect for academic rules."

This mixed "North Sea style" then moved into other media, the Trondheim theory proposes. Norwegian art historian Erla Bergendahl Hohler, in her 1999 study of stave churches, found Norwegian wood-carvers veered away from the old Viking styles in the twelfth century. An English type of "beast chain" graces the doorway of one stave church, English foliage decorates another. Norwegian ivory carvers also joined the North Sea school—including the presumed carvers of the Lewis chessmen, Hohler argued. Examining king number 79 in the British Museum, whose throne bears two lions chewing vines and a pinecone-in-pouch motif, she described it as "so-typical Anglo-Saxon 'barking lions'" among later "Southern School" English foliage. "The Anglo-Saxon motifs are at the basis of everything," she explained, "while the later English features and sculptural technique are superimposed on them. Simplified by the local craftsmen, they may then look 'early.'"

These simplifying locals need not have been in Trondheim. When Icelandic art historian Bera Nordal studied the motifs on the Lewis chessmen in 1992, she compared them to the stone carvings and stave churches of Norway and to the four familiar walrus-ivory objects—the reliquary (or chair leg), the sword guard and pommel, and the possible tau crozier—but also to the little-known collection of Romanesque wood carvings in the National Museum of Iceland. After examining all the available models in wood, ivory, and stone, she came up with "no conclusive answers as to whether the Lewis chessmen originated in Norway or Iceland."

THE TRONDHEIM QUEEN

Nordal's work on the Icelandic wood carvings is missing from most discussions of the Lewis chessmen. She wrote in Icelandic and published in an obscure journal. Instead, experts cite a short report from two years earlier by a pair of archaeologists working in Trondheim, Christopher McLees and Oeystein Ekroll, who published in English in the prestigious journal *Medieval Archaeology*. For many, McLees and Ekroll clinched the Trondheim theory. Their report discusses "a small sculpture of a Madonna with the Christ child, beautifully carved in ivory," that was found on the ancient site of Saint Olav's Church in Trondheim in the 1880s—and subsequently lost. All that remains are three sketches.

Rifling old files for information on Saint Olav's church, which was demolished in 1702, archaeologist Ian Reed stumbled upon the sketches and a few details from the finder's report: The Madonna was found "in gravel," in pieces, and had been burned. Nearby was "a broken and burnt Romanesque carved stone fragment which can probably be dated to the third quarter of the twelfth century." Reed shared this information with McLees and Ekroll. To them the sculpture was no Madonna but a Lewis chess queen. As sketched, the figure wears a veil but no crown. Only her head and one arm remained to be drawn (no Christ child), but the right hand was all that the researchers needed: She holds her hand to her cheek. "There can be no doubt," McLees and Ekroll wrote, "that the Trondheim queen derives from the same workshop which produced the Lewis pieces." That workshop, they argued, must have been "located in an appropriate and dynamic cultural setting," which they identified as Trondheim.

Touring modern-day Trondheim, especially with the authors of this report, it's not hard to find motifs like those on the Lewis thrones in Nidaros Cathedral, on stones displayed in the Bishop's Palace Museum, on the wall of a small church down a side street, and in the ruins of Saint Olav's Church—preserved inside the new library. But dip into the pages of a twelfth-century English illuminated manuscript like the *Saint Albans Psalter* (conveniently online in its entirety) and the likenesses also leap out: barking lions, fleshy foliage, a bishop's crozier, drapery, fingers, flowers—all match the look of the Lewis chessmen. This

manuscript—which also contains the *Life of Saint Alexis,* in which the spurned bride holds her hand to her cheek—was commissioned by Abbot Geoffrey of Saint Albans Abbey, just north of London, between 1125 and 1145 for the hermitess Christina of Markyate. Many of the same designs can be found in the *Hunterian Psalter* (formerly known as the *York Psalter*), about which we know much less; it was made in England sometime between 1150 and 1170, in York or Canterbury or possibly even Lincoln. The *Hunterian Psalter* is often paired with the *Copenhagen Psalter,* which, despite its name, is also English. The two psalters are thought to have been produced simultaneously in the same scriptorium, though illuminated by different artists. In 2012, a scholar suggested that the *Copenhagen Psalter* was commissioned by Archbishop Eystein of Trondheim as a coronation gift for the eight-year-old King Magnus Erlingsson, whom we'll meet later in this chapter.

Two other chess pieces support the Trondheim theory. Both are kings, seated on thrones with swords athwart their knees. One, carved of whale's tooth, was found among the beach wrack on an island fifty miles from Trondheim; the second, of wood, was retrieved from an excavation at the site of the new town library. The first cannot be scientifically dated; the second is mid- to late 1200s. Only the pose of these kings recalls the Lewis chessmen. Their faces, crowns, and clothes are quite different; their thrones are plain.

The whale's-tooth king had not yet been discovered when the report on the Trondheim queen was published; McLees and Ekroll considered the wooden king too late to mention. Instead, to support their theory, they listed "the characteristic 'Trondheim Group' of stave-church portals; the local strain of ornamental stone carving in the district's Romanesque stone churches . . . ; and, if the inferences implicit in the motifs common to a number of carved ivories, including a possible crozier head found on the nearby island of Munkholmen, can be trusted, the range of skills and motifs shared by local sculptors also extended to the intricate carving of walrus ivory." The number of qualifiers in that last clause flags a problem the researchers readily acknowledge: Few of the artworks compared to the chessmen can be scientifically dated. Except for the stone carvings, none is indisputably a product of Trondheim.

Take the "Trondheim Group" of stave-church portals. These elaborately carved wooden doorposts and archways were saved by antiquarians when the churches they adorned were torn down. Few of these churches were near Trondheim; instead, they were scattered about Norway. To choose three at random, the Rissa church was 30 miles north, across the Trondheim Fjord; Vaga was in the mountains 185 miles south; and Hopperstad was over 300 miles south, much closer to Bergen than to Trondheim. (For comparison, the distance between Iceland's two cathedrals, Holar and Skalholt, is 250 miles.) The portals are grouped because they share visual motifs. The city's name was attached to them through a set of assumptions—that master wood-carvers traveled to Trondheim and were inspired by what they saw, and that the Trondheim stones with similar motifs were in the city at that time to be admired. Yet Hohler, the stave church expert, concedes, "The dating of the individual stones in Trondheim is nearly impossible." Without dates, we cannot say who was the innovator and who the mimic.

As for the ivory carvings, two of our four familiar ivories are linked to the "Trondheim milieu": the walrus-tusk reliquary (or chair leg) in the British Museum and the possible tau crozier in the Danish National Museum. But only the crozier has any provenance at all. Why would we assume that an ivory piece found in the sand on an island off Trondheim in 1715 was made in that city, when we do not assume that ninety-three ivory pieces found in a sandbank or cist on the Isle of Lewis in 1831 were made anywhere near there?

The Trondheim theory, in short, assumes that the stone-carvers working on Nidaros Cathedral combined English and Viking motifs to create the North Sea style, which was then copied by the same or other artists working in wood or ivory, including those who carved the Lewis chessmen. But as British Museum curator Michael Taylor noted in 1978, "When one is dealing with sculpture of the quality of the 'crozier,' the walrus tusk [reliquary], and the chessmen, it is probably unwise to assume that the minor sculpture must lag behind the monumental, as opposed to actually leading it and acting as its inspiration."

An ivory chess king, after all, would fit in an artist's pocket. The entire Lewis hoard could easily be transported by a group of carvers coming from, say, Lund.

THE LUND KNIGHT

The head of the Trondheim queen is not the only Lewis fragment known. In the city of Lund in the 1980s, a bit of ivory was recovered from the debris of a bone and antler workshop that specialized in combs. It's a small part off the front of a Lewis knight's horse, including its two forelegs and the knight's feet in his stirrups.

Lund was founded by the king of Denmark around 990 as a royal town centered on a church and a mint. In 1103, it became the seat of the archbishop of the North. All bishops from Denmark, Sweden, Norway (five bishops, including Trondheim), the Orkney and Shetland Islands, the Faroe Islands, Man and the Hebrides, Iceland (two bishops), and Greenland reported to the archbishop of Lund. They traveled there, instead of to Hamburg or Bremen, to be consecrated until 1153, when Norway's and the six North Atlantic bishoprics were reorganized into a new archdiocese at Trondheim. Some bishops, like Iceland's Pall Jonsson, were consecrated in Lund much later, for between 1190 and 1202, Archbishop Eirik of Trondheim, his bishops, his retainers, and their households lived in exile in Lund, fomenting rebellion and providing posterity (through Saxo the Grammarian, who was then writing his *History of the Danes* in Lund) with their opinion that Norway's King Sverrir had "lied about his origins" to gain the throne.

Eirik's host was Archbishop Absalon, the brilliant military strategist we met in chapter 2 who wore a gabled miter like those of the Lewis bishops. According to the thirteenth-century Icelandic *Knytlinga Saga,* Absalon was familiar with chess: Recall the chess match when King Valdemar was attacked and Absalon, coming upon the scene, cradled a bloody corpse in his lap before seeing, with relief, that it was not his beloved foster brother. But Absalon probably did not place the first two bishops on the chessboard, as we saw in chapter 2: The bishops are weak pieces, subservient to the king and queen, while Absalon was the king's confidant and equal, more like the vizier, or *firz,* in Arabic chess.

Absalon was not a cathedral builder, either. Lund's cathedral was begun some years before Trondheim's and consecrated in 1145; it was completed about the same time Absalon became archbishop in 1178. Many of its stone-carvers came from Lombardy—a part of Italy on the

regular pilgrimage route from northwestern Europe to Rome. One pilgrim from Lund must have engaged a company of stone-carvers to follow him home, for they chiseled their names, in Latin, on the stones they carved; their master mason was called Donatus. Their carvings, experts say, "show Lombardic influence with loops, interlace, and stylized animals." Other carvings on Lund Cathedral show Byzantine or German influences. All three styles spread into the surrounding countryside, where they can be seen on baptismal fonts and doorways. An artist named Marten signed five fonts, Tove signed another, Carl signed a portal, and Master Majestatis left his name on six fonts carved in a "lively narrative style" notable for "elongated figures with thoughtful faces."

Lund, in fact, seems as likely a spot as Trondheim for the chess maker's workshop. Not only was a Lewis fragment found there, in a datable archaeological context, many of the motifs on the Lewis thrones can be seen on Lund Cathedral. There's the pinecone-in-pouch, for example, and the fleshy foliage. One obvious connection with the Lewis chessmen is the kings' hairstyle: Their long hair, twisted into four or more ropes, is matched by that of Samson, tearing apart the jaws of a two-headed dragon, on the cathedral's north portal. True, the same hairstyle is found elsewhere: on one of Master Majestatis's stone baptismal fonts, on a wooden Christ figure from Iceland, on a gilt-copper-over-oak crucifix from Denmark, on King David in the twelfth-century French *Bible of Stephen Harding*, and on various stone noblemen at the cathedrals or cloisters of Notre-Dame-en-Vaux, Notre-Dame de Corbeil, Bourges, Saint Denis, and Rochester.

In spite of these shared motifs, there is no "Lund theory" to counterbalance the Trondheim theory. The Lund knight was never the focus of an article in *Medieval Archaeology*, though pictures of it have been published. A 1997 British Museum booklet presents the fragment side by side with a complete Lewis knight; the caption states, "No further commentary is required; the piece was clearly a 'Lewis knight.'" Still, the author finds the sketch of the Trondheim queen "more significant." The curators of the 1992 *From Viking to Crusader* exhibition in Copenhagen agree: "There are a few other signs that walrus ivory was worked in Lund," they write, "but in this case the object is more likely to have come from a Norwegian workshop."

Art historians prefer Trondheim, says one, because there's "good evidence for walrus-ivory workshops there." But the evidence is not appreciably better than that for Lund. The tithe from Greenland is thought to have been delivered to Trondheim after the archbishopric was established in 1153, leaving the city awash in walrus ivory. But from 1190 to 1202, the archbishop of Trondheim and his entourage lived in exile in Lund; Greenland's tithe would have been sent there (if at all).

As for ivory artifacts, from Trondheim we have the Madonna or chess queen (now lost), a walrus-ivory loom weight, a tiny figure of a walrus that matches one found in Greenland, two tusks labeled with runes saying "Ketil owns," and thirteen pear-shaped gaming pieces (some of which may have been dyed red, like the Lewis chessmen when they were first examined). The gaming pieces were found outside the doors of various buildings, as if they'd been swept out with a broom.

From Lund, in addition to the comb workshop containing the fragment of a Lewis knight, we have a discarded walrus skull, some ivory waste material, and a famous walrus-ivory amulet of Thor. The Norse god is depicted with "large, staring eyes and an open mouth," seated and pulling on his long beard. It may be a gaming piece rather than an amulet, though in the Icelandic *Saga of Hallfred the Troublesome-Poet* a Norwegian slanders an Icelander before the missionary King Olaf Tryggvason by saying, "He is probably still following his old habit of secret heathen worship—he carries an image of Thor made of walrus ivory in his pouch."

Similar archaeological evidence for Viking Age and medieval walrus-ivory workshops turns up in Dublin, Canterbury, Cologne, Hedeby, Ribe, Sigtuna, and Novgorod as well as in the Isle of South Uist in the Hebrides (just south of Lewis), Greenland, and Iceland. Such evidence is not easy to find or to interpret, and it generally turns up by accident. A 2009 review of the ivory trade, for example, identifies the harbor at Gasir in northern Iceland as the site of an ivory workshop based on a fragment of walrus tusk dated to the fourteenth century: "The tusk already had been extracted from the frontal and was being prepared for a carver, demonstrating that Gasir may have had craftsmen on-site." According to the field reports, the harbor was excavated "on an unprecedented scale for a trade site in Iceland," uncovering an area over a quarter of an acre

in size. The work took five years, though only a hundred years' worth of occupation was studied. Combining this ivory fragment with the three walrus tusks found in Reykjavik in 2001, secreted under a sleeping bench in a Viking Age longhouse, the review concludes that "Icelanders were doing more than simply storing walrus ivory in transit from Greenland to Scandinavia" over a four-hundred-year time span.

Modern archaeology is costly and time consuming. The digs in Trondheim and Lund were rescue operations. In Trondheim, the site is now a library. In Lund, when the neighborhood known as the quarter of Saint Marten was developed in the 1980s—nearly 1.25 acres in size—archaeologists, by law, were allowed to study only 4 percent of the area and 1 percent of the occupation layers. Otherwise, they'd hold up construction too long. No archaeologist has yet been granted the time or money to excavate twelfth-century Skalholt, where Margret the Adroit worked, or to systematically explore Uig on the Isle of Lewis, where the chessmen were found. The question of where the chessmen were carved may never be answered, unless a winter storm—or work on a shopping mall—accidentally unearths the ivory-carver's workshop.

THE KINGS OF NORWAY

What Trondheim has, that Lund and Skalholt and Lewis do not, is a warehouse of Romanesque stone carvings, which were uncovered during the reconstruction of the cathedral in the late 1800s—as well as some in the restored cathedral itself and other churches in town. Though none exactly match the backs of the Lewis chessmen, they all display the boisterous swirls and scrolls and leaves and beasts of the North Sea style. Dating them stylistically may be "nearly impossible," but we have two other ways to try, using historical records and the marks their masons cut into them. These could tell us when styles in Trondheim changed—and provide another clue to when and where the Lewis chessmen were carved.

Stone carving in Trondheim began about 1066. The city was founded in 997 by King Olaf Tryggvason and burned to the ground in 1015. Rebuilt by King Olaf II, it grew in importance as the site of his shrine when he was acknowledged a saint in 1031. The Icelander Snorri Sturluson,

whose *Heimskringla* is our main source for the history of Norway in this period, credits King Olaf III, Olaf the Peaceful (1068–1093), with erecting the first "stone minster," Christ Church, on the spot where Saint Olaf had briefly been buried. "King Olaf's shrine was moved there and set above the altar. Many miracles then occurred there."

Olaf the Peaceful was a progressive king. He introduced corner stoves, instead of the traditional central long fires, to heat his feast hall and, having reduced the fire hazard, had the floors strewn with rushes in the winter as well as the summer. He founded the market town of Bergen, Snorri writes, and "soon it became the residence of many rich men and of merchants who brought goods in from other lands." The king encouraged new fashions: His courtiers wore "fancy breeches laced tight around their legs and sometimes clasped with gold rings around their ankles." Over these were "trailing gowns, laced up the side, with sleeves five ells" (seven and a half feet!) "long and so tight that they had to be pulled on with straps and laced all the way up to the shoulders." They had "high shoes, embroidered all over with silk, and sometimes laced with gold." Olaf the Peaceful liked the good life: He had cupbearers to pour his drink, candle-bearers to light his table, 120 bodyguards as well as sixty men of lesser rank whom he sent on errands, and sixty house servants.

He spent little time in Trondheim, preferring his country estates. He died on his farm in Viken, the Norwegian province around Oslo Fjord, in 1093, after twenty-six years on the throne. His corpse was carried north to Nidaros and buried beside the stone church he had built, Snorri says. "He was the most popular of kings, and Norway grew much richer and more magnificent under his rule"—though his saga fills only four pages in a modern edition of *Heimskringla*, compared to the ninety pages devoted to his much more interesting predecessor, Harald Hard-Rule, who died at the Battle of Stamford Bridge while trying to conquer England in 1066.

Snorri wrote *Heimskringla* in Iceland between 1220 and 1241. He does not name many of his sources and gives none for the chapters on Olaf the Peaceful, so we can't judge their accuracy. For his history of Olaf's son and successor, the kilt-wearing Magnus Bare-Legs, Snorri names only Bjorn Cripple-Hand, the king's court poet, yet we can guess that one of his better sources was his own foster father, Jon Loftsson.

Jon's mother, Thora, was King Magnus's illegitimate daughter; she lived with Jon at Oddi in Iceland until her death in 1175.

King Magnus Bare-Legs, Snorri writes, "was a bold and warlike and energetic man." He was "in every way more like his grandfather Harald in character than like his own father." He spent his ten-year reign fighting, much of the time in the Orkney Islands, the Hebrides, Scotland, and Ireland. In one poem Snorri cites, Bjorn Cripple-Hand describes the king's violent passage through the Hebrides with an exact sense of geography, beginning in the North:

> The fire over Lewis
> Played high in the heaven;
> Far fled the folk;
> The flame rose from the houses.
> The prince went through Uist
> With fire; and the bonders lost
> Wealth and life; the king
> Dyed his sword red in blood.

He raided Skye and Tirey, then moved south to Mull. "To the level Sanday the sharp king brought the shield of war," the poem says. "There was smoke over Isla," over Cantire, and last over the Isle of Man. Then Magnus Bare-Legs turned west to Ireland, where he was killed in 1103. He gave little thought to Trondheim.

Thora's half-brothers, Sigurd and Eystein (and a third who died young), shared the throne of Norway—successfully, for Sigurd soon sailed off to the Holy Land, earning his epithet "the Jerusalem-Farer." Left in charge, King Eystein I embarked on a building program. He concentrated on developing Bergen, which was larger than Trondheim and more centrally located. There Snorri says he built a great hall, which was "the most magnificent wooden building ever erected in Norway." In Bergen, too, he built Saint Michael's Church, "the most magnificent stone minster." Trondheim around 1100 was a tidy town of two streets flanking the river Nid, the harbor in the center, Christ Church—site of the future cathedral—off to the west. On the grounds of the royal palace between Christ Church and the river, King Eystein built the church of

Saint Nicholas; a wooden church, it was "decorated all over with carvings and all kinds of artwork."

King Eystein I died in 1122 and, says Snorri, "over no other man's body had so many men in Norway stood in such sorrow," for Eystein's death left Sigurd the Jerusalem-Farer as sole king—and Sigurd, though beloved, was going insane. One time, Snorri writes, when King Sigurd was taking a bath "and the awning was pulled over the tub, the king thought a fish had slipped by him in the water. Then he was struck with such a fit of laughter that his mind was unhinged, and this happened to him quite frequently after that." He died in his bed in 1130, age forty.

Near the end of his life King Sigurd also turned to church building, erecting a wooden church in his favorite town of Konungahella in the southern district of Viken. To it he gave the treasures he had acquired on his crusade, including the Holy Cross—a splinter of Christ's cross encased in a large processional cross—and a Greek altarpiece made of bronze and silver, enameled and set with jewels. The church was burned and the altarpiece looted when Konungahella was attacked by the Wends in 1135, but Andreas the priest saved the Holy Cross. Snorri's probable source for this story, Jon Loftsson, was raised in Konungahella; Andreas was his foster father.

The royal hall in Bergen, Saint Nicholas's Church, and Holy Cross Church, according to Snorri, were all constructed of wood, not stone. Other than the original Christ Church in Trondheim and the "magnificent stone minster" of Saint Michael's in Bergen, it seems most monumental architecture in Norway at this time was wooden. Yet Snorri's *Heimskringla* is a history of the *kings* of Norway, not a history of the church. Unrecorded by him, stone cathedrals were under way soon after 1120 in Oslo and Stavanger, while those in Bergen and Trondheim were expanded, for that year, twenty-four years later than Iceland, Norway instituted the tithe. The church no longer depended on the king's generosity. It could make its own plans.

MASONS' MARKS

Those plans included an archbishopric. Tired of kowtowing to Lund—and before that, to Hamburg-Bremen—the Norwegian church embarked

on a campaign to win its independence. King Sigurd the Jerusalem-Farer started it, according to Snorri: He acquired the Holy Cross in Constantinople from the patriarch himself, on the condition that he establish an archbishopric in his land "if he could."

Saxo the Grammarian, writing from the Danish point of view, implies that the papal legate, Nicholas Breakespeare, simply turned up in Trondheim with a pallium—the insignia of an archbishop—in his saddlebags. It's unlikely. The papal legate left Rome in 1151 in the company of another bishop heading for Ireland to establish two archbishoprics there. It was "a coordinated effort by the pope to establish control of the periphery of Europe," says one scholar, for at that time the pope and the Holy Roman Emperor, Frederick Barbarossa, did not see eye to eye about who should appoint bishops. The emperor threatened to invade Denmark. If he did so, Lund might come under the control of Hamburg-Bremen again. The pope could not chance that; he needed archbishops loyal only to Rome.

Trondheim was willing to supply one, if it meant independence from Lund. As if anticipating the arrival of an archbishop, work on Christ Church in Trondheim picked up in about 1140. Leaving the old church in use, the architects planned a grand cathedral around it. The old west tower was to become the midpoint of a new cross-shaped basilica, with a new nave to the west and new transepts to the north and south. On November 26, 1161—according to an inscription carved on the wall—the south transept chapel was dedicated by Eystein Erlendsson, the second archbishop of Trondheim.

The first level of that chapel, and of its twin to the north, is decorated in an English style, recalling the motifs on the Lewis chessmen's thrones. But Archbishop Eystein preferred the new, simpler Cistercian style. Chevrons, visible in the oldest parts of the cathedral, disappear in the 1160s. Moldings become more prominent, and a different leaf, like a water lily's, starts appearing on the capitals of pillars.

Then came a hiatus. In 1174, a young priest named Sverrir arrived in Norway from the Faroe Islands. He "lied about his origins," according to Saxo, claiming to be a king's son, and plunged Norway into civil war. Archbishop Eystein, a strong supporter of Sverrir's rival, fled to England in 1180.

His journey was not smooth. His ship wrecked on the Yorkshire coast. An English document notes the fines imposed on Ralph of Redcar, who allegedly lured the ship onto the rocks and pillaged it. The archbishop survived, however: August 1181 finds him acting as the temporary abbot of Bury Saint Edmunds—Eystein's credentials transferred easily throughout the Latin-speaking world. At the election of a new abbot in February 1182, he was appointed temporary bishop of Lincoln. There's no record of where Eystein went after leaving Lincoln in August 1182. Chances are he visited the shrine of Saint Thomas Becket at Canterbury. He may also have seen the ivory carvings being produced in Canterbury at the time: Compared to the stocky, blocky Lewis chessmen, these are looser, more fluid, the figures lithe and elongated, heralding the new Gothic style of art.

On Eystein's return from exile in 1183—having made peace with King Sverrir—the plans for Nidaros Cathedral changed. Romanesque design was out of date: The high vaults, bright windows, and pointed arches of Gothic architecture were now the rage. Work on the nave in Trondheim stopped for seventy years. Instead, Eystein built a rotunda over the grave of Saint Olaf. Known as the Octagon, it was meant to echo the Holy Sepulchre in Jerusalem, as does the tomb of Saint Thomas in Canterbury.

After Eystein died in 1188, work on the cathedral stopped again: His successor fell out with King Sverrir and fled to Lund. Only after King Sverrir died, in 1202, did work resume—again in a new style, again reflecting that of Lincoln Cathedral, which was in the process of being rebuilt after a catastrophic earthquake in 1185. Work on the chancel of Nidaros Cathedral began in 1210, ending in 1230; in 1248, the foundation for the west front was laid.

These stops and starts and changes in style are written in the stones of the cathedral. Over five thousand stones bear masons' marks—the signatures of more than two hundred stone-carvers over a period of 250 years. Unlike the cathedral at Lund, these "signatures" are not names but geometrical signs: crosses, squares, letters, runes, tools, and weapon shapes. The stone-carvers marked their work, not out of pride or for posterity, but to get paid: Stone carving was piecework. When the masons' marks changed, presumably, new crews were brought in, providing

a way to date the phases of the building. In 1965, a massive study of these masons' marks was published. Much has been based on this work. Yet a 2012 reassessment found that the researcher may have been afraid of heights: He recorded the masons' marks only up to a certain level, ignoring large parts of the cathedral.

His conclusions about which parts were built when are now suspect, and there are no written records to back them up: The church archives were lost to fire. These fires—in 1328, 1432, and 1531—also left the nave in ruins and the choir damaged. The church had no money for repairs—the last Roman Catholic archbishop spent the treasury fighting the Danish army, which had come to impose Reformation. In 1552 and 1568, the new Lutheran bishop tore down "redundant" smaller churches in Trondheim and used their stones to rebuild the cathedral. Fire struck again in 1708 and 1719. By 1762, when a Norwegian antiquarian published a *Description of the Cathedral of Trondheim* in hopes of revealing its "ancient glory," much of the great church lay in ruins. Restoration began in 1869 and still continues. The current Nidaros Cathedral "contains considerably less original building materials than most medieval cathedrals on the continent," wrote an architectural historian in 2010. It was put together like "a giant jigsaw puzzle" by nineteenth-century architects working in "the common Gothic Revival style of the times."

The carved stones Martin Blindheim considered to be "of central importance to the understanding of Romanesque art in the area"— including the Lewis chessmen—were found during the restoration of the main tower in 1888 and set aside as not really belonging to the cathedral. They are thought to have been originally carved for the "redundant" churches in the town that were torn down in the sixteenth century. In the tower, they were structural pieces—so their carvings were shielded from the weather and well preserved. The best are now displayed in the Bishop's Palace Museum; others are warehoused. Some stones from the ruins of Saint Olav's church, preserved in situ in the atrium of the modern town library, also bear Romanesque motifs, including one indistinct winged dragon—cracked and pitted by centuries of bad weather—very like the dragon on Lewis king number 78 in the British Museum.

If the Lewis chessmen were made in Trondheim, these stones sug-
gest they were carved before the Romanesque style went out of fashion
in the city. That end date could be as early as 1161, when Archbishop
Eystein introduced the simpler Cistercian elements into the cathedral's
design, or 1180, when he fled to England and was inspired by Gothic art.
If, however, the Lewis chessmen were carved between 1180 and 1200—
or even later—they likely were not made in Trondheim.

CIVIL WAR

If the Lewis chessmen were carved in the last decades of the twelfth cen-
tury, two of the kings on our chessboard are Sverrir, who reigned from
1184 to 1202, and the king he deposed, Magnus V, who was crowned in
1164. Magnus V was killed in battle after twenty years on the throne: He
was then twenty-eight. Sverrir was twenty-four when he first claimed the
crown. Both are fantastic characters who challenge our assumptions of
kingship in the Middle Ages and of the limits of the Norwegian realm.
Neither spent much time in the city of Trondheim. Neither provided the
stable, wealthy royal courts we assume an ivory-carver would seek out.
Nor had the kings who preceded them.

From 1130, when Sigurd the Jerusalem-Farer died, insane, Norway
was engaged in almost constant civil war until 1240. The kings had no
permanent royal court but moved among Trondheim, Bergen, Oslo, and
other sites as the fighting and factions dictated. For much of the time,
there was more than one crowned king: Traditionally, any king's son,
born in wedlock or out, could inherit the title, and two came from the
farthest reaches of the realm.

Harald Gilli, for example, was raised in Ireland. He was living in the
Hebrides when he met the young "master of nine skills," Kali Kolsson,
who would become Earl Rognvald Kali of Orkney. Kali grew up on his
father's estate in Norway. As Bishop Pall writes in the *Orkney Islanders'
Saga:*

Kali was fifteen when he went with some merchants west to England.
They had a good cargo and headed for a town called Grimsby. Great
crowds of men had come there, both from the Orkney Islands and

from Scotland, and even from the Hebrides. There Kali met a man who called himself Gillikrist; he was asking many questions about Norway. He talked most with Kali, and they became great friends. He told Kali in confidence that he was really named Harald and that King Magnus Bare-Legs was his father, but on his mother's side he was partly from the Hebrides and partly from Ireland.

With Kali's encouragement, Gillikrist, or Harald Gilli as he began calling himself, went to Norway. King Sigurd was not too surprised to learn he had an Irish half-brother: Magnus Bare-Legs had left behind a love poem to an Irish girl who made him "feel young again." Still, to prove his paternity, Harald Gilli had to undergo an ordeal: to walk on red-hot plowshares. When his burns healed cleanly and did not fester, he was acknowledged King Sigurd's brother, even though "he wasn't fluent in the Norse tongue and often stumbled over his words, and many men mocked him for that," Snorri Sturluson writes in *Heimskringla*.

Upon the king's death, Harald Gilli and his nephew Magnus agreed to share the throne; their truce lasted four years. Harald Gilli, says Snorri, was merry, generous, and "not haughty." Magnus IV, in contrast, was not only haughty, he was greedy and a hard drinker. He was also, it's true, a great athlete and "more handsome than any other man in Norway," but in Snorri's opinion, "it was mostly his father's popularity that gained him people's friendship."

Fighting broke out when both kings decided to winter near Trondheim. Harald Gilli, the eventual victor, found ready allies in Denmark, for Magnus IV had made a political gaffe: He agreed to marry the sister of King Valdemar, then sent her back home to Denmark as unsuitable.

In a battle in Bergen, Harald Gilli captured his nephew. To keep Magnus from ever again sitting the throne, Harald had him blinded and castrated and cut off one foot. Magnus the Blind found refuge in the cloister at Munkholmen near Trondheim.

Harald Gilli then sent for the English bishop of Stavanger and accused him of hiding the royal treasury. Bishop Reinald denied it. Harald Gilli fined him fifteen marks of gold. The bishop refused to pay. Harald Gilli sentenced him to hang. As the bishop walked to the gallows, "he shook off one of his boots and swore on his oath, 'I don't know about

any more of King Magnus's treasure than what's in this boot.' In it was a gold ring." The king hanged him anyway. Wrote Snorri, "This act was much decried."

Harald Gilli made another blunder: He captured and imprisoned his half-brother, another Sigurd, nicknamed "the Sham Deacon." This Sigurd had been raised in the Orkney Islands and served for several years under King David of Scotland before coming to Norway where he, like Harald Gilli, proved himself a true son of Magnus Bare-Legs by undergoing an ordeal. Sigurd the Sham Deacon escaped and murdered Harald Gilli in 1136. He then released Magnus the Blind from his monastery, but the Norwegian nobles spurned them both. Magnus tried to reclaim his throne with Danish support, and civil war erupted again.

Norwegian historians say it's anachronistic to call these clashes a "civil war." Yet they did pit brother against brother. Take the experience of Ivar Skrauthanki. In 1140, Ivar (though an Icelander) would become bishop of Trondheim; his son, Eirik, would be chosen archbishop in 1189. But in November 1139, Ivar Skrauthanki was a fighting man aboard the dragonship of Magnus the Blind during a sea battle in the Oslo Fjord. When he saw King Magnus killed, Snorri writes, Ivar fled to the ship of his brother Jon—who was fighting on the opposing side. Jon arranged his ransom but could not save Bishop Ivar's companion and namesake, Ivar Dynta. "So said Bishop Ivar, that of all the things that had happened to him, the worst was when Ivar was led up onto land to the axe, and before he was beheaded, he turned to them and prayed that they would meet again." For this anecdote, Snorri is very clear about his sources. He writes, "So Gudrid, Birgir's daughter and the sister of Archbishop Jon, told Eirik Oddsson, and she said she had heard Bishop Ivar himself speak of it." Jon Birgisson of Stavanger became the first archbishop of Trondheim in 1153.

Instead of Magnus the Blind, the Norwegian chieftains acclaimed as kings two sons of Harald Gilli. Ingi the Hunchback was crowned at two years old; his half-brother Sigurd Mouth (called that because his was ugly) was a few years older. They admitted a third half-brother, Eystein, into the rule in 1142, but the three kings eventually fell out. Sigurd grew up to become brave and strong and well-spoken, but he was "a tremendously arrogant man and overbearing in all things," Snorri says.

Eystein was "intelligent and sensible," but "the greediest and stingiest" of them all. Ingi, the only legitimate one of the three, was the least likely king, at least by the standards of the Lewis chessmen, who are all sturdy, impressive figures. "He was short in stature and had difficulty walking alone, because one of his legs was withered, and he was a hunchback." He was kindly, Snorri concedes, and "openhanded with his wealth." But the secret to his popularity was that "he mostly let the chieftains rule the country with him." Because he was born in wedlock, he was also preferred by the papal legate, Nicholas Breakespeare, who established the archbishopric of Trondheim in 1153 and became Pope Adrian IV in 1154.

Ingi the Hunchback ambushed and killed Sigurd Mouth in 1155 and Eystein in 1157, before being killed himself by one of Sigurd's sons in 1161. Civil war erupted once more, as many noblemen held equal claims to the throne.

THE RIGHTEOUS KING

The eight-year-old Magnus Erlingsson was crowned in 1164 to put an end to the strife, but many Norwegians were not satisfied. Magnus was not the son of a king—as every previous king of Norway had been—but of a king's daughter. He was not elected by the chieftains but crowned by the church. True kings' sons—such as Hakon Broad-Shouldered, Olaf Ill-Luck, and Eystein Girlie—easily found support. All were defeated by Magnus's warrior father, Erling, who was the real ruler of Norway until his death in 1179.

Erling Skew-Neck we met in chapter 2. As a young man, he sailed to the Holy Land with Rognvald Kali, earl of Orkney. Along the way, while Kali was busy composing troubadour songs to the lovely but unattainable Lady Ermingerd of Narbonne, according to the *Orkney Islanders' Saga*, Erling was leading Viking-style raids. He was the best tactician on the earl's fifteen ships. It was Erling's strategy that captured a castle in Islamic Spain: "Things went the way Erling expected: The lime-mortar could not withstand the fire and the castle walls tumbled down, leaving a wide opening." Erling's tactics sank a much larger African trading ship, or dromond. The Africans "poured burning sulfur and flaming

pitch down onto them," but with their dragonships snug against its side as they hacked their way in, the Vikings were shielded by the great dromond's own camber. "It turned out as Erling expected: Most of it missed their ships." When the Vikings swarmed aboard, however, "Erling took a great wound on his neck. . . . It healed so badly that from then on he held his head crooked," earning his nickname.

Returning home, the earl and his men traded their ships for horses and followed the pilgrim route north from Rome. "This was the most famous of journeys, and everyone who took it was considered a much greater man afterward." Once back in Norway, Erling Skew-Neck joined King Ingi the Hunchback and (unlike many others) "never left him as long as they both lived."

Another staunch member of King Ingi's party was Eystein Erlendsson: Before becoming the second archbishop of Trondheim, he was the king's chaplain and treasurer. As Snorri Sturluson tells the tale, when Ingi fell in 1161, Eystein and Erling put their heads together. Erling was married to Princess Kristin, daughter of King Sigurd the Jerusalem-Farer and cousin to King Valdemar of Denmark. Ingi's party had no better-bred candidate than their son, Magnus. "And though Magnus would not be chosen king according to the old ways here in our land," Erling told the archbishop, "you can with your power give him the crown according to God's law, and so consecrate him king of the realm."

The archbishop drove a hard bargain, other records show. From then on, the church levied fines in pure silver, not the coin of the realm, in which silver was mixed with other metals, and so took in twice as much. Young Magnus swore a coronation oath proclaiming that he received his crown and his right to rule from God. He consecrated his kingdom to Saint Olaf and announced himself Saint Olaf's vassal. The archbishop then wrote a new law of succession based on this concept of *rex iustus*, the just or righteous king whose power comes from his deep Christian faith. Unlike "the old ways," the new law permitted only one king at a time, allowed only sons of the previous king to be elected (with preference to the eldest), and disbarred all illegitimate sons. The king was to be elected at a national assembly in Trondheim, where the bishops held the deciding votes. Anyone who was named king in any other fashion was to be excommunicated and treated like an outlaw.

To seal their bargain, Erling Skew-Neck gave Nidaros Cathedral a priceless relic: a ring containing a drop of the Holy Blood of Christ. Young Magnus was crowned in Bergen in 1164 by a papal legate. Attending the ceremony, and recognized as kin, was the uncrowned king of Iceland, Jon Loftsson, father of the future Bishop Pall.

Denmark also seems to have had a hand in the crowning of the young king. Soon after the coronation, the queen mother, Kristin, went to visit her cousin, King Valdemar, and his foster brother, Archbishop Absalon of Lund. The next summer, Erling Skew-Neck joined her in Denmark. Depending on which source you read, Erling had bought Danish support for his son Magnus by handing over control of the southern Norwegian province of Viken. Or King Valdemar had conquered the province while Erling was busy fighting elsewhere. Saxo the Grammarian claims Valdemar intended to conquer all of Norway but delayed too long and missed his opportunity. Whatever the truth, Erling Skew-Neck returned to Norway as Earl Erling, pledged to rule Viken in King Valdemar's name. In 1170, he went further, agreeing to foster the newborn Danish prince, who would inherit the Norwegian throne if King Magnus had no legitimate sons.

A glimpse into Earl Erling Skew-Neck's lifestyle during these turbulent years comes from the Icelandic *Saga of Gudmund the Good,* written in about 1237. Ari, Gudmund's father, went to Norway one summer to try his fortune. He joined Erling's forces and distinguished himself in a battle against the pretender Hakon Broad-Shoulders. The next spring he sailed home to Iceland in Earl Erling's gift: a new ship. After two years at home with a toddler, Ari grew bored. He returned to Norway and took his place in Earl Erling's bodyguard. That winter a grandson of King Harald Gilli raised an army. The rebels caught Erling unawares in a little village in Viken. Erling, says the saga, "had risen in the night as usual for matins, and went to church, along with his most trusted men." While the earl was praying, a trumpet sounded. The earl and his men were unarmed. They fled from the church with the enemy on their heels.

> They came up to a stockade fence and Bjorn and Ivar leaped it, but the earl could not make it over because he was too fat. Bjorn and Ivar turned back to help him, and Ari jumped in between the earl and the

armed men, shielding the earl with his own body. He turned to meet
the enemy, and so traded his life for the earl's, for Ari had not been
wounded before, yet now he was shot in the throat and pinned to the
fence, and so lost his life. But the earl got away.

In *Heimskringla,* Snorri contrasts the discipline and keen strategy of
Earl Erling's men with the "brave but unruly and ill-planned warfare"
of the rebels, notes modern historian Sverre Bagge. "It is not a strategy
of fixed armies, which move against strongholds or places of particular
strategic interest," he says, "but rather a question of moving in a way that
is likely to lead to maximum support."

Suddenly the game changes. *Heimskringla* ends in 1177, when a new
actor enters the stage. In the *Saga of King Sverrir,* which picks up the
story, "the descriptions of conflicts differ considerably." No longer are
the nobles simply jockeying for power. King Magnus and King Sverrir
fight to the death.

"WHERE ARE ALL OUR MEN?"

When Harald Gilli arrived from Ireland, says Saxo the Grammarian,
writing in the city of Lund surrounded by disgruntled Norwegian cler-
ics, "it was as though a thunderstorm came over the flourishing coun-
try." When Sverrir arrived from the Faroe Islands, the political weather
grew even worse, for this supposed son of Sigurd Mouth and grandson
of Harald Gilli, "protected by his turbulent and misguided warriors, and
by the credulous support of the vulgar, led the most savage slaughter,
and utter ruin, through the whole of Norway."

Roger of Hovedon, writing from England at about the same time,
claims Sverrir slew fifteen kings and their relatives to seize the throne,
while to celebrate his crowning he "had a rival decapitated and the
freshly severed head presented to those assembled for the coronation
feast."

The view from Iceland was a bit different. In 1185, a year after Sver-
rir buried his rival, Magnus Erlingsson, an Icelandic abbot visited the
king's court. He stayed by Sverrir's side for three years, apparently taking
dictation, for the prologue of the saga that has come down to us says,

"The beginning of this book follows the one that Abbot Karl Jonsson wrote while King Sverrir himself sat next to him and determined what he should say." Abbot Karl returned to Iceland in 1188 and resumed his post at Thingeyrar Monastery; he died in 1212, ten years after Sverrir.

The *Saga of King Sverrir* was the first King's Saga; it inspired Snorri Sturluson's *Heimskringla*. Dense with descriptions of late twelfth-century politics and military strategy, it is above all "a portrait of an uncommon man," notes the translator of a French edition. Abbot Karl obviously admired King Sverrir; he was also a keen observer. His Sverrir is eloquent, ironic, energetic, talented, a clever tactician, and, above all, persistent.

He might not, however, have been the son of a king.

Throughout the saga, Abbot Karl testifies to its truth, insisting, "This book is written based on the accounts of men who remembered what happened because they themselves had seen or heard the events." Yet on the crucial question he is silent.

The saga begins with Bishop Hroi of the Faroe Islands and his brother Unas the Comb-Maker. Unas, we're told, was living in Norway, where he "married a Norse woman named Gunnhild." Shortly afterward she had a son, Sverrir, who "was said to be the son of Unas"—emphasis on the *said to be*. The couple had two more sons and several daughters, then Unas the Comb-Maker drops out of the saga. In 1155—the year King Sigurd Mouth was killed—Gunnhild sent the five-year-old Sverrir to the Faroes. There he was brought up by Bishop Hroi, who "set him to books." When he finished his education, Sverrir was ordained a priest—against his will. "He didn't settle into the role of a priest, and was rather unruly," the saga says. He had dreams of grandeur, including one in which Saint Olaf handed him a sword. His mother dreamed of Sverrir's greatness, too, and after a pilgrimage to Rome—pilgrimages being popular with people of all classes in those days—she had a crisis of conscience. She sailed to the Faroe Islands and revealed that Sverrir, now twenty-four, was really a prince. Sverrir set off for Norway to claim his kingdom.

He traveled in disguise. He infiltrated Earl Erling's court and "concealed himself so well that the earl had no idea what Sverrir had in mind or who he really was." He canvassed distant relations, finding little

support. They were already backing Sverrir's cousin, Eystein Girlie (saddled with that unfortunate nickname because he was handsome, young, and short). Eystein had gathered to himself a ragtag band of rebels contemptuously called the *Birkibeinar,* or "Birchlegs," because they were too poor for boots and instead wrapped birch bark around their calves. Sverrir investigated Eystein's plans. He found them "childish" and decided not to join the Birchlegs. He was contemplating his own pilgrimage to Rome when Eystein Girlie was killed and the Birchlegs begged him to lead them. Sverrir agreed, it seems, out of pity. Says the saga, "The troop was in a shameful state: Some were badly wounded, some were without clothes, nearly all of them were weaponless. They were all, as well, such young men that they didn't seem up to making any big plans."

If Sverrir was an imposter, remarks one reader, then he was "an imposter of genius," for he turned the Birchlegs into a lethal fighting force. At the onset of one battle, "The Birchlegs shot their shields together so tight that nowhere were they unprotected. They let their ships drift about and now and then made a feint; it was easy to see that they were used to this kind of work." When the enemy began to tire of throwing stones and to run out of arrows, King Sverrir ordered the attack: "Now be Birchlegs and let them know how your weapons bite."

Often Sverrir gathered his own intelligence. Before his first battle at Trondheim, "he went himself to scout it out, taking along one other man, named Jon, and they snuck in among the army itself. Then they learned exactly how great the odds against them were"—about twelve to one. But the leaders of this huge army, Sverrir decided, were only unimaginative townsmen. He ignored the odds and waited until his enemies thought the threat had passed, then attacked. His men "captured the banner of King Olaf the Saint, and bore it through the town in triumph" while their enemies scattered "like mice to their holes." All who asked for mercy received it. So Sverrir built his army.

He stole ships and sank others in daring raids. Once he had so many ships and so few sailors that "men had to be ferried from ship to ship in order to raise the masts and put up the sails." He had other ships built, to his own (not always seaworthy) specifications. He erected fortresses and palisades and armed them with catapults. He planned ahead: His men had cleats for their shoes before a battle on the ice; because their

opponents' shoes "had mere soles and the ice was slippery with blood," they were easy to chase down and slaughter. Sverrir himself led each charge: "It was his work to give one spear-thrust to every man he attacked, and the Birchlegs performed what further service was needed for death," Abbot Karl writes, adding, "His spear was all bloody all the way down the shaft, so that the blood ran over his hands." Fighting at sea, "King Sverrir shot all day with a crossbow." His opponents' leaders "drew no nearer to the battle than to see which side was winning. And when they saw that the Birchlegs had the advantage, they rowed away out of the fjord as fast as they could."

Sverrir was not always victorious, but he was never defeated. He snuck away in the night, in disguise, in "a long black hooded cloak"— "Don't call me king for a bit, all right?" he joked after one disaster. He crisscrossed the country, traveling hard, through snow, with little food, chivvying his exhausted troops, challenging them to be worthy of Saint Olaf's aid, hauling them along with sheer charisma to reappear when and where they were least expected. "Their spies have not warned them of our movements," he said, arriving at Trondheim late one night in 1179. "They will by now be dead drunk and sleepy and without a plan, some on their ships, others here and there in the town, and they will hardly know where to go or what to do." With eloquence, he roused the Birchlegs further: "To us will fall the victory, I do believe it: for I have dreamed it." And he offered concrete rewards: "He who slays a baron, and has proof of it, shall become a baron. Whoever slays a king's man becomes a king's man. Each of you will be a nobleman of some rank, if you clear room for yourself, and there are other honors to win as well. Such is the game we are playing."

Sverrir was twenty-nine. He was stout and strong, Abbot Karl writes, though not tall, and had rather short legs, so that he looked most kingly when he was sitting down. He had a broad face, with handsome features, and he kept his beard short. He had light brown eyes, well set, and a keen gaze. "He was quiet and introspective, but of all men he was the most eloquent speaker, with big ideas and a clear delivery, and his strong voice cut through the conversation without him ever needing to raise it." He had great endurance and could go a long time without sleep; he ate sparingly, and he "never drank so much alcohol that he lost his wits."

His rival, Magnus Erlingsson, though crowned to be a *rex iustus*, was not notable for his deep Christian faith; rather he is described as "a great drinker and ladies' man. He enjoyed games, and was better than all others at feats of agility." He had an open hand and a witty tongue. These qualities, the abbot notes, made him popular with young men. Six years Sverrir's junior, Magnus was tall and muscular, with a slender waist and well-shaped hands and feet, altogether a handsome man, though his mouth was "rather ugly." He was a flashy dresser, quite particular about his clothes, and though he was strong and "most deadly with weapons," he was not much of a strategist.

The true leader of his army was his father, Erling Skew-Neck. It was he whom Sverrir wanted to defeat that night at Trondheim in 1179— and he succeeded. When the war trumpets sounded, arousing Magnus's dead-drunk and sleepy troops, Erling's captain urged him to flee. "I don't know, Ivar, but that it would make the most sense," Erling agreed. "Yet I cannot abide the thought of that devil's priest, Sverrir, sitting in my son's seat." He armed himself, gathered what men he could, and marched to the cathedral, where he met the king, his son. Abbot Karl writes: "Erling was wearing a stout coat of red fustian cloth, a silk cap, and a byrnie of plate mail that did not close completely in the front. He drew his sword and waved it in the air and said, 'You'll say again today, that this old man knows how to make a sword bite.' He told his trumpeters to blow their loudest. But when they came out of the chapel, the earl looked from left to right and said, 'Where are all our men?'"

Erling was felled by a halberd thrust to the stomach. "And when King Magnus reached him, the earl could no longer speak. The king said, 'We will meet again on the day of joy, father!' The earl's lips trembled, and then he was dead. With the earl fell most of the men who were fighting beside him; after that, the army scattered." King Magnus fled through the town and across the river and away. Sverrir had the earl's body buried on the south side of Nidaros Cathedral. He made a speech over the grave, saying, "It would not be proper to keep silence at the burial of so noble a man as the one whose grave we stand over today." Then he made a comment that was later held against him by members of the church: "Times have greatly changed, as you can see. They have

taken an unbelievable turn, when one man stands here now in place of three, in place of king, and earl, and archbishop. And I am he."

THE OLD GAME WITH ONE KING

When times change, so do games. In the *Saga of Ref the Sly*, a Greenlander hoping to win the favor of a king sends him a set of walrus-ivory pieces good for playing both "the old game with one king and the new game with two." Chances are he sent along a two-sided game board as well. Several of these have been found in archaeological digs, two even in twelfth-century Trondheim, though none was made for these two games. The old game in the story is *hnefatafl*, in which a single king and his small band of defenders are ringed by a kingless mob that outnumbers them two to one. The new game is chess, in which a king faces off against another king.

Though the *Saga of Ref the Sly* was written much later than Sverrir's reign and the king in the story is Harald Hard-Rule, who died in 1066, it's easy, reading of King Sverrir's battle tactics, to imagine him playing *hnefatafl*—until his opponents flipped over the board and he had to learn the new game of chess.

Hnefi literally means "fist," but here it denotes the king-piece of the game. *Tafl* derives from the Latin *tabula*, meaning game board or table: The name, and the first board games, were brought into the North by Roman soldiers. *Hnefatafl* is thought to be a variant of the Roman game *ludus latrunculorum*, or "Game of Little Soldiers," with a peculiarly Norse twist: The two sides are not equal. Like King Sverrir, the *hnefi* wins, not by strength, but by strategy.

Hnefatafl is mentioned many times in the Icelandic sagas, and numerous artifacts throughout the North, dating from Viking times to the thirteenth century, have been identified as *hnefatafl* pieces and boards. A famous set found in Iceland in 1860, for example, led to the establishment of the National Museum of Iceland. Discovered in a tenth-century grave, it consists of twenty-four knobs of walrus ivory or whale bone and the figure of a king, seated and stroking his long beard. His stylized features, though much weathered, remind some experts of the Lewis

chessmen. Others suggest that some pieces in the Lewis hoard—the oc-tagonal pawns, the discs, the warrior rooks, even the kings, could have been used to play *hnefatafl*.

No medieval rule books for *hnefatafl* remain. Until 1913, no one knew how to play the game. Then H. J. R. Murray, in his *History of Chess*, linked it to a Sami board game mentioned by Swedish botanist Carl Lin-naeus in the 1732 diary of his travels in Lapland. Linnaeus called the game *tablut*. Using his description and the evidence of game boards found in archaeological sites, gamers have reconstructed *hnefatafl*—though they don't all agree on the rules.

Like chess, *hnefatafl* is played on a checkerboard, but with some differences. The size can vary—boards ranging from seven-by-seven to nineteen-by-nineteen squares have been found—and the grid is laid out with a distinct central square. The king, or *hnefi*, goes there. He is guarded by eight or more defenders, depending on the size of the board. Twice as many attackers are ranked on the outermost squares. All pieces move like the rook in chess—as many spaces as they want in a vertical or horizontal line. A piece is captured if sandwiched between two opposing men. If the king is trapped, he loses. If the king escapes to the perimeter of the board, he wins.

Unlike chess, *hnefatafl* is an asymmetrical game: Each side has a different objective. "According to game theory," writes *hnefatafl* expert Sten Helmfrid, "such games are always unbalanced unless the correct outcome of the game is a draw. When two skilled opponents meet, one side will in the end turn out to be easier to play and always win the game. The degree of imbalance," he adds, "can be adjusted by changing the rules." If you play by the rule that the king wins by reaching *any* square on the board's perimeter, then no matter how you set up the pieces ini-tially (within reason), the king's side has the advantage. If you limit his winning squares to the four corners of the board, the attackers do. To even the odds and make the game more challenging requires rules that we do not know. Dice may be involved. Some experts suggest the king is "weaponless" and cannot help capture his attackers. That would not fit with King Sverrir's strategy, and test games show that a weaponless king favors the attacking side. Overall, to win at *hnefatafl*, Helmfrid says, "The king has to make clever sacrifices to create paths into the open, but

without weakening his own forces too much"—exactly the way King Sverrir fought.

One night in Jamtaland, before the death of Earl Erling Skew-Neck, Sverrir awoke to find himself betrayed. The baron who hosted him had given away his whereabouts: An army of twelve hundred yeomen, in three divisions, would soon have the house surrounded. He roused his troop of a hundred men; they took their weapons and snuck out. Coming upon the enemy host, Sverrir told his men to "egg each other on using the same phrases as you hear the Jamts using" and so pass quickly through the enemy force. They were to meet again on the far side of the Jamt army, out by the islands. "But first we attack." The Birchlegs yelled their war cry and rushed at the Jamts. Writes Abbot Karl, "It was so dark that night that no one could recognize his neighbor. After a hard fight, the Birchlegs slipped through the yeomen's army and out to the islands. The yeomen did not realize this right away, and continued fighting among themselves for a long time, until it began to grow light. And just when the yeomen stopped fighting, having learned they'd been killing each other, the Birchlegs burst on them again with such a fierce attack that the yeomen fled."

But after the death of Earl Erling Skew-Neck in 1179, Sverrir's opponents flipped the board. Except for the single king piece, the defenders and attackers in *hnefatafl* are all the same. Chess introduces pieces of different weights. To the rooklike *hnefatafl* men, chess adds pawns, knights, bishops, and a queen, along with a second, opposing king. The game is symmetrical; each side has the same objective.

In Norway, in the last decades of the twelfth century, King Sverrir fought an unending series of real-life chess matches. As soon as he defeated one king—Magnus was killed in a sea battle in 1184—another royal pretender would take his place. The important pieces in this new game were the bishops: As in chess, the church had the power to win the war.

Archbishop Eystein of Trondheim had crowned Magnus Erlingsson king in 1164 and stood by him, but Eystein was a cathedral builder and law maker, not a warrior. After the archbishop fled to England in 1180, his place at King Magnus's side was taken by Bishop Eirik of Stavanger, who was much more of a fighter. Upon Archbishop Eystein's death in

1188, Eirik was chosen to replace him—though King Sverrir, then rul-
ing unopposed, objected. Eirik traveled to Rome and received the pal-
lium, his mark of office, from the pope. Next his old post, bishop of
Stavanger, had to be filled. The clergy elected Nikulas Kings-brother,
half-brother to the slain King Magnus. Again, King Sverrir objected, so
Nikulas Kings-brother brought another chess piece into play: He ap-
pealed to Sverrir's queen, who was distantly related to Nikulas, both be-
ing the great-grandchildren of a king of Sweden. Sverrir acquiesced to
his queen's pleas, though he would regret it—especially after Nikulas
moved to the richer bishopric of Oslo, in the part of Norway claimed by
Denmark.

Soon, writes Abbot Karl in the *Saga of King Sverrir,* king and arch-
bishop were at odds. The abbot tries to be fair. He's a churchman, after
all—and writing during either Eirik's archbishopric (1189–1202) or that
of his successor, Archbishop Thorir (1205–1214), who was a student of
Archbishop Eystein. Yet the abbot's partisanship shines through.

The first quarrel was over church fines. Eystein had collected fines in
pure silver, rather than coins, effectively doubling his take. "They made
a bargain," said King Sverrir. "The archbishop would crown his son king
and Earl Erling would allow the archbishop" to change the tax laws.
King Sverrir demanded that the old law be reinstated: Both church and
king should collect taxes and fines in coins. Archbishop Eirik refused,
accusing the king of trying to rob the church.

The second quarrel was over the building of churches. The king
presented as evidence the laws of King Olaf the Saint, as recorded in
the law book called *Gray Goose:* These said that any man could build
a church and hire a priest. "The archbishop presented the book called
Gold Feather, that Archbishop Eysteinn caused to be written, along with
God's Roman law, and part of a letter he had with the pope's seal": With
these, the archbishop claimed control over all churches and priests, no
matter who paid to have the building erected.

The third quarrel concerned the number of warriors and the size
of a ship an archbishop was allowed. The law said an archbishop could
have thirty men, and his ship could carry twelve shields. Archbishop
Eirik's bodyguard numbered ninety men, and his ship was large enough
to carry twenty shields. Said the king:

We Birchlegs well remember that we thought this same ship was rather too strongly manned when the archbishop sent it to attack us under Hattarhamar. So also in Bergen, when we went after the fleet, the archbishop's ship and his men were more eager to arm themselves and fight with us than was the king's troop. It would seem to me to be more godly for the archbishop to have no bodyguard larger than is legal, for no man will attack either him or the church. He should rather spend his money sending men to the quarries, to carry stone and carve it and so further the building of the cathedral.

In 1190, the archbishop of Trondheim took his men, his ship, his shields, and all the money and valuables he could carry and sailed south to Lund, where Archbishop Absalon welcomed him. He stayed for twelve years, plotting to overthrow King Sverrir. With Absalon's support, as we have seen, Eirik appealed to the pope, who excommunicated the king of Norway until he gave the archbishop "everything he wanted and all that he claimed for himself." When King Sverrir sent messengers to the pope on his own behalf, they died in Lund on their way home from Rome. Sverrir believed they were poisoned.

The king of Denmark, at the archbishops' request, began supplying ships and warriors to Norwegian rebels, including a troop from the Orkney Islands whom King Sverrir soundly trounced in 1194. Bishop Pall of Iceland was on hand when the king called an assembly of bishops in Bergen to try Earl Harald of Orkney for treason. Pall was most likely Abbot Karl's source for this part of the *Saga of King Sverrir:* Harald was the earl to whom Pall had pledged his allegiance as a young man; in the earl's party was Pall's friend Bishop Bjarni, with whom he had coauthored the *Orkney Islanders' Saga.* The earl and bishop begged for mercy and, as always, Sverrir granted it. He also, however, assessed heavy fines throughout the Orkney Islands and put the Shetland Islands under direct royal control. He then accused Bishop Nikulas of aiding the Orkney rebels. To make amends, the bishop was forced to oversee Sverrir's formal coronation. Soon afterward, he too fled to Lund. There he made peace with his archbishop and became Sverrir's fiercest enemy.

It was Bishop Nikulas who led the next army to attack from Denmark. His troops called themselves the *Bagals,* or Bishop's Croziers. In

1198, they burned Bergen to the ground. It was no accident: They set fire to the city in three places, then "stationed their boats out in the bay, and shot into the flames at the men who were trying to save the houses and put out the fire." The bishop himself "was on one of the boats that carried fire to the town. He even told them where the fire should be set, and where they should shoot, and he was widely hated for this. This fire was so damaging and harmful that many rich men were stripped of everything. The men of Bergen remembered this often and held it against Bishop Nikulas. Mary's Church and five others were burned."

Eventually, even Abbot Karl grew tired of the war: "Many more attacks and much shooting and boarding of ships could be described," he writes, "but not everything can be written in one book."

The end came in Viken, which the king of Denmark had again claimed for himself. King Sverrir trapped the enemy captain in the fortress of Tunsberg and besieged it all winter. The rebels were reduced to eating their walrus-hide ropes—and the attackers were not much better off—when King Sverrir sent word that he would give the rebels quarter. They limped out of the fortress, more dead than alive. The rebel captain shared the king's own cabin on the way back to Bergen and received the same nursing, for King Sverrir himself had fallen sick. He lingered into the spring and died on March 9, 1202, still excommunicated.

"Being king has brought me war and trouble and hard work, not an easy life," he sighed at the end, sounding just like a Lewis chess king, sitting grim and weary on his throne.

THE VOYAGE OF GUDMUND THE GOOD

That spring, in the north of Iceland, the chieftains and clergy elected a new bishop of Holar, Gudmund the Good. He would turn out to be a stiff-necked and uncompromising reformer: His contemporaries compared him to Saint Thomas Becket; modern historians call him a reckless fanatic. His insistence on the separation of church and state, some say, was the catalyst that led to Iceland's loss of independence in 1262.

In 1202, however, Gudmund the Good was merely a chieftain's chapel priest. His father, Ari, had distinguished himself by dying to save Earl Erling Skew-Neck. Gudmund, illegitimate, had inherited

nothing but his father's pride, and so entered the church. He had an excellent singing voice. He was known for wandering the country, blessing cliffs and springs. The common people loved him. At forty-one, he did not want to be bishop. He wrote a letter to Bishop Pall of Skalholt, revealing his reluctance and asking Pall's advice. Pall, in turn, consulted his brother Saemund of Oddi. According to the *Saga of Gudmund the Good*, Saemund replied, "You know, brother, that Gudmund, the bishop-elect, has not been much of a friend to us," yet "many men praise him." He was generous, had high morals, and was chaste—a quality becoming increasingly important in a clergyman. "And there's this to consider, too," Saemund added. "The Northerners didn't ask our advice when they chose him; let them now take responsibility for what comes of it."

Wrote Bishop Pall to the bishop-elect, "God has chosen you to be bishop, as do we, and you have been truly chosen by God's law and man's, as conclusively as can be done in this country." Gudmund should, indeed, sail to Trondheim that summer to be consecrated, and, therefore, "it is most important that we meet as soon as possible," Bishop Pall said. "I have much pressing business to bring before the archbishop, and for this reason I ask you to come to meet me before you go abroad." Gudmund dutifully went south to see Pall at Skalholt "and picked up the letters that he was sending to the archbishop." What else might Pall have asked Gudmund to slip into his luggage? Perhaps a present from the bishop to his kinsman King Sverrir? We can only speculate, but we know from the *Saga of Ref the Sly* that an ivory chess set would have been a suitable gift for a king.

Gudmund asked his friend Hrafn Sveinbjornsson to accompany him to Norway. Hrafn is the chieftain who led the only walrus hunt mentioned in the Icelandic sagas, who traveled to Canterbury to present two walrus tusks to Saint Thomas, thus fulfilling his vow, and who died like a saintly martyr himself. His and Gudmund's voyage is recorded in *Hrafn's Saga* as well as in two versions of the *Saga of Gudmund the Good*.

They took passage on a Norwegian trading ship, bringing with them twenty other Icelanders; there was at least one woman on the ship, we're told. They sailed from the harbor at Gasir in the north of Iceland on July 14, but the winds were against them. They struggled east, were

blown west, then drifted, were becalmed, met a storm, and were driven out to sea.

They decided to circle Iceland and made it halfway around before "they ran into a northeast wind and were driven south across the sea, and spotted some islands in the Hebrides that they recognized: They had come to the islands called Hirtir." Now known as the Isles of Saint Kilda, the largest of which still bears the name Hirta, this archipelago lies forty miles west of Lewis, from where it is visible on a clear day. Immediately recognizable for their sheer-sided cliffs and stacks, the highest rising fourteen hundred feet out of the sea, the islands were named not for a saint (there is no Saint Kilda) but from the Norse words for "sweet wellwater." According to one version of the story, Gudmund came to land on Hirta and learned of the death of King Sverrir; the other versions say he did not hear the news until he reached Norway.

Traveling on from Saint Kilda, Gudmund and his party again met contrary winds. "They were carried southward from there through the Irish Sea, even south of Ireland, in stormy weather, and they could hear breakers crashing all around them." Gudmund heard everyone's confession. To avert shipwreck, he promised the church all sorts of things: a half mark of wax from every man, an ell of cloth from every sack, to send a man on pilgrimage to Rome. "Finally, they were borne back to Scotland and lay a few nights off the Point of Stoer." When they tried to pass Cape Wrath, the northwesterly tip of Scotland, one of the poets on board made a verse, which began: "The foaming sea is surging past; / off Cape Wrath now rages the south wind; / the towering seas are stronger than ever."

Gudmund's ship was blown back south through the Hebrides, and he begged Hrafn to take the helm. Says the saga, "Tomas Thorarinsson the priest remembered three times while they were sailing that night, that he said he could see nothing ahead of them other than land, and no one could tell if there was any passage through or not." Another poet made a verse: "The sail was stiff with frost and the cold waves roared." And a third: "The waves are dashing toward the stars."

At daybreak, Hrafn steered them into a harbor formed by a long sand spit between the small islands of Sanday and Canna in the Inner Hebrides, a little south of the Isle of Skye. It "is still one of the best

harbors in the Hebrides, and one to which fishermen head in storms," notes Scottish historian Rosemary Power.

And it is here in this safe harbor that the voyage of Gudmund the Good intersects with the story of the Lewis chessmen, for on Sanday the bishop-elect met the king of the Isles.

KING OF THE ISLES

Since Frederic Madden in 1832, scholars have used the story of the voyage of Gudmund the Good to argue that the chessmen arrived on Lewis by way of "an Icelandic *kaupmann* or merchant who carried these articles to the Hebrides or Ireland for the sake of traffic; and the ship in which they were conveyed being wrecked, these figures were swept by the waves on shore, and buried beneath the sandbank."

Other sagas confirm the North Atlantic's wild winds and wicked waves and the daily likelihood of shipwreck. On another voyage from Iceland to Norway, for example, a ship wrecked spectacularly in the Orkney Islands: "They were long at sea and the weather was terrible; they got utterly turned around. One day the waves washing over the ship were three times the size of before. Flosi said they were breaking on a shoal close to land. But the fog was thick, the storm grew until it became a blizzard, and they saw nothing before they were driven up on land one night. All the men were saved, though the ship was smashed to bits and all their goods were lost."

But the chessmen need not have ended up on Lewis entirely by accident. The place-names in the part of Lewis where the hoard was found are almost all Norse, though now spelled in Gaelic; two, in particular, mean "Bay of the Icelanders" and "Place of the Merchants." Western Lewis was clearly a stop on the Icelanders' trade route for centuries. It was also, for a time, the home of the king of the Isles.

The thirteenth-century *Chronicles of the Kings of Man and the Isles* date the founding of that kingdom to 1079 and its dissolution to 1260. Based on the Isle of Man, the kingdom included the Hebrides (when the earl of Orkney did not claim them) and parts of mainland Scotland (when the Scottish kings, likewise, were looking elsewhere). The kings of the Isles were not true kings: Like the earls of Orkney, they recognized

the king of Norway as their overlord. From 1153 on, they also recognized the right of the archbishop of Trondheim to oversee the Isles' churches. Still, except when the Norwegian king Magnus Bare-Legs was harrying in the islands between 1093 and 1103—earning his nickname by wearing kilts and begetting the future King Harald Gilli—the kings of the Isles ruled independently.

In 1187, as Godred, king of the Isles, lay dying on the Isle of Man, he chose his son Olaf as his successor. But Olaf was a boy. According to the *Chronicles,* the Manx preferred his older half-brother, Reginald. When Olaf came of age, Reginald gave him Lewis as his fiefdom. Olaf was not satisfied with Lewis—but not because it was poor or out of the way. By the twelfth century, Lewis had become an administrative center, overseeing an eighth of the kingdom. As archaeologists working in the Outer Hebrides have concluded, "These were not people on the edge," but thriving communities with international ties. Their "marginality" exists only in our imagination. Olaf was unsatisfied with Lewis simply because it wasn't enough: His father had bequeathed him the entire kingdom.

In 1207, Olaf came south to Man—perhaps with an army—to complain, and Reginald sent him over to the mainland to King William of Scotland, who promptly imprisoned him, probably at Reginald's request. On King William's death in 1214, Olaf was freed. He went on a pilgrimage to Compostela in Spain, then returned to Lewis with a wife of his brother's choosing. With the collusion of the bishop of the Isles, Olaf managed to swap this wife for one better bred: a daughter of the powerful Scottish earl of Ross. He forced Reginald to split the kingdom in 1223 and succeeded him in 1226.

In the summer of 1202, however, this Olaf was, like Gudmund the Good, storm-driven to Sanday. According to the *Saga of Gudmund the Good,* the bishop-elect went on shore and held mass. King Olaf attended, and afterward invited Gudmund to dine. Then Gudmund returned to his ship and in the morning sailed to Trondheim, this time with a favorable wind.

In *Hrafn's Saga,* the visit's a bit messier. This saga is thought to have been written by Hrafn's friend Berg or perhaps by the priest Tomas— both of whom accompanied Hrafn and Gudmund on the voyage. While

the bishop-elect was dining with the king, *Hrafn's Saga* says, the king's reeve boarded Gudmund's ship. He "demanded they pay the landing fee, according to Hebridean law, and calculated that they should pay twenty hundreds in homespun cloth, because there were twenty Icelanders on the ship." The Icelanders refused to pay, "because they reckoned they would have to pay the same in Norway."

The "Hebridean law" referred to here is the law of Norway, under whose jurisdiction the Isles then fell: The reeve is claiming the landing tax due when an Icelandic trading ship entered Norwegian territory. Whether he had the right to do so is debatable; some modern readers see it as a classic scam. The Icelanders, too, doubted the legality—so King Olaf increased the pressure: The dinner invitation became a kidnapping. When Gudmund rose from the table to return to his ship, the king's men barred his way. "The king said that they should give him his just dues, or else, he said, he would have to hold them." Word flew back to the ship. The bishop's men armed themselves and formed ranks on the seashore. Then Hrafn, the peacemaker, spoke up. "Hrafn said it was to be expected. He suggested they give the king something to show him honor." Might it have been a collection of ivory chessmen? If Bishop Pall had entrusted the Lewis chessmen to Gudmund the Good, with orders to deliver them to his kinsman King Sverrir, Hrafn certainly would have known about it. With King Sverrir dead and the bishop-elect in a fix, the chessmen could have offered the perfect solution.

In 1832, Madden concluded that "the number of sets" in the Lewis hoard "forbids us to regard them in the light of a present." But among the appropriate gifts for a king in the medieval Irish *Lebor na Cert*, or "Book of Rights," are weapons, jewelry, slave girls, hunting dogs, ships, and "sets of gaming pieces"—always multiple sets, so that many men can play at a time. That these sets became treasured heirlooms is clear from the thirteenth-century "Poem of Angus Mor MacDonald, King of the Isles." Of Angus's father, the poet says, "To you he left his position, yours each breastplate, each treasure, his hats, his stores, his slender swords, his brown ivory chessmen."

Leaving Sanday when the weather turned, King Olaf likely went home to Lewis. Perhaps he buried the chessmen for safekeeping when

he left the island in 1207 or 1223 to challenge his half-brother. We will
never know.

In fact, this whole story is only a flight of fancy. We can't say Bishop
Pall intended the Lewis chessmen for King Sverrir of Norway. We can't
say Gudmund the Good carried them on his voyage. We can't say King
Olaf of the Isles took them home to Lewis.

But so is every explanation of how the chessmen arrived on Lewis a
flight of fancy—even some that have been presented for many years as
fact. We can't say, as a 2002 book on *The Art of Chess* confidently does,
"In the late twelfth century a merchant stashed four chess sets and other
trade items in a hole on the Isle of Lewis, in the Outer Hebrides of Scot-
land. He never returned for his treasure." This merchant appears in no
medieval saga or chronicle. He is much more a fiction than are Bishop
Pall, Gudmund the Good, King Olaf of the Isles, or the masterful artist
Margret the Adroit, whose handiwork these chessmen might be.

If Margret made the Lewis chessmen at the behest of Bishop Pall
around the year 1200, many people other than Gudmund the Good
could have carried them from Iceland. Jon Smyrill, the bishop of Green-
land, traveled from Iceland to Norway in 1203, after spending a winter
at Skalholt with Pall. He then continued on to Rome, where he presented
Pall's apology for having supported the excommunicated King Sverrir.
Five years later, in 1208, Pall's son Loft traveled to the Orkney Islands
and Norway, giving and receiving gifts.

Equally, there were many people other than King Sverrir for whom
Pall might have intended the chessmen. Sverrir's illegitimate son, King
Hakon, took the throne in 1202 at the age of twenty and died at twenty-
two (possibly poisoned). Sverrir's nephews, Ingi and Hakon, whom Loft
Palsson visited, ruled from 1204 to 1217. Earl Harald of Orkney, under
whom Pall had served as a young man and upon whom he sat in judg-
ment in Norway in 1195, died in 1206, leaving the earldom to his three
sons; Loft Palsson may also have met them.

Archbishop Thorir was consecrated in Trondheim in 1205. For him,
says the *Saga of Bishop Pall,* Margret made a crozier "so skillfully that no
one in Iceland had seen such artistry before." She may also have made
the crozier discovered in the grave of the bishop of Greenland. A crozier
seems a more suitable gift for a churchman than a war game, but, as we

have seen, several of the churchmen Bishop Pall knew and corresponded with were leaders of armies. One, in particular, stands out. After King Sverrir's death, the king's fiercest enemy, Nikulas King's-brother, now the bishop of Oslo, sent Pall a heavy gold ring set with a precious stone, along with a large quantity of rare balsam. Gift-giving in the Norse world was an expression of status: A gift did not go unrequited. What might Bishop Pall have sent him in return? And where might it ultimately have ended up, owing to the vagaries of winds, waves, and warfare?

By placing the kings on the chessboard, the society in which the Lewis chessmen were created becomes clear. It was a world connected by sea roads; a world in which Iceland and the Isle of Lewis were not on the periphery but central; a world in which a campaigning king's by-blow (Harald Gilli, born in Ireland) or an indiscretion removed from court (Sverrir, raised in the Faroes) could become Norway's sovereign and found a dynasty. It was a world in which the roles of kings and bishops in the new Christian kingdoms of the North were still in flux, and one in which no one knew the rules of the game.

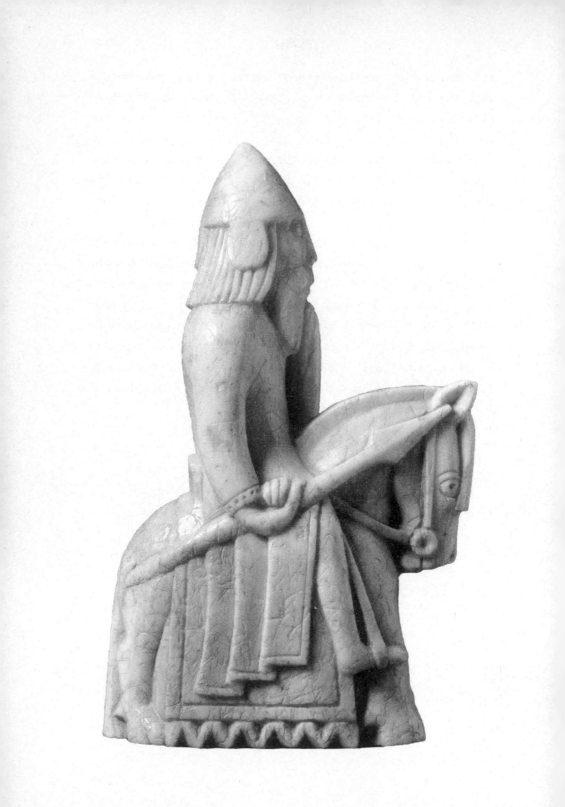

FIVE

The Knights

The knight is the last piece to place on the chessboard, for knights, as we think of them, *in shining armor,* were unknown in the North in the twelfth century. All of King Sverrir's many battles were fought at sea or on foot. Horses, to his warriors, were taxis to the battlefield, not war machines. The warhorse, or destroyer, that could carry a knight wearing sixty pounds of armor, with a lance weighing another forty pounds, the animal itself outfitted in heavy plate, did not yet exist.

In eleventh-century Italy, a Norman knight rode a horse so small his stirrups bumped the ground. French and English horses were no taller, as we can see from the Bayeux Tapestry, sewn about 1075 to celebrate the Norman Conquest. Crusaders' horses averaged thirteen hands high, or about fifty-two inches at the withers: pony size. In 1200, at the dawn of the Age of Chivalry (named from the French for horse, *cheval*), the common horse in northern Europe remained "uselessly small." "Great horses" of sixteen or more hands tall (sixty-four inches at the withers) would not appear until late in the century, after stallions from Central Asia or Spain or North Africa were imported and put to the biggest

native mares, and their foals led to graze on watery fens with calcium-rich limestone soil, their diets supplemented further with oats. Until this selective breeding regime took hold, a knight's mount resembled today's Icelandic horse, which has remained purebred since the twelfth century. Pony-sized, but strong and agile, Icelandic horses have no difficulty transporting large, heavy men, whose stirruped feet dangle well below the animal's belly. Even Icelanders acknowledge that it can look ridiculous. A popular cartoon, printed on postcards, shows an Icelandic rider wearing roller skates.

The chessmen's mounts look "misleadingly" like "stocky, docile ponies," experts say, and so furnish proof of their carver's sense of humor. But "stocky" and "docile" are not genetically linked—as anyone knows who's ridden an Icelandic horse. Plus, the chessmen's stockiness is functional. A chess knight must be easy to grasp, well weighted and stable, with few protuberances to snap off when the piece is dropped or thrown, or the board overturned in a pique. Artistic license also applies: If the horses' bodies are disproportionately small compared to their heads, so, too, are the tiny feet of the knights. A chess-piece carver working in walrus ivory, as well, must make a rectangular form (the horse) from an oval-shaped material (the section of tusk) to fit a square space (on the chessboard).

That the size of the horse is not simply a comic touch can be proved, finally, by comparing it to other chivalric images of the time. The knight's horse on the church door from Valthjofsstad, Iceland, carved in wood with no such restrictions, is significantly more fluid and graceful than the chessmen's mounts. But it is just as short—as are the horses on an early thirteenth-century enamel from Limoges, France, and a tapestry from Baldishol church in southern Norway. A horse in the *Hunterian Psalter*, an English manuscript dated before 1170, is a perfect match for the mounts of the Lewis knights. In each case, the rider's feet dangle down, way down, below the horse's belly.

The carver's sense of humor does peek through, however, in the horses' expressions. Like the dragon on Bishop Pall's crozier or the Lewis berserks, there's a touch of whimsy to them, as they peer from beneath their long, shaggy forelocks. Some even seem to be looking askance, as if to say, *What are we in for now?* Yet their manes are neatly roached or

braided. Their tack is quite exact. The arch in their necks and lack of tension on their reins show they are well trained; the prick of their ears shows they are alert—this artist was well acquainted with horses and their moods.

But how well was she acquainted with knights? Hers seem to wear no armor, only long leather coats. They carry leaf-bladed spears as long as their mounts. Some grip their spears overhand, some (quite awkwardly) underhand. Their stout swords are belted at their waists. From a strap across their shoulders hang kite-shaped shields marked with crosses and other geometric devices. Their helmets are of various shapes: cones, caps, kettles, buckets.

If we think of them not as chevaliers but merely as mounted warriors, the weaponry of our knights tallies well with Icelandic texts from about 1200. Abbot Karl in the *Saga of King Sverrir* describes the king riding a black horse and wearing "a good byrnie, with a stout leather coat over it"—the long coat thus hid the chain-mail shirt. He wore "a wide steel cap, such as the Saxons have," Karl continues. He had "a sword by his side and a spear in his hand." No mention of a shield. But in *Heimskringla*, from about 1230, Snorri Sturluson says another king rushing to battle "threw on his mail shirt and girded himself with the sword named Quern Biter, set on his head a gilded helmet, took a spear in his hand and a shield by his side." In *Egil's Saga*, which Snorri may have written as early as 1202, the hero's brother Thorolf "had a wide and thick shield, a strong helmet on his head, and was girded with a sword that he called Long, a sizable weapon and a good one. He had a spear in his hand; its blade was two ells long," about thirty-six inches. Egil, Snorri adds, "had the same equipment as Thorolf. . . . Neither of the brothers had a mail shirt."

Frederic Madden used these examples in 1832 to argue that the chessmen were made in Iceland. David Caldwell of the National Museum of Scotland is not convinced. Other than the shield-biting berserks, he says, "There's very little about the Lewis chessmen that you can pin down and say *that's* Scandinavian. What the Lewis chessmen are portraying is the contemporary kit."

If not *where* they were made, "contemporary" implies the knights' kit can tell us *when*. And to some extent, that's true. The knights' (and

rooks') shields rule out a Viking Age date: Viking shields were round; envision them ranked along the gunwales of a dragonship, brightly painted. One rare example, dating to the ninth century, was found when the Gokstad ship was excavated in Norway in the 1880s. Its painted leather cover was gone, but the wooden shield itself was strangely unde-cayed: It was round as the moon and a yard across.

The Lewis knights' shields are not round. Termed *kite-shaped*, they're roughly triangular—broad at the top and tapering to a point. Some have curved tops. Such shields are carried by the Norman con-querors in the Bayeux Tapestry; they went out of fashion in about 1200. Others have flat tops. The dragon-fighting knight on the Valthjofsstad church door in Iceland carries one like this (though his is petite). Flat-topped shields came into fashion about 1200 and soon went out again. In 1216, a German in Snorri Sturluson's household in Iceland gave fenc-ing lessons: The newfangled, small round bucklers protected the sword hand, not the torso, so the swordsman had to dart and dance, not stand stalwart and thwack.

Experts also deconstruct the designs on the shields' faces. Due to the lack of "obvious heraldry," no scholars date the chessmen later than the twelfth century. Most of the shields bear a simple cross of some kind, as do the shields in the Bayeux Tapestry and on the Valthjofsstad church door. Such marks are the precursors to heraldry, which became popular as a way of distinguishing one armored knight from another in the mid-1100s. The earliest datable coat of arms belonged to the Count of Anjou, Geoffrey Plantagenet, who died in 1151. His *lioncels rampant or, on an azure ground* appears on an enamel plaque on his tomb in Le Mans Ca-thedral and is described in a text from 1160. Dragons do appear on some shields in the Bayeux Tapestry, but true heraldry, in which each knight bears a unique coat of arms proclaiming his name and lineage, was not widespread until about 1200.

The shields, then, date the Lewis chessmen to between about 1150 and the early 1200s. But helmet fashions also changed. Most of the knights wear steel (or leather) cones: simple to make and fashionable from antiquity through the fourteenth century. Some helmets may have nasals—flaps to protect the nose. Caldwell and his co-author Mark Hall, who examined each chessman minutely for their 2009 study, saw

no nasals. Yet Madden, who studied the chessmen within a year of their discovery, did. In the Bayeux Tapestry, the Normans wear huge, unmistakable nasals: You wonder how they could see past them. The Valthjofsstad knight has a dainty one: It protects only half his nose. If there's a nasal on a Lewis knight's cap, it fits over his nose exactly, from bridge to tip. The only way the carver marked it is by the absence of a single cut: Of the eleven knights wearing conical caps, seven seem to be missing a two- to three-millimeter-long groove across the bridge of the knight's nose. These seven knights might wear helmets with nasals; the other eight knights and the eleven helmeted rooks do not.

The flaps over the ears and nape of the neck on the knights' conical helmets are, by contrast, unmistakable. They're not, like the nasal, standard helmet design. Caldwell and Hall located only one parallel, from the portal of the main door of a wooden stave church, dated between 1170 and 1200, that once stood in Hylestad, in the far south of Norway. "It shows Sigurd the Dragon-Slayer with a conical helmet provided with protective pieces at side and rear," they write, "but also a nasal."

Protective pieces is a bit of an exaggeration for these tiny flaps: Sigurd's ear is completely bare. The Lewis knights' helmets, by comparison, sport big lappets. They look like Peruvian *chullo* caps. Plus, Sigurd's ear flaps appear on his helmet in only one of the three scenes. They might be curls of hair. The neck flap appears only when the nasal does not—it seems Sigurd swiveled his conical cap to make it easier to eat the dragon's heart.

Instead of conical caps (with or without flaps and nasals), some of the Lewis knights wear helmets that look like bowler hats. These, paired with spears and round-topped shields, can be seen on the upward of eighty Vikings cramming one ship in an illustration for the *Life of Saint Aubin* in a French manuscript from about 1100.

But one odd Lewis knight, in rather bad condition, wears a "carinated, flat-topped kettle-hat." A rook, in good condition, wears the same style. *Carinated* means it has a horizontal keel-like ridge. It looks like a lampshade. Caldwell and Hall found a close match to these helmets in an illustration from the Book of Saul in the Crusader Bible, made in Paris between 1245 and 1255 and now in the Morgan Library in New York.

The Lewis chessmen must have been made in a town like Trond-heim, Caldwell and Hall argue, since the carver had "a good under-standing" of a knight's clothing and weapons and so must have seen a king's retinue. But did the carver have such an understanding? These knights are not wearing a standard uniform. They've come to this battle wearing the best they could scrounge. They've all got the basic kit, true. But some are wearing antique steel caps and carrying their grandpa's shields, while others sport the very latest kettle-hats. Such a hodgepodge of styles would be typical of Iceland, where for hundreds of years young men routinely spent a few years at the Norwegian court, then returned to Iceland with the weapons and armor they'd won.

Gauging just from shields and caps, some of the Lewis knights could have been made as early as 1075, like the Bayeux Tapestry, others as late as 1255, like the Crusader Bible. They could have been carved in Ice-land, Norway, England, France, Scotland, or anywhere in between. They could be serious portrayals of mounted warriors or spoofs of knights. They could be the work of one carver, or many, collected over a span of years. The Lewis knights raise more questions than they answer.

THE HOUSE OF THE BLACK WOMEN

On Lewis today, huge wooden replicas of the chessmen greet you at the airport in Stornoway, at the Uig Historical Society, at the whisky distill-ery in Carnais, and down the road toward the campground in Ardroil, where the chessmen were found "buried fifteen feet under a bank of sand" at the head of Uig Bay.

Or, some say, they were found six miles away at the "House of the Black Women," thought to be an ancient nunnery, "in a vaulted room."

There was a shipwreck—and a murder.

They were dug up by a cow, or a cow fell into a hole, or a wild storm scoured the dunes and exposed a strange ovenlike cist out of which a bevy of little elf faces peered.

In a 1997 British Museum booklet on the chessmen, curator Neil Stratford reprints nine early reports of their discovery; their conflict-ing accounts, he notes, "produce in the reader a mounting sense of the power of legend over historical truth."

The Isle of Lewis is, indeed, a land of legends.

The verbal embroidery was evident early on. In Edinburgh on April 11, 1831, the Society of Antiquaries of Scotland examined, "by permission of Mr. Roderick Pirie of Stornoway, a number of figures carved in ivory, apparently chessmen and of Scandinavian workmanship in the Middle Ages, which were lately found buried fifteen feet under a bank of sand in the Island of Lewis," the meeting minutes say, adding, "Some extracts of a letter regarding the discovery of these interesting curiosities were read to the Society." Two years later, when antiquarian David Laing went looking for the letter, it was lost. "It is evident," he complained, "that to serve some purpose, contradictory statements were circulated by the persons who discovered or who afterwards obtained possession of these chessmen, regarding the place where the discovery was actually made."

Regarding the number of pieces in the hoard too.

Fredcric Madden, the assistant keeper of manuscripts at the British Museum, treasured the chessmen from the moment he saw them in October 1831. He wrote in his journal: "If our Trustees do not purchase them, I fear the sets will be broken up and sold separately, which will be a great pity." The trustees did buy the hoard—all forty-eight face pieces, nineteen pawns, fourteen checkers, and the buckle—for £80, from an Edinburgh watchmaker and jeweler named T. A. Forrest.

Madden, ecstatic, published a voluminous treatise on them and their place in the history of chess. Describing their finding, he quoted a Scottish newspaper from June 1831:

> Some months ago, a very curious discovery was made in the parish of Uig, Isle of Lewis, which must prove highly interesting to Scottish antiquaries. A peasant of the place, whilst digging a sand bank, found upwards of seventy pieces of bone, most of them representing Kings, Bishops, and Knights, dismounted and on horseback. The figures are of excellent workmanship; and, judging from the costume, certainly of very remote antiquity. That they were originally carved for the ancient purpose of Chess-play, seems the most probable conjecture, and had been destined to relieve the sadness of cloistered seclusion; for they were discovered near the ruin known to have been a nunnery,

and still named *Taignir collechin dugh an Uig,* the House of Black
Women in Uig.

Unbeknownst to Madden, the sets had already been broken up. Though
the Society of Antiquaries of Scotland had talked about buying the
chessmen when they were exhibited in Edinburgh, "by some oversight
or delay, this arrangement was frustrated," Laing wrote in 1833. Only
Charles Kirkpatrick Sharpe, an Edinburgh antiquarian of "exceptional
connoisseurship" who "lived in and for the past," did not let the op-
portunity slip by. A painter of portraits and caricatures, a dabbler in
poetry and playwriting, and editor of the "standard history of witch-
craft in Scotland," according to the *Dictionary of National Biography,*
Sharpe apparently kept his purchase a secret. After Madden's trea-
tise came out, however, he showed Laing his collection of two kings,
three queens, two bishops, one knight on horseback, and two standing
knights, "one biting his shield." He also shared a receipt stating that
Roderick Ririe (not Pirie, as the society's minutes spelled the name)
had deposited a total of ninety-three ivory pieces into the Edinburgh
watchmaker's keeping, of which Sharpe had bought ten. An eleventh
piece, a bishop, later found its way into Sharpe's collection under mys-
terious circumstances.

Upon Sharpe's death in 1851, his chessmen were sold at auction
to Albert Denison, Lord Londesborough, who at £105 outbid both the
Society of Antiquaries of Scotland and the British Museum. When
Londesborough's estate was sold in 1888, the society finally prevailed,
purchasing the eleven chessmen for £100 ("less than half the expected
price"), with the British Museum graciously abstaining. These are the
eleven Lewis chessmen now displayed in the National Museum of Scot-
land in Edinburgh.

Sharpe also connected the House of the Black Women with the
chessmen, but he changed the newspaper's "sand bank" into the kind of
underground storeroom that archaeologists now call a souterrain. "They
were found in a vaulted room (as it was described to me)," Sharpe wrote,
"about six feet long; they were slightly covered with sand, and there was
a quantity of ashes on the floor. I could not learn whether there was
anything like a chimney. The room is near a spot where tradition affirms

a nunnery once stood. The name of the place in Gaelic signifies, 'The house of the black women.'"

Teagh na n cailichan dou, the house of the old black women, was placed on the map in 1795 by the minister of Uig Parish, Hugh Monro. A mild and easygoing preacher, Monro kept "a respectable distance from the conscience and daily life of his parishioners," said some, and was "ignorant of the gospel, and of the nature of true godliness," according to others. He built the manse at Baile-na-Cille (Gaelic for "Place of the Church") at the head of Uig Bay and preached in Uig Parish for forty-six years. He encouraged competitions in "putting the stone," or shot put, on Sunday afternoons. Once he announced from the pulpit that a pod of whales had been sighted: "Out of here, out of here every one of you. The whales have come into the bay. You can get a sermon any time, but you cannot often get the whales."

Like all Scottish ministers, Monro was required to file a "Statistical Account" of the parish; his, from 1797, displays an antiquarian bent. The name "Uig," he wrote, means "a solitary place, much sequestered from the public eye; which seems to apply with particular propriety to the local situation of this parish." Uig is, indeed, a good thirty miles over the moor from the town of Stornoway, where the ferry from mainland Scotland lands. But the name does not signify remoteness. Monro failed to see that "Uig" came from the Norse *vík,* or bay, though he noted that several farm names in the area "derived from the Norwegian or Icelandic tongues, such as Kenvick, Kirkibost, etc." and that the sea loch penetrating to the heart of Uig Parish "abounds with safe places of anchorage, sufficient to hold the whole British navy, nay, I may say the navy of Europe."

Monro was so struck by the ancient "druidical place of worship" in his parish—the ring of Standing Stones at Callanish—that he attached a diagram of it to his report. He described the ruined fourth-century broch at Carloway, built of "a double wall of dry stone," precisely: "It is, perhaps, the most entire of any of the kind in Scotland; it is very broad at the base, and towards the top contracts in the form of a pyramid; the height of the wall is thirty feet; the fabric is perfectly circular." He thought it was a Viking fortress. He did not describe "the house of the old black women" at Mealasta but merely called it "the

remains of a nunnery." No church records mention it. The Gaelic term *black women* could as easily describe widows (or witches) who dressed in black, or even a family of women with dark hair. An Ordnance Survey map from the 1850s marks Mealasta as "the place where chessmen were found seventy years ago." But if the Lewis chessmen were indeed found in the 1780s, the Reverend Monro was not informed—it's certainly the kind of historical tidbit he would have added to his *Statistical Account.*

That mysterious name, House of the Black Women (lacking the "Old"), remains on the map at Mealasta. It marks the very farthest western edge of Uig Parish, at the end of a winding one-lane road clinging to the sea cliffs. But in the 1200s, when trade traveled by the sea road, it was not at all remote. A brisk current off the Gulf Stream brought ship traffic into Mealasta's small bays; even now, coconuts (and drowned sailors) are known to wash ashore on its headlands. Its sandy, fertile machair fields, now fallow, once grew barley: A brief archaeological survey in 2011 produced one barley grain carbon dated to the twelfth century. Sheep still graze in the hills and on an uninhabited island close enough that cows could swim over to it. The best stones from the ruins have been scavenged over centuries to build dwellings and sheep pens. Lately rabbits—alien to the Outer Hebrides—have riddled the landscape with their holes. What remains is a maze of long hummocks and drainage ditches and evocative stone walls. Hanging onto the land's end is a little cemetery with what seems to be a chapel's foundation. Skeletons wash out of the dune-face beneath it. On any given day, walking past, you might pick two bits of skull and a chunk of arm bone out of the mouth of a rabbit burrow. A hiker in 2003 found a copper ring inscribed with crosses; now in the museum at Stornoway, it was dated stylistically to the twelfth or thirteenth century.

The name Mealasta—like 80 percent of the farm names on Lewis—is originally Norse: from *Mel,* a sandy hill covered with bentgrass, and *staðr,* or homestead. Nearby is Islavig, from *Íslendingavík* or bay of the Icelanders, and Mangersta, from *Mangarastaðr,* homestead of the merchants. Part of a Viking-style oval brooch and pieces of Norse pottery were found at Mangersta, eroding out of the cliffs, but the area has never been systematically excavated.

Neither has Mealasta. The National Museum of Scotland commissioned the quick survey that found the barley grain, and David Caldwell argues that Mealasta is the original findspot of the Lewis chessmen. Backing up the tale of the nunnery, an earlier survey found evidence of a souterrain at Mealasta, though its location has since been lost. But the cist in which the chessmen were secreted was not, Caldwell believes, beneath a nunnery: It was under a chieftain's house or perhaps even the royal estate of the king of the Isles. Summing up the latest archaeological findings, he said, "Mealasta looks like it was quite an important place in the medieval era. There's clearly a settlement here that goes back to the twelfth century. We don't know where the main centers were on Lewis," he added. "This could be such a place."

Yet according to Mary MacLeod Rivett, a former government archaeologist for the Outer Hebrides, such underground cists appear all over the Isle of Lewis. Though earlier than the Viking Age, they are often discovered near Norse place-names or medieval archaeological remains. "I can point out to you twenty other sites that have all those same factors," MacLeod Rivett said. She agrees that Mealasta was once important. "You have layers of occupation there from Neolithic times to the nineteenth century." But was it a center of power in the twelfth century? And was it the main one in Uig? She concluded, "I don't think there's enough evidence from Mealasta for David Caldwell's argument, about it being the findspot for the chessmen, to stand up."

THE COW AND THE ELVES

In the absence of scientific evidence, MacLeod Rivett prefers to stick with the story she was told as a child, visiting her aunt on the shores of Uig Bay. That story features a farmer named Malcolm MacLeod (no relation to Mary), his cow, his peat creel, his shrewd and uncompromising wife, his superstitions, and the winter storms that layer sand over the fields on the west coast of Lewis, creating the fertile machair soil and burying whole ancient villages—or, if the wind comes from another quarter, peeling the turf off a Viking Age graveyard, as happened just down the road, where the two teenagers on holiday in the early 1990s discovered a skull.

Three miles from side to side, at low tide Uig Bay glitters silver and gold, the sun coloring wet sand and dry; as the tide rises, ribbons of water band it in turquoise before it all turns an even ultramarine blue. Inland, beyond a rank of angular dunes once quarried for sand, is the estate of Ardroil. A handful of houses surrounded by hilly pasture, Ardroil was established just after the chessmen were found, by clearing the tenants out of their homes in five townships. The name in Gaelic, Eadar dha Fhadhail, means "between two fords." There's not a tree in sight. Behind the hunting lodge, erected by the landlord in the mid-1800s, the mountain of Suainaval rises fourteen hundred feet, a massive rumpled gray mound, as if made of giant clumps of uncleaned wool.

If the Lewis chessmen were secreted in a souterrain beneath a king or chieftain's house, then Ardroil, on the edge of Uig Bay, is just as likely as Mealasta to be the center of power. This bare and open landscape is the result of nine thousand years of burning and grazing: The earliest signs of settlement on Lewis are microscopic particles of charcoal, evidence of when the island's original covering of scrubby trees was burned to make grasslands for red deer. The first settlers seem to have herded these deer, like the Sami in Lapland did reindeer.

Stand on the dunes near the chessmen's traditional findspot and the later history of Uig Bay comes to life. Sweep your eyes slowly from east to west, from inland out to sea: There, a little island has a broch on top, a drystone Iron Age tower; the word *broch* comes from the Norse for fortress, *borg*, though the building long predates the Viking Age. A line of stones is a causeway connecting the broch to a headland, under which lies a Bronze Age cairn. By the shoreline sit the schoolhouse and the Church of Scotland manse at Baile-na-Cille, both dating from the eighteenth century. Beyond the manse's garden wall is a chapel and circular graveyard dating from time out of mind; one stone has been identified as a holy water stoup. Around the year 1000, small chapels surrounded by circular cemeteries were being built in Iceland and Greenland, patterned on Celtic ones like this. A hump beyond the cemetery marks another Bronze Age cairn. On the next headland, beside an important salmon river, archaeologists found a Viking Age boathouse, or *naust*. In the middle of the salt marsh is a ritual site from the early Iron Age: Excavating it, scientists uncovered "a heap of cremated bone in the middle."

Though no records exist of who was here in the twelfth century, by the fourteenth the chieftain of Clan Macaulay lived on that headland across the sands; in the sixteenth century, Clan MacLeod was headquartered on an island just offshore. For a center of power, concluded MacLeod Rivett, "this is a reasonable context. It's an area of high-status settlements, and it had an early church. If I had to put a pin on the map to locate the owner of the Lewis chessmen, I'd put it here."

So do the stories the locals have always told. Comparing them provides a lesson in how a legend grows.

The earliest version comes from a manuscript left by Donald Morrison, known as *An Sgoilear Bán,* or "The White Scholar," who died in 1834. Called "The Red Ghillie," it involves Big George Mackenzie, the tacksman, or overseer, of several tenant farms at Baile-na-Cille in the early 1600s. He was "a rich as well as a valiant man, a powerful swordsman, and a dexterous marksman with a bow," according to Captain F. W. L. Thomas of the Royal Navy, who summarized Morrison's tale in a letter to the Society of Antiquaries of Scotland in 1863. Big George pastured cattle "at a remote shieling in the southern end of the parish, called Aird Bheag, near the entry to Loch Resort. Mackenzie employed a young man to herd the cattle there; and on a stormy night, a ship was driven ashore at Aird Bheag." The young man, known as the Red Ghillie, killed a survivor of the wreck and stole his bag, which unaccountably was filled with little ivory figurines. The Red Ghillie buried his loot, then ran home to inform his employer of the wreck. Rather than plundering it, as the herdsman expected, Big George rescued the remaining sailors and banished the Red Ghillie, who "went on from bad to worse until, for his abuse of women, he was sentenced to be hanged on the Gallows Hill at Stornoway. When he was brought forth for execution, he told of many wicked things which he had done, and, among others, how he had murdered the sailor, and where he had buried the images." Two hundred years passed without anyone bothering to dig them up. Continued *An Sgoilear Bán,* "Thereafter, in AD 1831, Malcolm MacLeod, tenant of Penny Donald, in Uig, found upwards of eighty of these carved relics; and those images were sold in Edinburgh by the late Captain Ryrie, for £30, for the above Malcolm MacLeod."

"Needless to say," write Caldwell and Hall, "there is no record of this tale being told prior to 1831."

MacLeod Rivett agrees that the shipwreck and murder—though they may have happened—probably have nothing to do with the Lewis chessmen. "It's two stories that were conflated. One is the story of the boy who escaped the shipwreck with treasure," only to be foully murdered. "The second is the finding of the chessmen. The story of the finding I heard from my relatives." She believes it to be true, in the way of oral folktales—exaggerated, perhaps, but with a factual basis—because "there were specific names associated with it, specific individuals."

But "very little is known about Malcolm MacLeod, the hoard's finder," Caldwell and Hall counter. "Indeed, the first time his name is actually recorded is in 1863, and none of the nineteenth-century experts who wrote on the hoard seem to have had the opportunity to meet or to discuss his discovery with him."

That oversight may be due to the Clearances. Following the fashion throughout Scotland, Lewis's landlord thought large sheep ranches could be more profitable than diversified farms like Penny Donald, which, according to a tally in 1824, had sixty-eight cattle, ninety-seven sheep, and eleven horses, looked after by several farm families. In 1840, Penny Donald was cleared—emptied of people and livestock—to make the estate of Ardroil. Malcolm's family and their neighbors were moved to the far north of Lewis, at Ness. Eleven years later, they were shipped from there to Canada, the landlord booking their passage whether they wanted to emigrate or not. The people of Mealasta—cleared in 1838— were shipped to Canada as well. Altogether, more than four hundred people from Uig Parish were sent away.

Who knows if the missing pieces from the four Lewis chess sets— one knight, four rooks, and forty-four pawns—might have been carried to Canada as souvenirs? Perhaps they were refashioned into handles for knives or letter openers, like a later walrus-ivory bishop that archaeologists found when excavating a ruined Danish monastery in 1996. The pawns, especially—slender octagons decorated with pretty knotwork designs—were easy to adapt to such practical uses.

In 1851, after nearly everyone in Uig who knew about the chessmen had left, Daniel Wilson of Edinburgh published a new version of their discovery. In *The Archaeology and Prehistoric Annals of Scotland*, he provides another reason no one knows much about Malcolm MacLeod:

What educated antiquarian would stoop to interview the greedy, dim-witted (and Gaelic-speaking) peasant Wilson describes here?

In the spring of 1831, the inroads effected by the sea undermined and carried away a considerable portion of a sandbank in the parish of Uig, Isle of Lewis, and uncovered a small subterranean stone building like an oven, at some depth below the surface. The exposure of this singular structure having excited the curiosity, or more probably the cupidity, of a peasant who chanced to be working in the neighborhood, he proceeded to break into it, when he was astonished to see what he concluded to be an assemblage of elves or gnomes upon whose mysteries he had unconsciously intruded. The superstitious Highlander flung down his spade, and fled home in dismay; but incited by the bolder curiosity of his wife he was at length induced to return to the spot, and bring away with him the singular little ivory figures, which had not unnaturally appeared to him the pigmy sprites of Celtic folk-lore.

In 1914, the story was enhanced even more, with the introduction of the greedy and stupid peasant's cow. According to the ninth report of the Royal Commission on Ancient and Historical Monuments and Constructions of Scotland (published fourteen years later), the souterrain in which the chessmen were hidden was "exposed by a cow rubbing itself against a sandhill." From then on, the cow was central to the tale.

Donald MacDonald, a retired medical doctor, collected folktales until his death in 1961; they were printed in 1967 as *Tales and Traditions of the Lews*. Of the chessmen, he wrote:

One day in 1831, Malcolm MacLeod of Penny Donald, known as Calum nan Sprot, was herding his cattle along the sand dunes when he saw one of the beasts rubbing itself against a sand bank and acting in a queer manner, so he went along, and saw her pull out some whitish objects with her horn. He lifted some of them up and examined them and took them to be idols or graven images of some kind which he did not understand. A gentleman from Stornoway heard of their discovery and came over and dug out all the pieces, for Calum nan

Sprot would meddle no more with them. There were eighty pieces in all, and when they were put into a creel they made a substantial burden for a man.

Here the peasant comes off a bit better—more religious than superstitious, and no longer greedy—while his bold wife is replaced by a gentleman from Stornoway, possibly the Captain Pirie, Ririe, or Ryrie mentioned in several accounts as having brought the chessmen to Edinburgh. Note, however, that a modern estimate of the weight of that "substantial burden" is a little over three pounds.

The most recent version—published as an audio file on the Uig Trails tourism website—brings all the threads together in under three minutes. The storyteller, Finlay MacLeod, was "born and bred in Lewis and spent my life thinking about it," he wrote. "I have been collecting the oral traditions of Lewis for a long time and I drew on this for the Uig stories. I didn't have to script them and just recorded them all at the actual scene of the stories, in both languages"—Gaelic and English.

He recorded this tale while standing beside the wooden statue of the Lewis king at the edge of the campground in Ardroil. MacLeod begins, "At this spot was found what is probably the most famous element connected with the district of Uig, and that's the Uig chessmen or, as they're sometimes called, the Lewis chessmen." He introduces Malcolm MacLeod and his cow: "In 1831, a local crofter here, Calum MacLeod from a village just nearby, had his cow grazing in this valley here running down to the beach." The cow, as in MacDonald's version, does something queer: "His cow was supposed to have been digging with its horn into the sandbanks here" and opened up a souterrain. Calum "saw a number of yellowish figures" (not whitish ones) "inside what seemed like a little enclosure of stone." Then, omitting both the bold wife and the gentleman, the storyteller says that Calum on his own "was supposed to have gone home and come back with a creel." He "put ninety-three pieces of ivory into his creel"—the number of pieces we now have from the hoard, not necessarily the number Calum found. A nod toward the elf motif comes next: "Some people say he thought they were fairies and he was a bit afraid of them." Unlike any of our previous storytellers, however, Finlay MacLeod then describes the stir the chessmen

created in the neighborhood, and the crippled woman who was carried over the sands to see them in Calum's barn. The chessmen were sold for £30, "and Calum is supposed to have got that money," as well as a new name, Calum nan Sprot: "They nicknamed [him] Calum of the Spikes because of how he found these supposed spikes." Presumably "spike" is a reference to walrus tusk. As for why no one has a tale from Malcolm MacLeod himself, Finlay MacLeod (no relation) says that Calum "did not live long after '31." And "his family, along with all the families from the villages around here, was cleared from here in 1840."

When Mary MacLeod Rivett told the story one afternoon in 2014, standing on the dunes at Ardroil, she gave it an added twist—the cow had not just opened up the souterrain, it had fallen in, as a tractor and hay baler had done not too long ago in a field in North Uist, two islands south. Nor did MacLeod Rivett forget Malcolm's wife: "Calum MacLeod went out after dark to rescue his cow. He put the light down, saw all these little faces, and went rushing home," she said. "His wife was much braver and collected them all."

Storytellers tell stories, they don't itemize facts. Embellishments and exaggeration are part of the fun—they seldom confuse the story's intended audience. Edinburgh elites laughed at the timid Uig cowherd fleeing from fairy faces in 1851. Uig locals applaud his courageous—and practical—wife today.

The stories will never permit us to choose between Ardroil and Mealasta as the actual place where the Lewis chessmen were found. As Caldwell and Hall emphasize, "None of the writers of the published reports"—from the nineteenth century—"appears to have visited the findspot or have had any familiarity with Lewis." And none of the local storytellers today is ignorant of those published reports.

BAILE-NA-CILLE

All the accounts do, however, link the chessmen with Uig. The name in the 1830s referred to the parish, not just to the bay, an area of over two hundred square miles. Adventurers who came no further than Callanish and its famous "Druidical ring" of Standing Stones would say they'd been to Uig. And they had, indeed, crossed into the parish. But to reach

Uig Bay took a fifteen-mile ferry ride down Loch Roag, then a four-mile walk through the peat bogs above Valtos Glen to the manse at Baile-na-Cille. At low tide, the findspot at Ardroil would be a mile from there across the shining sands. The House of the Black Women was another six miles south. Still, for someone from Edinburgh, the House of the Black Women at Mealasta was "near" the Ardroil findspot and the likeliest ruin for an antiquarian to choose. Frederic Madden reached that conclusion in 1832. He wrote, "A private letter from Edinburgh states the story of the nunnery to be fictitious, but that a ruin of some note exists not far from the spot where these chessmen were found."

The accounts also link the chessmen with the Reverend Alexander MacLeod of Baile-na-Cille. "In 1831," said the Reverend MacLeod, reporting on Uig Parish for the 1833 *Statistical Accounts of Scotland,* "a considerable number of small ivory sculptures resembling chessmen, and which appeared to be of great antiquity, were found in the sands at the head of the bay of Uig, and have been since transmitted to the Antiquarian Society at Edinburgh."

Any such treasure found in Uig Parish between 1824 and 1843, when Alexander MacLeod was minister, would have made its way to the manse. For the Reverend MacLeod "ruled like an autocrat," writes a church historian. A founder of the Free Church of Scotland, Alexander MacLeod was an evangelist. He disapproved of ball games, colorful clothes, and "doing one's best." In his *Statistical Account* he was proud to say of Uig, "The people have hardly any public games or amusements of any kind. Their improvement, of late years, in religious knowledge, has been very perceptible, and has taught them to be contented with their circumstances and situation in life."

Comfort, to his two thousand or so parishioners, meant "a house, with plenty of peat, some grain, one to five cows, and a few sheep," wrote a visitor in 1841. Comfort, to the Reverend MacLeod (who kept twenty cows), was an illusion. A few months after arriving in Uig, he said of his congregation, "They seemed to be much afraid and astonished at the truths delivered, yet seemed at a loss to understand what they heard. . . . Their hope of salvation was based on good conduct, doing their best. . . . This shows that the polluted remains of Popery was the only notion they had of Christianity." A year and a half later, he remained eager to

reform them. On Christmas Day 1825, he preached from Matthew 28, verse 5. He wrote in his journal, "When I came to the practical applications of the discourse, and showed that the words 'fear not' were turned vice-versa to all unbelievers, and that their fears and terrors, terrors unspeakable, would never terminate through the rounds of eternal ages, if the offers of salvation were rejected, you would think every heart was pierced, and general distress spread through the whole congregation. May it bring forth fruit."

MacLeod fenced the communion table—literally put a fence around it, as strict Calvinists did. Only those deemed worthy could partake of the sacrament. Whereas his predecessor, the whale-hunting Reverend Monro, had served communion to eight hundred or a thousand people, twice a year, MacLeod served only six. "The whole of the unworthy communicants kept back," he reported in June 1827. "The congregation was much impressed the whole day." All Monday people came to the minister asking "who had spied on them, as the secrets of their hearts were revealed from the pulpit." The revelation came not from men, MacLeod declared, but from the Lord God Almighty. One communion Sunday in 1828, nine thousand people assembled to hear the Reverend MacLeod preach. The church being much too small to hold them all, he stood on the hillside before it. No record tells how many souls he invited in to the Lord's table that day. But a minister who heard him "fencing," as the practice was called, on another occasion remarked, "He debarred everyone in the congregation; he debarred me, and in my opinion he debarred himself."

Imagine the mental state of the cowherd unfortunate enough to unearth the Lewis chessmen—with those sixteen bishops!—in this anti-Catholic atmosphere of eternal terror. No wonder he "flung down his spade and fled home in dismay" and "would meddle no more with them." If his bold wife went back and filled the peat creel with the figurines, it wouldn't be long before she was shamed into delivering them to the doorstep of the tyrannical Reverend MacLeod. No objects in Uig Parish in 1831 so smacked of popery—not to mention sinful "games or amusements"—as the Lewis chessmen did. They were quickly "transmitted to the Antiquarian Society," as MacLeod wrote, to be sold.

The reverend, who could see the findspot at Ardroil out his study window, makes no mention of the £30 the chessmen fetched. Thirty

pounds was more than the schoolteacher in Uig, an educated man, made in a year. In his journal, the Reverend MacLeod brags of raising just £16 one year for the school: "Considering the circumstances of the people, I bear testimony that their liberality and zeal in this case have cause to provoke very many to similar duties. It was most delightful to see the hoary head, and the young scholar of eight or nine years, joining in this contribution." If the £30 landed in the pocket of Calum nan Sprot, the money was not idle long.

TWO KNIGHTS

Six months after they were exhibited to—and not purchased by—the Society of Antiquaries in Edinburgh, all but eleven of the Lewis chessmen turned up in London. Their price tag was considerably revised from the original £30. On October 17, 1831, just a year before he died, Sir Walter Scott wrote in his journal, "The morning beautiful today. I go to look after the transcripts in the [British] Museum and leave a card on a set of chessmen thrown up by the sea on the coast of Scotland which were offered to sale for £100."

To Sir Walter Scott is traced the "zeal for archaeological investigation" that spread through Europe in the mid-1800s. It was Scott who taught "all men this truth," proclaimed Thomas Carlyle in 1840, "that the bygone ages of the world were actually filled with living men."

As influential as Scott might be, he could not buy the Lewis chessmen in 1831: He was, surprisingly, bankrupt. His Scottish romance, *Waverly,* had been wildly successful, clearing £2,000 in its first year. Both *Rob Roy* and *Ivanhoe* were immediate best-sellers when they came out: 10,000 copies, priced at a little under half a pound apiece, sold in two weeks. But then came the financial crisis of 1825. It cleaned out Scott's publisher, and Scott, as a partner in the firm, was stuck with debts of £120,000. He sold his Edinburgh home. He sold the copyrights of his novels. He even sold the original manuscripts: *Waverly, Ivanhoe,* and *Rob Roy* combined brought only £80—not even enough to buy the Lewis chessmen.

Scott was also in poor health. Sixty years old, he had suffered a number of strokes, was plagued by gallstones, and needed a brace to support

one leg. As he wrote in his journal on the first of the year, 1831, "I cannot say the world opens pleasantly with me this new year. I will strike the balance. There are many things for which I have reason to be thankful." Yet a few days later, he was feeling as "gloomy as the back of the chimney when there is no fire in it. My walk was a melancholy one, feeling myself weaker at every step and not very able to speak." He was on his way from Edinburgh to the Isle of Malta for a health cure, a trip from which he would not return, when he stopped in at the British Museum.

Sickness or shame about his finances or both kept Scott from seeing the chessmen while they were in Edinburgh—even from examining those eleven purchased secretly by Charles Kirkpatrick Sharpe, his lifelong friend. But in London, Scott was sent a special invitation by the assistant keeper of manuscripts at the British Museum, Frederic Madden, who was in the process of convincing the museum to purchase the Lewis hoard.

Both avid antiquarians, Scott and the thirty-year-old Madden also shared an interest in Icelandic literature. Scott's novels teem with Norse valkyries, berserks, dragons, werewolves, elves, dwarves, ghosts, seers, magic runes, and magic swords. His library, which he refused to sell to settle his debts, contained nearly everything on Icelandic literature then available. In 1813, he published a translation of *Eyrbyggja Saga* that has been called the first English edition of an entire saga. (It has also been called "distorted," full of "crass errors," and "ponderous.") Some scholars say it inspired Scott to complete *Waverly,* which he had started in 1804 and stuck in a drawer for ten years. The sagas clearly inspired his 1821 novel, *The Pirate.* Set in the Shetland Islands around 1700, the story features a seer whose description was cribbed directly from the *Saga of Eirik the Red.* Scott's seer, in turn, writes one critic, "was much imitated by later novelists treating old northern themes—the glass beads, calf-skin shoes, goat's-milk gruel, or their equivalents appear time and again" and contributed to the nineteenth century's "romantic sense that the old north was misty, mysterious, and sublime."

Icelandic sagas were also on Madden's mind when he first saw the Lewis chessmen. In February 1831, he spent two weeks at Cambridge transcribing an odd manuscript for the earl of Cawdor: It was the only known copy of the Middle English romance "William and the Werewolf."

A rollicking tale, originally in French, it tells of the infant Prince William who is snatched up by a wolf and carried away. The wolf turns out to be a prince himself, under an evil spell, who had overheard a plot to kill young William; after many adventures, the spell is broken and the two princes reclaim their thrones. The werewolf theme sent Madden to Scott and to the Icelandic sagas. It crept into southern Europe, he wrote, "through the medium of the Northmen, among whom, as appears from various authorities, it was very general. A curious story of a *were-bear* in Rolf Kraka's Saga is quoted by Sir Walter Scott, which has some slight features of resemblance with our werewolf, and it is singular that this metamorphosis should have been accomplished by striking the person transformed with a glove of *wolf-skin*. In the *Volsunga Saga*, also, chapter twelve, we read of the similar change of Sigmund and Siufroth into wolves."

Madden's edition of "William and the Werewolf," printed privately, was reissued in 1867 as "a contribution of great importance to our knowledge of Early English literature. Sir F. Madden" (he was knighted in 1832) "justly claims to have been one of the first editors who insisted on the necessity of strict and literal accuracy, and it is impossible to say how much we owe to him, directly and indirectly." His reputation for scholarly precision has remained undiminished.

Madden read Latin, Greek, Hebrew, Syriac, Norman French, Anglo-Saxon, and Old Icelandic as well as most modern European languages. As assistant keeper (appointed in 1828) and keeper of manuscripts in the British Museum from 1837 to 1866, he "ended his department's amiably torpid eighteenth-century ways," says the *Dictionary of National Biography*, "and advanced it to a standing in the world of scholarship which it has maintained ever since." He restored the fire-damaged medieval manuscripts of the Cotton collection, now the heart of the British Library, which had been reduced when he first saw them, his biographers write, to "congealed lumps of vellum." He sought out dealers and agents and made many new acquisitions, taking "full advantage of the great buyers' market in manuscripts that followed the Napoleonic wars."

A dandy who sported a monocle, Madden was known for "extravagances of dress and expensive misadventures with horseflesh." He was a good dancer and a master at chess. An acquaintance described him

in a letter to a friend as "a young man with large whiskers and a smart stick and a waistcoat, and does not look half as much of a Bibliomaniac as you do, but notwithstanding his appearance is uncommon sly and knows more about the matter than anyone whom I have seen, except Angelo Mai [then the Vatican librarian] perhaps." Madden had an acute sense of honor, bristling at any slight, and was generally at odds with his colleagues, one of whom he characterized in his diary as "always an ass; always a bully; always a time-serving, lick-spittle booby and blockhead."

This diary Madden had begun keeping when he was eighteen; it would grow to over four million words by the time he broke off writing, a few months before his death in 1873. Through it we learn that in 1831, Madden was not (or not only) "furious," "complaining," "aggrieved," and "implacable"—as the biographer of his nemesis, the keeper of printed books, would describe him—but deeply depressed. His beloved wife, whom he'd courted for ten years before finally gaining her father's approval to marry, had died in childbirth. At Cambridge, near the first anniversary of her death, when he was working on "William and the Werewolf," Madden attended church. "The sermon I heard this afternoon, although filled with the usual fictions," he wrote, "made me extremely wretched, and the description of a death bed brought many bitter tears from my eyes. It is not for myself. I fear not. Why should I? I have never injured human beings, and if I have blasphemed the Creator, it has been wrung from me by the agony I suffer at the thoughts of that poor innocent girl's death. Oh God—God—how miserable am I!" His was a far different Christianity than that of the Reverend Alexander MacLeod of Uig, Lewis.

It was with "mechanical feelings," Madden wrote in his diary, that he buried himself in his work. And yet his excitement at seeing the Lewis chessmen comes through. On October 17, 1831, Madden wrote, "Sir Walter Scott came at two o'clock and stayed about an hour with me." The old gentleman was not in good form, Madden noted.

His appearance and manner struck me much. I should instantly have known him, from the portraits of him, but it is impossible to convey by the pencil an idea of the uncouthness of his appearance and figure. His hair almost white, large grey unexpressive eyes, a red-sandy

complexion and straggling whiskers, slow and thick manner of speak-
ing, and broad Scotch accent. His figure equally gauche—square built,
limping very much, so as to elevate the right shoulder above the left,
and using for support an immense thick stick; dressed in checkered
black and white trousers and dark square cut coat.

They spent little time on idle chitchat; grief and gallstones were much
less compelling than the Lewis chessmen. Wrote Madden of their hour
together:

> I had the pleasure of looking over with him a set of very curious and
> ancient chessmen brought to the Museum this morning for sale,
> by a dealer from Edinburgh named Forrest. They were discovered
> in a sand-bank on the west coast of Scotland, and are the most cu-
> rious specimens of art I ever remember to have seen. Mr. Harris
> mentioned them to me when last in London but I did not expect
> to have held them in my own hands. There are eighty-two pieces
> of different descriptions, all made (apparently) of the teeth of the
> sea-horse [walrus], or morse, of which number forty-eight are the
> superior chessmen—forming parts of four or five sets, but none of
> them perfect *per se,* although two complete sets can be selected from
> them. Besides these there are the pawns, which are plain, and a set
> of draughts-or table-men. An ivory buckle also was discovered with
> them. These pieces are apparently of the twelfth century, and of fine
> workmanship. As for the costume of the pieces (King, Queen, Bishop,
> Knight, and a warder or armed figure, in lieu of a Castle) in regard to
> the armour, episcopal dress, they will require some research and as
> the whole probably will be engraved in the *Archaeologia,* I shall say
> nothing more of them here.

He noted only the price—a hundred pounds—with no comment on
whether he thought it high or low, only that it would be "a great pity" if
the museum did not buy them.

His view prevailed. Sometime between November 1831 and Janu-
ary 1832, the British Museum did buy the Lewis hoard, bargaining the
price down to £80. Edward Hawkins, the keeper of antiquities, led the

negotiations. "There are not in the museum any objects so interesting to a native antiquary as the objects now offered to the trustees," he said. The "native antiquary" he had most in mind may have been Madden.

During those three months, the chessmen must have been rarely out of Madden's sight, for by January 1832 he had completed his research. His nearly hundred-page "Historical remarks on the introduction of the game of chess into Europe, and on the ancient chessmen discovered in the Isle of Lewis" was read to the Society of Antiquaries of London at two successive meetings in the next month, and published, along with a hundred drawings, in that year's *Archaeologia: Or, Miscellaneous Tracts Relating to Antiquity*. It "still reads today as a *tour-de-force* of research," wrote Neil Stratford, the keeper of antiquities at the British Museum in 1997.

It is here that Madden confidently concludes, "We cannot, I imagine, from all this evidence, hesitate in assenting to the proposition I have endeavoured to establish, viz. that the chessmen before us were executed in Iceland about the middle of the twelfth century." His strongest argument had to do with the berserks— which he called warders rather than rooks. As he writes, "One peculiarity, with regard to these figures of the Warders (Nos. 6, 7, 8), and which serves to confirm in no small degree my belief that they are of Norwegian or Icelandic workmanship, is the singular manner in which they are represented *biting their shields*. Now this was a characteristic of the Scandinavian *Berserkar*," he says. Yet, following his reasoning on "William and the Werewolf," if a werewolf could migrate south through France to appear in an English romance, couldn't a berserk travel a similar route to surface as a Scottish chessman?

THE LEWIS CHESSMEN

Art historians usually assume, in the absence of other evidence, that an object was made close to where it was found. But while these chessmen found on Lewis in 1831 are universally known as "the Lewis chessmen" (except in Uig, where they are "the Uig chessmen"), few experts have championed the Isle of Lewis as the home of an ivory carver of such sophistication. Uig is, after all, "a solitary place, much sequestered from

the public eye." That archaeologists have recently discovered walrus-ivory waste material—evidence of a "workshop"—on the nearby Hebridean island of South Uist has not changed anyone's mind.

Yet as early as 1851 Daniel Wilson, secretary to the Society of Antiquaries of Scotland, argued that the Lewis chessmen could easily have been made in Scotland. The theory that they were Scandinavian, "like a snowball, gathers as it rolls, taking up indiscriminately whatever chances to lie in its erratic course," he quipped in his book on Scottish archaeology, the first ever published. To counter Madden's references to Icelandic literature, Wilson turned to the visual arts, comparing the designs on the chessmen's thrones to those on cathedrals at Durham and Dunfermline. The chess knights, he said, resembled those on a lintel at Fordington Church in Dorchester as well as on the seals of several Scottish noblemen, while their horses' heads found a match on the corbel table in the apse at Dalmeny Church, Linlithgowshire.

In 1863, Captain Thomas, who recorded the story of "The Red Ghillie," thanked Wilson for "rescuing these relics from the Scandinavian origin attributed to them." He was a bit premature.

In 2010, Angus MacNeil tried—a bit more vociferously—to rescue them again. MacNeil was then the Nationalist member of Parliament for the Western Isles, which includes Lewis. What incensed him was a poster for the BBC Radio 4 series, "A History of the World in 100 Objects," in which the Lewis chessmen are Number 61, sandwiched between a collection of Kilwa potsherds and a Hebrew astrolabe. The poster, displayed in the London Underground stations, featured one of the Lewis queens, hand clapped to her cheek, over the caption "AD 1150–1200 Norway." According to the *Times* of London, "Mr MacNeil—who has seen the posters at a number of stations—has laid an early day motion (EDM) before the Commons stating that 'this House deplores the historical airbrushing of the Lewis chessmen by the British Museum in a poster campaign.'" It "deplores the fact that references to Lewis or the Hebrides are nowhere to be seen." And it professes that "the only thing certain about the chessmen . . . is that they are made from walrus ivory or whale teeth and that they were found on the Isle of Lewis." MacNeil insisted the British Museum reprint the posters, substituting "Lewis" or "Scotland" for "Norway."

The museum's official spokeswoman dissimulated: "It is generally accepted that the chessmen were made in Norway." Then she added, "During this period the Western Isles, where the chessmen were buried, were part of the kingdom of Norway, not Scotland"—implying that even if they *were* carved on Lewis, we should label them "from Norway."

The poster kerfuffle must be understood as part of a larger call to "repatriate" the Lewis chessmen. In 2007, Alex Salmond, the First Minister for Scotland and the leader of the Scottish independence movement, repeated the claim he had made in 1996 that the chessmen should be returned to Scotland. "I find it utterly unacceptable that the Lewis chessmen are scattered around Britain," he remarked, adding, "I will continue campaigning for a united set in an independent Scotland." Explained a Scottish government spokesman, "It is absurd and unacceptable that only eleven rest in the National Museum of Scotland."

The commentary surrounding Salmond's speech was in some ways equally absurd. The *Herald Scotland* noted, "Historians believe the ninety-three figurines were crafted in Norway." *The Independent* said, "Despite the Norwegian origin of the chessmen, Mr Salmond insisted they should be returned to Scotland." *The Guardian* commented, "What could the arguments behind the chessman claim be? . . . That they somehow embody 'the spirit of the place'? A problematic argument, given their origins in Norway." Writing in the *Penn State Law Review* in 2011, a legal scholar tried to distinguish the concepts of property and heritage. To him, Salmond's campaign "stands as a good example of the kind of irresponsible and base nationalistic claim that does a disservice to legitimate repatriation claims."

As the 2014 referendum on Scottish independence loomed, the Scottish Democratic Alliance included the Lewis chessmen in a policy paper titled "The Future Governance of Scotland." In a list of five points for which "there is a need for an agreed exit strategy from the U.K.," number 3 read: "Negotiation on division of the U.K. assets (oil, financial, military, Lewis chessmen, etc.)." But not even the alliance, assigning such an extraordinary value to the chessmen, thought to raise the questions: *Were* they carved in Norway? *How do we know?*

The British Museum deflated the repatriation campaign somewhat by sending twenty-five of its chessmen on a tour of Scotland from 2010

to 2011. In 2012, it made another gesture: It signed an agreement with a museum in Stornoway, the largest town on Lewis, to lend six chessmen for a permanent exhibition in the restored Lews Castle. "These amazing little pieces will undoubtedly attract new visitors to the islands," the Isle of Lewis's development chief told the *Hebrides News,* adding, "Heritage is one of our most important assets." Yet the newspaper went on to say that the Lewis chessmen "are believed to have been made in Norway."

THE ICELANDIC THEORY

In 1874, the Norwegian chess historian Antonius Van der Linde belittled Frederic Madden's suggestion that Iceland could produce anything approaching the sophistication of the Lewis chessmen. Icelanders, he scoffed, were too backward to even *play* chess.

Reading Van der Linde, Willard Fiske became annoyed. Founder of *The American Chess Monthly,* first librarian of Cornell University, and fluent in Icelandic, Danish, Swedish, and German (he also read Latin, French, and Persian), Fiske amassed a private collection of Icelandic literature that rivaled that of the Royal Library in Copenhagen. He traveled to Iceland in 1879, crossing the island on horseback. Pleased the Icelanders shared his twin passions for books and chess, he endowed libraries and donated chess sets to several towns.

Fiske's preface to *Chess in Iceland,* published posthumously in 1905, promised a second volume that would contain "notes on the carved chessmen and other chess objects found in the museums of Scandinavia and England, commonly regarded as the productions of Icelandic workshops." Sadly, he never completed that volume. *Chess in Iceland* makes no direct reference to the Lewis chessmen. Fiske doesn't mention Madden's name. But he takes great enjoyment in rebutting Van der Linde, whose "knowledge of Iceland and Icelandic is too limited to enable him to treat Icelandic chess with the extraordinary accuracy and logical judgment evinced in his investigations into other domains."

Fiske brings up numerous examples from medieval literature and from more recent letters of Iceland's long fondness for chess. In 1627, an Icelandic priest wrote that he was sending a "set of Icelandic chessmen" to the Danish antiquarian Olaus Worm. Another priest in 1648

sent Worm "a snuff-box carved out of a whale's tooth," commenting that "the young artisan who wrought it also made pretty chessmen of the same material, and at a moderate price." Said Fiske, "Thus we have accounts, by two contemporary parish priests of Iceland, of the manufacture by natives of sets of chessmen—two centuries and a half ago—which does not look as if the Icelanders had so little fondness for the game as Dr. Van der Linde would have us believe."

The next to take up the Icelandic theory was H. J. R. Murray. Murray's father, James, founded the *Oxford English Dictionary*, to which Harold was a prolific contributor, responsible for some 27,000 quotations. Fluent in twelve languages, including Icelandic, Harold decided to make his own mark by writing a definitive history of chess; it took him sixteen years. Published in 1913, Murray's nine-hundred-page *A History of Chess* is still the authority. Fittingly, a Lewis knight is embossed on the cover.

Agreeing with Madden, Murray wrote of the Lewis chessmen, "The carving of the rooks as warriors on foot undoubtedly points to Icelandic workmanship." But he questioned whether the chessmen were as old as everyone said. "If there were any truth in the tradition which Captain Thomas discovered to be current in Lewis, they may be the work of Icelandic carvers of the beginning of the seventeenth century only." The tradition he means is the story of "The Red Ghillie," which brings the chessmen to Lewis with a shipwreck and murder in the early 1600s—about the same time an Icelandic priest sent a walrus-ivory chess set to Olaus Worm in Copenhagen.

Romanesque art, which went out of fashion almost everywhere else in the thirteenth century, in fact held on in Iceland for hundreds of years. Studying a group of drinking horns made in Iceland between 1400 and the late 1600s, Danish art historian Ellen Marie Mageroy noted that "the decoration is mainly Romanesque." She continued, "The horn carvers were conservative, retaining medieval styles well into modern times. This makes it difficult to decide whether a drinking horn is earlier or later than the breakthrough of Protestantism in 1550, a date which is taken to mark the end of the Middle Ages." The chess carvers might have been equally conservative.

Murray's query met with no reply. Art historians had little reason to read *A History of Chess* or Fiske's *Chess in Iceland*. They had no interest in

the game, only in the art. When Ormande M. Dalton published his *Catalogue of the Ivory Carvings of the Christian Era in the British Museum* in 1909, he responded only to Madden's original argument that the chessmen were carried to Lewis by "an Icelandic *kaupmann* or merchant," who was shipwrecked. "The theory that these objects were wrecked with a Scandinavian vessel," he wrote, "is discredited by their discovery in a chamber"—a reference to Charles Kirkpatrick Sharpe's description of the findspot, as reported in 1833. Dalton concluded, "There seems no greater reason to assign them a Norse than a British origin." But he expressed no doubt that they were made in the Middle Ages.

German art historian Adolf Goldschmidt also believed the Lewis chessmen were from the twelfth—not the seventeenth—century. He included them in his exhaustive survey of Romanesque ivory carvings, published in several volumes between 1923 and 1926. There he pronounced the chessmen "distinctly Norwegian, as opposed to English, in character," by comparison with other medieval ivory carvings—including the possible tau-crozier head and the sword pommel and grip—none of which, as we discussed in chapter 4, was found in a datable archaeological context.

The Norwegian (or now Trondheim) theory was strengthened between 1965 and 1999 by a series of studies of Romanesque sculpture by Norwegian art historians Martin Blindheim and Erla Bergendahl Hohler and by the 1990 publication by Trondheim archaeologists Christopher McLees and Oeystein Ekroll of the sketch of the broken chess queen found in the ruins of Saint Olav's Church in the 1880s (and subsequently lost). But mostly the Norwegian theory has been strengthened by repetition—that snowball effect Daniel Wilson warned of in 1851.

The two museums that own the chessmen have been the most influential: It is to these institutions that people turn for the truth.

The British Museum over the years has grown to be a forceful backer of the Norwegian theory—perhaps without even realizing it. Museum publications went from describing the chessmen as "Scandinavian" in 1978, to "Scandinavian, and in particular Norwegian" in 1997, to "probably made in Norway" in 2008. The museum's "Objects in Focus" booklet from 2004 is an exception: Here curator James Robinson states, fairly, "The question of their place of origin, however, will

probably never be satisfactorily settled. A number of different sugges-
tions have been made, describing them as English, Scottish, Irish, Ice-
landic, Danish, or Norwegian. Occasionally, it has even been suggested
that they were made on the Isle of Lewis, but the lack of archaeological
evidence makes this a very distant possibility." Yet when interviewed
for the BBC Radio 4 special in 2010, Robinson was more blunt: "The
chess pieces were probably made in Norway." The poster, as we've seen,
dispensed with all doubt. Beneath the image of the Lewis chess queen it
said: "AD 1150–1200 Norway."

The National Museum of Scotland has followed the same trajec-
tory. The book accompanying the museum's 2010 traveling exhibition,
The Lewis Chessmen: Unmasked, coauthored by David Caldwell, Mark
Hall, and Caroline Wilkinson, carefully lays out the Norwegian theory.
It concludes, "None of this makes it certain that Trondheim was the
place many or all of the Lewis chessmen were made, but it is at least
a strong possibility." The museum's website cuts all the nuance: "They
were probably made in Trondheim."

Yet a second strong possibility is Iceland.

In 2010, Icelandic chess aficionado and civil engineer Gudmundur
G. Thorarinsson focused attention on the story of Margret the Adroit,
the woman who—perhaps—carved the Lewis chessmen for Bishop Pall
of Skalholt. Gudmundur commissioned an artist, Svala Soleyg, to imag-
ine what Margret looked like and draw her portrait. He posted his Ice-
landic theory on a chess website created by his friend (and the artist's
husband) Einar S. Einarsson. A retired banker and former head of VISA
Iceland, Einarsson is a consummate networker. Outgoing where Thora-
rinsson is quiet, efficient where Thorarinsson is idealistic, Einarsson had
pressed him to publish. But that first version of "The Icelandic Theory"
was a rambling and erudite saga, marked by the breadth of learning of
an amateur—one for whom history is a passion, not a profession. Tho-
rarinsson was unafraid to cross disciplinary boundaries. At times, he
acted more like a journalist than a historian, quoting experts he had
interviewed, not books and papers he had read.

His readers were not so accepting. After the website ChessBase
linked to Thorarinsson's paper and his theory found its way into the
beautiful coffee-table book *Chess Masterpieces,* the Norwegian chess

master Morten Lilleoren erupted: "The content is literally filled with faults and oversights. . . . This whole argument seems far-fetched."

And in some ways, I agree, it *was* far-fetched. Thorarinsson made too much of the idea that Icelandic was the first language to use the chess term *bishop;* as I wrote in chapter 2, a Latin reference to *episcopi* might predate the one in the Icelandic saga to *biskup*.

Thorarinsson also overstressed the resemblance of the knights' mounts to Icelandic horses, as have other experts: Most horses in twelfth-century Europe were as small.

But "faults and oversights"? I found very few as I traced his path through libraries, cathedrals, and museums, from Reykjavik to Skalholt, from Edinburgh to Trondheim, Lund, and Lewis. Fewer, in fact, than I found exploring the Norwegian theory, which seems mostly to be based on that grand medieval concept of *authority*.

Thorarinsson's argument, Lilleoren insisted, "is filled with errors— i.e., not in accordance with well-established historical knowledge." That may be, I determined, a very good thing. Rather than blindly accepting the pronouncements of great art historians like Goldschmidt ("distinctly Norwegian") or Blindheim ("people trained as woodcarvers were frequently engaged to work in stone"), Thorarinsson took a fresh look at the subject. As Icelanders say, *Glöggt er gests augað:* The guest's eye is clear.

Building on Madden and Murray, Thorarinsson added the insights of scholars who wrote in Icelandic and whose voices had not entered the international debate on the origins of the Lewis chessmen. Art historian Bera Nordal, for example, placed medieval Icelandic wood carvings, along with Bishop Pall's crozier, into the set of like objects to which the designs on the backs of the chessmen's thrones must be compared. Excavating Skalholt, archaeologist Kristjan Eldjarn and his colleagues painted a picture of an extraordinarily rich twelfth-century bishopric, with a wooden church larger than any in Norway, and validated the basic truth of the *Saga of Bishop Pall* by uncovering his stone sarcophagus. Historian Helgi Gudmundsson traced the connections among Greenland, Iceland, and the larger Norse world, concluding that Iceland was a hub for the walrus trade and that ivory profits funded the writing of the sagas. Likewise, historian Helgi Thorlaksson found a series

of place-names that mapped exactly from Lewis to Iceland, showing the strong connection between those two islands. Before Thorarinsson wrote his paper, none of these scholars had made the news in London, Edinburgh, Trondheim, or Lewis. None was cited in books or articles about the Lewis chessmen.

But Thorarinsson's greatest contribution was to take the sagas seriously. He knew—as did few of the experts who have written about the Lewis chessmen—which sagas are considered to be largely historical and which, in general, are not. And he could read them. The *Saga of Bishop Pall* is hard going, even if you've studied Old Icelandic, and no English translation exists. Without Thorarinsson, the story of Margret the Adroit, who carved walrus ivory "so skillfully that no one in Iceland had seen such artistry before," would have remained untold.

No one, of course, listens to outsiders. A seminar in conjunction with the exhibition *The Lewis Chessmen: Unmasked* was planned for September 2010. Einarsson wrote to the National Museum of Scotland offering Thorarinsson's services as a speaker. He received no reply. He sent Thorarinsson's paper to the British Museum; again, no response. Balked, Einarsson simply took another tack: He spoke with his friend Dylan Loeb McClain, chess columnist for the *New York Times*. And he called the Icelandic embassy in London.

The story broke in the *New York Times* the week before the conference. It appeared on the front page of *The Scotsman* and in the London *Daily Telegraph* the day of the seminar. "The people at the British Museum told us afterwards," Einarsson recalled, "that they get so many letters every day from nutheads! They considered us nutheads!" The embassy arranged a meeting for Thorarinsson and Einarsson with the British Museum curators; the pair then traveled on to the seminar in Edinburgh. Though he was not scheduled to give a talk, Thorarinsson was asked informally to present his theory. He told the story of Margret the Adroit.

Nor, having made a splash, did Einarsson let the idea die. He and Thorarinsson organized an all-day symposium at Skalholt in August 2011—on the eight hundredth anniversary of Bishop Pall's death—to further explore the Icelandic theory. Experts who initially scoffed were invited, including David Caldwell and Mark Hall, representing the

National Museum of Scotland, and James Robinson of the British Museum. Alex Woolf, the Scottish medievalist who had described Iceland to the *New York Times* as "a scrappy place full of farmers," particularly became intrigued. "On reflection," he afterward wrote to Thorarinsson, "I came to realise that in the Sturlung Age, when the chess pieces were produced, the social and economic structures of the Icelandic freestate had developed considerably. . . . Chieftains and bishops of the later twelfth and thirteenth century were, unlike their predecessors of the tenth and eleventh centuries, perfectly capable of retaining high quality craftsmen in their households."

Thorarinsson and Einarsson included Woolf's statement, with his permission, in the third edition of their illustrated booklet, *The Enigma of the Lewis Chessmen: The Icelandic Theory,* published in 2014. Their goal, Thorarinsson told me, was to change the history of Iceland. "Medieval Icelanders are known for writing the sagas, a literature of world quality. But if the Icelandic theory is right, Iceland was also a country of ivory carvers"—that is, of world-class visual artists as well. If Margret the Adroit did carve the Lewis chessmen, Iceland could claim those "outstanding examples of Romanesque Art" that "embody truly monumental values of the human condition."

MARGRET'S WORKSHOP

The Edinburgh conference generated a set of scholarly papers, published in late 2014 by the National Museum of Scotland and the Society of Antiquaries as *The Lewis Chessmen: New Perspectives.* The book includes a chapter by Thorarinsson. Caldwell, who edited the volume, told me, "It's absolutely clear that we should be able to present the Icelandic theory in this book. If it turns out that the Lewis chessmen were made in Skalholt, I'll be very happy."

Yet to prove that conclusively would require reopening the archaeological dig at Skalholt and finding evidence of Margret's ivory workshop. A broken bit of a Lewis chessman—a queen's head, a horse's forelegs— would be a plum. Mjoll Snaesdottir of the Archaeological Institute of Iceland explained to me how chancy that would be. "The first question," she said, "is this: You have very well preserved ruins at Skalholt from the

early 1600s. Do we want to continue to preserve them, or do we decide it's worth sacrificing them to look at the next stage?" The ruins from Margret's day are not in danger from erosion or modern construction. They are safe in the ground—while getting a look at them would require destroying four hundred years of history. "It's a difficult question," Snaesdottir said. "Maybe it doesn't have an answer."

The second question concerns the enormous size of the overall site: Skalholt was a bishop's seat and served as the capital of Iceland for eight hundred years. Said Snaesdottir, "The dwellings are very numerous. Even if they're not palaces—they are turf buildings—they were in use for a very long time. There are a lot of preserved remains." The institute's excavations there between 2002 and 2007 uncovered 50,000 artifacts.

And if Margret's ivory workshop is not directly underneath the already uncovered school and living quarters from the 1600s, it could be anywhere on the estate. "It wouldn't be hard to make holes in middens," or trash heaps, Snaesdottir acknowledged. "There's nothing impossible about digging trial trenches and finding an area with lots of worked bones," but the archaeologists also might dig in the wrong place and miss the workshop entirely.

When she spoke to Thorarinsson, Snaesdottir said, "I tried to explain the size of the area—he's an engineer, so he would understand volumes and areas. We were working for six summers—two months at a time, ten people—to uncover this": the living quarters from the 1600s, covering an area of about half an acre.

"You can't take a backhoe and look for little bits of bone," she explained. "To try and locate the twelfth-century workshop would be very time-consuming and expensive. It's doubtful. You might not be successful at all."

And yet the discovery of a twelfth-century chessman in the midden of a fishing camp at Siglunes in northern Iceland in 2011 has given Thorarinsson hope. Though half the size of the smallest Lewis chessman, and made of fishbone, not walrus ivory, the resemblance of this Siglunes chessman to a Lewis rook is uncanny. "See the shield, the helmet, the way he carries his sword, his clothes down to his feet," said Thorarinsson, examining a photograph. "Do we know of any nation that

used berserks as rooks?" he asked. "No. But excavations in Iceland have found a berserk."

Later, in the library of the Icelandic Archaeological Institute, I studied the Siglunes chessman with a hand lens. His kite-shaped shield, like that of a Lewis rook or knight, bears a preheraldric geometric pattern. His helmet's a conical cap (no nasal, or else it's been rubbed off); his hairstyle's an exact match for that of the Lewis rooks. He holds what looks to me like a spear—where Thorarinsson sees a sword—upright against his side, the fingers of his gripping hand clearly incised. He wears a long robe or gambeson. I think I see a hint of a sword poking out from under his shield (even magnified, it's hard to tell; it might be just a wrinkle in his robe) and a faint trace of a sword belt at his waist. He does not bite his shield, true, but neither do most of the Lewis rooks.

Archaeologist Birna Larusdottir, who headed the team that dug at Siglunes in 2011, dates this chessman between 1104 and 1300—in both of those years, a volcanic eruption left a convenient, distinct line of ash or tephra in the ground. There's no scientific method for narrowing the dates down further; for carbon dating to work, you need many more samples from a site. This layer of soil, except for its chessman, was barren—and the spot has since eroded into the sea.

"It's about time for somebody to write about chess in Iceland," Larusdottir remarked, "something general. We have had lots of excavations in recent years. We're getting a lot of gaming pieces. We have other chess pieces from the same time as the one from Siglunes." She showed me photos from other sites in Iceland. None of these chessmen is figural; some look ancient, others modern. One complicated cone with a topknot, identified as a chess king by the artifact specialist at the excavation, was found in a soil layer carbon dated between 1150 and 1250. The other chess pieces are less precisely dated, but all were found beneath the tephra layer from 1300.

Many are made of fishbone. This particular bone, the cleithrum from the head of a large haddock, *Melanogrammus aeglfinnus,* was more recently used to make toy birds. New, fishbone toys are creamy white and smooth, almost soapy in texture. But the bone is not as lasting or luxurious a material as walrus tusk. After eight hundred years in damp earth and a professional cleaning at Iceland's National Museum, the

Siglunes rook is a milky tea color, the bone porous and grainy, the face almost worn away—no nose left, the eyes and mouth ravaged holes. The back is a maze of cracks. It feels light and insubstantial, not weighty like a Lewis chessman. Set on the table, it makes no satisfying *click*. And yet the shield, the helmet, the way he holds his weapon, his clothes— Thorarinsson is right. The Siglunes chessman might be a cheap knock-off, but it's a copy of something the carver has seen. The Siglunes artist knew what a rook should look like: a berserk.

Asked what the Siglunes find says, scientifically, about the likeli-hood that Margret the Adroit made the Lewis chessmen, Larusdottir smiled. She took the little rook from the artifact box and cradled it in her palm. "They were making chessmen in Iceland at the same time as the Lewis chessmen were made," she replied. "We can say that."

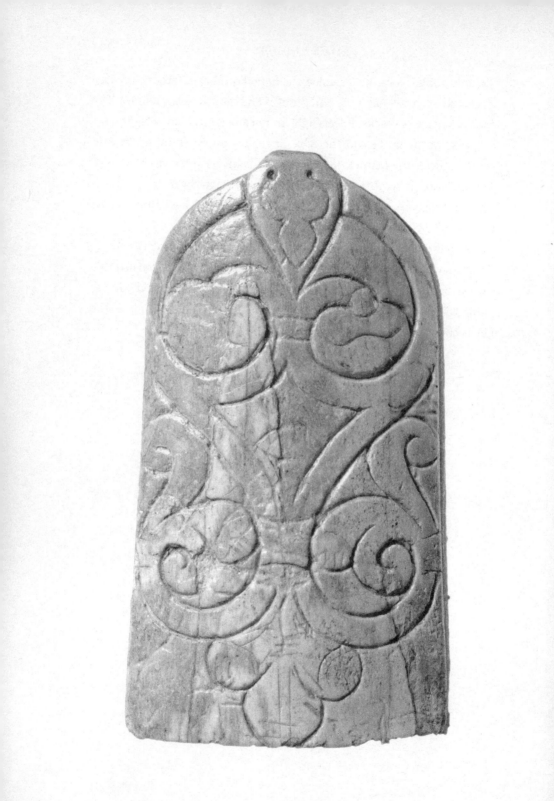

ACKNOWLEDGMENTS

The Pawns

Many people helped me play this game. Jacqueline Moran, George Dalgleish, and James Robinson of the National Museum of Scotland showed me the enormous honor of letting me examine four of the Lewis chessmen outside of their display case. Birna Lárusdóttir at Fornleifastofnun Íslands likewise gave me unlimited access to the Siglunes rook. A number of scholars and thinkers were generous with their time, answering questions and providing me with research material; in Iceland: Guðmundur G. Þórarinsson and Einar S. Einarsson, Mjöll Snæsdóttir, Orri Vésteinsson, Helgi Þorláksson, Guðný Zoëga, Kristján Valur Ingólfsson, and Sandra Sif Einarsdóttir; in Scotland: David Caldwell, Mary MacLeod Rivett, Kevin Murphy, Dave and Rosie Roberts, Stephanie Carter, and Finlay Macleod; in Denmark: Jette Arneborg and Kate Driscoll; and in Norway: Øystein Ekroll, Christopher McLees, and Margrete Syrstad Andås. All errors remain my own.

For access to libraries, historical collections, and images, I thank John Maciver of the Uig Historical Society, Matthew J. Driscoll and Ragnheiður Mósesdóttir of the Arnamagnaean Institute in Copenhagen, Ólöf Benediktsdóttir and Gísli Sigurðsson of the Stofnun Árna

Magnússonar in Reykjavík, Margaret Wilson of the National Museum of Scotland's Image Service, Patrick J. Stevens of Cornell University Library, and Linda Wooster of Saint Johnsbury Academy. I am particularly grateful to Dartmouth College for its open stacks and guest borrowing policies. Sheila Post helped with translations from Norwegian, and Elizabeth Ashman Rowe supplied pages from her translation in progress of the Icelandic annals.

Friends and acquaintances who provided travel and logistical help, and sparked my thinking with their good questions, include: Þórður Grétarsson, Guðný Þórðardóttir, Guðbjörg Sigurðardóttir, Sigríður Sigurðardóttir, Silvia Hufnagel, Soren and Birgit Dyssegaard, Gísli Palsson, Jonas Andreasson, Emily Lethbridge, Annie Swap, Hólmfríður Ingólfsdóttir, Richard Gollin, Catriona MacLeod, Nancy Serrell, Carol Andrew, Peter Travis, Martin Fors, Mary Sturtevant, Susan Taylor, Claire Van Vliet, and Friðrík Erlingsson, who also answered my prompt, "What is the queen thinking?," along with Sandy Tabin, Denice Hicks, Paul Acker, Ginger McCleskey, Marc Blaydoe, David Johnson, Jon Anders Ofjord, Pete Anderson, Marge Dean, Lisa Stepp, Guðrún Bjarnadóttir, Sandy Greene, Joe LaSarge, Hastings Ragnarsson, Gerry Blair, Christina Romano, Dan Nelson, James Finn, and many others who did not give their names.

Jeff Mathison continued the tradition of enriching my books with his illustrated maps. My agent, Michelle Tessler, worked her special magic, encouraging me to give visible form to a vague idea, and the staff at Palgrave Macmillan (now St. Martin's Press) were immediately supportive. Thanks to my editor, Elisabeth Dyssegaard, for her enthusiasm, her clear eye, and her quiet direction; to Laura Apperson and Donna Cherry for keeping everything on track and triple-checked; and to Gabrielle Gantz for her drive.

Chess takes two to play: Thanks to my husband, Charles Fergus, for playing this game with me.

Tables

The Lewis Hoard

The British Museum, London (82 pieces)

1 buckle

67 chessmen, including:

 6 kings
 5 queens
 13 bishops
 14 knights
 10 rooks, including 3 berserks
 19 pawns
 14 checkers

The Scottish National Museum, Edinburgh (11 pieces)

11 chessmen, including:

 2 kings
 3 queens
 3 bishops
 1 knight
 2 rooks, including 1 berserk

Bishop Pall of Iceland and the Kings of Norway

King Magnus III Bare-Legs
(1093–1103)

Thora King's-daughter

Jon Loftsson

Bishop Pall Jonsson
(1195–1211)

King Harald IV Gilli
(1130–36)

King Eystein II
(1142–57)

King Sigurd II Mouth
(1136–55)

Sesselja

King Ingi II
(1205–17)

King Ingi I Hunchback
(1136–61)

King Sverrir
(1184–1202)

King Hakon II
(1161–63)

King Hakon III
(1202–05)

King Hakon IV
(1217–63)

King Sigurd I Jerusalem-Farer
(1103–30)

Kristin

King Magnus V
(1164–84)

King Magnus IV
(1130–35)

Important Dates

770	Iceland discovered by Nadodd
782	Charlemagne massacres 4,500 Saxons
787/9	Portland reeve killed by Vikings
793	Vikings attack Lindisfarne Abbey
795	Vikings found Dublin
808	Hedeby founded
834	Vikings sack Dorestad
839	first Latin mention of Rus traders
845	Vikings raid Paris
850	first Arabic handbook on chess
865	Vikings conquer York, sack London
872	Harald Fair-Hair unifies Norway
874	Ingolf Arnarson settles in Iceland
890	Ottar visits King Alfred the Great
911	Gongu-Hrolf (Rollo) given Normandy
958	Denmark converted to Christianity
960–75	Age of Gunnhild
982	Greenland discovered by Eirik the Red
990	Vikings attack England, accept Danegeld
997	Einsiedeln verses on chess written
1000	America discovered by Leif Eiriksson
1000	Iceland and Greenland convert to Christianity
1016–35	Canute the Great, king of England, Denmark, and Norway
1053	bishopric of Iceland established
1066	Norman Conquest
1075	Gregorian Reform
1093–1103	Magnus III Bare-Legs of Norway conquers the Scottish islands
1096	Iceland is first Scandinavian country to institute the tithe

1096–99	First Crusade
1129	Council of Troyes forbids chess to Knights Templar
1130–1240	throne of Norway is contested
1145–49	Second Crusade
1152	Skalholt Cathedral dedicated
1152–53	archbishopric of Trondheim established
1164	Magnus V Erlingsson (age 8) crowned king of Norway
1170	murder of Thomas Becket in Canterbury Cathedral
1171	death of "the last Viking," Svein Asleifarson
1174	Sverrir Sigurdsson arrives in Norway from the Faroes
1180–1183	Archbishop Eystein in exile in England
1184–1202	Sverrir, king of Norway
1190–1202	Archbishop Eirik in exile in Lund
1194	King Sverrir excommunicated by Pope Celestine III
1195–1211	Pall Jonsson, bishop of Skalholt, Iceland
1196–1202	Bishop Nikulas of Oslo leads the Bagals against King Sverrir
1198	Bishop Thorlak of Iceland declared a saint
1202–37	Gudmund the Good, bishop of Holar, Iceland
1220–41	Snorri Sturluson writes *Heimskringla*
1262–64	end of Icelandic independence
1266	Treaty of Perth: Scottish isles returned to Scotland
1831	Lewis chessmen discovered

Notes

Ivory Vikings draws upon the work of many scholars and thinkers. Guðmundur G. Þórarinsson inspired me by connecting the Lewis chessmen with Margret the Adroit; see *The Enigma of the Lewis Chessmen: The Icelandic Theory,* 3rd ed. (Reykjavík: Gallery Chess, 2014) or his chapter in *The Lewis Chessmen: New Perspectives,* edited by David Caldwell (Edinburgh: National Museums of Scotland, 2014).

Caldwell and his colleagues Mark Hall and Caroline Wilkinson influenced my thinking in many ways through their comprehensive 2009 research paper, "The Lewis Hoard of Gaming Pieces: A Re-examination of Their Context, Meanings, Discovery and Manufacture," *Medieval Archaeology* 53 (2009): 155–203, and the exhibition guidebook based on it, *The Lewis Chessmen Unmasked* (Edinburgh: NMS Enterprises, 2010). Both publications include images of each of the chessmen; numerous photographs can also be found online by searching the collections of the British Museum (http://www.britishmuseum.org/research/collection_on line/search.aspx) and the National Museum of Scotland (http://www.nms.ac.uk/explore/ search-our-collections/).

Earlier books published by the British Museum in London enriched my understanding of the chessmen, in particular, *The Lewis Chessmen* by James Robinson (2004), *The Lewis Chessmen and the Enigma of the Hoard* by Neil Stratford (1997), and *The Lewis Chessmen* by Michael Taylor (1978). An additional excellent source was the blog written by Barbara Boehm and her colleagues to accompany the 2011–2012 exhibition, "The Game of Kings: Medieval Ivory Chessmen from the Isle of Lewis," at The Cloisters gallery of the Metropolitan Museum of Art in New York (http://www.metmuseum.org/exhibitions/listings/2011/the-game-of-kings-medieval-ivory-chessmen-from-the-isle-of-lewis/exhibition-blog). Finally, every exploration of the Lewis chessmen must begin with Frederic Madden's "Historical Remarks on the Introduction of the Game of Chess into Europe, and on the Ancient Chessmen Discovered in the Isle of Lewis," *Archaeologia* 24 (1832): 203–91.

A note on language: To minimize confusion, I have standardized and Anglicized the spelling of all names (even within quotations) throughout *Ivory Vikings*. I have dropped all accents and diacritical marks. For Icelandic names, I have changed the letters ð ("eth") to *d*, þ ("thorn") to *th*, and æ ("ash") to *ae*. In the following notes, names are given in the authors' original spellings. Although modern Icelanders prefer to be called by their first names, for the sake of consistency I use their last names on second reference, following English practice.

Translations from Icelandic throughout this book are my own, unless otherwise noted here by the abbreviation "tr."

INTRODUCTION: THE MISSING PIECES

1 **ninety-two game pieces:** the British Museum, London, owns 82 pieces from the Lewis hoard, including 67 chessmen, 14 checkers, and the buckle (BM 1831,1101.78-159); the National Museum of Scotland, Edinburgh, owns 11 chessmen (H. NS 19-29).

Beginning in 2015, six pieces from the British Museum's collection will be on display at Lews Castle Museum, Stornoway, Lewis.

1　**about three pounds, "translate that worth":** David Caldwell, Mark Hall, and Caroline Wilkinson, *The Lewis Chessmen Unmasked* (Edinburgh: NMS Enterprises, 2010), 22, 11; David Caldwell, interviewed in Edinburgh, November 16, 2013.

3　**contradictory:** David Laing, "A Brief Notice of the Small Figure Cut in Ivory . . . Discovered in Dunstaffnage Castle: Paper Read to the Society of Antiquaries of Scotland, 11 March 1833," *Archaeologia Scotia* 4 (1857): 369.

3　**worm channels, etching:** Neil Stratford, *The Lewis Chessmen and the Enigma of the Hoard* (London: British Museum Press, 1997), 55; **marine gastropods:** "Identification of the Ivory of the Lewis Chessmen," www.britishmuseum.org/explore/highlights /articles/i/identifying_the_ivory.aspx.

4　**different artists, "crudely carved":** David Caldwell, Mark Hall, and Caroline Wilkinson, "The Lewis Hoard of Gaming Pieces: A Re-examination of Their Context, Meanings, Discovery and Manufacture," *Medieval Archaeology* 53 (2009): 181–85.

5　**"gateway objects":** David Francis, Steve Slack, and Claire Edwards, in *Museum Gallery Interpretation and Material Culture,* ed. Juliette Fritsch (London: Routledge, 2012), 156.

5　**"few objects compete":** James Robinson, "#61 Lewis Chessmen," *A History of the World in 100 Objects,* http://www.bbc.co.uk/ahistoryoftheworld/objects/LcdERPxmQ_a2n pYstOwVk; **"Elgin Marbles":** Robinson, quoted by Barrymore Laurence Scherer, "Lively, Ivory Warriors," *Wall Street Journal,* November 24, 2011, http://online.wsj .com/article/SB10001424052970204531404577054060946233208.html.

5　**"most famous":** Dylan Loeb McClain, "A New Theory on the Origin of the Lewis Chessmen," *New York Times,* September 7, 2010, http://gambit.blogs.nytimes.com/ 2010/09/07/a-new-theory-on-the-origin-of-the-lewis-chessmen/.

5　**"robot":** Cynthia Matuszek et al., "Gambit: An Autonomous Chess-Playing Robotic System," *Proceedings of the Robotics and Automation Conference (ICRA) 2011,* 4291–97.

6　**Dougie MacLean:** "Marching Mystery," written by Douglas Menzies MacLean. Published by Limetree Arts and Music. Sub-published by Fintage Publishing, B.V. Used by permission. All rights reserved.

6　**"one peculiarity":** Frederic Madden, "Historical Remarks on the Introduction of the Game of Chess into Europe," *Archaeologia* 24 (1832): 291.

7　**"mention of Iceland":** Willard Fiske, *Chess in Iceland* (Florence, Italy: Florentine Typographical Society, 1905), 62.

7　**"a workshop":** Christopher McLees and Øystein Ekroll, "A Drawing of a Medieval Ivory Chess Piece from the 12th-Century Church of St Olav, Trondheim, Norway," *Medieval Archaeology* 34 (1990): 151–54.

7　**physical tests:** David Caldwell, interviewed in Edinburgh, November 16, 2013; Mary MacLeod Rivett, interviewed in Uig, Lewis, June 13, 2014; Jette Arneborg, interviewed in Copenhagen, November 13, 2013; Jette Arneborg, Niels Lynnerup, and Jan Heinemeier, "Human Diet and Subsistence Patterns in Norse Greenland AD c.980–AD c.1450: Archaeological Interpretations," *Journal of the North Atlantic,* Special Volume 3 (2012): 119–33.

8　**"the limited evidence favors Trondheim":** Caldwell et al. (2010), 66.

8　**theory about Margret:** Guðmundur G. Þórarinsson, interviewed in Reykjavík, May 23, 2013; Þórarinsson, "Are the Isle of Lewis Chessmen Icelandic?" (revised 2011), https://sites.google.com/site/bolholt6ny/the-lewis-chessmen/gudhmundur-g-thor arinsson-grein; Morten Lilleøren, "The Lewis Chessmen Were Never Anywhere Near Iceland!" ChessCafe.com (2011), http://en.chessbase.com/post/norwegian-icelandic -war-over-the-lewis-chemen-; Amanda Moffet, "The Icelandic Woman behind the Lewis Chessman," September 13, 2010, http://www.bletherskite.net/2010/09/13/lewis -chessman-made-by-a-woman/.

9　**"scrappy place":** Alex Woolf, quoted by McClain, *New York Times,* September 7, 2010, http://gambit.blogs.nytimes.com/2010/09/07/a-new-theory-on-the-origin-of-the -lewis-chessmen/.

9 **"backwards":** Oren Falk, "The Bishop as Widower," paper presented at the International Medieval Congress, Kalamazoo, MI, May 11, 2013.

9 **Clerics writing in Latin:** Gerald of Wales, *Topography of Ireland*, tr. Thomas Forester (Cambridge, ON: In Parentheses Publications, 2000), 41, 12; Adam of Bremen, *History of the Archbishops of Hamburg-Bremen*, tr. Francis J. Tschan (New York: Columbia University Press, 1959, rpt. 2002), 217, 194; Tore the Monk or Theodoricus Monachus, *Historia de Antiquitate Regum Nowagiensium*, tr. David and Ian McDougall (London: Viking Society for Northern Research, 1998), 37; Saxo Grammaticus, tr. P. Fisher, cited in Gísli Sigurðsson, *The Medieval Icelandic Saga and Oral Tradition* (Cambridge, MA: Harvard University Press, 2004), 4–5.

11 **Iceland's literary output:** Margaret Clunies Ross, *The Cambridge Introduction to The Old Norse-Icelandic Saga* (Cambridge, UK: Cambridge University Press, 2010), 6; Matthew J. Driscoll, personal communication, January 6, 2015.

11 **Icelandic texts are labeled "sagas":** Clunies Ross (2010), ix, 29, 36, 53; **"glory":** Milan Kundera, in *The Sagas of Icelanders: A Selection* (New York: Viking, 2000), dust jacket; **"miracle," "simple, lucid":** Peter Hallberg, *The Icelandic Saga* (Lincoln: University of Nebraska, 1962), 70, 46; **"beauty of human conduct":** E. V. Gordon, *An Introduction to Old Norse* (Oxford: Oxford University, 1927; rpt. 1981), xxxiii; **"illusion of reality":** Einar Ól. Sveinsson, *Dating the Icelandic Sagas* (London: Viking Society for Northern Research, 1958), 116; **"suspense fiction":** Theodore M. Andersson, *The Icelandic Family Saga* (Cambridge, MA: Harvard University Press, 1967), 64, **"great world treasure," "human literary endeavor":** Jane Smiley, in *Sagas of Icelanders* (2000), ix–x; **"farmers at fisticuffs":** Jón Ólafsson frá Grunnavík (1740), tr. Jesse L. Byock, *Viking Age Iceland* (New York: Penguin, 2001), 154.

12 **"brush these sagas aside":** Sigurður Nordal, cited in Byock (2001), 149.

13 **"one of many datasets":** Jesse L. Byock and Davide Zori, "Interdisciplinary Research in Iceland's Mosfell Valley," *Backdirt: Annual Review of the Cotsen Institute of Archaeology at UCLA* (2013): 124–41.

13 **sift fact from fiction:** Barbara Crawford, *Scandinavian Scotland* (Leicester, UK: Leicester University Press, 1987), 9.

14 **"associated with romance":** Marilyn Yalom, *Birth of the Chess Queen* (New York: HarperCollins, 2004), 62.

14 *Saga of King Heidrek the Wise: Hervarar saga og Heiðreks*, ed. G. Turville-Petre (London: Viking Society for Northern Research, 1956; rpt. 2014), 23.

14 **influenced *Egil's Saga:*** Torfi Tulinius, *The Matter of the North* (Odense, Denmark: Odense University Press, 2002), 251.

15 **"King Sverrir himself":** *Saga Sverris konúngs*, ed. Carl Christian Rafn and Finnur Magnússon (Copenhagen: H. Popp, 1834), 1, 5.

15 *Saga of King Olaf:* Snorri Sturluson, "Ólafs saga helga," in *Íslenzk fornrit 27*, ed. Bjarni Aðalbjarnarson (Reykjavík: Hið íslenzka fornritafélag, 1945), 285.

15 **"earliest appearance of chess":** H. J. R. Murray, *A History of Chess* (Oxford: Clarendon Press, 1913), 443.

16 **"Many events":** "Hrafns saga," in *Sturlunga saga*, ed. Guðbrandr Vigfússon (Oxford: Clarendon Press, 1878), 2: 275.

16 **"I started looking":** Guðmundur G. Þórarinsson, interviewed in Reykjavík, May 23, 2013.

16 *Saga of Bishop Pall:* The definitive edition is "Páls saga biskups," in *Íslenzk fornrit 16*, ed. Ásdís Egilsdóttir (Reykjavík: Hið íslenzka fornritafélag, 2002), 295–332. I also consulted "Páls saga biskups," in *Biskupa sögur*, ed. Jón Sigurðsson and Guðbrandr Vigfússon (Copenhagen: Hinu Íslenzka bókmentafélagi, 1858), 1: 127–45; and Einar Ól. Sveinsson, ed., *Páls saga biskups* (Skálholt, Iceland: Skálholtsfélagið, 1954).

17 **sail to the wedding:** Halldór Hermannsson, *Saemund Sigfússon and the Oddaverjar* (Ithaca, NY: Cornell University Press, 1932), 21.

18 **written by Pall's son:** Sveinbjörn Rafnsson, *Páll Jónsson Skálholtsbiskup* (Reykjavík: Sagnfræðistofnun Háskóla Íslands, 1993), 33–34, 129.

18 **two works of art, similar crozier:** Bishop Pall's stone coffin resides in the crypt of
 the new church at Skálholt, Iceland, his crozier in the National Museum of Iceland,
 Þjóðminjasafn Íslands, Reykjavík (S 2); the crozier found in Greenland is in the Na-
 tional Museum of Denmark, Nationalmuseet, København, Udstilling om Danmarks
 Middelalder og Renæssance: Nordboerne i Grønland (DNM D11154).
19 **Siglunes chessman:** archived at Fornleifastofnun Íslands, Reykjavík; Guðmundur G.
 Þórarinsson, *The Enigma of the Lewis Chessmen,* 2nd ed. (Reykjavík: Gallery Chess,
 2012); Birna Lárusdóttir, interviewed in Reykjavík, May 24, 2013, and May 23, 2014.

CHAPTER ONE: THE ROOKS

21 **rooks:** H. J. R. Murray, *A History of Chess* (Oxford: Clarendon Press, 1913), 772; Rich-
 ard Eales, "The Game of Chess: An Aspect of Medieval Knightly Culture," in *The
 Ideals and Practice of Medieval Knighthood,* ed. C. Harper-Bill and R. Harvey (Wood-
 bridge, UK: Boydell Press, 1986), 1: 17.
21 **Charlemagne's own:** Bibliothèque nationale, Paris, Cabinet des Médailles (Ivoire 305,
 306, 308–23); Marilyn Yalom, *Birth of the Chess Queen* (New York: HarperCollins,
 2004), 32–34.
21 **Abstract chess pieces:** Murray (1913), 405–6; O. M. Dalton, "Early Chessmen of
 Whale's Bone Excavated in Dorset," *Archaeologia* 77 (1928): 77–86; Andy Chapman,
 "The Bishop and King of Angel Street," *Museum of London Archaeology Blog,* Decem-
 ber 31, 2014, http://www.mola.org.uk/blog/bishop-and-king-angel-street.
22 **berserks:** Snorri Sturluson, "Ynglingasaga," in *Íslenzk fornrit 26,* ed. Bjarni Aðalbjar-
 narson (Reykjavík: Hið íslenzka fornritafélag, 1941), 17.
22 *Harald's Lay:* Haraldskvæði, tr. John Lindow, *Norse Mythology* (Oxford: Oxford Uni-
 versity, 2001), 75 (first stanza cited), and R. I. Page, *Chronicles of the Vikings: Records,
 Memorials, and Myths* (Toronto: University of Toronto Press, 1995), 108 (second
 stanza).
23 **buffoons:** Kaaren Grimstad, "The Comic Role of the Viking," in *Studies for Einar
 Haugen,* ed. Evelyn Firchow et al. (New York: De Gruyter, 1972), 243–52.
23 *Grettir the Strong:* "Grettis saga Ásmundarsonar," in *Íslenzk fornrit 7,* ed. Guðni Jóns-
 son (Reykjavík: Hið íslenzka fornritafélag, 1936), 136.
24 **"resting like a sledge":** Nette Levermann et al., "Feeding Behaviour of Free-Ranging
 Walruses with Notes on Apparent Dextrality of Flipper Use," *BMC Ecology* 3 (2003),
 http://www.biomedcentral.com/1472–6785/3/9.
24 **walrus hunters:** John Giaever, *In the Land of the Musk-Ox* (London: Jarrolds, 1958),
 100–101; Edward Marshall Scull, *Hunting in the Arctic and Alaska* (Philadelphia: John
 C. Winston, 1914), 130–31, 135; **Nansen:** quoted by Scull (1914), 136; **Olaus Magnus:**
 Description of the Northern Peoples, tr. Peter Fisher and Humphrey Higgens (London:
 Hakluyt Society, 1996), 3: 1111–12; **in 1775:** Molineux Shuldham, "Account of the
 Sea-Cow and the Use Made of It," *Philosophical Transactions of the Royal Society of
 London* 65 (1775): 249–51; **in 1603:** Frederic Madden, "Historical Remarks on the
 Introduction of the Game of Chess into Europe," *Archaeologia* 24 (1832): 245 note;
 "wild excitement": James Lamont, quoted by Robert McGhee, *The Last Imaginary
 Place* (Oxford: Oxford University, 2005), 185–86.
26 **oyster knives:** Ross D. E. MacPhee, "The Walrus and Its Tusks," *Metropolitan Mu-
 seum of Art, Game of Kings Exhibition Blog* (November 14, 2011), http://www.met
 museum.org/exhibitions/listings/2011/the-game-of-kings-medieval-ivory-chessmen
 -from-the-isle-of-lewis/exhibition-blog/game-of-kings/blog/the-walrus-and-its
 -tusks.
27 **walrus hide:** Lúdwík Kristjánsson, *Íslenzkir sjávarhættir* (Reykjavík: Bókaútgáfa
 menningarsjóðs, 1986), 5: 99; **dismasted:** "Íslendinga saga," in *Sturlunga saga,* ed.
 Guðbrandr Vigfússon (Oxford: Clarendon Press, 1878), 2: 82; **besieged:** *Saga Sver-
 ris konúngs,* ed. Carl Christian Rafn and Finnur Magnússon (Copenhagen: H. Popp,
 1834), 440; **hoisting:** Olaus Magnus, tr. Fisher and Higgens (1996), 3: 1111.

27 **"tower she lives in":** Sandra Straubhaar, *Old Norse Women's Poetry* (Cambridge, UK: D. S. Brewer, 2011), 91.

28 **"When properly tanned":** David Gove, "Killing Off the Walrus," *Technical World Magazine* (November 1914): 428–30.

28 **Ivory art:** Anthony Cutler, "Prolegomena to the Craft of Ivory Carving in Late Antiquity and the Early Middle Ages," in *Artistes, Artisans, et Production Artistique au Moyen Age,* ed. Xavier Barall i Altet (Paris: Picard, 1987), 2: 431, 433, 442, 471; Elizabeth C. Parker and Charles T. Little, *The Cloisters Cross: Its Art and Meaning* (New York: Metropolitan Museum of Art, 1994), 16; Danielle Gaborit-Chopin, in *Viking to Crusader,* ed. Else Roesdahl and David M. Wilson (New York: Rizzoli, 1992), 204.

28 **"statues of the gods," "This is odd":** Paul Williamson, *An Introduction to Medieval Ivory Carvings* (London: Her Majesty's Stationery Office, 1982), 5, 9.

28 **"smoother":** Else Roesdahl, "Walrus Ivory—Demand, Supply, Workshops, and Greenland," in *Viking and Norse in the North Atlantic,* ed. Adras Mortensen and Simun V. Arge (Tórshavn, Faroe Islands: Annales Societatis Scientiarum Faeroensis Supplement 44, 2005), 184.

29 *Saga of Ref the Sly:* "Króka-Refs saga," in *Íslenzkt fornrit 14,* ed. Jóhannes Halldórsson (Reykjavík: Hið íslenzka fornritafélag, 1959), 142.

29 **popcorn:** Pete Dandridge, "From Tusk to Treasure, Part 1," *Metropolitan Museum of Art, Game of Kings Exhibition Blog,* December 6, 2011, http://www.metmuseum .org/exhibitions/listings/2011/the-game-of-kings-medieval-ivory-chessmen-from -the-isle-of-lewis/exhibition-blog/game-of-kings/blog/from-tusk-to-treasure-part-i.

29 **market crashed:** Kirsten A. Seaver, *The Last Vikings* (New York: I. B. Tauris, 2010), 104.

29 **"profitably marketing":** Sophia Perdikaris and Thomas H. McGovern, "Codfish and Kings, Seals and Subsistence," in *Human Impacts on Ancient Marine Environments,* ed. Torben Rick and Jon Erlandson (Los Angeles: University of California at Los Angeles Press, 2008), 194.

29 **"chess":** Olaus Magnus, tr. Fisher and Higgens (1996), 3: 1112.

30 **North African elephant:** E. W. Bovill, *The Golden Trade of the Moors* (Oxford: Oxford University Press, 1968), 98, 101; Sarah M. Guérin, "Avorio d'ogni ragione: The Supply of Elephant Ivory to Northern Europe in the Gothic Era," *Journal of Medieval History* 36 (2010): 160; John Beckwith, *Ivory Carvings in Early Medieval England* (London: Harvey Miller and Medcalf, 1972), 116; Anthony Cutler, *The Craft of Ivory* (Washington, DC: Dumbarton Oaks, 1985), 23, 30.

30 **Baghdad:** Richard Hodges and David Whitehouse, *Mohammed, Charlemagne, and the Origins of Europe* (Ithaca, NY: Cornell University Press, 1983), 54–56, 70–71, 126, 129, 149–51; Jeff Sypeck, *Becoming Charlemagne* (New York: HarperCollins, 2006), 68; Gene W. Heck, *Charlemagne, Muhammad, and the Arab Roots of Capitalism* (New York: De Gruyter, 2006), 273, 285; Maya Shatzmiller, "The Role of Money in the Economic Growth of the Early Islamic Period (650–1000)," in *Sources and Approaches across Disciplines in Near Eastern Studies,* ed. Verena Klemm and Nuha al-Sha'ar (Walpole, MA: Uitgeverig Peeters, 2013), 302; Christian Keller, "Furs, Fish, and Ivory: Medieval Norsemen at the Arctic Fringe," *Journal of the North Atlantic* 3 (2010): 13.

31 **antidote to poison:** Arthur MacGregor, *Bone, Antler, Ivory, and Horn* (London: Croom Helm, 1985), 40; Norbert J. Beihoff, *Ivory Sculpture through the Ages* (Milwaukee, WI: Milwaukee Public Museum, 1961), 59.

31 **"Rus":** Jonathan Shepard, in *The Viking World,* ed. Stefan Brink and Neil Price (New York: Routledge, 2008), 497; **"inhabit the sea":** tr. Thomas F. X. Noble, *Charlemagne and Louis the Pious* (University Park, PA: Pennsylvania State University, 2010), 170; *haunt the tide:* tr. Eric Christiansen, *The Norsemen in the Viking Age* (Malden, MA: Blackwell, 2002), 117; Egil Mikkelsen, in Brink and Price (2008), 543, 545; **Ibn Khurradadhbih, Byzantium:** Thorir Jónsson Hraundal, "The Rus in Arabic Sources," PhD dissertation (University of Bergen, 2013), 56, 63–68, 121–22; *Russian Primary Chronicle,* tr. Page (1995), 98, 100; **Ibn Rusta:** tr. Paul Lunde and Caroline Stone, *Ibn Fadlan*

and the Land of Darkness (New York: Penguin, 2012), 116, 126; **Ibn Fadlan:** tr. Lunde and Stone (2012), 8–54.

32 **Permian rings:** Hraundal (2013), 130; Jane Kershaw, "From Russia (with Love)," in *Viking Metal* (September 2013), http://vikingmetalwork.blogspot.com/2013_09_01 _archive.html.

32 **silver dirhams, silver mines:** Anders Winroth, *The Conversion of Scandinavia* (New Haven, CT: Yale University Press, 2012), 98–99; Svein H. Gullbekk, in Brink and Price (2008), 162; Gene W. Heck, "Gold Mining in Arabia and the Rise of the Islamic State," *Journal of the Economic and Social History of the Orient* 42 (1999): 379–82; Hodges and Whitehouse (1983), 129; Shatzmiller (2013), 281.

33 **125 million Arabic dirhams:** Thomas Noonan, cited by Hraundal (2013), 137.

33 **seven hard portages:** Robert Ferguson, *The Vikings* (New York: Viking Penguin, 2009), 126; Hraundal (2013), 27.

33 **Charlemagne's elephant, "ravenous, and prone to wander":** Sypeck (2006), 161–73.

34 **an influential theory:** Henri Pirenne, cited by Heck (2006), 164; Hodges and White-house (1983), 120, 158.

34 **House of Wisdom:** Nancy Marie Brown, *The Abacus and the Cross* (New York: Basic Books, 2010), 43–45.

35 *shatranj,* **"inheritance":** Richard Eales, *Chess: The History of a Game* (New York: Facts on File, 1985), 19, 22, 41; **"herself as a pawn":** Charles Tomlinson, *Amusements in Chess* (London: John W. Parker, 1845), 24.

35 **sent Charlemagne a chess set:** Heck (2006), 179–80; Helena M. Gamer, "The Earliest Evidence of Chess in Western Literature: The Einsiedeln Verses," *Speculum* 29 (October 1954): 745.

35 **"ludicrous expression":** Thomas Pruen, *An Introduction to the History and Study of Chess* (Cheltenham: H. Ruff, 1804), 38.

35 **Romances of Charlemagne:** Murray (1913), 736, 740, 742; Pruen (1804), 38; Yalom, (2004), 33.

36 **board games:** Mark A. Hall and Katherine Forsyth, "Roman Rules? The Introduction of Board Games to Britain and Ireland," *Antiquity* 85 (2011): 1326.

36 **which travelers:** Gamer (1954), 735, 745; Eales (1985), 41, 47.

36 **"If it is lawful to play games":** Gamer (1954), 742, 744.

37 **feudalism:** Murray (1913), 498; Gamer (1954), 748; Eales (1985), 64.

37 **"war over the board":** Bobby Fischer, quoted in David Shenk, *The Immortal Game* (New York: Doubleday, 2006), 5.

37 **"rushed to the place," "devastating," "deported," "came with his fleet," "transfer-ring":** tr. Bernard Walter Scholz, *Carolingian Chronicles* (Ann Arbor: University of Michigan Press, 1970), 59–63, 83, 88–89; **Alcuin:** tr. Benjamin Thorpe, quoted by Sypeck (2006), 54; **a new law:** "Laws of Charles the Great," tr. Dana Carleton Munro, *Translations and Reprints from the Original Sources of European History* (Philadelphia: P. S. King & Son, 1899), 6: 2.

38 **Hedeby:** Gwyn Jones, *A History of the Vikings* (London: Oxford University Press, 1968), 99, 167; Hodges and Whitehouse (1983), 112–13; Else Roesdahl, *The Vikings* (London: Penguin Press, 1991), 120, 122; Michael Müller-Wille, "Hedeby in Ohthere's Time," in *Ohthere's Voyages,* ed. Janet Bately and Anton Englert (Roskilde, Denmark: Viking Ship Museum, 2007), 157–65; Volker Hilberg, "Hedeby in Wulfstan's Days," in *Wulfstan's Voyage,* ed. Anton Englert and Athena Trakadas (Roskilde, Denmark: Viking Ship Museum, 2009), 80, 97–98; Winroth (2012), 80–81, 89, 99; Peter Pentz, in *Viking,* ed. Gareth Williams, Peter Pentz, and Mattias Wemhoff (Copenhagen: National Museum of Denmark, 2013), 209; Dagfinn Skre and John Ljungkvist, in Brink and Price (2008), 84–91.

38 **Dorestad:** Hodges and Whitehouse (1983), 93, 109, 111; Jones (1968), 211; Pamela Crabtree, ed. *Medieval Archaeology* (New York: Routledge, 2013), 94–95.

39 **"usual surprise attack":** Winroth (2012), 26.

39 **"infest the Gallic sea," "endless flood":** tr. Barry Cunliffe, *Facing the Ocean* (Oxford: Oxford University Press, 2001), 94, 483.

39 **"aroused the emperor":** tr. Scholz (1970), 91–92.

39 **"nose for weakness":** Magnús Magnússon, *Vikings!* (New York: Elsevier-Dutton, 1980), 71–74.

39 **art of ransom:** Angus A. Somerville and R. Andrew McDonald, *The Vikings and Their Age* (Toronto: University of Toronto Press, 2013), 17–18, 21; Winroth (2012), 28, 36.

40 **"savage Northmen race":** Albert D'Haenans, cited by M. Magnússon (1980), 61; **"wild Northmen":** tr. Winroth (2012), 24.

40 **"frenzy beyond compare":** Abbo of Saint-Germain-des-Prés, *Viking Attacks on Paris,* tr. Nirmal Dass (Leuven, Belgium: Peeters, 2007).

40 **"blood eagle":** Roberta Frank, "Viking Atrocity and Skaldic Verse," *English Historical Review* (April 1994): 332–43.

40 **flow of silver . . . ebbed:** Hodges and Whitehouse (1983), 150, 165; Heck (2006), 177; Hraundal (2013), 137.

41 **economy revolved around gifts:** David G. Kirby and Merja-Liisa Hinkkanen, *The Baltic and the North Seas* (New York: Routledge, 2000), 104–5; Winroth (2012), 5, 10–11, 49; Sunhild Kleingärtner and Gareth Williams, in Williams et al. (2013), 54, 129.

41 *Listen, ring-bearers: Haraldskvæði,* tr. Page (1995), 107–8.

41 **slave girls, swords:** Shatzmiller (2013), 290; "Laxdaela saga," in *Íslenzkt fornrit 5,* ed. Einar Ól. Sveinsson (Reykjavík: Hið íslenzka fornritafélag, 1934), 23; James Graham-Campbell et al., eds. *Cultural Atlas of the Viking World* (New York: Facts On File, 1994), 54; Anne Pedersen, in Brink and Price (2008), 204; Gareth Williams, in Williams et al. (2013), 87, 104.

42 **Edict of Pîtres:** R. H. C. Davis, *The Medieval Warhorse* (London: Thames and Hudson, 1989), 53.

42 **king's gift:** "Eyrbyggja saga," in *Íslenzk fornrit 4,* ed. Einar Ól. Sveinsson and Matthías Þórðarson (Reykjavík: Hið íslenzka fornritafélag, 1935), 61–63; "Heiðarvíga saga," in *Íslenzk fornrit 3,* ed. Sigurður Nordal and Guðni Jónsson (Reykjavík: Hið íslenzka fornritafélag, 1938), 219; "Laxdaela saga," in *Íslenzkt fornrit 5* (1934), 44.

43 **build a Viking ship:** Jan Bill, in Brink and Price (2008), 170; Jan Bill, "Viking Age Ships and Seafaring in the West," in *Viking Trade and Settlement in Continental Western Europe,* ed. Iben Skibsted Klaesøe (Copenhagen: Museum Tusculanum Press, 2010), 34; Gareth Williams, in Williams et al. (2013), 86.

43 **"fight best on shipboard":** Ibn Rusta, tr. Lunde and Stone (2012), 126; **"fire in the mouth," "mane of the serpent":** A. W. Brøgger and H. Shetelig, *Viking Ships* (New York: Twayne, 1951), 113; **"water washes," "froth":** Snorri Sturluson, *Edda,* tr. Anthony Faulkes (London: J. M. Dent, 1987), 139, 141; **"wave runes":** *Saga of the Volsungs,* tr. Jesse L. Byock (New York: Penguin, 1990), 68.

44 **isle of Groix:** Neil S. Price, in *Vikings: The North Atlantic Saga,* ed. William W. Fitzhugh and Elisabeth I. Ward (Washington, DC: Smithsonian Institution Press, 2000), 126.

44 **name, *Vikings:*** Eldar Heide, "*Víking*—'rower shifting'?" *Arkiv för nordisk filologi* 120 (2005): 41–54.

44 **first Viking ships:** Arne Emil Christensen, in Fitzhugh and Ward (2000), 86–97; Bill, in Brink and Price (2008), 172, 176; Bill (2010), 23, 35, 38; Peter Pentz, in Williams et al. (2013), 206–16; Gareth Williams, in Williams et al. (2013), 92; Ferguson (2009), 41.

45 **Lindisfarne:** *Anglo-Saxon Chronicle,* tr. Benjamin Thorpe (London: Longman, Greene, Longman, and Roberts, 1861), 48; **"bolt from the blue":** Jones (1968), 194; *The Historical Works of Simeon of Durham,* tr. Joseph Stevenson (London: Seeleys, 1855), 457.

45 **Irish monasteries:** Roesdahl (1991), 223.

46 *Alas, holy Patrick:* tr. Donnchadh Ó Corráin, in Brink and Price (2008), 429.

46 **Viking bands in the Irish Sea:** Poul Holm, "The Slave Trade of Dublin," *Peritia* 5 (1986): 334; Barbara Crawford, *Scandinavian Scotland* (Leicester, UK: Leicester University Press, 1987), 47; "Eyrbyggja saga," in *Íslenzk fornrit 4* (1935), 4; "Grettis saga Ásmundarsonar," in *Íslenzk fornrit 7* (1936), 8.

46 *Bitter is the wind:* tr. M. Magnússon (1980), 152.

46 · "on the one side": *The War of the Gaedhil with the Gaill,* tr. James Henthorn Todd (London: Longmans, Green, Reader, and Dyer, 1867), 159, 163; Charles Doherty, in *Ireland and Scandinavia in the Early Viking Age,* ed. Howard B. Clarke, Máire Ní Mhaonaigh, and Raghnall Ó Floinn (Dublin: Four Courts Press, 1998), 296.

46 **England:** Clare Downham, in Brink and Price (2008), 342–43; Eleanor Shipley Duckett, *Alfred the Great* (Chicago: University of Chicago Press, 1956), 58–61.

47 *Anglo-Saxon Chronicle,* **"All the English people submitted":** tr. Duckett (1956), 85; **"insolent and fearless," "unspeakable evil":** tr. Thorpe (1861), 105–6, 113; **"in the east":** tr. Page (1995), 16.

47 **Danegeld:** Winroth (2012), 30.

47 **Canute the Great:** Roesdahl (1991), 251; Benjamin Hudson, *Viking Pirates and Christian Princes* (Oxford: Oxford University Press, 2005), 108.

48 **"Ohthere":** Howard B. Clarke, in Clarke et al. (1998), 380; Bately and Englert (2007), 24; **"he lived furthest north":** tr. Bately and Englert (2007), 44–47.

48 **trading centers:** Graham-Campbell et al. (1994), 38; Orri Vésteinsson, in Vésteinsson, Helgi Þorláksson, and Árni Einarsson, *Reykjavík 871±2* (Reykjavík: Reykjavík City Museum, 2006), 28; Sophia Perdikaris and Thomas H. McGovern, "Walrus, Cod Fish, and Chieftains," in *Seeking a Richer Harvest,* ed. T. L. Thurston and C. T. Fisher (New York: Springer, 2007), 194.

49 **"inroad from the sea":** Alcuin, tr. Dorothy Whitelock, in Angus A. Somerville and R. Andrew McDonald, *The Viking Age: A Reader* (Toronto: University of Toronto Press, 2010), 232–33; Peter Sawyer, quoted by Bjørn Myhre, in Clarke et al. (1998), 18–19; Christiansen (2002), 313.

49 **"way of wearing the hair":** Alcuin, tr. Whitelock, in Somerville and McDonald (2010), 233; Graham-Campbell (1994), 68; Ferguson (2009), 123.

49 **"first ships of Danish men," "the reeve rode up":** *Anglo-Saxon Chronicle,* tr. Thorpe, in R. I. Page, *"A Most Vile People"* (London: Viking Society for Northern Research, 1987), 21–25.

49 **"misunderstanding with the customs":** Alan Binns, quoted by Crawford (1987), 39; Hudson (2005), 46.

50 **five hundred graves:** Egon Wamers, in Clarke et al. (1998), 37, 42, 51; Bjørn Myhre, in Clarke et al. (1998), 26; Bjørn Myhre, "The Early Viking Age in Norway," *Acta Archaeological* 71 (2000): 43–44.

50 **Borg in the Lofoten Islands:** Roesdahl (1991), 107; Gerd Stamsø Munch, in Bately and Englert (2007), 100–105; Anne Pedersen, in Williams et al. (2013), 125–26; G. S. Munch et al., "Borg in Lofoten," in *Proceedings of the Tenth Viking Congress,* ed. James E. Knirk (Stockholm: Universitets Oldsaksamlings Skrifter, 1987), 149, 154; Perdikaris and McGovern (2007), 195; Keller (2010), 11–12.

51 **Sami:** Kevin McAleese, in *Vinland Revisited,* ed. Shannon Lewis-Simpson (St. John's, Newfoundland: Historic Sites Association, 2003), 354; Inger Zachrisson, in Brink and Price (2008), 36.

51 **Harald Fair-Hair:** Helgi Þorláksson, in Vésteinsson et al. (2006), 34; Duckett (1956), 164; Egon Wamers, in Clarke et al. (1998), 72.

51 **Skiringssalr:** Bately and Englert (2007), 47, 128; Dagfinn Skre, in Brink and Price (2008), 118; Seaver (2010), 106; Hodges and Whitehouse (1983), 116; Dagfinn Skre, ed., *Kaupang in Skiringssal* (Aarhus, Denmark: Aarhus University Press, 2007).

51 **chips of walrus ivory:** Roesdahl (2005), 183.

51 **"Sailing ships skillfully":** tr. Donnchadh Ó Corráin, in Brink and Price (2008), 433.

52 **"binding force":** Cunliffe (2001), 18, 36; Crawford (1987), 11–12; Neil S. Price, in Fitzhugh and Ward (2000), 34.

52 *Book of Settlements: Landnámabók,* ed. Guðni Jónsson (Reykjavík: Bókaverslun Sigurðar Kristjánssonar, 1942), 23–31; Orri Vésteinsson, in Vésteinsson et al. (2006), 32.

53 **Ketil Flat-Nose:** "Laxdaela saga," in *Íslenzkt fornrit 5* (1934), 3–5.

54 **"out-of-the-way headland":** tr. Helgi Þorláksson, in Vésteinsson et al. (2006), 44.

54 **Walrus was added:** Orri Vésteinsson, interviewed in Reykjavík, May 3, 2006, and November 18, 2013. Helgi Þorláksson, interviewed in Reykjavík, May 24, 2013;

Vésteinsson et al. (2006), 32–39, 44; Elizabeth Pierce, "Walrus Hunting and the Ivory Trade in Early Iceland," *Archaeologia Islandica* 7 (2009): 55–63; Bjarni Einarsson, "Hvallátur," *Gripla* 1 (1984): 129–34; Perdikaris and McGovern (2008): 192, 207; Thomas McGovern, "Walrus Tusks and Bone from Aðalstræti 14–18, Reykjavík, Iceland," *NORSEC Report 55* (New York: City University of New York Northern Science and Education Center, 2011); Thomas Amorosi, "Icelandic Archaeofauna," *Acta Archaeologica* 61 (1990): 272–81.

56 **Greenland:** Jette Arneborg, interviewed in Copenhagen, May 8, 2006, and November 13, 2013; *Landnámabók*, ed. Jónsson (1942), 77–78; *The King's Mirror*, tr. Laurence Marcellus Larson (New York: American-Scandinavian Foundation, 1917), 142; Arneborg, in Brink and Price (2008), 588.

57 *gales, ugly sons:* "Norðseta-drápa," in *Corpus poeticum boreale*, ed. Guðbrandr Vigfússon and F. York Powell (Oxford: Oxford University Press, 1883), 2: 54.

57 **Vinland:** Kirsten A. Seaver, in Fitzhugh and Ward (2000), 270; Else Roesdahl, in Lewis-Simpson (2003), 151; Birgitta Wallace, in Lewis-Simpson (2003), 173; Nancy Marie Brown, *The Far Traveler* (New York: Harcourt, 2007), 180.

58 **population:** Arneborg, in Brink and Price (2008), 591; Gunnar Karlsson, *The History of Iceland* (Minneapolis: University of Minnesota Press, 2000), 44.

58 **one calculation:** Thomas H. McGovern, in *The Archaeology of Frontiers and Boundaries*, ed. S. Green and S. Perlman (New York: Academic Press, 1985), 304–8; Perdikaris and McGovern (2007), 209.

58 **tusks:** Thomas H. McGovern et al., "A Study of the Faunal and Floral Remains from Two Norse Farms in the Western Settlement, Greenland," *Arctic Anthropology* 20 (1983): 107; McGovern et al., "Vertebrate Zooarchaeology of Sandnes V51," *Arctic Anthropology* 33 (1996): 114; McGovern (1985), 297–99; Perdikaris and McGovern (2007), 210; Perdikaris and McGovern (2008), 193.

59 **haunting find:** Jette Arneborg, *Saga Trails* (Copenhagen: National Museum of Denmark, 2006), 51; Seaver (2010), 84.

59 **Greenlandic ivory:** Roesdahl, in Lewis-Simpson (2003), 146; Andrew J. Dugmore, Christian Keller, and Thomas McGovern, "Norse Greenland Settlement," *Arctic Anthropology* 44 (2007): 17.

59 **"as far as the Polar star":** tr. Helgi Þorláksson, in *Taxes, Tributes and Tributary Lands in the Making of Scandinavian Kingdoms in the Middle Ages*, ed. Steinar Imsen (Trondheim, Norway: Tapir, 2011), 134.

59 **How much ivory:** Keller (2010), 5.

59 *Saga of Ref the Sly:* "Króka-Refs saga," in *Íslenzkt fornrit 14* (1959), 139, 142, 157; **"old game with one king":** tr. George Clark, in *Sagas of Icelanders* (2000), 613.

60 **buttons, amulets:** Dugmore et al. (2007), 17; Else Østergård, *Woven into the Earth* (Copenhagen: Aarhus Universitetsforlag, 2004), 102, 132; McGovern (1985), 302; Roesdahl, in Lewis-Simpson (2003), 146.

60 **broken chess queen:** Nationalmuseet, København, Udstilling om Danmarks Middelalder og Renæssance: Nordboerne i Grønland; Roesdahl (2005), 187; Jette Arneborg, personal communication, September 23, 2014.

60 **bishop's crozier:** Nationalmuseet, København, Udstilling om Danmarks Middelalder og Renæssance: Nordboerne i Grønland (DNM D11154); Louis Rey, "The Evangelization of the Arctic in the Middle Ages," *Arctic* 37 (December 1964), 331; Jette Arneborg, in Fitzhugh and Ward (2000), 312.

60 **Romanesque style:** Erla Bergendahl Hohler, *Norwegian Stave Church Sculpture* (Oslo: Scandinavian University Press, 1999), 2: 106.

61 **Margret the Adroit:** "Páls saga biskups," in *Íslenzk fornrit 16*, ed. Ásdís Egilsdóttir (Reykjavík: Hið íslenzka fornritafélag, 2002), 324.

CHAPTER TWO: THE BISHOPS

63 **"obedience":** Sverrir Jakobsson, "The Peace of God in Iceland," in *Sacri Canones Servandi Sunt*, ed. Pavel Krafl (Prague: Historicky ustav AVCR, 2008), 205–13.

64 **psalter of Henry of Blois:** or Winchester Psalter, British Library, Cotton MS Nero
 C IV, folio 34r, http://www.bl.uk/manuscripts/Viewer.aspx?ref=cotton_ms_nero_c
 _iv_fs001r.

64 **beards, miters:** Janet Mayo, *A History of Ecclesiastical Dress* (New York: Holmes &
 Meier, 1984), 32, 35, 40–41; Michael Taylor, *The Lewis Chessmen* (London: British
 Museum Press, 1978), 14; *Nordisk Familjebok Uggleupplagan,* 2nd ed. (Stockholm:
 Nordisk Familjeboks Förlags, 1917), 26: 1155–56; Frederic Madden, "Historical Re-
 marks on the Introduction of the Game of Chess into Europe," *Archaeologia* 24 (1832):
 255.

64 **oldest extant sets:** Richard Eales, *Chess: The History of a Game* (New York: Facts On
 File, 1985), 18; Neil Stratford, *The Lewis Chessmen and the Enigma of the Hoard* (Lon-
 don: British Museum Press, 1997), 35, 48; David Caldwell, Mark Hall, and Caroline
 Wilkinson, *The Lewis Chessmen Unmasked* (Edinburgh: NMS Enterprises, 2010), 67.

65 **Einsiedeln verses:** Helena M. Gamer, "The Earliest Evidence of Chess in Western Lit-
 erature," *Speculum* 29 (October 1954): 748.

65 **"bald-head":** H. J. R. Murray, *A History of Chess* (Oxford: Clarendon Press, 1913),
 499–500.

65 *al-fil:* Madden (1832), 225; Murray (1913), 424, 503, 507.

65 **Alexander Neckam:** Murray (1913), 500; Marilyn Yalom, *Birth of the Chess Queen*
 (New York: HarperCollins, 2004), 91.

65 *"alphini sunt episcopi":* Madden (1832), 225; Murray (1913), 530–33.

66 *Magus Saga:* "Mágus saga jarls," in *Fornsögur Suðrlanda,* ed. Gustaf Cederschiöld
 (Lund: Fr. Berlings Boktryckeri och Stilgljuteri, 1884), 5, 11; Murray (1913), 468, 503;
 Marianne Kalinke in *Old Norse-Icelandic Literature,* ed. Carol J. Clover and John Lin-
 dow (Toronto: University of Toronto, 2005), 316–21.

66 **"dreariest things":** W. P. Ker, cited by Kalinke (2005), 316; **"find fault":** Kalinke
 (2005), 318.

67 **"The Bishops some name Alphins":** Madden (1832), 228 (spelling normalized).

67 **"runner":** Willard Fiske, *Chess in Iceland* (Florence, Italy: Florentine Typographical
 Society, 1905), 4.

67 **Hrafn Sveinbjornsson:** Fiske (1905), 7–9; *Hrafns saga Sveinbjarnarsonar,* ed. Guðrún
 P. Helgadóttir (Oxford: Clarendon Press, 1987), lxxiii–cvii, 3; Anne Tjomsland,
 Hrafns saga Sveinbjarnarsonar (Ithaca, NY: Cornell University Press, 1951), xi–xii,
 xxii; "Hrafns saga," in *Sturlunga saga,* ed. Guðbrandr Vigfússon (Oxford: Clarendon
 Press, 1878), 1: cxv, 185–86; 2: 275.

68 **"Thorolf leaped forward":** "Egils saga Skalla-Grímssonar," *Íslenzk fornrit 2,* ed. Sig-
 urður Nordal (Reykjavík: Hið Íslenza Fornritafélag, 1933), 53–54.

69 **how Christianity transformed the North:** David G. Kirby and Merja-Liisa Hink-
 kanen, *The Baltic and the North Seas* (New York: Routledge, 2000), 111.

69 **"some Northmen":** Anders Winroth, *The Conversion of Scandinavia* (New Haven, CT:
 Yale University Press, 2012), 105.

69 **first Christian crosses:** Neil Price, in *Viking,* ed. Gareth Williams, Peter Pentz, and
 Mattias Wemhoff (Copenhagen: National Museum of Denmark, 2013), 186.

69 **Jelling:** Gwyn Jones, *A History of the Vikings* (London: Oxford University Press, 1968),
 114–16.

69 **Canute:** Carl Phelpstead, in *The Making of Christian Myths in the Periphery of Latin
 Christendom,* ed. Lars Boje Mortensen (Copenhagen: Museum Tusculanum Press,
 2006), 62.

70 **Olaf Tryggvason:** Jones (1968), 131; "Óláfs saga Tryggvasonar," in *Íslenzk fornrit 26,*
 ed. Bjarni Aðalbjarnarson (Reykjavík: Hið íslenzka fornritafélag, 1941), 316, 323.

70 **Olaf "Crack-a-Bone":** Benjamin Hudson, *Viking Pirates and Christian Princes* (Ox-
 ford: Oxford University Press, 2005), 88.

70 **more like Thor:** Ragnhild Finnestad, in *Old Norse and Finnish Religions and Cultic
 Place-Names,* ed. Tore Ahlbäck (Abo: Donner Institute for Research in Religious and
 Cultural History, 1990), 266.

71 **"king of the wind-house," "king of the sun," "luck of the White Christ":** Elena Mel-
 nikova, "How Christian Were Viking Christians?" *Ruthnica,* Suppl. 4 (2011), 90–107.
71 **baptism was the ultimate gift:** Winroth (2012), 140–45.
71 **sea roads:** Robert Macfarlane, *The Old Ways* (New York: Viking, 2012), 89; Barbara
 Crawford, *Scandinavian Scotland* (Leicester, UK: Leicester University Press, 1987),
 11–21, 104.
71 **Unn the Deep-Minded:** "Laxdaela saga," in *Íslenzkt fornrit 5,* ed. Einar Ól.
 Sveinsson (Reykjavík: Hið íslenzka fornritafélag, 1934), 7–13; *Landnámabók,* ed.
 Guðni Jónsson (Reykjavík: Bókaverslun Sigurðar Kristjánssonar, 1942), 81–87.
72 **names in the *Book of Settlements*:** Jónas Kristjánsson, in *Ireland and Scandinavia in
 the Early Viking Age,* ed. Howard B. Clarke et al. (Dublin: Four Courts Press, 1998),
 265.
72 **genetic tests:** S. Goodacre, A. Helgason et al., "Genetic Evidence for a Family-Based
 Scandinavian Settlement of Shetland and Orkney during the Viking Periods," *Hered-
 ity* 95 (2005): 1–7; Agnar Helgason et al., "mtDNA and the Origin of the Iceland-
 ers," *American Journal of Human Genetics* 66 (2000): 999–1016; Agnar Helgason et
 al., "Estimating Scandinavian and Gaelic Ancestry in the Male Settlers of Iceland,"
 American Journal of Human Genetics 67 (2000): 697–717; Helgi Þorláksson, "Did the
 Early Icelanders Include Hebridean Descendants of Björn 'buna'?" in Orri Vésteins-
 son, Helgi Þorláksson, and Árni Einarsson, *Reykjavík 871±2* (Reykjavík: Reykjavík
 City Museum, 2006), 58–59; Maja Krzewinska et al., "Mitochondrial DNA Variation
 in the Viking Age Population of Norway," *Philosophical Transactions of the Royal Soci-
 ety B* 370, January 19, 2015.
72 **Place-name studies:** Barbara Crawford, "The Scandinavian Contribution to the De-
 velopment of the Kingdom of Scotland," *Acta Archaeologica* 71 (2000): 123–34; James
 Graham-Campbell et al., eds., *Cultural Atlas of the Viking World* (New York: Facts
 On File, 1994), 74; Colleen E. Batey and C. Paterson, "A Viking Burial at Balnakeil,
 Sutherland," in *Early Medieval Art and Archaeology in the Northern World,* ed. A.
 Reynolds and L. Webster (Leiden: Brill, 2012), 656–57.
73 **Viking Age burials:** A. J. Dunwell et al., "A Viking Age Cemetery at Cnip, Uig, Isle of
 Lewis," *Proceedings of the Society of Antiquities of Scotland* 125 (1995): 719–52; R. D.
 E. Welander, Colleen Batey, and T. G. Cowie, "A Viking Burial from Kneep, Uig, Isle
 of Lewis," *Proceedings of the Society of Antiquaries of Scotland* 117 (1987): 149; Brittany
 Schorn and Judy Quinn, *The Vikings in Lewis* (Nottingham, UK: Center for the Study
 of the Viking Age, 2014).
73 **Viking settlements:** Colleen E. Batey, "Archaeological Aspects of Norse Settlement
 in Caithness, North Scotland," *Acta Archaeologica* 61 (1990/91): 29–34; **"people on
 the edge":** Mike Parker Pearson, ed., *From Machair to Mountains* (Edinburgh: Oxbow
 Books, 2012), unpaged Kindle edition; James H. Barrett et al., "Diet and Ethnicity
 during the Viking Colonization of Northern Scotland," *Antiquity* 75 (2001): 152; T.
 Pollard, "The Excavation of Four Caves in the Geodha Smoo near Durness, Suther-
 land" (2005), http://archaeologydataservice.ac.uk/archives/view/sair/contents.cfm
 ?vol=18; Steven P. Ashby, "Combs, Contact, and Chronology," *Medieval Archaeology*
 53 (2009): 1–33.
74 **Friendly trading links:** James Barrett, in *The Viking World,* ed. Stefan Brink and Neil
 Price (New York: Routledge, 2008), 411–22; Barry Cunliffe, *Facing the Ocean* (Oxford:
 Oxford University Press, 2001), 500; Olwyn Owen, "The Scar Boat Burial," in *Scandi-
 navia and Europe 800–1350,* ed. Jonathan Adams and Katherine Holman (Turnhout,
 Belgium: Brepols, 2004), 24, 30.
74 **"who art in heaven":** Sigurd Towrie, "Viking Runestone Found on Medieval
 Scholar's Farm," *Orkneyjar,* October 10, 2013, http://www.orkneyjar.com/archae
 ology/2013/10/10/viking-runestone-found-on-medieval-scholars-farmland/.
74 **farm names:** Helgi Þorláksson, in Vésteinsson et al. (2006), 58–59.
75 **"prime-signed":** "Egils saga Skalla-Grímssonar," *Íslenzk fornrit 2* (1933), 128.
75 **Bishop Frederick:** "Þáttr af Þorvaldi Víðförla," in *Biskupa sögur,* ed. Jón Sigurðsson
 and Guðbrandr Vigfússon (Copenhagen: Hinu Íslenzka bókmentafélagi, 1858), 1: 42.

76 Saga of Christianity: *Kristnisaga,* ed. B. Kahle (Halle, Germany: Verlag von Max Niemeyer, 1905), 39.

76 "Change of Ways": *Íslendingabók,* ed. Guðni Jónsson (Reykjavík: Bókaverslun Sigurðar Kristjánssonar, 1942), 10–11.

76 "With laws shall our land be built": A saying recorded in several Old Norse texts, including "Brennu-Njáls saga," *Íslenzk fornrit 12,* ed. Einar Ól. Sveinsson (Reykjavík: Hið íslenzka fornritafélag, 1954), 172.

77 "Isleif was more accomplished": *Íslendingabók,* ed. Jónsson (1942), 13.

78 "a white bear": "Húngrvaka," in *Biskupa sögur* (1858), 1: 61, 62.

78 "Audun of the West Fjords": "Auðunar þáttr Vestfirzka," in *Íslenzk fornrit 6,* ed. Björn K. Þórólfsson and Guðni Jónsson (Reykjavík: Hið íslenzka fornritafélag, 1943), 362.

79 Adam of Bremen: *History of the Archbishops of Hamburg-Bremen,* tr. Francis J. Tschan (New York: Columbia University, 1959, rpt. 2002), 134, 182–83, 216–18.

80 Gissur: "Húngrvaka," in *Biskupa sögur* (1858), I: 66–67; Theodore M. Andersson, "The King of Iceland," *Speculum* 74 (October 1999): 923–34; Peter G. Foote, "Sturlusaga and Its Background," *Saga-Book* 13 (1953): 207–37.

80 "I release all Christian men": Barbara H. Rosenwein, *A Short History of the Middle Ages* (Orchard Park, NY: Broadview Press, 2002), 120–21.

80 census: Gunnar Karlsson, *The History of Iceland* (Minneapolis: University of Minnesota Press, 2000), 44.

81 "pay a tithe": *Íslendingabók,* ed. Jónsson (1942), 15; "Most noblemen were educated": "Kristni saga," in *Biskupa sögur* (1858), 1: 29; Karlsson (2000), 40.

81 His own property: Mjöll Snæsdóttir et al., *Saga Biskupsstólanna* (Reykjavík: Bókaútgáfan Hólar, 2006), 91.

81 Gissur was popular: "Kristni saga," in *Biskupa sögur* (1858), 1: 29; "Húngrvaka," in *Biskupa sögur* (1858), I: 67.

82 220 churches in the diocese: "Páls saga biskups," in *Biskupa sögur* (1858), 1: 136; Þór Magnússon, "On Arts and Crafts in the Middle Ages," paper presented at the Skálholt Symposium, Skálholt, Iceland, August 19, 2011; "Jóns saga biskups," in *Biskupa sögur* (1858), 1: 235–40; Guðbrandr Vigfússon, *Sturlunga saga* (Oxford: Clarendon Press, 1878), 1: cxxi; Halldór Hermannsson, *Saemund Sigfússon and the Oddaverjar* (Ithaca, NY: Cornell University Press, 1932), 29; Einar Ól. Sveinsson, *Age of the Sturlungs* (Ithaca, NY: Cornell University Press, 1953), 108; Dag Strömbeck, *The Conversion of Iceland* (London: Viking Society for Northern Research, 1975), 91–93; average book: Árni Björnsson, in *Approaches to Vínland,* ed. Andrew Wawn and Þórunn Sigurðardóttir (Reykjavík: Sigurðar Nordal Institute, 2001), 53, 55; chant: Magnús Magnússon, *Iceland Saga* (London: Bodley Head, 1987), 176.

82 playing a harp: "Jóns saga biskups," in *Biskupa sögur* (1858), 1: 220–21.

82 Klaeng: "Jóns saga biskups," in *Biskupa sögur* (1858), 1: 238; Guðrún Nordal, *Tools of Literacy* (Toronto: University of Toronto Press, 2001), 37–39; Karlsson (2000), 39; Kristján Eldjárn, Håkon Christie, and Jón Steffensen, *Skálholt Fornleifarannsóknir 1954–1958* (Reykjavík: Lögberg, 1988), 22; Foote (1953), 214; "Húngrvaka," in *Biskupa sögur* (1858), 1: 81–83.

83 "Strong is the building": tr. G. Nordal (2001), 39.

83 Thorlak: Jesse Byock, *Medieval Iceland: Society, Sagas, and Power* (Berkeley: University of California Press, 1988), 156; "Þorláks saga biskups, hin elzta," in *Biskupa sögur* (1858), 1: 90, 92, 266.

84 narwhal: Helgi Guðmundsson, *Um Haf Innan* (Reykjavík: Háskólaútgáfan, 1997), 54, 60–61; Ceremonial staff, A.79–1936, Victoria and Albert Museum, http://collections.vam.ac.uk/item/O96516/ceremonial-staff-unknown/.

84 Lincoln: Martin Blindheim, *Norwegian Romanesque Decorative Sculpture 1090–1210* (London: Alec Tiranti, 1965), 14; Candice Bogdanski, "A 'North Sea School of Architecture'?" *Journal of the North Atlantic,* Special Volume 4 (2013): 79, 99; Hudson (2005), 188; Murray (1913), 413; David Cliff, *Lincoln c. 850–1100: A Study in Economic and Urban Growth,* PhD dissertation (University of Huddersfield, 1994), 266–69,

329–31; William Kay, *Living Stones: The Practice of Remembrance at Lincoln Cathedral (1092–1235)*, PhD Dissertation (University of St Andrews, 2013), 10, 17, 60; Sigurður Sigurðsson, *Þorlákur helgi og samtíð hans* (Reykjavík: Skálholt, 1993), 52; Martin Brett, in *Archbishop Eystein as Legislator,* ed. Tore Iversen (Trondheim, Norway: Tapir Academic Press, 2011), 98, 99.

85 **Paris:** John W. Baldwin, *Paris, 1200* (Stanford, CA: Stanford University Press, 2010).

85 **Bernard of Clairvaux:** Marie Gildas, in *The Catholic Encyclopedia* (New York: Robert Appleton Company, 1907), Vol. 2, http://www.newadvent.org/cathen/02498d.htm.

86 **Arnold of Brescia:** Elphège Vacandard, in *The Catholic Encyclopedia* (New York: Robert Appleton Company, 1907), Vol. 1, http://www.newadvent.org/cathen/01747b.htm; S. Sigurðsson (1993), 34–39.

86 **Thomas Becket:** Anne J. Duggan, in *Eystein Erlendsson: Erkebiskop, politiker, og kirkebygger,* ed. Kristin Bjørlykke et al. (Trondheim, Norway: Nidaros Domkirkes Restaureringsarbeiders forlag, 2012), 27; **"free the church":** Rosenwein (2002), 119; Jón Viðar Sigurðsson, in Brink and Price (2008), 576.

87 **"Each king," "There do bells":** tr. Eric Christiansen, *The Norsemen in the Viking Age* (Malden, MA: Blackwell, 2002), 274, 276.

87 **Saint Olaf:** Bruce Dickins, "The Cult of S. Olave in the British Isles," *Saga-Book* 12 (1937–45): 53–80; Adam of Bremen, tr. Tschan (1959), 213.

88 **"battle-strong beam of the sun":** tr. Katrina Attwood, in *A Companion to Old Norse-Icelandic Literature and Culture,* ed. Rory McTurk (Malden, MA: Blackwell Publishing, 2005), 51; **"Trondheimers and all Norsemen," "I know that the rulers":** tr. Martin Chase, *Einar Skulason's "Geisli"* (Toronto: University of Toronto, 2005), 61, 115.

88 **"the Lazy":** Sverre Bagge, in Iversen (2011), 11; **"the Flabby":** *Laxdaela Saga,* tr. Magnús Magnússon and Hermann Pálsson (New York: Penguin, 1969), 178.

88 **Eystein Erlendsson:** Sverre Bagge, in Iversen (2011), 11–12, 17; Margrete Syrstad Andås, in *The Nidaros Office of the Holy Blood,* ed. G. Attinger and A. Han. (Trondheim, Norway: Nidaros Domkirkes Restaureringsarbeiders forlag, 2004), 175–97; Øystein Ekroll, in *Nidaros Cathedral and the Archbishop's Palace,* ed. Ekroll et al. (Trondheim, Norway: Nidaros Cathedral Restoration Workshop, 1995), 31, 33; Åslaug Ommundsen, "Books, Scribes, and Sequences in Medieval Norway," PhD dissertation (University of Bergen, 2007), 1: 49, 55–56; Carl Phelpstead, ed. *Historia Norvegiae* (London: Viking Society for Northern Research, 2001), xxiii, xxx; Haki Antonsson, Sally Crumplin, and Aidan Conti, in *West Over Sea,* ed. Beverly Ballin Smith, Simon Taylor, and Gareth Williams (Leiden: Brill, 2007), 205; Steinar Imsen, ed. *Ecclesia Nidrosiensis 1153–1537* (Trondheim, Norway: Tapir Academic Press, 2003), 80, 384.

89 **"almost lifeless":** tr. Bagge, in Iversen (2011), 19.

90 **"Triumphant king":** tr. Ommundsen (2007), 1: 42–43.

90 **"after some time of penance," "caused a scandal":** tr. Peter Landau, in Iversen (2011), 66.

90 **"Now here in the land":** tr. Anne J. Duggan, in Bjørlykke et al. (2012), 27.

90 *Chess in Iceland:* Fiske (1905), 7–9.

91 **Peter Damian:** Madden (1832), 210.

91 **Petrus Alfonsi, Council of Troyes:** James Robinson, *The Lewis Chessmen* (London: British Museum Press, 2004), 50.

91 **restricted to a single jump:** Mark N. Taylor, in *Chess in the Middle Ages and Early Modern World,* ed. Daniel E. O'Sullivan (New York: De Gruyter, 2012), 180.

92 **"hear with their ears":** Murray (1913), 498.

92 **"just as humble":** "Þorláks saga biskups, hin elzta," in *Biskupa sögur* (1858), 1: 92.

92 **"uncrowned king":** Hermannsson (1932), 11–12.

92 **"the noblest man":** "Sturlusaga," in *Sturlunga saga* (1878), 1: 84.

92 **"would yield to no one," reforms:** "Þorláks saga biskups, hin ýngri," in *Biskupa sögur* (1858), I: 282–83, 291–92.

93 **"life of iniquity," "Lust in this country":** tr. Sveinsson (1953), 63–64.

93 **marriage was a sacrament:** Margarete Syrstad Andås, in *The Medieval Cathedral of Trondheim*, ed. Andås et al. (Turnhout, Belgium: Brepols, 2007), 66; Jenny Jochens, *Women in Old Norse Society* (Ithaca, NY: Cornell University Press, 1995), 37.

94 **"God breathes it into my breast":** tr. Sveinsson (1953), 24.

94 **Iceland's patron saint:** Hans Kuhn, "The Emergence of a Saint's Cult as Witnessed by the *Jarteinabœkr Þorláks Byskups*," *Saga-Book* 24 (1994–97): 240–54; Karlsson (2000), 39.

94 **"Because of the holy Bishop":** tr. Kirsten Wolf, in *Sanctity in the North*, ed. Thomas A. Dubois (Toronto: University of Toronto Press, 2008), 263.

95 *I am eager to play chess:* tr. G. Nordal (2001), 31.

95 **"old game with one king":** *Saga of Ref the Sly*, tr. Clark, in *Sagas of Icelanders* (2000), 612–13.

95 **"the latter is very likely":** Judith Jesch, "Earl Rognvaldr of Orkney, a Poet of the Viking Diaspora," *Journal of the North Atlantic*, Special Volume 4 (2013): 154–60.

95 **Its author:** H. Guðmundsson (1997), 233.

95 **Snorri Sturluson:** Nancy Marie Brown, *Song of the Vikings: Snorri and the Making of Norse Myths* (New York: Palgrave Macmillan, 2012).

96 **new alphabet:** Vigfússon (1878), 1: xl; G. Nordal (2001), 25.

96 **Saemund the Wise:** In Old Icelandic, Ari the Learned and Saemund the Wise have the same nickname, *hinn fróði;* I have chosen a different translation for each to better distinguish them; **Folktales:** Njördur Þ. Njardvík, *The Demon Whistle: Sæmundur the Wise and his Dealings with the Devil* (Reykjavík: Iceland Review, 1995); **Ari the Learned:** *Íslendingabók,* ed. Jónsson (1942), 1; **"Now I have counted ten rulers":** tr. Vigfússon (1878), 1: xxxvii.

96 **"learning things by heart":** "Páls saga biskups," in *Biskupa sögur* (1858), 1: 127.

96 *Skjoldunga Saga:* G. Nordal (2001), 312.

96 *Orkney Islanders' Saga:* Orkneyinga saga, *Íslenzk fornrit 34*, ed. Finnbogi Guðmundsson (Reykjavík: Hið íslenzka fornritafélag, 1965); Hermann Pálsson and Paul Edwards, "Introduction," in *Orkneyinga Saga: The History of the Earls of Orkney* (New York: Penguin Books, 1981), 10.

97 **"married young":** "Páls saga biskups," in *Biskupa sögur* (1858), 1: 127.

97 **written his father's saga:** Sveinbjörn Rafnsson, *Páll Jónsson Skálholtsbiskup* (Reykjavík: Sagnfræðistofnun Háskóla Íslands, 1993), 33–34, 129.

97 **the Greenland trade:** H. Guðmundsson (1997), 55.

97 **Eirik the Red:** "Eiríks saga rauða," in *Íslenzk fornrit 4*, ed. Einar Ól. Sveinsson and Matthías Þórðarson (Reykjavík: Hið íslenzka fornritafélag, 1935), 209–12.

98 *The Greenlanders' Tale:* "Grænlendinga þáttr," in *Íslenzk fornrit 4* (1935), 273–92.

98 **Thorkel Walrus:** "Íslendinga saga," in *Sturlunga saga* (1878), 1: 210–12; H. Guðmundsson (1997), 55–56, 60–61.

99 **betrothed to the daughter of Earl Harald:** Hermannsson (1932), 21.

99 **many other links:** H. Guðmundsson (1997), 67, 71, 284.

99 **"red color":** Lúdvík Kristjánsson, *Íslenzkir sjávarhættir* (Reykjavík: Bókaútgáfa menningarsjóðs, 1986), 5: 109; H. Guðmundsson (1997), 56–57.

100 **surplus of grain:** Crawford (1987), 135.

100 **Pall and Bjarni collaborated:** H. Guðmundsson (1997), 268–70; G. Nordal (2001), 30.

100 **"the last Viking":** John Haywood, *The Penguin Historical Atlas of the Vikings* (New York: Penguin Putnam, 1995), 130.

101 **"It was Svein's habit," "they sewed the cloth":** Orkneyinga saga, *Íslenzk fornrit 34* (1965), 283–85.

101 **"beautiful eyes":** "Páls saga biskups," in *Biskupa sögur* (1858), 1: 127; Hermannsson (1932), 21.

101 **Pall's bones, "gracile":** Guðný Zoëga, interviewed in Sauðárkrókur, Iceland, June 4, 2013; Jón Steffensen, "Bein Páls Biskups Jónsssonar," *Skirnir* (1956): 172–86.

102 **"Narbonne":** Orkneyinga Saga, *Íslenzk fornrit 34* (1965), 208–10.

102 **"war-weary," "To my linen-decked lady," "The black warriors":** Orkneyinga Saga, tr. Pálsson and Edwards (1981), 171, 172, 176.

103 **art of courtly love:** Alison Finlay, "Skalds, Troubadours, and Sagas," *Saga-Book* 24 (1994–97), 105, 115, 117; Yalom (2004), xxii.

103 **"learned so much":** "Páls saga biskups," in *Biskupa sögur* (1858), 1: 127; H. Guð-mundsson (1997), 273–74.

104 **similarities to Lincoln Cathedral:** Bogdanski (2013), 99.

104 **Rome's rules:** Byock (1988), 156–58.

104 **"certain treasures," "son or brother":** "Páls saga biskups," in *Biskupa sögur* (1858), 1: 129.

105 **the king's partner:** Anders Leegaard Knudsen, in *Archbishop Absalon of Lund and his World,* ed. Karsten Friis-Jensen and Inge Skovgård-Petersen (Roskilde, Denmark: Roskilde museums forlag, 2000), 34.

105 *Knytlinga Saga:* Jómsvíkingasaga ok Knýtlinga, ed. Þorsteinn Helgason et al. (Copen-hagen: H. F. Popp, 1828), 367.

105 **"sheltered his head":** Saxo Grammaticus, *Danorum Regum heroumque historia, Books X–XVI,* tr. Eric Christiansen (Oxford: BAR, 1980–81), 408.

106 **spiritual sword, "real issue":** Neils Lund, in Friis-Jensen and Skovgård-Petersen (2000), 9, 10.

106 **"abounded in courage," "had his plan ready":** Saxo, tr. Eric Christiansen (1980–81), 479, 524 (adapted).

106 **"penitent crusader," unite the kingdom:** Angelo Forte, Richard Oram, and Frederik Pedersen, *Viking Empires* (Cambridge, UK: Cambridge University Press, 2005), 376, 384.

107 **excommunication:** Rafnsson (1993), 24–27, 118–22; **"from the pope," "ban and curse":** *Saga Sverris konúngs,* ed. Carl Christian Rafn and Finnur Magnússon (Co-penhagen: H. Popp, 1834), 293; **"blinded by covetousness":** *Sverrissaga: The Saga of King Sverri of Norway,* tr. J. Sephton (London: David Nutt, 1899; facsimile reprint Felinfach, Wales: Llanerch Press, 1994), 241.

108 **Pall Jonsson arrived in Lund:** "Páls saga biskups," in *Biskupa sögur* (1858), 1: 135; Saxo, tr. P. Fisher, cited in Gísli Sigurðsson, *The Medieval Icelandic Saga and Oral Tradition* (Cambridge, MA: Harvard University Press, 2004), 4–5; H. Guðmundsson (1997), 275.

CHAPTER THREE: THE QUEENS

111 **"icon of female power":** Marilyn Yalom, *Birth of the Chess Queen* (New York: Harper-Collins, 2004), xvii.

111 **"aslant," "the heart of the enemy's position":** H. J. R. Murray, *A History of Chess* (Oxford: Clarendon Press, 1913), 530, 470.

111 **"went mad," "Other ferses":** Mark N. Taylor, in Daniel E. O'Sullivan, ed. *Chess in the Middle Ages and Early Modern World* (New York: De Gruyter, 2012), 169, 176–77.

112 **very slow game:** Colleen Schafroth, *The Art of Chess* (New York: Harry N. Abrams, 2002), 76; Richard Eales, *Chess: The History of a Game* (New York: Facts On File, 1985), 69.

112 **"queen's chess" or "mad chess":** Eales (1985), 72; Mark N. Taylor (2012), 169.

112 **Isabella:** Yalom (2004), xxi.

112 **Theophanu:** Yalom (2004), 24–25; Nancy Marie Brown, *The Abacus and the Cross* (New York: Basic Books, 2010), 65, 154-56, 163-64, 172-74; Adelbert Davids, ed., *The Empress Theophano* (Cambridge, UK: Cambridge University Press, 1995), 212; *Otton-ian Germany: The Chronicon of Thietmar of Merseburg,* tr. David Warner (Manchester, UK: Manchester University Press, 2001), 144.

113 **chess pieces to look like women:** Yalom (2004), 31, 36, 56.

113 **Queenship:** Yalom (2004), xxi–xxii, 91–92.

114 **valkyries:** Nancy Marie Brown, *Song of the Vikings* (New York: Palgrave Macmillan, 2012), 122, 169.

114 **Hervor:** Andrew Wawn, *The Iceland Journal of Henry Holland, 1810* (London: Hakluyt Society, 1987), 8; Jenny Jochens, *Old Norse Images of Women* (Philadelphia: University of Pennsylvania Press, 1996), 97–100.

115 *Graves begin to open:* tr. Patricia Terry, *Poems of the Vikings* (New York: Bobbs-Merrill Co., 1969), 252–53.

115 **prevalent in Viking art:** Judith Jesch, *Women in the Viking Age* (Rochester, NY: Boydell Press, 1991), 124–26.

115 **three-dimensional valkyrie figurine:** Maev Kennedy, "Flight of the Valkyrie: The Viking Figurine That's Heading for Britain," *The Guardian,* March 4, 2013, http://www.guardian.co.uk/culture/2013/mar/04/viking-valkyrie-figurine-british-museum; Judith Jesch, "Viking Women, Warriors, and Valkyries," *British Museum Blog,* April 19, 2014, http://blog.britishmuseum.org/tag/iceland/.

115 **Saxo disapproved:** Saxo, quoted by Jesch (1991), 176; Jochens (1996), 104.

116 **"women with weapons":** Neil Price, in *Viking,* ed. Gareth Williams, Peter Pentz, and Mattias Wemhoff (Copenhagen: National Museum of Denmark, 2013), 116.

116 **"noise in the data":** Martin Rundkvist, "Shield Maidens: True or False?" *Aardvarchaeology,* July 29, 2013, http://scienceblogs.com/aardvarchaeology/2013/07/29/shield-maidens-true-or-false.

116 **"problematic":** Judith Jesch writing as "Viqueen," "Valkyries Revisited," *Norse and Viking Ramblings,* July 29, 2013, http://norseandviking.blogspot.com/2013/07/valkyries-revisited.html.

116 **Roman theater, manuscripts from Canterbury:** Charles R. Dodwell, *Anglo-Saxon Gestures and the Roman Stage* (Cambridge, UK: Cambridge University Press, 2000), 111–21.

117 *Life of Saint Alexis: Chanson of St Alexis,* quire 5, p. 1, Dombibliothek Hildesheim (HS St. God. I), Basilica of St. Godehard, Hildesheim; "The Alexis Quire: Commentary," in *Saint Albans Psalter Online,* ed. Jane Geddes (Aberdeen, UK: University of Aberdeen, 2003), p. 57, https://www.abdn.ac.uk/stalbanspsalter/english/commentary/page057.shtml.

117 **despair, contemplation:** James Robinson, *The Lewis Chessmen* (London: British Museum Press, 2004), 44; **composure, patience:** Neil Stratford, *The Lewis Chessmen and the Enigma of the Hoard* (London: British Museum Press, 1997), 48; **disapproving:** Irving Finkel, *The Lewis Chessmen and What Happened to Them* (London: British Museum Press, 1995; rpt. 2014), 13, 35, 39; **aghast:** Michael Taylor, *The Lewis Chessmen* (London: British Museum Press, 1978), 7. Other adjectives supplied by readers of my blog post, "What Is the Queen Thinking?" *God of Wednesday,* April 2, 2014, http://nancymariebrown.blogspot.com.

117 **meanings of gestures:** Annika Hüsing, "Humour in the Game of Kings: The Sideways Glancing Warder of the Lewis Chessmen," *Mirabilia* 18:1 (2014): 108–15.

117 **"D'oh!":** Ken Johnson, "Medieval Foes with Whimsy," *New York Times,* November 17, 2011, http://www.nytimes.com/2011/11/18/arts/design/the-game-of-kings-medieval-ivory-chessmen-from-the-isle-of-lewis-at-the-cloisters.html.

117 **Gunnhild the Grim:** Jochens (1996), 182; "Haralds saga ins Hárfagra," "Haralds saga Gráfeldar," and "Óláfs saga Tryggvasonar," in *Íslenzk fornrit 26,* ed. Bjarni Aðalbjarnarson (Reykjavík: Hið íslenzka fornritafélag, 1941), 135, 149, 155, 162, 200, 204, 226–29; "Egils saga Skalla-Grímssonar," *Íslenzk fornrit 2,* ed. Sigurður Nordal (Reykjavík: Hið Íslenza Fornritafélag, 1933), 123, 180–81; *Orkneyinga saga, Íslenzk fornrit 34,* ed. Finnbogi Guðmundsson (Reykjavík: Hið íslenzka fornritafélag, 1965), 19-20 note; "Brennu-Njáls saga," *Íslenzkt fornrit 12,* ed. Einar Ól. Sveinsson (Reykjavík: Hið íslenzka fornritafélag, 1954), 12–15, 20–21, 24; "Laxdaela saga," in *Íslenzkt fornrit 5,* ed. Einar Ól. Sveinsson (Reykjavík: Hið íslenzka fornritafélag, 1934), 16, 44, 52, 60.

118 **"mockery," "dabbled my blade":** *Egil's Saga* tr. Hermann Pálsson and Paul Edwards (New York: Penguin Books, 1978), 104, 147; ***Gunnhild must pay:*** tr. Bernard Scudder, in *The Sagas of Icelanders: A Selection* (New York: Viking, 2000), 102.

119 **"Age of Gunnhild":** Odd the Monk, cited by Jóna Guðbjörg Torfadóttir, "Gunnhildur and the Male Whores," Sagas and Societies Conference, Borgarnes, Iceland, 2002, https://publikationen.uni-tuebingen.de/xmlui/handle/10900/46213.

121 **"whet me to cruelty," motif of the "whetter":** Jochens (1996), 181-83, 196, 201.

121 **Ivo of Chartres, Thomas of Chobham:** Sharon Farmer, "Persuasive Voices: Clerical Images of Medieval Wives," *Speculum* 61 (1986): 517–19.

122 **Ingunn:** "Jóns saga biskups, eptir Gunnlaug múnk," in *Biskupa sögur,* ed. Jón Sigurðsson and Guðbrandr Vigfússon (Copenhagen: Hinu Íslenzka bókmentafélagi, 1858), I: 241; Helga Kress, "What a Woman Speaks," in *Nordisk Kvindelitteraturhistoire,* ed. Elisabeth Møller Jensen (Copenhagen: KVINFO, 1993–98), http://www.nordic womensliterature.net/article/what-woman-speaks.

122 **"weaving checks":** *tefla,* in Richard Cleasby and Gudbrand Vigfusson, *An Icelandic-English Dictionary,* 2nd ed. (Oxford: Clarendon Press, 1957; rpt. 1969), 627.

123 **clerical marriage:** Dyan Elliot, *Fallen Bodies* (Philadelphia: University of Pennsylvania Press, 1999), 104.

123 **"The darkness flees":** tr. Bernard Scudder, "Officium S. Thorlaci," *Voces Thules* (recorded 2006), www.vocesthules.is.

123 **Herdis:** Helgi Guðmundsson, *Um Haf Innan* (Reykjavík: Háskólaútgáfan, 1997), 33, 80, 129.

124 **"scandal":** tr. Peter Landau, in *Archbishop Eystein as Legislator,* ed. Tore Iversen (Trondheim, Norway: Tapir Academic Press, 2011), 66.

124 *skörungskapr:* "Páls saga biskups," in *Biskupa sögur* (1858), I: 131; Nancy Marie Brown, *The Far Traveler* (New York: Harcourt, 2007), 71–75, 146–47, 223–36.

125 **"darkness across the south":** tr. Elizabeth Ashman Rowe, *Icelandic Annals,* personal communication, February 23, 2010.

125 **Skalholt:** Kristján Eldjárn, Hákon Christie, and Jón Steffensen, *Skálholt Fornleifa rannsóknir 1954–1958* (Reykjavík: Lögberg, 1988), 21–45; Mjöll Snæsdóttir et al., *Saga Biskupsstólanna* (Reykjavík: Bókaútgáfan Hólar, 2006), 678, 91; Gunnar Karlsson, *The History of Iceland* (Minneapolis: University of Minnesota Press, 2000), 39, 44; Frank Ponzi, *Eighteenth-Century Iceland: A Pictorial Record from the Banks and Stanley Expeditions* (Reykjavík: Almenna bókafélagið, 1980), 55; Óskar Guðmundsson, *Snorri: Ævisaga Snorra Sturlusonar 1179–1241* (Reykjavík: JP Útgáfa, 2009), 48; Bruce Gelsinger, *Icelandic Enterprise* (Columbia: University of South Carolina Press, 1981), 11–15.

126 **drowned:** "Páls saga biskups," in *Biskupa sögur* (1858), I: 137.

127 **Loft as author:** Sveinbjörn Rafnsson, *Páll Jónsson Skálholtsbiskup* (Reykjavík: Sagnfræðistofnun Háskóla Íslands, 1993), 36, 129; "Íslendinga saga," in *Sturlunga saga,* ed. Guðbrandr Vigfússon (Oxford: Clarendon Press, 1878), 1: 212, 245.

127 **Pall liked nothing better:** "Páls saga biskups," in *Biskupa sögur* (1858), I: 130, 133, 135–36, 140; Einar Ól. Sveinsson, *Age of the Sturlungs* (Ithaca, NY: Cornell University Press, 1953), 115; Einar Ól. Sveinsson, ed., *Páls saga biskups* (Skálholt, Iceland: Skálholtsfélagið, 1954), 4–11; "Páls saga biskups," in *Íslenzk fornrit 16,* ed. Ásdís Egilsdóttir (Reykjavík: Hið íslenzka fornritafélag, 2002), xxi; Snæsdóttir et al. (2006), 95.

128 **windows, bells:** Kirsten A. Seaver, *The Last Viking* (New York: I. B. Tauris, 2010), 83; Thór Magnússon, *A Showcase of Icelandic National Treasures* (Reykjavík: Iceland Review, 1987), 34; Kristján Valur Ingólfsson, interviewed in Skálholt, Iceland, November 8, 2013; Kristján Eldjárn and Hörður Ágústsson, *Skálholt: Skrúði og áhöld* (Reykjavík: Hið íslenska bókmenntafélag, 1992), 257.

128 **an Icelandic ell:** Jenny Jochens, *Women in Old Norse Society* (Ithaca, NY: Cornell University Press, 1995), 158, 139. A modern Icelandic dictionary will give a length of 24 inches for an ell—English dictionaries may even say 45 inches—but the word has been used for various lengths over the centuries. The ell in Pall's day was still the "primitive" ell of 18 inches. See *alin,* Cleasby and Vigfusson (1957), 13.

128 **Amundi the Smith:** Guðrún Nordal, *Tools of Literacy* (Toronto: University of Toronto Press, 2001), 156–58; "Páls saga biskups," in *Biskupa sögur* (1858), I: 132, 146.

129 **craft guilds:** Colum Hourihane, *The Grove Encyclopedia of Medieval Art and Architecture* (Oxford: Oxford University Press, 2012), 2: 96.

129 **tool chests:** Charlotte Blindheim, "Smedgraven fra Bygland i Morgedal," *Viking Tidsskrift for norrøn arkeologi* 26 (1963): 25–79; Anders Winroth, *The Conversion of Scandinavia* (New Haven, CT: Yale University Press, 2012), 72.

130 **"extraordinarily meticulous":** Johan Callmer, "Wayland," *Uppåkra Studies* 7 (2002): 337–361.

130 **urban artists:** Dagfinn Skre, in *The Viking World,* ed. Stefan Brink and Neil Price (New York: Routledge, 2008), 90.

130 **"traces of specialized crafts":** John Ljungkvist, in Brink and Price (2008), 190.

130 **"a Volund of a smith":** *Hrafns saga Sveinbjarnarsonar,* ed. Guðrún P. Helgadóttir (Oxford: Clarendon Press, 1987), 2; Margaret Clunies Ross, *A History of Old Norse Poetry and Poetics* (Cambridge: D. S. Brewer, 2005), 7–8; "The Lay of Volund," tr. Terry (1969), 93–100; Winroth (2012), 64–65.

131 **stave churches:** Martin Blindheim, *Norwegian Romanesque Decorative Sculpture 1090–1210* (London: Alec Tiranti, 1965), 3, 5; **"abundance of roofs":** M. Blindheim (1965), 31.

131 **inscriptions carved in runes, "Torolf made me":** M. Blindheim (1965), 49; Erla Bergendahl Hohler, *Norwegian Stave Church Sculpture* (Oslo: Scandinavian University Press, 1999), II: 39, 45-46.

131 **portals:** Hohler (1999), II: 9, 21, 30–40, 44–46, 73; **"belong to another world":** Hohler (1999), II: 76; **"Any scholar's view," "dragon imagination":** Hohler (1999), II: 12.

131 **Urnes style:** Holger Koefoed, *Viking Art* (Reykjavík: Gudrun, 2006), 21; David M. Wilson, *The Vikings in the Isle of Man* (Aarhus, Denmark: Aarhus University Press, 2008), 334.

132 ***On Divers Arts:*** Theophilus, *De Diversis Artibus,* tr. C. R. Dodwell (Oxford: Clarendon Press, 1986), xxxiii–x; Heidi C. Gearhart, *Theophilus'* On Diverse Arts: *The Persona of the Artist and the Production of Art in the Twelfth Century,* PhD dissertation (University of Michigan, 2010), 34, 38–40, 44, 80, 140, 264–66.

133 ***Didascalion:*** Gearhart (2010), 54.

133 **door from Valthjofsstad:** Þjóðminjasafn Íslands, Reykjavík (no. 11009); Ellen Marie Mageröy, *Planteornamentikken í íslandsk treskurd* (Copenhagen: Den Arnamagnæanske Kommission, 1967), 140; Robert E. Cutrer, "The Wilderness of Dragons: The Reception of Dragons in Thirteenth-Century Iceland," Master's thesis (University of Iceland, 2012), 14, 19; Th. Magnússon (1987), 35; Erla Hohler, in *Viking to Crusader,* ed. Else Roesdahl and David M. Wilson (New York: Rizzoli, 1992), 207; Richard L. Harris, "The Lion-Knight Legend in Iceland and the Valþjófsstaðir Door," *Viator* 1 (1970): 125–45; Björn Magnússon Ólsen, "Valþjófsstaðahurðin," *Árbók hins íslenzka fornleifafélags* (1884): 24–37.

134 **Physiologus:** tr. T. H. White, *The Book of Beasts* (New York: G. P. Putnam's Sons, 1954; rpt. Dover, 1984), 7, 161, 167.

135 **Markus, Randalin:** "Íslendinga saga," in *Sturlunga saga* (1878), I: 193; "Hrafns saga," in *Sturlunga saga* (1878), II: 280; "Brennu-Njáls saga," *Íslenzkt fornrit 12* (1954), 238; Barði Guðmundsson, *Höfundur Njálu* (Reykjavík: Menningarsjóður, 1958), cited by Guðmundur G. Þórarinsson, *The Enigma of the Lewis Chessmen,* 3rd ed. (Reykjavík: Gallery Chess, 2014), 33.

135 **"adroit":** Anna Sigurðardóttir, *Vinna kvenna á Íslandi í 1100 ár* (Reykjavík: Kvennasögusafn Íslands, 1985), 298.

136 **chapel:** Ebbe Nyborg, in Roesdahl and Wilson (1992), 212, 214; Björn Þ. Björnsson, *Íslenzka teiknibókin í Árnasafni* (Reykjavík: Heimskringla, 1954), 125–26; Guðbjörg Kristjánsdóttir, *Íslenska teiknibókin* (Reykjavík: Crymogea, 2013).

136 **Saint Thorlak's relics:** "Páls saga biskups," in *Biskupa sögur* (1858), I: 134; Th. Magnússon (1987), 38.

137 **shrine of Saint Olaf:** Øystein Ekroll, in *The Medieval Cathedral of Trondheim,* ed. Margrete Syrstad Andås et al. (Turnhout, Belgium: Brepols, 2007), 155–56, 197–98; Snorri Sturluson, "Magnúss saga ins góða," in *Íslenzk fornrit 28,* ed. Bjarni Aðalbjarnarson (Reykjavík: Hið íslenzka fornritafélag, 1951), 20. Snorri ascribes the shrine to King Magnus the Good (1034–46); Ekroll attributes it to King Magnus Erlingsson.

137 **"If the shrine still existed":** Kristján Eldjárn, in Eldjárn and Ágústsson (1992), 215–25.

137 **Gudmund the Worthy:** "Guðmundar saga dyra," in *Sturlunga saga* (1878), I: 141.

138 **funerals:** William Kay, *Living Stones*, PhD dissertation (University of St Andrews, 2013), 102; "Jóns saga helga," in *Biskupa sögur*, ed. Guðni Jónsson (Reykjavík: Íslendingasagnaútgáfan, 1948), II: 62.

139 **Skalholt's importance:** John F. West, ed., *The Journals of the Stanley Expedition to the Faroe Islands and Iceland in 1789* (Tórshavn: Føroya fróðakaparfélag, 1970), I: 115; Mjöll Snæsdóttir, interviewed in Reykjavík, May 24, 2013.

139 **"From the beginning of our researches":** Kristján Eldjárn, in Eldjárn et al. (1988), 147.

140 **Pall's sarcophagus:** steinkistan Páls biskups Jónssonar, Skálholtsstaður, Skálholt, Ísland; Jón Steffensen, "Bein Páls biskups Jónssonar," *Skírnir* (1956): 172–86; Sveinsson (1954), 3–4.

140 **skeleton . . . of Pall:** Guðný Zoëga, interviewed in Sauðárkrókur, Iceland, June 4, 2013; Jette Arneborg, interviewed in Copenhagen, Denmark, November 13, 2013; Jette Arneborg et al., "Human Diet and Subsistence Patterns in Norse Greenland AD c.980– AD c.1450," *Journal of the North Atlantic*, Special Volume 3 (2012): 119–33.

141 **attribute the crozier:** Þjóðminjasafn Íslands, Reykjavík (S 2); Th. Magnússon (1987), 43; Kristján Eldjárn, in Eldjárn et al. (1988), 48; Elizabeth Pierce, "Walrus Hunting and the Ivory Trade in Early Iceland," *Archaeologia Islandica* 7 (2009): 59.

141 **a second twelfth-century crozier:** Nationalmuseet, København, Udstilling om Danmarks Middelalder og Renæssance: Nordboerne i Grønland (DNM D11154).

141 **Bishop Jon Smyrill:** Pierce (2009), 59; Roesdahl and Wilson (1992), 384; Seaver (2010), 83–84; Jette Arneborg, *Saga Trails* (Copenhagen: National Museum of Denmark, 2006), 51; "Páls saga biskups," in *Biskupa sögur* (1858), I: 135; Jette Arneborg, in *Vikings: The North Atlantic Saga*, ed. William W. Fitzhugh and Elisabeth I. Ward (Washington, DC: Smithsonian Institution Press, 2000), 312.

141 **Roger of Helmarhausen:** Gearhart (2010), 134; **"style, structure, fabrication":** Gearhart (2010), 141.

142 **"centerpiece of the Cloisters treasury":** The Cloisters Collection (63.12), Metropolitan Museum of Art, New York; Elizabeth C. Parker, and Charles T. Little, *The Cloisters Cross* (New York: Metropolitan Museum of Art, 1994), 13, 17, 19, 36, 37, 38, 213.

144 **common motif for bishops' croziers:** A. M. Cust, *The Ivory Workers of the Middle Ages* (London: George Bell and Sons, 1902), 131–32; Rafnsson (1993), 87, 123; O. M. Dalton, *Catalogue of the Ivory Carvings of the Christian Era in the British Museum* (London: British Museum, 1909), 75; Th. Magnússon (1987), 43.

145 **"At that time Loft . . . went abroad":** "Páls saga biskups," in *Íslenzkt fornrit 16* (2002), 324–25.

146 **balsam:** Lúdwík Kristjánsson, *Íslenzkir sjávarhættir* (Reykjavík: Bókaútgáfa menningarsjóðs, 1986), 5: 106.

147 **"old game with one king":** *Saga of Ref the Sly,* tr. Clark, in *Sagas of Icelanders* (2000), 612–13.

148 **very few tools:** John Beckwith, *Ivory Carvings in Early Medieval England* (London: Harvey Miller and Medcalf, 1972),116; Norbert J. Beihoff, *Ivory Sculpture Through the Ages* (Milwaukee, WI: Milwaukee Public Museum, 1961), 18, 27; see also Anthony Cutler, *The Hand of the Master* (Princeton, NJ: Princeton University Press, 1994), 91–99, 114, 119, 133, 135.

148 **"Cutting across the grain":** Anthony Cutler, "Prolegomena to the Craft of Ivory Carving in Late Antiquity and the Early Middle Ages," in *Artistes, Artisans, et Production Artistique au Moyen Age,* ed. Xavier Barall i Altet (Paris: Picard, 1987), 2: 443–45.

148 **On Divers Arts:** tr. Dodwell (1986), 165–67.

148 **were red:** Frederic Madden, "Historical Remarks on the Introduction of the Game of Chess into Europe," *Archaeologia* 24 (1832): 244.

149 **to make chessmen:** Hourihane (2012), 441; Pete Dandridge, "From Tusk to Treasure," December 6, 2011, and Ross D. E. MacPhee, "The Walrus and Its Tusks," November 14, 2011, *Metropolitan Museum of Art, Game of Kings Exhibition Blog,* http://www .metmuseum.org/exhibitions/listings/2011/the-game-of-kings-medieval-ivory

-chessmen-from-the-isle-of-lewis/exhibition-blog; Arthur MacGregor, *Bone, Antler, Ivory, and Horn* (London: Croom Helm, 1985), 55, 58; David Caldwell, Mark Hall, and Caroline Wilkinson, "The Lewis Hoard of Gaming Pieces," *Medieval Archaeology* 53 (2009): 187, 189; Danielle Gaborit-Chopin, in Roesdahl and Wilson (1992), 204; Stratford (1997), 4.

149 **five chessmen:** Robinson (2004), 60.

150 **"graining":** MacGregor (1985), 139.

150 **error:** Caldwell et al. (2009), 185–87; David Caldwell, Mark Hall, and Caroline Wilkinson, *The Lewis Chessmen Unmasked* (Edinburgh: NMS Enterprises, 2010), 63.

150 **forensic art:** Caldwell et al. (2009), 182–89.

152 **"about the artist, his milieu":** Hohler (1999), II: 12.

152 **"psychologically charged":** G. Henderson, "Part III: The English Apocalypse," *Journal of the Warburg and Courtauld Institutes* 31 (1968): 103–47.

152 **"naturalistic":** MacGregor (1985), 139.

152 **"self-confident style":** Michael Taylor (1978), 9.

CHAPTER FOUR: THE KINGS

155 *Egil's Saga:* "Egils saga Skalla-Grímssonar," *Íslenzk fornrit 2,* ed. Sigurður Nordal (Reykjavík: Hið íslenzka fornritafélag, 1933), 143–44.

156 **such dragons:** O. M. Dalton, *Catalogue of the Ivory Carvings of the Christian Era in the British Museum* (London: British Museum, 1909), 36; Martin Blindheim, *Norwegian Romanesque Decorative Sculpture 1090–1210* (London: Alec Tiranti, 1965), 7; George Zarnecki, *The Early Sculpture of Ely Cathedral* (London: Alec Tiranti, 1958), 33, 36; Øystein Ekroll, interviewed in Trondheim, November 19 and 20, 2013.

156 **four walrus-ivory carvings:** reliquary (British Museum, London, MLA 1959, 12-2.1), sword guard and pommel (Nationalmuseet, København, Inv. 9105), tau crozier (Nationalmuseet, København, Inv. 9101); Neil Stratford, *The Lewis Chessmen and the Enigma of the Hoard* (London: British Museum Press, 1997), 41–44; Michael Taylor, *The Lewis Chessmen* (London: British Museum Press, 1978), 9–11.

156 **"various scrolls":** Frederic Madden, "Historical Remarks on the Introduction of the Game of Chess into Europe," *Archaeologia* 24 (1832): 213.

157 **"as far north as the Hebrides":** P. E. Lasko, "A Romanesque Ivory Carving," *British Museum Quarterly* 23 (September 1960), 12–15.

157 **"British origin":** Dalton (1909), 63–64.

157 **"unprecedented exchange of ideas":** Paul Williamson, *Introduction to Medieval Ivory Carvings* (London: Her Majesty's Stationery Office, 1982), 15.

157 **English influence, "trained as woodcarvers," "blended":** Blindheim (1965), 5, 11, 14.

157 **saint's cult, daughter houses:** Bruce Dickins, "The Cult of S. Olave in the British Isles," *Saga-Book* 12 (1937–45): 53–80.

158 **Alexander "the Magnificent":** Candice Bogdanski, "A 'North Sea School of Architecture'?" *Journal of the North Atlantic,* Special Volume 4 (2013): 77–106.

158 **English type of "beast chain," "Anglo-Saxon motifs":** Erla Bergendahl Hohler, *Norwegian Stave Church Sculpture* (Oslo: Scandinavian University Press, 1999), II: 60, 63, 82.

158 **Icelandic art historian:** Bera Nordal, "Af tanntafli útskurður í röstungstönn," *Árbók listasafns Íslands* (1990–92): 31–49.

159 **"a small sculpture of a Madonna":** Christopher McLees and Øystein Ekroll, "A Drawing of a Medieval Ivory Chess Piece from the 12th-Century Church of St Olav, Trondheim, Norway," *Medieval Archaeology* 34 (1990): 151–54.

159 **Touring modern-day Trondheim:** Christopher McLees and Øystein Ekroll, interviewed in Trondheim, November 19 and 20, 2013.

159 *Saint Albans Psalter:* Dombibliothek Hildesheim (HS St. God. I), Basilica of St. Godehard, Hildesheim; Jane Geddes, ed., *Saint Albans Psalter Online,* https://www.abdn.ac.uk/stalbanspsalter/english/index.shtml.

160 *Hunterian Psalter:* Glasgow University Library Special Collections, Glasgow, MS Hunter U.3.2. (229), http://special.lib.gla.ac.uk/exhibns/month/may2007.html.

160 *Copenhagen Psalter:* Det Kongelige Bibliotek, København, MS. Thott 143 2°; Christopher Norton, in *Eystein Erlendsson: Erkebiskop, politiker, og kirkebygger,* ed. Kristin Bjørlykke et al. (Trondheim, Norway: Nidaros Domkirkes Restaureringsarbeiders forlag, 2012), 185, 203.

160 two other chess pieces: Christopher McLees, *Games People Played* (Trondheim, Norway: Riksantikvaren Utgravningskontoret for Trondheim, 1990), 194; Christopher McLees, "A Carved Medieval Chess King Found on the Island of Hitra, Near Trondheim, Norway," *Medieval Archaeology* 53 (2009): 315–21.

161 "Trondheim Group" of stave-church portals: Hohler (1999), II: 67, 63, 82, 61, 81.

161 "unwise to assume": Taylor (1978), 14.

162 Lund knight: Stratford (1997), 44; Claes Wahlöo, in *Viking to Crusader,* ed. Else Roesdahl and David M. Wilson (New York: Rizzoli, 1992), 390.

162 Lund: Peter Carelli, in *Lübecker Kolloquium zur Stadtarchäologie im Hanseraum I,* ed. M. Gläser (Lübeck, Germany: Verlag Schmidt-Römhild, 1997), 429–40.

162 "lied about his origins": Saxo Grammaticus, *Danorum Regum heroumque historia, Books X–XVI,* tr. Eric Christiansen (Oxford: BAR, 1980–81), 548, 408.

162 Archbishop Absalon: Madden (1832), 255; Niels Lund, in *Archbishop Absalon of Lund and His World,* ed. Karsten Friis-Jensen and Inge Skovgård-Petersen (Roskilde, Denmark: Roskilde museums forlag, 2000), 9; Ólafia Einarsdóttir, in Friis-Jensen and Skovgård-Petersen (2000), 37–38, 66; *Jómsvíkingasaga ok Knýtlinga,* ed. Þorsteinn Helgason et al. (Copenhagen: H. F. Popp, 1828), 367.

162 Lund's cathedral: Zarnecki (1958), 29; Olaf Olsen, in *Viking to Crusader,* ed. Else Roesdahl and David M. Wilson (New York: Rizzoli, 1992), 158; Jan Svanberg, in Roesdahl and Wilson (1992), 211.

163 motifs on the Lewis thrones: Lasko (1960), 14–15.

163 hairstyle: Thór Magnússon, *A Showcase of Icelandic National Treasures* (Reykjavík: Iceland Review, 1987), 33; Williams et al. (2013), 192; Janet E. Snyder, *Early Gothic Column-Figure Sculpture in France* (Burlington, VT: Ashgate, 2011), 82; Margarete Andås, interviewed in Trondheim, November 20, 2013, and personal communication, November 21, 2013.

163 "No further commentary": Stratford (1997), 44; Roesdahl and Wilson (1992), 390.

164 "good evidence": James Robinson, *The Lewis Chessmen* (London: British Museum Press, 2004), 35.

164 ivory artifacts from Trondheim: Clifford D. Long, "Excavations in the Medieval City of Trondheim, Norway," *Medieval Archaeology* 19 (1975): 21; Sæbjørg Walaker Nordeide, "Activity in an Urban Community," *Acta Archaeologica* 60 (1989):145; McLees (1990), 43; Oskar Spjuth, "In Quest for the Lost Gamers," Master's thesis in historical archaeology (Lund University, 2012), 38.

164 ivory waste material: Else Roesdahl, in *Viking and Norse in the North Atlantic,* ed. Adras Mortensen and Simun V. Arge (Tórshavn, Faroe Islands: Annales Societatis Scientiarum Faeroensis Supplement 44, 2005), 183, 187–88.

164 walrus-ivory amulet of Thor: *Saga of Hallfred,* tr. Richard Perkins in "The Gateway to Trondheim," *Saga-Book* 25 (1998–2001): 187–92.

164 walrus-ivory workshops: Roesdahl (2005), 187–88; Roesdahl, in *Vinland Revisited,* ed. Shannon Lewis-Simpson (St. John's, Newfoundland: Historic Sites Association, 2003), 146.

164 review of the ivory trade: Elizabeth Pierce, "Walrus Hunting and the Ivory Trade in Early Iceland," *Archaeologia Islandica* 7 (2009): 59, 61.

164 harbor at Gasir: Adolf Friðriksson et al., *Fornleifastofnun Íslands Annual Report 2006* (Reykjavík: Fornleifastofnun Íslands, 2006), 24.

165 quarter of Saint Marten: Carelli (1997), 430.

165 "nearly impossible": Hohler (1999), II: 82.

166 Olaf the Peaceful: Snorri Sturluson, "Óláfs saga kyrra," in *Íslenzk fornrit 28,* ed. Bjarni Aðalbjarnarson (Reykjavík: Hið íslenzka fornritafélag, 1951), 203–9.

166 Magnus Bare-Legs: "Magnúss saga berfætts," in *Íslenzk fornrit 28* (1951), 218.

167 *fire over Lewis:* Bjorn Cripple-Hand, "Icelandic Verse," tr. Erling Monsen, in *Highlands and Islands,* ed. Mary Miers (London: Eland, 2010), 74.

167 developing Bergen: Margarete Syrstad Andås et al., eds., *The Medieval Cathedral of Trondheim* (Turnhout, Belgium: Brepols, 2007), 10; "Magnússona saga," in *Íslenzk fornrit 28* (1951), 254.

167 Trondheim around 1100: Karl-Fredrik Keller and Øystein Ekroll, *Middelalderbyen Nidaros* (Oslo: Karl-Fredrik Keller, 2008), 14; "Magnússona saga," in *Íslenzk fornrit 28* (1951), 255.

168 Sigurd the Jerusalem-Farer: "Magnússona saga," in *Íslenzk fornrit 28* (1951), 262–63, 276, 288–95, 250.

168 make its own plans: Blindheim (1965), 2; Olafía Einarsdóttir, in Friis-Jensen and Skovgård-Petersen (2000), 39.

169 "coordinated effort": Øystein Ekroll, interviewed in Trondheim, November 19, 2013.

169 grand cathedral: Øystein Ekroll, in *Nidaros Cathedral and the Archbishop's Palace,* ed. Ekroll et al. (Trondheim, Norway: Nidaros Cathedral Restoration Workshop, 1995), 29–30; Ekroll, in Andås et al. (2007), 150, 174–78, 186, 194–95.

169 "lied about his origins": Saxo, tr. Christiansen (1980–81), 548.

170 Ralph of Redcar: Anne J. Duggen, in *Archbishop Eystein as Legislator,* ed. Tore Iversen (Trondheim, Norway: Tapir Academic Press, 2011), 30–31.

170 Canterbury: John Beckwith, *Ivory Carvings in Early Medieval England, 700–1200* (London: Arts Council of Great Britain, 1974), 10; John Beckwith, *Ivory Carvings in Early Medieval England* (London: Harvey Miller and Medcalf, 1972), 103–7.

170 masons' marks: Kjersti Kristofferson, in Bjørlykke et al. (2012), 181; Anne Eriksen, "Making Facts from Stones," *Sjuttonhundratal* 7 (2010): 97–122; Andås et al., (2007), 11.

171 "jigsaw puzzle": Dag Nilsen, "The Cathedral of Nidaros," *Future Anterior* 7 (Winter 2010): 1–17.

171 "understanding of Romanesque art": Blindheim (1965), 7.

172 any king's son: Claus Krag, in *The Viking World,* ed. Stefan Brink and Neil Price (New York: Routledge, 2008), 650.

172 "Kali was fifteen": *Orkneyinga Saga, Íslenzk fornrit 34,* ed. Finnbogi Guðmundsson (Reykjavík: Hið íslenzka fornritafélag, 1965), 130.

173 "feel young again": Benjamin Hudson, *Viking Pirates and Christian Princes* (Oxford: Oxford University Press, 2005), 195.

173 Harald Gilli, Magnus IV: "Magnúss saga blinda ok Haralds gilla," in *Íslenzk fornrit 28* (1951), 267, 278.

173 Bishop Reinald: "Magnúss saga blinda ok Haralds gilla," in *Íslenzk fornrit 28* (1951), 288.

174 "Sham Deacon": Saxo, tr. Christiansen (1980–81), 466, note 354.

174 "civil war": Sverre Bagge, in Iversen (2011), 13.

174 Ivar Skrauthanki: "Haraldssona saga," in *Íslenzk fornrit 28* (1951), 317.

174 Ingi the Hunchback: "Haraldssona saga," in *Íslenzk fornrit 28* (1951), 330–31.

175 Erling Skew-Neck: *Orkneyinga Saga, Íslenzk fornrit 34* (1965), 216, 224, 236; "Magnúss saga Erlingssonar," in *Íslenzk fornrit 28* (1951), 396.

176 hard bargain: Sverre Bagge, in Iversen (2011), 13–16; Lars Hermanson, in *Settlement and Lordship in Viking and Early Medieval Scandinavia,* ed. Bjørn Poulsen and Søren Michael Sindbæk (Turnhout, Belgium: Brepols, 2011), 71.

177 seal their bargain: Margrete Syrstad Andås, in *The Nidaros Office of the Holy Blood,* ed. G. Attinger and A. Han. (Trondheim, Norway: Nidaros Domkirkes Restaureringssarbeiders forlag, 2004), 189–91.

177 Viken: Olafía Einarsdóttir, in Friis-Jensen and Skovgård-Petersen (2000), 60–65.

177 "came up to a stockade": "Guðmundar biskups saga, hin elzta," in *Biskupa sögur,* ed. Jón Sigurðsson and Guðbrandr Vigfússon (Copenhagen: Hinu Íslenzka bókmentafélagi, 1858), I: 413–14.

178 **"strategy of fixed armies"**: Sverre Bagge, *Society and Politics in Snorri Sturluson's Heimskringla* (Berkeley: University of California Press, 1991), 94, 197.

178 **"thunderstorm"**: Saxo, tr. Ólafia Einarsdóttir, in Friis-Jensen and Skovgård-Petersen (2000), 43; **"utter ruin"**: Saxo, tr. Christiansen (1980–81), 548.

178 **Roger of Hovedon:** cited by Björn Weiler, "Matthew Paris in Norway," *Revue Benedictine* 122.1 (2012): 153–81.

179 **Abbot Karl Jonsson:** Jónas Kristjánsson, *Eddas and Sagas* (Reykjavik: Hið íslenska bókmenntafélag, 2007), 151, 153.

179 *Saga of King Sverrir: Saga Sverris konúngs*, ed. Carl Christian Rafn and Finnur Magnússon (Copenhagen: H. Popp, 1834), 5, 7–9, 15–16.

179 **"uncommon man"**: Torfi H. Tulinius, tr., *La Saga de Sverrir* (Paris: Les Belles Lettres, 2010), 17.

180 **"Birchlegs"**: "Magnúss saga Erlingssonar," in *Íslenzk fornrit 28* (1951), 411.

180 **"imposter of genius"**: Þórleifur Hauksson, cited by Tulinius (2010), 23.

180 **battle:** *Saga Sverris konúngs* (1834), 289, 35, 39, 146, 405–6, 352, 387, 74, 93–94, 446–47, 238, 94–96, 98, 99–100.

183 **"old game with one king"**: *Saga of Ref the Sly*, tr. George Clark, in *Sagas of Icelanders* (2000), 612.

183 **two-sided gameboard:** Caldwell et al. (2009), 180; Spjuth (2012), 18.

183 *hnefatafl:* Mark A. Hall and Katherine Forsyth, "Roman Rules?" *Antiquity* 85 (2011): 1325–38; Th. Magnússon (1987), 31; Lúdvík Kristjánsson, *Íslenzkir sjávarhættir* (Reykjavík: Bókaútgáfa menningarsjóðs, 1986), 5: 101; Pierce (2009), 60; B. Nordal (1992), 46; McLees (1990), 58; David Caldwell, Mark Hall, and Caroline Wilkinson, *The Lewis Chessmen Unmasked* (Edinburgh: NMS Enterprises, 2010), 71.

184 *tablut:* H. J. R. Murray, *A History of Chess* (Oxford: Clarendon Press, 1913), 444–49.

184 **"According to game theory"**: Sten Helmfrid, "Hnefatafl, the Strategic Board Game of the Vikings," published online 2005, http://hem.bredband.net/b512479/.

185 **One night in Jamtaland:** *Saga Sverris konúngs* (1834), 67–68.

185 **real-life chess matches:** *Saga Sverris konúngs* (1834), 259, 268–70, 277–80, 359–61, 440–46; Sveinbjörn Rafnsson, *Páll Jónsson Skálholtsbiskup* (Reykjavík: Sagnfræðistofnun Háskóla Íslands, 1993), 27.

188 **Gudmund the Good:** Eiríkr Magnússon, "The Last of the Icelandic Commonwealth, Part I," *Saga-Book* 5 (1906–7): 324; W. P. Ker, "The Life of Bishop Gudmund Arason," *Saga-Book* 5 (1906–7): 92; "Guðmundar saga góða," in *Sturlunga saga*, ed. Guðbrandr Vigfússon (Oxford: Clarendon Press, 1878), I: 122–25; *Hrafns saga Sveinbjarnarsonar*, ed. Guðrún P. Helgadóttir (Oxford: Clarendon Press, 1987), 19–22.

190 **"the foaming sea," "the sail was stiff," "the waves are dashing"**: tr. Anne Tjomsland, *Hrafns saga Sveinbjarnarsonar* (Ithaca, NY: Cornell University Press, 1951), 27–29.

190 **"one of the best harbors"**: Rosemary Power, "Norse-Gaelic Contacts," *Journal of the North Atlantic*, Special Volume 4 (2013): 19–25.

191 **"an Icelandic *kaupmann*"**: Madden (1832), 289–90.

191 **"They were long at sea"**: "Brennu-Njáls saga," *Íslenzkt fornrit* 12, ed. Einar Ól. Sveinsson (Reykjavík: Hið íslenzka fornritafélag, 1954), 438.

191 **"Bay of the Icelanders"**: Helgi Guðmundsson, *Um Haf Innan* (Reykjavík: Háskólaútgáfan, 1997), 56–57.

191 **king of the Isles:** Caldwell et al. (2010), 46–51; Rosemary Power, "Meeting in Norway," *Saga-Book* 29 (2005): 10.

192 **an eighth of the kingdom:** Hudson (2005), 201.

192 **"people on the edge"**: Mike Parker Pearson, ed. *From Machair to Mountains* (Edinburgh: Oxbow Books, 2012), unpaged Kindle edition.

192 **written by Hrafn's friend:** Guðbrandr Vigfússon, ed., *Sturlunga saga* (1878), cxv; Guðrún P. Helgadóttir, ed., *Hrafns saga Sveinbjarnarsonar* (1987), lxxxix.

193 **scam:** Power (2013), 22.

193 **"the number of sets"**: Madden (1832), 290.

193 **"Book of Rights"**: Caldwell et al. (2009), 168, 176–77.

193 **"Poem of Angus":** tr. Thomas Clancy, in *A History of Everyday Life in Medieval Scotland, 1000 to 1600,* ed. Edward J. Cowan and Lizanne Henderson (Edinburgh: Edinburgh University Press, 2011), 150; Caldwell et al. (2009), 155.

194 **"a merchant stashed four chess sets":** Colleen Schafroth, *The Art of Chess* (New York: Harry N. Abrams, 2002), 50.

CHAPTER FIVE: THE KNIGHTS

197 **horses:** R. H. C. Davis, *The Medieval Warhorse* (London: Thames and Hudson, 1989), 21, 23, 30, 34, 41, 43, 61, 85; Anthony Dent, *The Horse Through Fifty Centuries of Civilization* (New York: Holt, Rinehart, and Winston, 1974), 9, 23–26.

197 **"uselessly small":** Davis (1989), 30.

198 **"misleadingly":** David Caldwell, Mark Hall, and Caroline Wilkinson, *The Lewis Chessmen Unmasked* (Edinburgh: NMS Enterprises, 2010), 33.

198 **"stocky, docile," functional:** Michael Taylor, *The Lewis Chessmen* (London: British Museum Press, 1978), 7.

198 **door from Valthjofsstad:** Þjóðminjasafn Íslands, Reykjavík (no. 11009); Thór Magnússon, *A Showcase of Icelandic National Treasures* (Reykjavík: Iceland Review, 1987), 35.

198 **enamel from Limoges:** Chasse with the Adoration of the Magi, Musée national du Moyen Âge, Thermes de Cluny, Paris (Cl. 23822); Barbara Drake Boehm, "Horsing Around," *Metropolitan Museum of Art, Game of Kings Exhibition Blog,* December 29, 2011, http://www.metmuseum.org/exhibitions/listings/2011/the-game-of-kings-medieval-ivory-chessmen-from-the-isle-of-lewis/exhibition-blog/game-of-kings/blog/horsing-around.

198 **tapestry from Baldishol:** Kunstindustrimuseet, Oslo; see Per Hofman Hansen, "The Norwegian Baldishol Tapestry," http://www.aldus.dk/baldishol/default-eng.html.

198 *Hunterian Psalter:* Glasgow University Library Special Collections, Glasgow (MS Hunter U.3.2. (229), folio 3r), http://special.lib.gla.ac.uk/exhibns/month/may2007.html.

199 **mounted warriors:** *Saga Sverris konúngs,* ed. Carl Christian Rafn and Finnur Magnússon (Copenhagen: H. Popp, 1834), 403–4; "Hákonar saga góða," in *Íslenzk fornrit 26,* ed. Bjarni Aðalbjarnarson (Reykjavík: Hið íslenzka fornritafélag, 1941), 185; "Egils saga Skalla-Grímssonar," *Íslenzk fornrit 2,* ed. Sigurður Nordal (Reykjavík: Hið íslenzka fornritafélag, 1933), 136.

199 **made in Iceland:** Frederic Madden, "Historical Remarks on the Introduction of the Game of Chess into Europe," *Archaeologia* 24 (1832): 257.

199 **"contemporary kit":** David Caldwell, interviewed in Edinburgh, November 16, 2013.

200 **shields:** Madden (1832), 269; David Caldwell, Mark Hall, and Caroline Wilkinson, "The Lewis Hoard of Gaming Pieces," *Medieval Archaeology* 53 (2009): 195; Williams et al. (2013), 89.

200 **fencing lessons:** Óskar Guðmundsson, *Snorri: Ævisaga Snorra Sturlusonar 1179–1241* (Reykjavík: JP útgáfa, 2009), 243.

200 **heraldry:** Caldwell et al. (2010), 38; James Robinson, *The Lewis Chessmen* (London: British Museum Press, 2004), 26.

200 *lioncels rampant or:* Neil Stratford, *The Lewis Chessmen and the Enigma of the Hoard* (London: British Museum Press, 1997), 38.

200 **nasals:** Caldwell et al. (2009), 194; Madden (1832), 299, 261.

201 **"Sigurd the Dragon-Slayer":** Hylestad portal, Universitetets Oldsaksamling, Oslo; Caldwell et al. (2009), 195; Erla Bergendahl Hohler, *Norwegian Stave Church Sculpture* (Oslo: Scandinavian University Press, 1999), II: 102.

201 **bowler hats:** *Life of Saint Aubin,* Bibliothèque nationale, Paris (NAL 1390, folio 7); *Vikings: The North Atlantic Saga,* ed. William Fitzhugh and Elisabeth I. Ward (Washington, DC: Smithsonian Institution Press, 2000), 117.

201 **"carinated":** The Crusader Bible, The Morgan Library and Museum, New York (MS M.638, fol. 23v), www.themorgan.org/exhibitions/Crusader-Bible; Caldwell et al. (2009), 194.

202 **"good understanding":** Caldwell et al. (2010), 66.

202 **"power of legend," "by permission of Mr. Roderick Pirie":** Stratford (1997), 8, 50.

203 **"contradictory statements," "by some oversight":** David Laing, "A Brief Notice of the Small Figure Cut in Ivory . . . Discovered in Dunstaffnage Castle: Paper Read to the Society of Antiquaries of Scotland, 11 March 1833," *Archaeologia Scotia* 4 (1857): 369.

203 **"If our Trustees do not purchase them":** Frederic Madden, cited by Stratford (1997), 4–5.

203 **"Some months ago":** Madden (1832), 211–12.

204 **Charles Kirkpatrick Sharpe:** Patrick Cadell, "Sharpe, Charles Kirkpatrick (1781–1851)," in *Oxford Dictionary of National Biography,* Vol. 50, ed. H. C. G. Matthew and Brian Harrison (Oxford: Oxford University Press, 2004), 45–46; Laing (1857), 367, 369; Caldwell et al. (2009), 168; Daniel Wilson, *The Archaeology and Prehistoric Annals of Scotland* (Edinburgh: Sutherland and Knox, 1851), 567n.

204 **Lord Londesborough:** Stratford (1997), 9.

205 **Hugh Monro:** Reverend Murdo Macaulay, *Aspects of the Religious History of Lewis up to the Disruption of 1843* (Inverness: John G. Eccles, 1980), 102, 108, 186, 103; Reverend Hugh Monro, "Parish of Uig, County of Ross and Cromarty," in *Statistical Account of Scotland, 1791–99,* Vol. 19, 280, 283, 286, http://stat-acc-scot.edina.ac.uk/link /1791–99/Ross%20and%20Cromarty/Uig/.

206 **Mealasta, Mangersta:** Caldwell et al. (2010), 17; Dave Roberts, interviewed in Uig, Lewis, June 14, 2014; David Caldwell, interviewed in Edinburgh, November 16, 2013; Mary MacLeod Rivett, interviewed in Uig, Lewis, June 13, 2014; Caldwell et al. (2009), 172; James Graham-Campbell and Colleen Batey, *Vikings in Scotland* (Edinburgh: Edinburgh University Press, 1988, rpt. 2001), 72, 74; Helgi Guðmundsson, *Um Haf Innan* (Reykjavík: Háskólaútgáfan, 1997), 56.

207 **discovered a skull:** A. J. Dunwell et al., "A Viking Age Cemetery at Cnip, Uig, Isle of Lewis," *Proceedings of the Society of Antiquaries of Scotland* 125 (1995): 719–52.

208 **Ardroil:** Bill Lawson. *Lewis: The West Coast in History and Legend* (Edinburgh: Birlinn Ltd., 2008), 220, 222.

208 **Uig Bay comes to life:** Mary MacLeod Rivett, interviewed in Uig, Lewis, June 13, 2014.

209 **"The Red Ghillie":** F. W. L. Thomas, "Notes on the Lewis Chessmen," *Proceedings of the Society of Antiquaries of Scotland* 4 (1863): 411–13; Caldwell et al. (2010), 15, 16; Mary MacLeod Rivett, interviewed in Uig, Lewis, June 13, 2014.

210 **Clearances:** Lawson (2008), 221–22; Anon., *Discovering Uig* (Uig, Lewis: Uig Community Centre Association, 1996; revised Uig Community Council, 2011), 20.

210 **handles for knives:** Helle Reinholdt, "En pragtkniv og andre ting fra dagligdagen på Øm," in *Øm Kloster: Kapitler af et middelalderligt cistercienserabbedis historie,* ed. Bo Gregersen and Carsten Selch Jensen (Ry, Denmark: Syddanks Universitetsforlag, 2003), 135–43; Morten Lilleøren, "The Most Dangerous Chess Piece," *Chess News,* March 23, 2014, http://en.chessbase.com/post/the-most-dangerous-chess-piece.

210 **a new version:** Wilson (1851), 566; *The Royal Commission on Ancient and Historical Monuments and Constructions of Scotland, Ninth Report* (Edinburgh: His Majesty's Stationery Office, 1928), 23–24; Donald MacDonald, *Tales and Traditions of the Lews* (Edinburgh: Birlinn, 2009), 114.

212 **three pounds:** Caldwell et al. (2010), 22.

212 **most recent version:** Finlay MacLeod, personal correspondence, July 21, 2014, and http://www.uigtrail.com/the-stories; Mary MacLeod Rivett, interviewed in Uig, Lewis, June 13, 2014; Caldwell et al. (2009), 171.

214 **"ruin of some note":** Madden (1832), 212.

214 **Reverend MacLeod:** Reverend Alexander MacLeod, "Parish of Uig," in *Statistical Account of Scotland of 1834–45,* Vol. 14, 151–56, http://stat-acc-scot.edina.ac.uk/link

/1834–45/Ross%20and%20Cromarty/Uig/; MacDonald (2009), 116; Macaulay (1980), 173, 175, 177, 186, 195; Anon., "A Revival of Religion in the Isle of Lewis," *Scottish Christian Herald* July 16, 1836, 310–12.

216 **Walter Scott:** W. E. K. Anderson, ed., *The Journal of Sir Walter Scott* (Oxford: Clarendon Press, 1972), xxiii, xxix, xlv, 621, 667; Carlyle, quoted by Wilson (1851), xi.

217 **"crass errors":** Julian D'Arcy and Kirsten Wolf, "Sir Walter Scott and Eyrbyggja Saga," in *Studies in Scottish Literature* 22 (1987): 30–34.

217 **"mysterious and sublime":** Andrew Wawn, in *Approaches to Vínland,* ed. Wawn and Þórunn Sigurðardóttir (Reykjavík: Sigurðar Nordal Institute, 2001), 195.

217 **"William and the Werewolf":** Walter W. Skeat, *The Romance of William of Palerne* (London: Early English Text Society, 1867; rpt. 1890), ii, ix.

218 **scholarly precision, "congealed lumps," "Bibliomaniac," "furious":** Robert W. and Gretchen P. Ackerman, *Sir Frederic Madden: A Biographical Sketch and Bibliography* (New York: Garland Publishing, 1979), ix, 4–5, 15, 41.

218 **"amiably torpid," "buyer's market," "extravagances," "booby":** Michael Borrie, "Madden, Sir Frederic (1801–1873)," in *Oxford Dictionary of National Biography,* Vol. 36 (2004), 67–68.

219 **At Cambridge:** T. D. Rogers, ed., *Sir Frederic Madden at Cambridge* (Cambridge: Cambridge Bibliographical Society, 1980), x, xi, 2.

219 **October 17, 1831:** Anderson (1972), 667 note; Stratford (1997), 4–5, 8.

221 **"tour-de-force":** Stratford (1997), 5; Madden (1832), 271.

222 **South Uist:** Else Roesdahl, in *Viking and Norse in the North Atlantic,* ed. Adras Mortensen and Simun V. Arge (Tórshavn, Faroe Islands: Annales Societatis Scientiarum Faeroensis Supplementum 44, (2005), 188.

222 **made in Scotland:** Wilson (1851), xiv; Thomas (1863), 413.

223 **call to "repatriate":** Charlene Sweeney, "MPs Angered by 'Norwegian' Chessmen," *The Times,* February 24, 2010; James Morgan, "Museum Repels Salmond's Opening Move to Repatriate Lewis Chessmen," *Herald Scotland,* December 24, 2007; Arifa Akbar, "Salmond Makes First Move in Battle to Win Back Lewis Chessmen," *The Independent,* December 26, 2007; Ian Jack, "Our Chessmen Were Taken, but Scotland Is Heaving with Stolen Art," *The Guardian,* January 11, 2008; Derek Fincham, "The Distinctiveness of Property and Heritage," *Penn State Law Review* (2011): 641, 679; Scottish Democratic Alliance, "The Future Governance of Scotland," January 18, 2012, http://scottishdemocraticalliance.org; Tim Cornwell, "Lewis Chessmen Reunited with Mates," *The Scotsman,* May 21, 2010; Taylor Edgar, "Politicians Welcome Start of Lewis Chessmen Tour," *Stornoway Gazette,* May 20, 2010; "Permanent Exhibition for Lewis Chessmen," *Hebrides News,* June 13, 2012.

224 **Willard Fiske:** Patrick Stevens et al., "The Passionate Collector: Willard Fiske and His Libraries," Cornell University Library Web site, http://rmc.library.cornell.edu/collector/index.html; Willard Fiske, *Chess in Iceland* (Florence, Italy: Florentine Typographical Society, 1905), 33, 36, 42.

225 **H. J. R. Murray:** David Shenk, *The Immortal Game* (New York: Doubleday, 2006), 46–47; H. J. R. Murray, *A History of Chess* (Oxford: Clarendon Press, 1913), 759.

225 **drinking horns:** Ellen Marie Mageröy, *Islandsk Hornskurd* (Copenhagen: C. A. Reitzels Forlag, 2000), 4, 34.

226 **"British origin":** O. M. Dalton, *Catalogue of the Ivory Carvings of the Christian Era in the British Museum* (London: British Museum, 1909), 63–64.

226 **"distinctly Norwegian":** A. Goldschmidt, *Die Elfenbeinskulpturen aus der Romansichen Zeit* (Berlin: Deutscher Verlag für Kunstwissenschaft, 1923–26), III: 50–51, IV: 4–8 and plates 69–72; Goldschmidt, quoted in Christopher McLees and Øystein Ekroll, "A Drawing of a Medieval Ivory Chess Piece from the 12th-Century Church of St Olav, Trondheim, Norway," *Medieval Archaeology* 34 (1990): 153.

226 **two museums:** Taylor (1978), 12; Stratford (1997), 41; British Museum Press Office, "The Lewis Chessmen" (January 2008), http://www.britishmuseum.org/about_us/news_and_press/statements/the_lewis_chessmen.aspx; James Robinson, *Objects in Focus: The Lewis Chessmen* (London: British Museum Press, 2004), 14; James

Robinson, "#61 Lewis Chessmen," *A History of the World in 100 Objects*, http://www.bbc
.co.uk/ahistoryoftheworld/objects/LcdERPxmQ_a2npYstOwVkA; Caldwell et al.
(2010), 67; National Museum of Scotland, "Scottish History and Archaeology Collec-
tion: Lewis Chessmen Fact File," http://www.nms.ac.uk/explore/collections-stories
/scottish-history-and-archaeology/lewis-chessmen/.

227 **Icelandic theory:** Morten Lilleøren, "The Lewis Chessmen Were Never Anywhere
Near Iceland!" ChessCafe.com (February 2011), http://en.chessbase.com/post/nor
wegian-icelandic-war-over-the-lewis-chemen-; Bera Nordal, "Af tanntafli útskurður
í röstungstönn," *Árbók Listasafns Íslands* (1990–92): 31–49; Kristján Eldjárn, Håkon
Christie, and Jón Steffensen, *Skálholt Fornleifarannsóknir 1954–1958* (Reykjavík: Lög-
berg, 1988), 21–45; H. Guðmundsson (1997), 36–84; Helgi Þorláksson, in Orri Vés-
teinsson et al., *Reykjavík 871±2* (Reykjavík: Reykjavík City Museum, 2006), 58–59;
Guðmundur G. Þórarinsson and Einar S. Einarsson, interviewed in Reykjavík, May
23, 2013.

230 **"On reflection":** Alex Woolf, quoted in Guðmundur G. Þórarinsson, *The Enigma of
The Lewis Chessmen: The Icelandic Theory*, 3rd ed. (Reykjavík: Gallery Chess, 2014),
52.

230 **"It's absolutely clear":** David Caldwell, interviewed in Edinburgh, November 16,
2013.

230 **Margret's ivory workshop:** Mjöll Snæsdóttir, interviewed in Reykjavík, May 24, 2013;
Guðmundur G. Þórarinsson interviewed in Reykjavík, May 23, 2013.

231 **Siglunes chessman:** Fornleifastofnun Íslands, Reykjavík; Birna Lárusdóttir, inter-
viewed in Reykjavík, May 24, 2013, and May 23, 2014; Colleen E. Batey, in *Upp á Yfir-
borðið*, ed. Orri Vésteinsson et al. (Reykjavík: Fornleifastofnun Íslands, 2011), 65; Orri
Vésteinsson et al., *Archaeological Investigations at Sveigakot 2003* (Reykjavík: Fornlei-
fastofnun Íslands, 2004), 39.

Select Bibliography

THE LEWIS CHESSMEN

Boehm, Barbara Drake, et al. "The Game of Kings: Medieval Ivory Chessmen from the Isle of Lewis." Exhibition blog, online at http://www.metmuseum.org/exhibitions /listings/2011/the-game-of-kings-medieval-ivory-chessmen-from-the-isle-of-lewis /exhibition-blog.

Caldwell, David H. and Mark A. Hall, eds. *The Lewis Chessmen: New Perspectives.* Edinburgh: National Museums of Scotland, 2014.

Caldwell, David H., Mark A. Hall, and Caroline M. Wilkinson. "The Lewis Hoard of Gaming Pieces: A Re-examination of Their Context, Meanings, Discovery and Manufacture." *Medieval Archaeology* 53 (2009): 155–203.

Caldwell, David H., Mark A. Hall, and Caroline M. Wilkinson. *The Lewis Chessmen Unmasked.* Edinburgh: NMS Enterprises, 2010.

Madden, Frederic. "Historical Remarks on the Introduction of the Game of Chess into Europe, and on the Ancient Chessmen Discovered in the Isle of Lewis." *Archaeologia* 24 (1832): 203–91.

McLees, Christopher, and Øystein Ekroll. "A Drawing of a Medieval Ivory Chess Piece from the 12th-Century Church of St Olav, Trondheim, Norway." *Medieval Archaeology* 34 (1990): 151–54.

Nordal, Bera. "Af tanntafli: útskurður í rostungstönn." *Árbók Listasafns Íslands* (1990–92): 31–49.

Robinson, James. *The Lewis Chessmen.* London: British Museum Press, 2004.

Stratford, Neil. *The Lewis Chessmen and the Enigma of the Hoard.* London: British Museum Press, 1997.

Taylor, Michael. *The Lewis Chessmen.* London: British Museum Press, 1978.

Þórarinsson, Guðmundur G. *The Enigma of the Lewis Chessmen: The Icelandic Theory,* 3rd ed., rev. Reykjavík: Gallery Chess, 2014.

THE HISTORY OF CHESS

Eales, Richard. *Chess: The History of a Game.* New York: Facts On File, 1985.

Fiske, Willard. *Chess in Iceland.* Florence, Italy: Florentine Typographical Society, 1905.

Gamer, Helena M. "The Earliest Evidence of Chess in Western Literature: The Einsiedeln Verses." *Speculum* 29 (October 1954): 734–50.

McLees, Christopher. *Games People Played: Gaming Pieces, Boards, and Dice from Excavations in the Medieval Town of Trondheim, Norway.* Trondheim: Riksantikvaren Utgravningskontoret for Trondheim, 1990.

Murray, H. J. R. *A History of Chess.* Oxford: Clarendon Press, 1913.

Spjuth, Oskar. "In Quest for the Lost Gamers: An Investigation of Board Gaming in Scania, during the Iron and Middle Ages." Master's thesis in historical archaeology. Lund, Sweden: Lund University, 2012.

Yalom, Marilyn. *Birth of the Chess Queen*. New York: HarperCollins, 2004.

THE VIKING AGE

Brink, Stefan, and Neil Price, eds. *The Viking World*. New York: Routledge, 2008.

Clarke, Howard B., Máire Ní Mhaonaigh, and Raghnall Ó Floinn, eds. *Ireland and Scandinavia in the Early Viking Age*. Dublin: Four Courts Press, 1998.

Fitzhugh, William W., and Elisabeth I. Ward, eds. *Vikings: The North Atlantic Saga*. Washington, DC: Smithsonian Institution Press, 2000.

Graham-Campbell, James, ed., with Colleen Batey, Helen Clarke, R. I. Page, and Neil S. Price. *Cultural Atlas of the Viking World*. New York: Facts On File, 1994.

Roesdahl, Else. "Walrus Ivory—Demand, Supply, Workshops, and Greenland." In *Viking and Norse in the North Atlantic: Select Papers from the Proceedings of the Fourteenth Viking Congress, Tórshavn, 19–30 July 2001*, pp. 182–91. Ed. Adras Mortensen and Simun V. Arge. Tórshavn, Faroe Islands: Annales Societatis Scientiarum Faeroensis, Supplement 44, 2005.

Roesdahl, Else, and David M. Wilson, eds. *Viking to Crusader: The Scandinavians and Europe 800–1200*. New York: Rizzoli, 1992.

Williams, Gareth, Peter Pentz, and Mattias Wemhoff, eds. *Viking*. Copenhagen: National Museum of Denmark, 2013.

Winroth, Anders. *The Conversion of Scandinavia*. New Haven, CT: Yale University Press, 2012.

THE HISTORY OF ICELAND

Eldjárn, Kristján, Håkon Christie, and Jón Steffensen. *Skálholt: Fornleifarannsóknir 1954–1958*. Reykjavík: Lögberg, 1988.

Eldjárn, Kristján, and Hörðir Ágústsson. *Skálholt: Skrúði og áhöld*. Reykjavík: Hið íslenska bókmenntafélag, 1992.

Guðmundsson, Helgi. *Um Haf Innan*. Reykjavík: Háskólaútgáfan, 1997.

Hermannsson, Halldór. *Saemund Sigfússon and the Oddaverjar*. Ithaca, NY: Cornell University Press, 1932.

Magnússon, Thór. *A Showcase of Icelandic National Treasures*. Reykjavík: Iceland Review, 1987.

Nordal, Guðrún. *Tools of Literacy: The Role of Skaldic Verse in Icelandic Textual Culture of the Twelfth and Thirteenth Centuries*. Toronto: University of Toronto Press, 2001.

Pierce, Elizabeth. "Walrus Hunting and the Ivory Trade in Early Iceland." *Archaeologia Islandica* 7 (2009): 55–63.

Rafnsson, Sveinbjörn. *Páll Jónsson Skálholtsbiskup*. Reykjavík: Sagnfræðistofnun Háskóla Íslands, 1993.

Snæsdóttir, Mjöll, Gavin Lucas, and Orri Vésteinsson. *Saga Biskupsstólanna: Fornleifar og rannsóknir í Skálholti*. Reykjavík: Bókaútgáfan Hólar, 2006.

Vésteinsson, Orri, Helgi Þorláksson, and Árni Einarsson. *Reykjavík 871±2: The Settlement Exhibition*. Reykjavík: Reykjavík City Museum, 2006.

THE NORWEGIAN EMPIRE

Andås, Margrete Syrstad, Øystein Ekroll, Andreas Haug, and Nils Holger Petersen, eds. *The Medieval Cathedral of Trondheim*. Turnhout, Belgium: Brepols, 2007.

Bjørlykke, Kristin, Øystein Ekroll, Birgitta Syrstad Gran, and Marianne Herman, eds. *Eystein Erlendsson: Erkebiskop, politiker, og kirkebygger*. Trondheim, Norway: Nidaros Domkirkes Restaureringsarbeiders forlag, 2012.

Blindheim, Martin. *Norwegian Medieval Art Abroad*. Oslo, Norway: Universitet Oldsakssamling, 1972.

Blindheim, Martin. *Norwegian Romanesque Decorative Sculpture 1090–1210*. London: A. Tiranti, 1965.

Crawford, Barbara. *Scandinavian Scotland*. Leicester, UK: Leicester University Press, 1987.

Ekroll, Øysteinn, Jill I. Løhre Krokstad, and Tove Søreide, eds. *Nidaros Cathedral and the Archbishop's Palace*. Trondheim, Norway: Nidaros Cathedral Restoration Workshop, 1995.

Friis-Jensen, Karsten, and Inge Skovgård-Petersen. *Archbishop Absalon of Lund and His World*. Roskilde, Denmark: Roskilde museums forlag, 2000.

Hohler, Erla Bergendahl. *Norwegian Stave Church Sculpture*, Vols. 1 and 2. Oslo, Norway: Scandinavian University Press, 1999.

Imsen, Steinar, ed. *Ecclesia Nidrosiensis 1153–1537*. Trondheim, Norway: Tapir Academic Press, 2003.

Imsen, Steinar, ed. *Taxes, Tributes and Tributary Lands in the Making of Scandinavian Kingdoms in the Middle Ages*. Trondheim, Norway: Tapir Academic Press, 2011.

Iversen, Tore, ed. *Archbishop Eystein as Legislator*. Trondheim, Norway: Tapir Academic Press, 2011.

Index